HENRI FOCILLON

THE ART OF THE WEST

ROMANESQUE ART

PHAIDON

THE ART OF THE WEST BY HENRI FOCILLON

VOLUME ONE · ROMANESQUE ART

VOLUME TWO · GOTHIC ART

TRANSLATED FROM THE FRENCH BY DONALD KING

WITH A GLOSSARY BY P. KIDSON

HENRI FOCILLON

THE ART
OF THE WEST

IN THE MIDDLE AGES

EDITED AND INTRODUCED

BY JEAN BONY

VOLUME ONE · ROMANESQUE ART

PHAIDON · LONDON & NEW YORK

© 1963 PHAIDON PRESS LTD · 5 CROMWELL PLACE · LONDON SW7
FIRST PUBLISHED 1963
SECOND EDITION 1969

PHAIDON PUBLISHERS INC · NEW YORK
DISTRIBUTORS IN THE UNITED STATES: FREDERICK A. PRAEGER INC
111 FOURTH AVENUE · NEW YORK · N.Y. 10003
LIBRARY OF CONGRESS CATALOG CARD NUMBER: 69–12792

Original French Text
ART D'OCCIDENT
first published by Librairie Armand Colin, Paris

Volume 1: SBN 7148 1352 4 (paper); SBN 7148 1357 5 (cloth)
Volume 2: SBN 7148 1353 2 (paper); SBN 7148 1358 3 (cloth)

MADE IN GREAT BRITAIN
PRINTED BY LONSDALE AND BARTHOLOMEW LTD · LEICESTER

CONTENTS

CHAPTER II (CONTINUED)

Norman art and its expansion. England. Flanders and neighbouring territories. Imperial art in Germany. The mediterranean zone. Italy.—Romanesque art in the crusading territories. Importation. New East-West contacts. Spain. The Holy Land. Bibliography.

CHAPTER III. ROMANESQUE DECORATION

PAGE 102

I. The epic sentiment in the iconography. The Apocalyptic source. Visionary theology. The ancient East. Theophany. The metamorphosis of man. II. The style. The architectural character of sculpture. The positioning of Romanesque sculpture. The form determined by the setting. The capital, the archivolt, the tympanum. The rectangular panel and the principle of contacts. Experiments to achieve movement.—The decorative character of the sculpture. Romanesque sculpture as a dialectic development. III. The sources.—The East Christian communities. Syria, Egypt, Transcaucasia, and Sumerian art.—Islam: geometrical forms.—Ireland: interlacements.—Carolingian art.—Local traditions: the Roman art of Gaul. IV. The question of beginnings. The Burgundy-Languedoc problem. The Spain-Languedoc problem.—The French workshops.—The peripheral groups.—The evolution of sculpture in the twelfth century. The baroque phase of Romanesque art. V. Romanesque art and colour. The problem of polychromy.—Relationships of metalwork, illumination, and wall-painting. The architectural rule governing colour.—Monumental painting. Technique, groups and workshops. Bibliography.

HENRI FOCILLON

BY JEAN BONY

HENRI FOCILLON

(1881—1943)

EVERYTHING that Henri Focillon wrote possesses that potent fascination which is the mark of great minds. And this cannot be explained merely by invoking the charm of his style, or the mastery of language which always enabled him to find a vigorous and suggestive turn of phrase. For in reading him what strikes us, over and above his natural and obvious literary gifts, is his unerring vision and the luminous penetration of his intellect. We admire the breadth of outlook with which he defines every problem, the authentic background which he restores to each work and the lucidity with which he conducts the steps of his argument. Hence his writings have been able to preserve over a quarter of a century their exhilarating quality of revelation; students of today discover him with the same astonishment which drew their elders to his lectures at the Sorbonne and, like them, find in him a reflection of the higher qualities of the mind.

Focillon's work has, moreover, the attraction of an extraordinary multiplicity of interests. His books go at most by couples; even his articles form no long, unified series but cover the most varied themes. Few experts have escaped with more sovereign ease from the bonds of specialisation. To each subject he brought an almost exhaustive knowledge and the attitude of mind peculiar to the specialist; but he was a specialist who seemed to have the power to vary his speciality at will, and the breadth of his scope is astonishing.

The sequence of his works does, it is true, enable us to draw a kind of graph of the main themes of his study. For more than ten years, during the whole of his period at Lyon, where he was both a professor of the University and director of the municipal museums, Focillon's interests were concentrated partly on engraving, and partly on the nineteenth century, whose inexhaustible vitality fascinated him. After his big book on Piranesi and a series of essays, extremely diverse in subject but generally gravitating around the great masters of the print, from Dürer, Elsheimer and Rembrandt down to Daumier and the lithographs of Manet, he undertook his two major volumes on nineteenth-century painting, which remain the most complete, subtle and suggestive treatment of that great theme. But in 1924, elected to succeed Emile Mâle at the Sorbonne, Focillon had to turn suddenly to medieval studies. Nor was that all, for within a few years he revolutionized both the approach to and even the very meaning assigned to Romanesque sculpture, and defined with new precision the stages in its forma-

tion. Turning thence to the origins of Gothic architecture, he wrought a no less fundamental transformation in the accepted view of its early development and its successive definitions of space and form. His researches extended to French Romanesque painting, of which he published the first systematic study, and to the later Middle Ages, where he revealed the presence of persistent and resurgent elements which had never formerly been analyzed. It is the medievalist that we find in *Art of the West*; but by about 1938 the main orientation of his researches had perhaps already shifted towards other problems. His celebrated courses of lectures on Fouquet and Piero della Francesca had already demonstrated his interest in the beginnings of the Renaissance, and his first lectures at the Collège de France pointed to a reinterpretation of this period as audacious as that which he had already effected in medieval studies. But for the brutal interruption brought about by the war, he would certainly have contributed fundamental revelations in this field also.

Such a schematic sequence of his main lines of study does not, however, conform strictly to the truth: Focillon's researches were always extremely varied, and when a complete bibliography of his writings is published it will undoubtedly show that some of his apparently most diverse enquiries were in fact proceeding simultaneously, and that certain themes recurred, like a counterpoint, in the background of his current interests.

No doubt Focillon owed this universal aptitude, this breadth of grasp to his far-ranging culture and intense intellectual curiosity, but still more to his wide sympathies and the richness of his personality. For his contacts with the works and life of the past were not merely intellectual, but intimate and vital, involving the whole man. Moreover, his discovery of the world of art was not inspired by books or museums. From childhood he had lived among artists, some of them very distinguished. At home he had seen Monet, Carrière and Rodin, who were all friends of his father, Victor Focillon, a well-known engraver; Gustave Geffroy was a family friend. Art had always been a natural part of his existence, not an academic discipline. Again, he was sensitive to all the urgencies and implications of life; he never held himself aloof from the unrest of his times. As a young student he took part in the movement of the *Universités Populaires* initiated by Jaurès, and for some years he continued to publish acute and witty articles on all the political and social questions of the day. Between the wars he engaged himself in work associated with the League of Nations and became one of the moving spirits of the *Institut International de Coopération Intellectuelle* and of the *Centre International des Musées*, which brought him many friends abroad. The second world war immersed him once more in historical action, making him one of the

spokesmen of Free France and a protagonist, in America, of the France of General de Gaulle as against the France of Vichy. Thus throughout his life he was involved in action; and his wartime writings, discounting the inevitable distortions of polemic, reveal again the wealth of enthusiasm and the warm humanity which enabled him to feel the past in all its rich life, its creative force, its ambitions, agonies and dreams. These human qualities, underlying all his intellectual work and research, explain the acuteness of his perceptions and the exceptional nature of his teaching.

Focillon had all the gifts of a great teacher. He belongs to that great line of masters whose influence is not confined within the walls of his University but leaves its mark on a whole generation. He received invitations from every foreign university and research institute; he held, in association with M. Marcel Aubert, a chair of art history at Yale University; and America had the honour of providing the refuge of his last years. His lectures in Paris attracted famous artists, a rare distinction for an historian. The history of literature and the history of music both benefited by his teaching, for he invariably attacked the fundamental problems of interpretation and method, and inculcated the essential interrogation of reality which is the soul of all research. A teacher can only obtain results of this kind if he can kindle enthusiasm and establish around him an atmosphere of confidence and friendship as well as admiration. To his pupils he was a friend as well as a teacher; his devotion to their interests knew no bounds, and when one thinks of all the hours which he spent every week in directing their work, one realises that with a little less generosity and a more niggardly husbanding of his time, he might well have written the works of which his early death has robbed us. But however precious these conversations were for the formation of those who benefited from them, it was nevertheless in his masterly lectures that Focillon provided the most brilliant demonstration of his method of enquiry; here he could display to the full the agility and penetration of his intellectual processes in alliance with the supreme charm of his oratory.

His eloquence was unforgettable and singularly personal. It commanded at need every tone in the scale. It was lively and precise, yet rich and powerful; you were spellbound by its wealth of associations and versatility of ideas. He underlined it with the authority of his gestures, which seemed to round off and punctuate his periods. For those who heard him, his writings are still resonant with the echoes of his voice. But one must guard here against a possible misunderstanding. One's conception of Focillon's personality would be strangely false if one were to imagine that this oratory was an accessory or extraneous ornament superimposed on the substance of his teaching. This gift of words, on

which he played like a great virtuoso, and the prodigious wealth of his vocabu-
lary were far from mere decoration. They were an integral factor in his processes
of understanding; and one was privileged at his lectures to discern through this
glittering surface the very formation of his thought.

When, having formulated an idea, he set out, seemingly improvising, to turn it
in all directions to ascertain its limits and define its content more precisely, the
words which he chose or rejected, the epithets which he touched in so delicately,
represented a strict operation of thought. In this way he spun all around his
subject a network of precise concepts which enabled him to chart its exact posi-
tion in the topography of the spirit. He would accept no approximate expression.
Each new concept, even if disguised at first in the still uncertain form of an
adjective, would be taken up again subsequently for its own sake, confronted with
related concepts and, at the end of this elaboration, would emerge as one more
serviceable tool, ready to bite more deeply into the aspect of reality which was
being studied or to glide more subtly over the contours of its surface. If one
considers his analysis of the nature of Romanesque sculpture, or recalls the
lectures at the Collège de France in which he developed his method of research
into the visionaries of the later Middle Ages, one recognizes that his words were
simultaneously the instrument of his enquiry and the mirror of his thought. In
this way, exercising the discernment of a great technician, he was able to create
for each subject and each special case the most appropriate and penetrating intel-
lectual tools. He never cultivated style for style's sake, and the cadences of his
phrases, their repetitions and conclusions, are the immediate expression of the
progress, the articulations and the fluid arabesque of a thought ever searching.

Certainly Focillon was not one of those for whom aridity of thought and
poverty of expression are the criteria of serious study. He realised that every
restriction of vocabulary is the material indication of an impoverishment of the
perspectives of the mind, and the very nature of his themes forced him to invoke
all the expressive resources of language and all its formulative powers. He was too
much aware of the quality of a work of art, the totality of emotion and meditation
which it incorporated and the unique individuality of its human message, ever to
lose sight of the art-historian's responsibility towards the artist whom he pre-
sumes to discuss. How can one do justice, with a poverty-stricken vocabulary, to
men who create new worlds and confer new poetry on human life? This sense of
the presence of the individual never lost its rare freshness and intensity in
Focillon. He could see the artist at work before him, with his tools and his
materials, bound by his habits and traditions, but engaged in an experiment
whose effects are unforeseeable. He was thus in no danger of losing himself in

artificial classifications or labyrinths of abstraction; this human contact, which
he was able to maintain throughout his analysis, was the guarantee of the truth
of his appreciation. Even in the most anonymous, the least documented work he
could detect some revealing hint of an unexpected inflexion, and it seemed that
no phase or convolution of the creative process could escape his eye. He could
not have communicated all this wealth of understanding without having re-
course to a vast treasury of expression. But Focillon was not the man to be
content with imprecise evocations or a vaguely impressionistic rendering, and the
greatness of his achievement lay in his rejection of all but the sharpest tools and
in his ability to introduce into the field of subtle perception the flawless precision
of the geometer.

It was for this reason that Focillon was justified in his preoccupation with
method. For him this word did not signify a more or less mechanical transmission
of certain elementary rules of verification, classification or scientific prudence: it
represented in his view the entire scope of the act of intellectual enquiry. His
critical mind never ceased to question the appropriateness and validity of the
means of study which were being applied to a question and it was thanks to this
constant awareness that he invariably succeeded in penetrating to the heart of
the problem, distinguishing its most subtle components, defining factors which
had hitherto remained intangible, and opening luminous perspectives in the
most impenetrable and sombre thickets of human sensibility.

THE best introduction to Henri Focillon's method remains the little book
which he published in 1934 under the title *Vie des Formes* and which, several
times reprinted and translated, is available in an English version, *The Life of Forms
in Art*, produced shortly before his death by his pupils at Yale University. This
book has the advantage of assembling in concise form and clear order the diverse
points of view and the multiple researches which were one of the most essential
characteristics of his development. But it must not be forgotten that this brief
summary gives at times a certain rigidity to what, in Focillon, remained infinitely
fluid and in a state of perpetual discovery. Rapidity of survey, just appreciation
of the elements of a problem and ability to re-orient an idea were no less essential
to his method than the application of more easily formulated principles. In this
respect, *Art of the West* remains a richer and more varied illustration of his
method in action. In it we find the expression, one after another, of the main
positions of his thought, and we find also his power of transforming a problem, of
illuminating obscure interchanges, and of discovering the central point in which a

style reveals its internal laws and the multiplicity of converging lines which come together in it. And yet, for one who followed his lectures over the years and who knew his teaching as it was, even *Art of the West* is too brief and skeletal a summary. What is needed, if it were possible, is to re-read *Vie des Formes* in the light of all that he said and wrote.

Focillon had the gift of coining forceful phrases, which impress themselves in the memory and mark the stages of the argument. But he mistrusted these instruments, whose very efficacy made them suspect, and he would often remodel and correct his happiest inventions, modifying their application, indicating possible variants and, in short, re-introducing them into the flux of life. In 1936, soon after the publication of *Vie des Formes*, he made the following comment on the significance of his work: 'I did not begin with a system. It was only after long years of work that I believed myself able to publish certain conclusions. Originally I aimed to become the naturalist of these imaginary worlds. And then it seemed to me a more useful and perhaps a finer thing to sketch out, even with imperfect strokes, the very special logic which presides over their creation and dominates their development. I have tried to indicate the relationship between this logic and the life of history. But this study of cause and effect is at the same time a study in free-will.'

One understands why Focillon felt the need, at a certain stage, to formulate and set down as precisely as possible the main principles of his method. But one senses also that, in his eyes, the attempt was not free from risk, by reason of the inevitable rigidity of any succinct definition of an idea. And it is certain that, to rediscover the truth of his thought, we ought to enrich each formula with all its innumerable varieties of application in the cases which he examined.

We must take care, therefore, not to distort the perspective of his mental processes, and when he gives a schematic expression to a particular idea, we should endeavour to envisage its context and the sequence of thought which determined its formulation. One example will suffice. Focillon often summarised the evolution of styles in the form of three periods: experimental, classical and baroque. But this formula was valid for him only as a leading thread. It symbolized a certain trend of thought, a re-agent whose effect might be tried, but it was in no sense a fixed inviolable framework, much less a satisfactory explanation. He did feel, on the other hand, in common with many others, that the human spirit inclines in certain given situations to follow certain natural tendencies and it was on the plane of human reactions, not of some metaphysical predestination, that he developed his speculations concerning the recurrence in history of curves of development which are, to some extent, analogous. As for the

triple formula, it was above all a precaution against the narrowness of the anti-nomies of Wölfflin: preceding the achievements of classical and post-classical periods, there is always a fundamental period of experiments, a period of dis-coverers, who explore new paths and re-create the world. In such periods, things happen differently and other spiritual qualities are needed to produce great artists. But his brief formula was never intended as an assertion that a style is composed of three periods and three only, nor that the experimental periods comprise only experiments and innovators.

Anyone who worked with Focillon on the beginnings of Romanesque sculpture or on early Gothic art, will know that he was always searching, all through the history of a style and from its very earliest stages, for signs of anticipated evolu-tion, for hints of static academism or nascent mannerism, as well as survivals from preceding periods. If he applied the term "Rayonnant" to Romsey, or to the south transept of Soissons sixty years later, the reason is that in both buildings he detected symptoms of a kind of historical short-circuit producing architectural styles which were already moving towards a skeletal system and the elegant effects of the transparent wall. But these precociously advanced developments were interrupted and swept aside by the vigour of new experiments. Similarly, after the classical formulae of a style had been established and in the midst of the classical phase itself, no one was more aware than Focillon of the innumerable modulations of sensibility, the refinements, the purisms, the nostalgias, contemp-lative or violent, the renewals of energy, baroque or visionary, and all the oscilla-tions in the life of the spirit which echo and re-echo, sometimes for centuries, until art moves on into some new cycle of fundamental experiments. He was always on the look-out for the inventive and daring genius, for audacity, fruitful or abortive, for the new departures and for the failures of history. His formulae were never more than instruments in the service of his intellect, and sometimes no more than working hypotheses or possible lines of enquiry. But it was the multiplicity of his tools which made him a kind of engineer of discovery and one of the most penetrating historians of our century. Since Focillon, we can no longer speak as we once did of Romanesque sculpture, Gothic architecture or late medieval painting. Indeed, no one can work at all in the field of art history in quite the same way as before.

THE TECHNICAL DATA

THE two points on which he expressed the most novel opinions are doubtless that of the role of techniques and that of the structure of historical time, and we

shall do well to examine in some detail the development of these two aspects of
his thought, for they will help us both to comprehend its originality and to
assess the value of the implements which he added to the apparatus of research.

Analysis of the technical data and the speculations to which they give rise
recurs like a Leitmotiv throughout Focillon's work. It was one of his main pre-
occupations, because he felt himself here to be in touch with one of the primordial
realities, the understanding of which would make it possible to reveal the secrets
of the creative spirit in action. At the beginning of the present century historians
and philosophers were still inclined, more or less consciously, to relegate to the
background the material aspects of art. In their reasoning, technique intervened
only as an accessory and almost superfluous factor, even an undesirable one, for,
it was said, it often impeded the realization of the most daring artistic concep-
tions. The idea of form itself tended to become too exclusively intellectual and
dematerialized. Focillon reacted strongly towards emphasizing the material
aspect; his own youthful experiments had given him a totally different under-
standing of the nature of creative effort. He was always, he tells us, 'attracted by
the secrets of matter and tool', and as early as 1919 he formulated his views
clearly in the preface to a collection of essays whose title is in itself revealing:
Technique et Sentiment. 'In my father's studio,' he wrote, 'I learned the touch of
all the tools of art, to recognize them, name them, handle them and love them.
Warm with humanity and bright with use, they were in my eyes not inanimate
instruments but forces endowed with life, not the curious apparatus of a labora-
tory but powers of magical suggestion.'

And, immediately, he makes a twofold protest. 'Our current conception of
technique is both inactive and narrow. Instruction in the schools only touches
the surface of its first secrets. Technique cannot be summarized in text-books
and manuals. It is a perpetual discovery.' Focillon does not stop there but, carry-
ing the argument into his own territory, that of the genesis of art, he denounces
the sterility of the idealist aesthetic which even now too often underlies the
historian's judgments. We must 'make a decisive break with the outworn forms
of idealism, with the idea of the solidity of matter as opposed to the subtle
essence and the creative gifts of the spirit'. This elementary dualism, invented by
theoreticians, is contrary to the reality of art as lived by artists, for in art matter
is not passive. 'So long as art is limited to states of consciousness and to generalized
ideas, it is no more than a blind turbulence beneath the surface of the mind.
It must enter into matter, it must accept it and be accepted by it.' In his
relationship with matter, the artist not only subdues it, he obeys it also: the tool
guides the hand and the accidents of the craft often lead to new discoveries. In

his last collection of articles, published shortly before his death, Focillon was still insisting on 'that harmony between hand, matter and tool which transfigures the world.' No doubt the technique of the artist is something more than craft-skill, but it is at this stage of direct contact with matter that the artist creates, that his reactions achieve form and that he discovers the characteristics of his personal style.

As the son of an engraver, it was in engraving that Focillon was first struck by the creative force of a technique. Let us re-read the Introduction to his *Maîtres de l'Estampe*, which dates from 1930: 'A print always possesses an enigmatic quality which derives from its powerful abstraction. It does not struggle to emulate life, but transposes it into a scale of two tones whose harmonies are more imperious than the vast resources of the spectrum. It is concentrated force, acting in depth. . . . Fascinating us by its eternal contrast of night and day, it lends a rich transparency to its shadows and, on its light, bestows a brilliance more strange than that of earthly light. Even when it is reduced to a pure line, the latter derives a mordant strength from the inflexible material in which it is incised. Even as a dot, it shines with hypnotic intensity. . . .' Thus purely technical characteristics define this mode of artistic expression, which contains in some degree its own potentiality of development since it directs the artist's imagination into certain definite channels and into that reflection on the values of the technique which, in Piranesi and Rembrandt, engendered a completely new vision of space and form. It is in this sense that we must understand Focillon's dictum that 'every technique is an environment whose influence equals or surpasses that of the historical environment'.

This definition of an art by its most material qualities is the very foundation of Focillon's method and he applied it in every field to which his researches extended; but there is no doubt that it was in his analysis of Romanesque sculpture that he pressed its application furthest. In *L'art des sculpteurs romans* and, more briefly, in the relevant chapters of *Art of the West*, he was at pains to demonstrate that purely technical considerations, relating to the use of sculpture, its materials and the ways in which they were handled, determined in the minds of the artists a highly individual conception of space, to which forms were forced to adapt themselves, and hence directed the sculptors towards certain clearly definable ways of organizing the forms. It is only when they are replaced in the perspective of these basic technical necessities that the other aspects of sculptural experiment regain their true significance and stature: for 'technique is not only matter, tool and hand . . . it is also mind speculating on space'. In clarifying the interrelationship of the various kinds of speculation to which the

sculptors of the eleventh and twelfth centuries devoted their talents, Focillon produced the first complete explanation of the world of Romanesque forms, and later research has only confirmed the correctness of the positions which he adopted. Each region defined itself through the predominance of certain privileged techniques which seem to have directed the development of sculptural feeling. Stone, plaster and metal each give rise to their own spatial universe. Hence we must not be surprised if, in regions where stone was not the dominant technique, other systems of form came into being. Focillon was the first to insist on this independent life of the different regions and on the tenacious preferences which they often exhibited. At the same time he emphasized the phenomena of transference and interference which operated not only between one region and another but also between one technique and another. It was in these terms that he envisaged the problem of the capitals of the choir of Cluny.

Focillon was scrupulous to carry his reasoning to its ultimate conclusions, thereby testing its validity. He developed his study of Romanesque sculpture on two complementary planes—those of the internal definition and of the historical evolution of the styles. He reconstructed, as a coherent system to some extent independent of time, the stylistic principles of the sculpture of the Romanesque period, defining the structure of its universe of forms and formulating its laws and its peculiar logic. But on the other hand he was at pains to follow its temporal development, retracing the sequence of experiments in which we can recognize its origins and its successive achievements and study, step by step, the progress of artistic discovery.

This concept of experiment, whose intervention we observe here, played a considerable rôle in Focillon's thought and became in his hands a remarkably penetrating instrument of historical research. For it enabled him to surprise in action, in the uniqueness of the moment, the reflections of the individual on his technique, the dialogue between artist and matter which is resumed with greater or less intensity in each new work. Indeed, it is only by this concrete method, by seeking to comprehend the individual, that we can rediscover and understand the authentic significance of a work of art as it emerged into historical time. All Focillon's work might bear as a motto the title he gave to an article on Bourges cathedral: 'genealogy of the unique'. 'We are dealing with sculpture, that is with a certain interpretation of space, and it is by interpreting space with the sculptors, by standing behind them, following with finger and mind the various contours, undulations, reliefs and hollows of their work, that we may have the good fortune to discover their creative secret.' Focillon wrote these words at the beginning of his *Art des sculpteurs romans*. In *Vie des Formes* he came back strongly

on this point, which is indeed the very centre and justification of his method: 'I have always felt that, in these very difficult studies . . . the examination of technical phenomena not only assures us of a certain objectivity, which can be verified, but also takes us into the very heart of the problems by presenting them to us in the same terms and from the same angle as they are seen by the artist.' It is 'by envisaging the technique as a continuing process and by endeavouring to re-construct it in that form' that we may 'penetrate beyond superficial phenomena to grasp the deeper relationships', for technique, considered in this way as the means and even the very substance of the experiment, becomes 'a mode of fundamental understanding, which reflects the process of creation'.

Naturally, the technique of an art can never be considered fixed. It is made up of acquisitions and losses which constantly modify its scope and treatment; it is always being transformed. But none of these transformations can be neglected, since it is here, in this manual, reciprocal contact between mind and matter, that the creative act is located, and not in some empyrean whence form descends, fully armed, to incorporate itself in some indifferent substance.

The Structure of Historical Time

HAVING thus defined a method which allows us to participate in the actual process of discovery, Focillon was led to apply his critical intelligence to a second series of problems. For the historian must comprehend the whole of the historical landscape and his explanations cannot confine themselves to the moments of most intense creative activity. In fact, the artistic production of a period reflects a multitude of other phenomena, often of doubtful meaning, which have to be related to one another and re-established in their true perspective. To achieve this, every historian is forced sooner or later to formulate his conception of the structure and behaviour of historical time.

It is not surprising that it was as an extension of the idea of experiment that Focillon first defined the variable motion of history. One of his last essays echoes his teaching on this point: 'History is a triple sheaf of active forces: traditions, influences, experiments.' Tradition 'represents the collaboration of the past in the historical present'. It is 'a vertical force rising from the depths of ages', but often deflected from its course and adapting itself to new periods by undergoing distortions and, sometimes, fundamental re-interpretations. As for influences, they operate essentially in the present; they are phenomena of horizontal trans-ference, exchanges between different contemporary environments; 'through them, peoples communicate with peoples'. Here too there are many variations:

'these foreign contributions are accepted with varying degrees of passivity, some-times as a result of infiltration, sometimes by sudden impact, sometimes because they respond to a deep-seated need of the community, sometimes because they are disconcertingly alien'. But 'it is the experiments, stimulated by the instinct to discover and create, which enrich and renew history. It is they that bite, as it were, into the future'. Doubtless they are not always successful nor always carried to a conclusion; 'but without them the historical substance would rapidly be-come exhausted, without them there would be no history but mere featureless exchanges between inert forms of conservatism'.

This simple sketch of the interrelationship of the various groups of phenomena which make up the history of the arts already enables us to perceive the trend of Focillon's thought: it was on the analysis of the concepts of simultaneity and actuality that his researches were to be concentrated, in order to restore depth and scale to the perspectives of the individual moment of time. It is important here to notice the mistrust with which he always regarded the word 'evolution'; for the term in itself suggests to the mind the idea of a uniform, continuous time, moving always at the same speed and in the same direction. It is precisely this oversimplified conception of the structure of time that the historian must over-come: 'History is not a single line, nor a simple sequence. . . .' 'Even a brief period of historical time comprises a great number of stages or strata. History is not the Hegelian state of becoming. It is not a river carrying events and the debris of events always at the same pace and in the same direction. What we call history is in fact produced by the very diversity and inequality of the currents.' And, returning once more to the metaphor of geological strata, he insists on the need for the art-historian to make not merely sections but strict stratigraphical analyses, which alone can reveal the complex structure of the historical present and demonstrate the simultaneous existence of data belonging to dif-ferent periods of time. 'The various environments of a period are not all living the same moment of time'; the present is not made up of a set of happy coinci-dences, but is primarily an interplay of discords. Experiment, achievement, decadence exist side by side. The movements of history rarely coincide, and then only for brief periods, for different sequences of facts are moving at different rates. 'History is normally a conflict between the advanced, the contemporary and the retarded.'

This concept of the varying speeds of different groups of simultaneous phenomena is no mere verbal subtlety: it enables us to observe and measure certain very delicate aspects of historical life. 'The history of art,' Focillon wrote in *Vie des Formes*, 'shows us survivals and anticipations juxtaposed in a single

moment of time, slow-moving, belated forms existing alongside bold and rapid forms. A monument of known date may be in advance or retard of that date, and it is precisely for this reason that it is important to date it first.' For chronology alone allows us to determine what is precocious and what retarded; its scales and fixed points enable us to measure the rapidity or languor of the pulse of time in any given environment and period. In fact, this greater or less tension, this urgency or listlessness in the rhythm of their internal time, are elements of the first importance in the definition of the life of the various regions; and it is essential that the historian should be able to grasp and evaluate 'the specific impulses which accelerate or decelerate the life of forms'. Thus the internal dynamism of history begins to reveal itself, and each impulse is assessed to determine its degree of intensity.

It is not enough, however, to isolate exactly the various strata of the historical present, nor to determine their specific wave-lengths. For these various forms of thought, though differing in age, none the less exist simultaneously; therefore they can at any moment coalesce, and a whole series of exchanges may be set up between the different zones of time which are assembled together in the community of the present. All the great events of history have resulted from a sudden contact between actualities of varying speeds. An element of the older one may be picked up and amplified by the other; these are the 'revivals', resurrections of past forms seized by a rapid innovating impulse, in contrast with the sluggish motion of survivals from earlier periods. In the last years of his life Focillon was especially drawn to the study of these resurgent phenomena, demonstrating, for example, the revival of Romanesque methods of composition in Enguerrand Charonton and the return to Gothic monumentality in the delicate painting of Jean Fouquet. The collection of essays on which he was engaged at the time of his death was significantly entitled: *Moyen-Age: Survivances et Réveils*.

Finally, in a single style and even a single work, different levels of thought are not necessarily synchronized. English Gothic architecture is a particularly striking example of this type of internal cleavage. Though it long remained faithful to the Norman conception of masses and though its structural researches were often hesitant and punctuated by returns into the past, nevertheless in its surface-modelling, in the contours of its curves and in its tracery-systems 'it advanced rapidly to the conclusions of the future, for it was at the same time both a precocious and a conservative art'.

We see with what flexibility and respect for the individual case Focillon conducted his researches into the structure of time and the multiple interferences which it constantly permits. Although most of the concepts which he utilized

were known before and although certain groups of facts which he studied had already attracted the attention of other students, it may be said that, thanks to a more systematic and complete analysis of the theoretical data of the problem and by virtue of a more highly developed intellectual technique, he succeeded in creating a new and reliable method of research, at once universal and exact, which now enables us to pursue even to their obscurest lair phenomena whose very identity was formerly in doubt. Every new system of references, every new way of envisaging facts, is an additional tool in the service of the intellect; and it is good for one's own studies to re-read Focillon often, to make sure that one has not forgotten some aspect which may well be important, though foreign to the traditional routines of scholarship.

At all stages of research Focillon made new inroads which afford air and space for intellectual advance. Here we have isolated two important strands of his method, but there are many others which we might follow, such, for instance, as the idea of 'spiritual families'. *Pasticheurs* and *virtuosi*, melancholic and choleric characters, intellectuals and visionaries all approach the universe of possible forms in their own ways and seek out the techniques best adapted to serve the structure and inclinations of their minds. Hence one finds correspondences between works hundreds of years apart, which are quite clearly related, though no historical link connects them. Natural predilections align themselves along such axes of affinity, for 'each man is first and foremost a contemporary of himself and his own generation, but he is also a contemporary of the spiritual group to which he belongs'. Every artist lives in the presence of ancestors of his own choosing. Thus periods and environments which are not historical insinuate themselves into history, and races appear which are unknown to anthropology. They may or may not be conscious of their own existence. But they exist.'

Insight of this sort and this degree of acuteness is to be found at almost every step in Focillon's work, and as one reads him one realizes to how great an extent he has enriched our understanding of the phenomena of art. All these points of view never become entangled in inessential aspects but always converge in the very act of the creation of form. It is for this reason that his views are not only brilliant, they are also profound and right. It was given to him to understand and to explain the true stature of the problems and of the works themselves.

Vie des Formes has appeared in two English editions under the title of *The Life of Forms in Art*. The first edition, translated by C. B. Hogan and G. Kubler, was published in 1942: New Haven, Yale University Press; London, H. Milford, Oxford University Press (Yale Historical Publications, History of Art, IV). The second edition (New York, Wittenborn-Schultz, 1948) is made up of a revised translation by C. B. Hogan and G. Kubler with the addition of a translation by S. L. Faison, Jr. of the essay 'In praise of hands' ('Eloge de la main').

INTRODUCTION

NOTE

The present edition of Focillon's text includes all the author's original annotation and bibilography. The Editor's additions to footnotes and bibilography are marked with an asterisk *. The Editor wishes to thank MM. André Chastel and Louis Grodecki for their kind assistance with some of the additional annotations. The numbers in the margins refer to the illustrations, which are grouped together in the plate-section following the text and which have been selected and arranged by the publishers.

INTRODUCTION

THE succeeding chapters of our civilization are each the product of a particular geographical area, and rooted in their native soil. One by one they glimmer and grow bright, like parts of some broad landscape illumined by an errant sunbeam. The characteristic humanity of Southern Europe was formed in classical antiquity; in the Mediterranean basin, Greece and Rome conceived and imposed principles of government, a system of thought, a vision of man, which acquired universal significance. From the Mediterranean and the East sprang Christianity, coloured both by Hellenistic culture and by that of the Asiatic communities. This heritage passed to Byzantium, which preserved it, with an admixture of elements from Iran and the nomadic peoples, over an immense but dwindling territory. Meantime Western Europe, overwhelmed by the barbarian invasions, was assimilating amid the debris of the imperial structure another condition of man and other cultural forms, which seemed to hark back to the primeval past. Obscurely, the work went on of bringing these opposing traditions into equilibrium. The vast rural empire founded by Charlemagne, obsessed though it was by its vision of Rome, was yet weighed down by an inert mass of more primitive ideas, which were indeed to remain a permanent stratum in the profound life of the Middle Ages. But by the eleventh century a new order was beginning to emerge and was shaping its ends with a vigour which never flagged. In the lands of the West, in the heart of the countries fronting the Atlantic, the founders of stable political systems, the town-builders, the great ecclesiastical bodies, began to use a more abundant population to create new kinds of organization, new types of man. By conquest and conversion they extended these into Northern and Central Europe and, through the Crusades, even into Byzantium and Asia. This centrifugal impetus exposed the West to contacts and reciprocal influences. But as we shall see, all that it received it made its own. In this way the Middle Ages were to become the specifically Western expression of European culture.

Medieval man, as defined by his social system and his intellectual activity, would remain half-hidden in the shadows, were he not still present among us in the stones of the monuments. These are not mere illustrations of his story. He lives within them. Architect, sculptor and painter were at one with philosopher and poet, all working together to build a city of the mind, with its foundations resting on the deepest strata of historical life. The *Divine Comedy* is a kind of cathedral. The *summae* provide the key to medieval imagery. Religious drama

and carved and painted decoration exchange resources. This powerful cohesion between different types of research and invention is a characteristic trait of great epochs.

No other age has left monuments so numerous and so vast. Hellenistic Asia and Imperial Rome, it is true, are remarkable for the scale and audacity of their construction. But the profiles of churches and castles silhouetted on the horizon of medieval Europe are so insistent, so bold, so skilfully composed, their volumes are so lofty and spacious, the equilibrium which maintains them is so robust, the disposition of their masses and the poetry of their decorative effects have such *élan*, that we should be tempted to regard them as the work of a race greater and stronger than our own, were it not that the amplitude of the dimensions remains related to the human scale and that these gigantic buildings submit to the spirit of proportion as the first rule of their being. The tendency towards the colossal, which in some civilizations betokens disorder and decline, is here associated with sound reason, and from the day when the latter looses its hold, it may be said that medieval art is at an end. But in its great centuries, particularly the twelfth and thirteenth, this art was constantly initiating new experiments and achieving fresh successes, evolving its forms step by step within various stylistic groups, until a point of harmonious maturity was reached at which the beauty of the solutions has not only a local but also a universal significance. Thus one may find artistically perfect buildings in the main street of tiny villages or the market place of little country towns. In some rural areas architectural masterpieces stand almost as thick as milestones.

Architecture does not absorb all the vital force of medieval art, but it does harness and direct it. This is a fundamental fact. The law of the predominant technique, enunciated by Bréhier, is here effective beyond dispute. In the centuries following the barbarian invasions, stone-construction is in decline and the arts of ornament are predominant. But stone is the essential material of the great period of the Middle Ages. Even hidden under polychrome paint, the stone is felt as both structure and decorative form. Romanesque sculpture, though it may appear a work of pure fantasy and caprice, is in fact entirely determined by the needs of architecture, and is at once evoked and held in check by the wall of which it forms a part, and to which it supplies a necessary accent. Gothic structure, based on arch, rib, and pier, tends to dispense with wall, but sculpture remains monumental, establishing its harmony with architecture by different means. The miniatures of the thirteenth century are framed in architecture. Furniture, too, is monumental, and forms devised to equilibrate ponderous stonework are reproduced in ornamental wood-carving. Even on this reduced

scale they are evocative of their original grandeur, recalling, amid the delicacy of the minutest craftsmanship, the enormous masses for which they were primarily conceived. Every subordinate technique evolves as a function of the predominant technique, and though some arts (such as that of enamel) tend to harden in special moulds—favourites of fashion or specialities of workshops— though, in other words, the development in the various techniques may be imperfectly synchronized, yet the powerful homogeneity of the whole remains intact. It is this homogeneity which justifies our employment of a generalized idea of a period-style; it is this, indeed, to which such a conception owes its validity and which permits us to follow and distinguish its various modulations.

The number of these modulations is countless. Even in such periods of stability as the first decades of the thirteenth century, when the possibilities of current artistic types are already so completely realized that for a time they beget only variants of the established forms, an experimental vigour remains apparent, which, though starting always from the same data and applying the same solutions, constantly produces different effects, imprinting each member of the stylistic group with a character distinct from all other members, the indisputable sign of its individual life. Of great importance in this respect are variations in the main design-unit, the bay, whose possible combinations of length, width, and height are unlimited save by the general programme of the building; and still more important are variations of structural members, which, although standardized according to function, may be endlessly diversified in number and dimension. In any one country at any given moment, Gothic architects may be found playing in this way with a variety of proportions. But such 'play' is no mere virtuosity. The calculation of effects invariably follows from the calculation of forces. As soon as this link is broken the dissolution of medieval art has begun, so that at the very moment when it is embarking on its most ambitious enterprises, it finds itself no longer able to hold the elements together.

It is not surprising that medieval art, dominated as it was by architecture, and hence by a vigorous structural logic, a reasoned inter-relationship of forces and forms, was characterized by a tendency towards universality. It is not the limited particular expression of a single group or a moment of time, nor yet a brilliant transitory episode in the history of a culture. We can, it is true, distinguish certain localities and expound certain circumstances propitious to the genesis and development of its most original creations, but these are scattered in the most diverse regions. Medieval architecture and the arts which derive from it constitute a common language of Western Christianity, a language spoken

with various accents, but expressing a single body of knowledge, a single intellectual order, in an idiom intelligible to all. The Gothic style, elaborated in less than three generations by the architects of the Ile-de-France, would never have achieved its European dissemination, but that its luminous authority was founded on qualities which were universally understood. In studying the various ways in which this diffusion took place, we shall see how rarely the new style was introduced as a whole, as an inflexible dogma to be passively accepted. Even when this does occur, the variety of the models gives scope for freedom of choice, differences of material produce new effects, and local methods create novel inflexions. But more often the intrusive art comes to terms with the local art and turns it to account, so that one finds it, sometimes after a period of relatively slow development, resuscitating and assimilating elements of older styles to which it lends an original colour and by which it is coloured in turn. Even in the uniformity of Cistercian art it is possible to distinguish localized groups. This adaptability, in one place limited, in another more fruitful, is one of the contributory factors of medieval universality and a proof of its vigour.

Medieval life was in fact twofold—sedentary and local, nomadic and European. Towns and provinces, feudal states and monarchies, formed more or less immobile backgrounds; trade routes and pilgrim roads were an environment in constant flux. Europe was as profoundly intermixed with Europe, and over an area still greater in extent, than it had been under the *pax romana*. It comprised, too, a greater diversity of race. The historical substance from which its art was created was an amalgam of great richness, combining within itself the debris of classical antiquity, the vestiges of barbarian cultures, and the contributions of the East. Hence it comprehended man under various aspects, which it never ceased to study. Caravans and Crusades constantly renewed the contact with Asia and with Africa. At the beginning of the Middle Ages, the rise of monasticism had scattered far and wide the sediments of the most ancient civilizations, clothed in the dress of Christian symbolism; thus in the British Isles the visions of Egyptian monks were mingled with the linear musings of the Celts. The foundations of the universality of medieval art were laid by such fusions, which transformed and enriched what one might call the human content of European man. This universality, fostered by the ceaseless rhythm of influences, was to find its supreme and most immediate expression in this higher form of invention, architecture and the imagery allied with it.

Medieval art, universal in appeal, was also encyclopaedic in content. Since all things are in God, it took all things as its theme. It showed man whole, from his basest impulses to his ecstasies and visions. As early as the twelfth century and

probably before, one may say that Christian thought had felt the need to encompass the universe and to comprehend itself. But it was the thirteenth century which imposed on the universe a hierarchic system, and distributed within the scheme of the cathedral (as if within the framework of a theological *summa*) the measureless diversity of created things. Romanesque art had perceived them only through a mesh of ornament and in a monstrous guise. It had combined man with beast and beast with chimera. It had festooned the capitals of the churches with a fantastic menagerie, and stamped the tympana with the seal of the Apocalypse. The very profusion and variety of these incessantly metamorphosed beings betray the impatience of their struggle to break out from the labyrinth of abstract style and to achieve life. It seems, not the created world, but the dream of God on the eve of the Creation, a terrible first-draft of his plan. It is the encyclopaedia of the imagination, preceding the encyclopaedia of reality. But just as the Romanesque world combines with such fictions an epic humanism, half fable, half fact, so Gothic humanism, though renouncing cryptograms and contemplating the world without the interposition of a fretted grille, still welcomes the strange marvels of ancient dreams as familiar friends without whom the picture of nature would be incomplete.

This humanism of the Middle Ages, as it emerges from the study of the monuments, clearly goes very far beyond any definition which might seek to limit it to a more or less precarious heritage from classical antiquity. There is, of course, a humanism of the humanists, but there is also another, wider in scope, and, one may perhaps say, more sincere, since it owes little to tradition and much more to life itself. The grandeur of its vision of man and of his relationship with the universe is revealed to us in medieval art. It does not present man in isolation. It shows him at grips with the exigencies, the miseries, and the splendours of his destiny. It does not dwell on the bloom of his youth—save when it lays him at last upon his tomb—but shows him at every age, in every condition, toiling, and enduring. The blind man high on Reims cathedral proclaims the twin glories of divine justice and human patience. To the sweetness of the Gospels, to the majesty of theology, the humanism of the images adds the strength of its sympathy for all things living, a wonderful compassion and sincerity and openness of heart. It encompasses all things and sets man in the centre, and this image of God is all humanity. In this context the word humanity attains its full meaning. The superb humanity of Greek sculpture is incomplete. It exists in the sphere of the incorruptible, and is so categorical an affirmation of man that it dedicates him to solitude. The Middle Ages, on the other hand, immerse him on every side in the stream of things animate and inanimate. And

this profusion of appearances is no mere surface-glitter of the senses. Close as it is to the flesh and the material world, fascinated by every aspect of life, sensitive even to the gentle sinuosity of a plant, medieval art remains an intellectual art. It pays homage to the works of the mind (the cathedral of Laon was dedicated to the Liberal Arts), and more than this, the laws which govern the distribution and composition of its forms are themselves the products of sublime thought. A considered arrangement of symmetries and repetitions, a law of numbers, a kind of music of symbols, silently co-ordinate these vast encyclopaedias of stone. In them we possess, not memorials of their own time only, but our completest and most coherent presentation of man and his ideas.

This universal, encyclopaedic art, creating and propagating a humanism of such breadth and stability, was the supreme expression of the Middle Ages; it is this art, indeed, which gives the period its organic significance, its importance as a distinct cycle in the series of civilizations. The name by which we call this period still bears the impress of the classical spirit, oriented towards antiquity and by that very bias less modern than the Middle Ages themselves. But in fact this was not a transition between two other ages which reached out towards each other across it; it was not a mere interregnum, but a separate and distinct epoch. (The centuries from the barbarian invasions to the foundation of the Carolingian Empire might perhaps be more properly called a middle age.) Not only was it not a transition between antiquity and modern times, it was also not a middle term between the civilizations of the South, North and East. In this latter connection we must take care not to be misled by the remote origin and the innate vitality (which alone might ensure their revival) of the many diverse elements which here meet and intermingle, and we must guard against the temptation, which besets each generation of students, to change the key of our general interpretation of history in order to lay stress on the particular field of our own discoveries. The thought which co-ordinates, knits together, and combines these elements transmitted by so many different Christian communities, all with varying success collaborating in the single universal task, the thought which submits them to architecture, conceived as a logic of structure—this thought is purely Western. It is here, in the West, that these materials from past time and distant lands are wrought into new forms, which are logically assembled to develop the utmost of their potentialities and to create the ancillary elements and the framework which are necessary to them; here, in a series of experiments, the new style is evolved; here, above all, the new vision of man is developed without which the Middle Ages would remain for us a scene of darkness and confusion. If we analyse the interrelationship of parts in a Western church

and in an East Christian building, if we compare their plans and the disposition of their ornament, we find fundamental differences at the very period when the connections between the two areas seem at their closest and most harmonious. As for the idea that the cathedrals are inspired by the genius of the Northern races—this doctrine of the Romantics, lately polemically revived and sustained with new data, is by no means negligible, in so far as it leads us to rediscover in the prelude to the Middle Ages certain formal concepts inherited from the rich protohistoric cultures. But, as we shall see, the Gothic church is distinguished from the timber church not only by the difference of material, but also by the functional difference between beam and arch, and, in a wider sense, by the logic of structure.

This brief review must not disguise from us the complexity of the problems which beset the study of medieval art. Deeply immersed in the historical life of its period, it was subject to the differential effects of time and place. Its development was not a consistent growth with successive stages linked by transitions in which the past made way smoothly for the future. Styles do not succeed each other like dynasties, by the death or expulsion of the last male heirs. On the contrary, a country may sometimes contain a number of different artistic currents pursuing their several courses, with greater or less vitality, side by side. In France, in the first half of the twelfth century, two great systems were in simultaneous evolution, one to the south and one to the north of the Loire— Romanesque art, in the full bloom of its classical period, and Gothic art, engaged in those bold and precocious experiments which were to lead within a few years to the establishment of its fundamental programme. In Germany, Romanesque art persisted until the thirteenth century, and still longer in Italy and Mediterranean Spain. In some French churches, the robust strength and rude energy of twelfth-century Gothic outlived the successful formula of the subsequent phase. Imported into England, classic French Gothic rapidly evolved towards Baroque ornamentation, whose elements, reimplanting themselves in the French soil which had formerly restrained their growth, ended by choking and distorting beneath their luxuriance the final form of medieval art, the Flamboyant style. In order to grasp the broad lines of this stylistic evolution, it seems legitimate at first sight to study it by centuries and countries, rather than in wider movements. But works of art, when interlinked in such great complexes, carry within themselves, even down to the ultimate variants and adaptations, the principle of a unitary development which must not be heedlessly subdivided. We must therefore combine the two methods of approach. The evolutionary impulse, the phase of experiments—some abortive, but the more successful following one from another as if in a chain of deduction—the

stability of the great periods, followed by crises of refinement, and then by the omissions and illogical usages of the decadence—all these stages of the complex development exist only in terms of time and place, and though in themselves they constitute a kind of logic, time has the power to advance or retard the moment at which its propositions and conclusions are worked out by different schools and different artists. Moreover, the artists are capable of original invention, which gives rise in the most homogeneous of styles to free and bold treatments of the formulae and even to fundamental mutations. The breadth of their freedom of choice is made apparent in the study of influences. The genealogy of churches rarely contains exact replicas, but shows many examples of a striking versatility of interpretation.

We feel nowadays such a desire for biographical detail, we surround the lives of artists with such a rich documentation of anecdotes, that some life-story of the great, be it true or false, has become a necessity for us. Confronted by works whose artists are unknown, or perhaps known only as names or brief mentions in a text, we are tempted to take this anonymity for impersonality, and to consider the monuments of the Middle Ages as natural phenomena whose genesis and development may be explained in terms of crystallography. But the Middle Ages are not a wilderness of stone. The human element is everywhere present, not only in representation, not only in the collective forces which impel and sustain the artist, but also in the manifestation of his own creative genius. He does not carry the model of his church in his hand as the donors do; he is not set up beside his work like some great hero; but he lives visibly within it, multiplied and magnified in his own creation. Sometimes, even in the earlier periods, he imposes his personality on it to such a degree that it becomes as expressive and distinctive as a portrait, though the language of form which he uses may be shared by whole groups of artists. These astounding men, wielding great forces, pitting themselves against gigantic masses, are not annihilated by their success; they never become mere blind depersonalized slaves of the ponderous and colossal. When their very names are lost, their churches stand as their signatures. It would, of course, be quite wrong to endeavour at all costs and in all cases to discern the characteristics of individuals in monuments which are so rich in accumulated resources and whose technical laws do not lend themselves to an endless renewal of invention; but to exclude the human and personal element would be no less serious an error.

Thus the human mind, the variable speed of time, the fixed data of place, the inconstant data of influence, all work together with the innate evolutionary factors of the styles, defining, amplifying, accelerating and colouring them. We

shall see these processes in action when we come to study Western art between the twelfth and the fifteenth century. But first we must acquire some knowledge of the broad lines of the eleventh century, for this was the basis on which the Middle Ages rested, its phase of preliminary elaboration. This period created over a considerable area the first Romanesque architecture, and it saw the birth of the ribbed vault, which was to achieve its full stylistic development in the following century; moreover, if one fails to take account of these hundred years of experiments—more numerous and systematic than was formerly imagined— the whole history of Romanesque sculpture is thrown out of focus, and the highly developed style of the early twelfth century is inexplicable. Thereafter we shall be able to follow the development of the Romanesque and then of the Gothic style, taking account of their synchronisms and mutual influences. The nineteenth-century scholars divided Gothic art into a number of periods, which remain generally acceptable, though their essential character must be sought in more profound qualities than the purely superficial features after which they were originally named. The great Gothic art of the twelfth century usually continued to utilize the programme and some of the details of Romanesque, but elaborated a tribuneless church-type, which, in conjunction with the systematic use of the flying-buttress, became the classical formula of the first half of the thirteenth century. That century of the cathedrals proceeded to raise its immense systems of stone, propounded and deduced with strict logic, each one a new and masterly statement of the same idea, and all peopled with a world of images as inexhaustibly various as the Creation itself. The second half of this period and the following century, refined, elegantly but sometimes drily, on these perfected solutions which had left no scope for fresh invention; meantime, form in sculpture and painting kept step with architectural evolution, and even the style of life itself lost in nobility what it gained in intimacy and charm. The study of man, which had emerged from the ornamental conception of sculpture and the universe at the end of the twelfth century, now forsook monumentality for adventitious graces. Changing forms reflected the profound life of the faith; obsessed at first by epic visions and dazzled by the Apocalypse, then nourished on a rich theological diet and expressive of the serenity of the Gospels, it now assumed a more fervent sensibility, welcomed the most passionate transports of the soul, and was led on by the mystics, step by step, to the cult of suffering and death. The intellectual order dominated by architecture gave way to a kind of stagecraft. The final phase of the Middle Ages is a period apart; though at first sight the Flamboyant style may seem a natural and inevitable consequence of the Gothic principle, it is in fact a deviation from it.

Architecture had ceased in the West to be the keynote of civilization, at least for this epoch. Gothic painting, meantime, confined in the Northern cathedrals to narrow spaces and competing with the splendour of glass, found on Italian walls a vast virgin field awaiting experiment and new solutions; the Tuscan studios sent far afield their precious icons; connoisseurship, and the passion for adorning life with images, clashed with monumental discipline. Finally, in the studios of the southern Netherlands, new resources were discovered which were not a mere refinement of technique, but which imposed on Europe new conceptions of form, space, and colour. These illumine with a warm mysterious glow the last thoughts of the Middle Ages, and open up the horizon beyond to take possession of a wider, more transparent world. It is the beginning of a new age of civilization.

BIBLIOGRAPHY

GENERAL WORKS

Répertoire d'art et d'archéologie, published under the direction of M. Aubert, Paris, 1911 *et seq.*; J. Calmette, R. Grousset and J. J. Gruber, *Atlas historique, II, Le moyen âge*, Paris, 1936; L. Courajod, *Leçons professées à l'école du Louvre*, 1887–91, 3 vol., Paris, 1905 *et seq.*; *Histoire de l'art*, published under the direction of André Michel, vol. I–III, Paris, 1905 *et. seq.*; *Histoire universelle de l'art*, published under the direction of Marcel Aubert, vol. I, Paris, 1932; R. Hamann, *Geschichte der Kunst*, Berlin, 1933; H. Pirenne, G. Cohen, H. Focillon, *La civilisation occidentale au moyen âge*, Paris, 1934; L. Réau, *L'art primitif, l'art médiéval* (Histoire universelle des arts, vol. II), Paris, 1934; L. Bréhier, *L'art chrétien*, 2nd edition, Paris, 1928; G. Dehio and G. von Bezold, *Die kirchliche Baukunst des Abendlandes*, 2 vol. and 5 albums of plates, Stuttgart, 1884–1901; A. Choisy, *Histoire de l'architecture*, 2 vol., Paris, 1899; F. Benoît, *L'architecture, l'Occident médiéval*, 2 vol., Paris, 1933–34; Dom Leclercq and Dom Cabrol, *Dictionnaire d'archéologie chrétienne et de liturgie*, Paris, 1907 *et seq.*; Dom Cottineau, *Répertoire topo-bibliographique des abbayes et prieurés*, Mâcon, 1935–38; Dom Berlière, *L'ordre monastique des origines au XIIIe siècle*, 2nd edition, Maredsous, 1921; S. Reinach, *Répertoire de peintures du moyen âge et de la Renaissance*, Paris, 1905–22; W. Molsdorf, *Christliche Symbolik der mittelalterlichen Kunst*, Leipzig, 1926; K. Künstle, *Ikonographie der christlichen Kunst*, 2 vols., Freiburg-im-Breisgau, 1924–28; R van Marle, *L'iconographie de l'art profane au moyen âge et à la Renaissance*, 2 vol., The Hague, 1932; Ch.-V. Langlois, *La connaissance de la nature et du monde au moyen âge*, Paris, 1911; E. Gilson, *La philosophie au moyen âge*, Paris, 1922.

R. de Lasteyrie and A. Vidier, *Bibliographie générale des travaux historiques et archéologiques publiés par les sociétés savantes de la France*, Paris, 1904–14; A. de Caumont, *Abécédaire d'archéologie française*, Caen, 1850 and 1870; E. Viollet-le-Duc, *Dictionnaire raisonné de l'architecture française du XIe au XVIe siècle*, 10 vol., Paris, 1867–73; C. Enlart, *Manuel d'archéologie française*, new edition, Paris, 1919 *et seq.*; J. Brutails, *Précis d'archéologie du moyen âge*, Paris, 1908; *Les églises de France, répertoire historique et archéologique*, under the direction of M. Aubert and J. Verrier, Paris, 1932 *et seq.*; V. Mortet and P. Deschamps, *Recueil de textes relatifs à l'histoire de l'architecture, XIe–XIIIe siècles*, 2 vol., Paris, 1911–29; R. Schneider, *L'art français. Moyen âge, Renaissance*, Paris, 1922; L. Réau and G. Cohen, *L'art du moyen âge et la civilisation française*, Paris, 1935; P. Vitry and G. Brière, *Documents de sculpture française du moyen âge*, Paris, 1904; P. Vitry, *La sculpture du moyen âge au musée du Louvre*, Paris, 1934. A. Venturi, *Storia dell'arte italiana*, vol. I–VII, Milan, 1901 *et seq.*; P. Toesca, *Storia dell'arte italiana, I. Il medioevo*, Turin, 1927; P. d'Ancona, R. Cattaneo and F. Wittgens, *L'arte italiana, I. Dalle origini alla fine del Trecento; II. Il Rinascimento*, Florence, 2 vol., 1931; R. van Marle, *The Development of the Italian Schools of Painting*, 15 vol., The Hague, 1923–34. V. Lamperez y Romea, *Historia de la arquitectura cristiana española en la edad media*, 2nd edition, 3 vol., Madrid, 1930, and *Arquitectura civil española*, Madrid, 1922; A Calzada, *Historia de la arquitectura en España*, Barcelona, 1928; A. I. Mayer, *Mittelalterliche Plastik in Spanien*, Munich, 1922, and *Geschichte der spanischen Malerei*, 2nd edition, Leipzig, 1922; G. Rouchès, *La peinture espagnole, le moyen âge*, Paris, 1932; R. R. Tatlock, R. Tyler, etc., *Spanish Art*, Burlington Magazine Monographs, II, London, 1927. *Germania sacra*, under the direction of E. Beitz, F. Lohmann and A. Wrede, Augsburg, Cologne and Vienna, in course of publication; G. Dehio, *Geschichte der deutschen Kunst*, I and

II, Berlin, 1923–27, and *Handbuch der deutschen Kunstdenkmäler*, 5 vol., Berlin, 1920–28; A. Stange, *Die Entwicklung der deutschen Plastik im Mittelalter*, Munich, 1923; C. Glaser, *Die Altdeutsche Malerei*, Munich, 1924, French translation, Brussels and Paris, 1931. F. Bond, *English Church Architecture*, London, 1913; E. S. Prior, *Mediaeval Architecture in England*, Cambridge, 1922; A. H. Thompson, The *Cathedral Churches of England*, London, 1925; E. S. Prior and A. Gardner, *An Account of Mediaeval Figure-sculpture in England*, London, 1912; A. Gardner, *A Handbook of English Mediaeval Sculpture*, Cambridge and New York, 1934; P. Clemen, *Belgische Kunstdenkmäler*, Munich, 1923; F.-a.-J. Vermeulen, *Geschiedenis der Nederlandsche Bouwkunst*, 3 vols., The Hague, 1922–29; Max J. Friedländer, *Die altniederländische Malerei*, I–VI, Berlin, 1924–29.

 * To this bibliography, compiled by H. Focillon for the original edition of *Art d'Occident*, 1938, can now be added: C. R. Morey, *Mediaeval Art*, New York, 1942; P. Lavedan, *Histoire de l'Art*, II, *Moyen-âge et temps modernes*, Paris, 2nd ed., 1950; N. Pevsner, *An Outline of European Architecture*, Harmondsworth, 1943 (re-edited a number of times); J. Harvey, *The Gothic World*, 1100–1600, London, 1950; L. Réau, *Iconographie de l'art chrétien*, 6 vols., Paris, 1955–59; J. Evans, *Art in Mediaeval France*, London, 1948; M. Aubert, *La Sculpture française au moyen-âge*, Paris, 1947; L. Grodecki, *Ivoires français*, Paris, 1947; J. Porcher, *L'enluminure française*, Paris, 1959; A. Chastel, *L'art italien*, 2 vols., Paris, 1956; E. Lavagnino, *Storia dell'arte medioevale italiana*, Turin, 1936; M. Kirchmayr, *L'architettura italiana*, I, *Dalle origini al secolo XIV*, Turin, 1958; G. Hermanin, *L'arte in Roma del secolo VIII al XIV*, Bologna, 1945; *Ars Hispaniae, Historia universal del arte hispanico*, Vols. II–IX, Madrid, 1947 *et seq.*; H. Weigert, *Geschichte der deutschen Kunst von der Vorzeit bis zur Gegenwart* (Propyläen Kunstgeschichte), Berlin, 1942; E. Gall, *Dome und Klosterkirchen am Rhein*, Munich, 1956; J. Gantner, *Die Kunstgeschichte der Schweiz*, Vols. I and II, Frauenfeld, 1936, and Basle, 1948; French edition of Vol. I revised: *Histoire de l'art en Suisse*, I, Neuchatel, 1941; J. Kvet and H. Swarzenski, *Czechoslovakia: Romanesque and Gothic Illuminated Manuscripts*, Greenwich, U.S.A., 1959; O. Lehmann-Brockhaus, *Lateinische Schriftquellen zur Kunst in England, Wales und Schottland vom Jahre 901 bis zum Jahre 1307*, 5 vols., Munich, 1955 *et seq.*; L. F. Salzman, *Building in England down to 1540*, Oxford, 1952; T. S. R. Boase, ed., *The Oxford History of English Art*, Vols. II–V, Oxford, 1949–1957; G. F. Webb, *Architecture in Britain: The Middle Ages* (Pelican History of Art), Harmondsworth, 1956; L. Stone, *Sculpture in Britain: The Middle Ages* (same collection), 1955; M. Rickert, *Painting in Britain: The Middle Ages* (same collection), 1954; S. Leurs, ed., *Geschiedenis van de vlaamsche kunst*, 2 vols., Antwerp, 1937–39; E. H. Ter Kuile, *De Bouwkunst van de middeleeuwen*, Amsterdam, 1948.

East and West: Romanesque Art

The Great Experiments: The Eleventh Century

I

THE Middle Ages were from the first involved in a clash of traditions. In one aspect, the history of the period may be envisaged as a long-drawn effort by the West to resolve the conflict of forces resulting from the barbarian invasions. Two kinds of humanity were at grips, of which one had advanced through a long and glorious era of civilization, while the other had remained attached to the most primitive systems of social and cultural life. One built cities of stone, the other temporary shelters. One regarded architecture as an element of prime importance in man's activity, and, in artistic representation, respected the appearances of life, while for the other art was ornament and consisted in abstract composition. Nor was this the only conflict. The axis of the Mediterranean world had long been shifting, and this movement was now accelerated and stabilized by a combination of new factors—the peace of the Church (the official recognition of an Oriental religion), the importance of Constantinian Jerusalem, the foundation of the Eastern Empire, the decline of Rome as against metropolitan Byzantium and the still prosperous Hellenistic cities, the prestige of the great Sassanian empire, and the submergence of the West beneath the barbarian hordes. Asiatics were the missionaries of Christianity, especially to the Gauls. Egypt gave birth to monasticism, which built its first monasteries and churches there and was then diffused abroad. In Syria, Anatolia and Transcaucasia, where Christianity was recognized from the third century, an intense religious life, strongly coloured by local genius, led to the erection of great numbers of buildings, very various in plan and structure, in which the ancient forms of Mesopotamia and Iran were adapted to Hellenistic techniques. The barbarians, too, played their part in the Orientalization of Europe, for their art was not only a repository of those less evolved Oriental motifs such as had long been incorporated in the La Tène style, but it was also in contact with, and transmitted, elements of remoter origin, from beyond the steppes. The advance of Islam to the Pyrenees, the exodus of Syrian monks during the iconoclastic disputes, the travels of merchants and pilgrims, introduced a succession of new factors. Thus the Middle Ages were from the first confronted with the problem, Orient or Rome ?—and with this was indissolubly linked the further problem, Mediterranean or barbarian culture ? The history of medieval art recounts the

manner in which the West, after a period of dependence on Mediterranean, Oriental and barbarian forms, established a judicious equilibrium, created its own forms, its architecture, its humanism, and defined its own specific culture.

The period following the invasions, during which the new political groupings were consolidated, shows not so much a sudden radical breach with the antique tradition, as a kind of shifting of values.[1] The towns continued to shelter within their walls, under the tutelage of the Bishops, institutions inherited from the Empire, and in some districts these survived for long periods. But the tone of civilization ceased to be urban; it absorbed rustic habits and primitive social formulae. Henceforward objects meant more than buildings, and symbols were more interesting than human figures. The newcomers, even those who had been clients of Rome and associates of her fortunes, retained their semi-nomadic ways, their mistrust of towns, and their taste for ornament and luxuriant, symmetrical, linear composition. On the rural estates, their life differed little from that of their forebears; they imposed new laws of property, a novel juridical system, and their own conception of the relationship of man with man. In the towns themselves, the decay of the crafts, and the shrinking of wealth and of trade, all contributed to a kind of narrowing of the patterns of life and of the scope of mental activity. By the time a conditional security had been restored, the tone of historical life was changed for centuries to come. The Roman buildings still stood; but often they had served as quarries when stone was needed for the ramparts, and it was long before they ceased to be despoiled of their columns for the adornment of Christian basilicas.[2] A few workshops of funerary sculptors remained faithful to the traditions of the Italian marble-workers, for of all the arts this is the slowest to renew itself and lives longest on its conventions and formulae. Princes were not antagonistic to the conservation of antique culture, some indeed prided themselves upon it, but they were concerned only with its external trappings, and their best-meant efforts to direct the life of the spirit remained unfruitful, the caprices of amateurs.

It is by no means certain that the invasions merely accelerated an already inevitable decline. It is true that antique art, in most of its official manifestations under the late empire, seems watered-down by the academism of copyists, but it still retained its capacity for self-renewal under the influence of regional traditions.

*[1]These ideas have been expanded by H. Focillon, *Du moyen-âge germanique au moyen-âge occidental*, in *Moyen-Age. Survivances et réveils*, Montreal, 1945, pp. 31–53.
[2]At Lyon, for instance, the columns of the Temple of Augustus were utilized for Saint-Martin d'Ainay. Similarly in the crypts (Jouarre, Grenoble) and baptisteries (Poitiers, Riez, Le Puy, etc.). See C. Enlart, *Manuel*, 2nd edition, I, p. 414, note 1, and p. 145.

This is apparent in Gaul, in the vitality of the popular genius as shown in the best of the small-scale sculpture—rightly considered to be a contributory factor in the genesis of medieval art.[1] Moreover, the architecture, sculpture and metalwork of imperial times was not unsympathetic to those influences, which, from the sixth century, came to dominate the West; indeed Rome had had a taste for them, and ever since the time of her first expansion into the Hellenistic cultural area had remained in close touch with the Orient; perhaps, even before she went to school with Greece, some older, remoter impressions had come to her by way of Etruria. In later times Asiatic traders had brought to her coasts and provinces a special kind of Christianity, a mixed bag of merchandise, masterpieces of cunning metalwork, and a number of decorative motifs which are found alike on the lintels of Syrian basilicas and the tombs of Merovingian hypogea. But Roman art powerfully consolidated all these exotic contributions into its own substance, its own development, even as it were into the very mortar of its masonry, and from these disparate factors constituted the luxuriant and massive unity of its mighty buildings.

When one considers the art of the Goths in Italy, that of the Visigoths in Spain, or that of the Franks in Gaul, they seem all to be put together from the same elements and display more or less identical characteristics. Fragmentary survivals or hard desiccated copies of antique art rub shoulders with Eastern motifs and with the ornamental vocabulary of the nomads, which was now sometimes transcribed into stone for purposes of monumental decoration. Upon these uneasy juxtapositions, a mosaic rather than a style, Byzantine stereotypes became encrusted. Architecture, known to us largely from texts, is hard to visualize. If the chroniclers may be believed, it was audacious and brilliant; but the crypts of Jouarre and Grenoble display mean technique and an unambitious programme. Clearly the keynote of the period is not to be found here. The decadence of the arts of stone is however counterbalanced by a wonderful development of the arts of ornament. The abolition or schematic reduction of the human figure coincides with a new skill and fertility in abstract design. This is the vital factor. It is this which characterizes the true interregnum between the two kinds of humanism. An encyphered conception of the universe, rejecting the human figure as inessential or even repugnant, replaces a plastic vision which had been entirely dominated by man and which had based itself on the realism

[1] L. Bréhier, *L'art en France, des invasions barbares à l'époque romane*, p. 9. Examples of indigenous survivals are the pediment-shaped lintels which are common in Auvergnat and Belgian Romanesque, the geometrical motifs of Gallo-Roman mosaics, and, in figure-sculpture, the god with the purse from Lezoux (Musée de Saint-Germain), the mother-goddesses, the god with the hammer, etc.

and actuality of its images. When we come to examine the origins of Romanesque sculpture, we shall see the parts played by the East, by the North, and by prehistoric cultures in the creation of this geometrical absolutism, its significance for Islam, and the manner in which the West reintegrated it into the monumental scheme by allying it with living forms. It must be realized that it was from the first an essentially innovating element.

Carolingian art was less concerned to change the elements of this complex than to modify their proportions. The restoration of the Western Empire, the work of learned clerks, who, to recompense the signal services rendered to Christianity by a great family, seized the opportunity of reviving a title and a formula associated in their minds with so much recollected splendour, naturally inclined the minds of men to consult the examples of ancient Rome and to emulate Byzantium. On the basis of traditions already several centuries old and within the framework of a composite Oriental-barbarous style, the art of the period is characterized by two dominant factors—a return to monumentality and a renaissance of the human figure. The former affected not only architecture, but also the development of the great cycles of history-painting in the palaces of the Rhine and the Moselle, and even, as was demonstrated recently, the mode of setting cabochon gemstones, which in other respects departed little from the traditional system.[1] As for the human figure, it did not—for reasons which will appear—assert itself in stone-sculpture. We have only insecure evidence of the way it was handled by the bronze-founders of the Aix workshops, but it abounds in the manuscripts, where, in certain presentation-miniatures, it is treated with the amplitude of monumental painting. Meantime, an ancient Celtic culture was maintaining and developing figure-art in quite another direction. From the seventh to the tenth century, the Irish manuscripts bring before us in their strange cypher a mysterious dream and a disconcerting logic which envelop man, beast and plant in the convolutions of their interlace—a kind of chaos preceding genesis.[2] Palmette-man, interlace-man and spiral-man confront the togaed evangelist and the count in ceremonial chlamys. They are opposing worlds, but they tend to interpenetrate. For a time Carolingian art resuscitated humanistic programmes, setting the human figure once again in the

[1] J. Seligmann, *L'orfèvrerie carolingienne, son évolution*, Institut d'art et d'archéologie de l'Université de Paris, Travaux du groupe d'histoire de l'art, 1928, p. 137.
[2] See L. Westwood, *Miniatures and Ornaments of Anglo-Saxon and Irish Manuscripts*, London, 1868; P. Gilbert, *Facsimiles of the National Manuscripts of Ireland*, 5 vols., London, 1874–84; H. Focillon, *L'art des sculpteurs romans*, p. 97, 102, 103. *See also G. L. Micheli, *L'enluminure du haut Moyen-âge et les influences irlandaises*, Brussels, 1939; F. Henry, *Irish Art in the Early Christian Period*, London, 1940; F. Masai, *Essai sur les origines de la miniature dite irlandaise*, Brussels, 1947 (whose conclusions have not been universally accepted).

field of the painted page, and transporting an equestrian emperor from the Eternal City to stand before the palatine chapel. But it did not prepare or secure the future of medieval art by such means; rather would it have condemned it to the monotonous repetition of exhausted themes. A greater promise lay in contact with that spirit of ornamental fantasy wherein the human figure seems bound and paralysed but where in fact it is extending the range of its experiences and, as it were, testing its capacity for the astonishing diversity of life.

Carolingian architecture is remarkable for its variety and technical accomplishment. Monuments like the Basse-Œuvre at Beauvais remained faithful to the current type of wood-roofed basilica, and in the North and East, where the influence of the court art of Charlemagne and his successors was more directly felt, this kind of church long resisted the advance of the Romanesque system. But the severe beauty of the gable relieved only with a cross of interlace, the elegant geometry of the ornament which circumscribes the window-opening, *46* betoken a fine sense of monumental plainness and that strength of wall which in itself is a sign of a great architectural style. Elsewhere, as at Savenières, Distré, *3* and Le Lion d'Angers, the wall surface is enriched with ornamental arrangements of the masonry—a feature which persists among the Romanesque architects of Auvergne. A whole group of Romanesque monuments derives from the palatine chapel at Aix, itself inspired by S. Vitale at Ravenna. The reduction of the sixteen sides of the outer face of the aisle to the eight of its inner face by the insertion of triangular vault-cells between square severies reveals a degree of skill of which the groined vaulting of contemporary crypts provides additional evidence. Here began the tradition of medieval mason-craft, along with that of an architectural style which for nearly two centuries was to remain a mason's style. As against this, it is an Oriental silhouette which is thrown against the sky of the Loire country by the church of Germigny-les-Prés, built at the beginning of the ninth century by Theodulf, abbot of Fleury and bishop of Orleans. Equally exotic are its horseshoe apses, and the composition and equilibration of the masses—four barrels, terminating in semidomes, abut a domed central tower, with lower square chapels between the arms of the cross. Theodulf was of Spanish origin, and the same type of church recurs a little later in northern Spain, at San Miguel de Liño. Both must derive from some unknown prototype inspired by an Oriental model—the latter doubtless the Armenian cathedral of Etschmiadzin, which was rebuilt after 618.

Rome, Byzantium and Asia bound the horizons of Carolingian art, but they do not define it completely. Its architecture bequeathed to the Romanesque

period more original and more fruitful ideas. One of these was the type of the great Benedictine churches—Alet, Saint-Riquier, St. Gall—planned on a colossal scale to house a whole populace of monks, churches with two apses and sometimes two transepts also, consisting as it were of two churches joined end to end, and in some degree symmetrical throughout.[1] These were the prototypes of the enormous Romanesque basilicas of the Rhineland which continued the tradition, superbly but uninventively, down to a late date. The feature of incorporated belltowers flanking the east end persisted over a still wider area.[2] But Carolingian art bequeathed to Romanesque an innovation more important than this, and destined to influence much more profoundly the composition of masses; it consisted of a passage, formed by the prolongation of the aisles around the sanctuary, with apsidal chapels opening from it—the ambulatory with radiating chapels. This plan is found in the substructure of the basilica of the treasurer

[1] The plan with an apse at each end of the building is of antique origin (Rome, Basilica Ulpia). It recurs in the Christian architecture of North Africa (Basilica of Reparatus at Tebessa). In the Carolingian age it was common in Neustria and Austrasia: ruins of the old cathedral of Alet (Ille-et-Vilaine), Besançon cathedral, Fulda St. Salvator (819, demolished), Reichenau St. Maria, etc. W. Effman has shown that Saint-Riquier, built by Angilbert 793–98, was not double-apsed (*Centula*, Münster, 1912). The best-known examples of the double-transept plan were, apart from Fulda, those of Centula (Saint-Riquier, 793–98) and Cologne cathedral (about 800). St. Gall, according to the plan (preserved in the library of the monastery) attributed to Einhard and sent to Abbot Gozpert about 830, no doubt as a project, was to have had two apses, but in the actual building the western apse was replaced by a vestibule, with an upper storey containing a chapel with three altars. See A. Hardegger, *Die alte Stiftskirche und die ehemaligen Klostergebäude in St. Gallen*, Zurich, 1917. The purpose of the western apses was to provide accommodation for new cults (e.g. tomb of St. Boniface at Fulda), and this usage persisted in the chapels situated in the upper storeys of porches. See J. Vallery-Radot, *Notes sur les chapelles hautes dédiées à saint Michel*, Bulletin monumental, 1929 (Werden-am-Ruhr, late ninth century; Saint-Benoît-sur-Loire, early eleventh century; Toul cathedral, late eleventh century; Payerne, Romainmôtier, Cluny, Autun, Vézelay, etc.). The question is bound up with that of the porches. See H. Reinhardt and E. Fels, *Étude sur les églises-porches carolingiennes et leur survivance dans l'art roman*, Bulletin monumental, 1933, 1937. *On Carolingian architecture, in addition to J. Hubert, *L'art pré-roman* (complemented by *L'architecture religieuse du haut moyen-âge en France*) and E. Lehmann, *Der frühe deutsche Kirchenbau*, see R. Krautheimer, *The Carolingian Revival of Early Christian Architecture*, Art Bulletin, 1942, pp. 1–38 (on the Early Christian elements which were taken up again by the architects of the eighth and ninth centuries). L. Grodecki, *L'architecture ottonienne*, Paris, 1958, is also essential.

The most recent research does not confirm the hypothesis of a Carolingian origin for the two-transept plan. Fulda had only one, at the West; Cologne had also one only, at the East, and the 'Westwerk' of Centula had only the external appearance of a transept. On Fulda, H. Beumann and O. Groszmann, *Das Bonifaciusgrab und Klosterkirche zu Fulda*, Marburger Jahrbuch für Kunstwissenschaft, 1949, pp. 17–56. On Cologne, O. Doppelfeld, *Der alte Dom zu Köln und der Bauriss von St. Gallen*, Das Münster, 1948, pp. 1–12. E. Reisser's excavations at Sankt Maria, Reichenau (published in Deutsche Kunst und Denkmalpflege, 1933 and 1935) have proved that this church had no western apse in the Carolingian period; on the other hand, western apses have been discovered at Saint Maurice d'Agaune (eighth century) and in Fulrad's church at Saint-Denis (before 768): see S. McK. Crosby, *Excavations in the Abbey Church of Saint-Denis* 1948, Proceedings of the American Philosophical Society, 1949, pp. 347–361, and *L'abbaye royale de Saint-Denis*. Paris, 1953.

[2] In the St. Gall plan the belfry-towers are not contiguous with the church, but two narrow galleries link them with the apse. *Latest study on the St. Gall plan: H. Reinhardt, *Der St. Galler Klosterplan*, St. Gallen, 1952.

Hervé at Tours and of the cathedral of Bishop Étienne II at Clermont[1] (where crypt and chapels are rectangular), and it occurs in complete and intact form in the choir of Notre-Dame-de-la-Couture at Le Mans. In these buildings we have an anticipation of the programme and architectural scheme of the great pilgrimage churches of the eleventh and twelfth centuries, with their extended plans and numerous reliquary altars, and there is already some hint, too, of the coronet of terraced masses at their eastern ends. Again, if the nave of Saint-Philbert-de-Grandlieu is as early as the late ninth century, it was Carolingian architecture which first replaced cylindrical and rectangular piers by the compound type, an innovation of cardinal importance, whose logical development in the course of the next two centuries was to transform architecture from a mural system, of passive forces, into a functional system, wherein specialized members act in specific ways. Finally, Carolingian architecture can show us buildings which are vaulted throughout—Aix and Germigny—as well as the vaulted ground storeys of the monumental porches. These latter are massive blocks, their upper storeys often of complex elevation, which comprise both western entrance and a chapel dedicated to the cult of the Saviour or some saint. Highly individual creations, they foreshadow the vast Romanesque porches and, in their tower development, the future of the harmonic façade.

It might appear that the components of Romanesque art were already present in this period, and that the beginnings of that art must therefore be put back beyond the eleventh century to the advent of the Carolingian architects. Yet, however important the groundwork which they laid, however interesting their experiments and however promising their results, they left untouched the problem of vaulting in stone the great basilican naves, together with the associated problems of abutment and direct lighting. These questions, on the other hand, were the major preoccupation of Romanesque research from the eleventh century onwards. There is moreover a fundamental distinction to be made between Romanesque and Carolingian art, for the latter did not incorporate its monumental decoration in the substance of the stone, but continued to apply a veneer of ornament—mosaic or painting—or employed substitute materials, especially plaster. The various techniques still led separate existences and were not yet

2

[1]This seems to be the earliest example. Dufraisse, *Origine des églises de France*, 1688, p. 486, gives the date of the consecration of the cathedral as 2nd June 946, and L. Bréhier has found confirmation of this in a chronicle of a monk of Mozat, of the tenth century, appended to a MS. of Gregory of Tours (Library of Clermont, MS. 145). From Clermont, the plan spread first of all in the Loire area—Tours (997), Nantes (992), Le Mans (995), and Orléans Saint-Aignan. Concerning this last church, see V. Mortet's collection of texts, pp. 55, 57, quoting from the *Epitome* of Helgaud's Life of King Robert, and the History of the Translation of the Relics of Saint Euspicius. On the question as a whole, cf. L. Bréhier, *L'art en France . . .* p. 140.

dominated and moulded by a unified architectural thought. It cannot be said that the sculptors of the period lacked the capacity for figure work—the skill displayed in great numbers of lovely ivories proves the contrary—but the taste for monumental stone sculpture was still dormant in the West, though certain Asiatic Christian communities were already creating, especially in the Trans-caucasian churches, important figures and grand compositions.[1] A pictorially biassed Middle Age, which hid the stone beneath a glittering surface decoration, hung plaster reliefs like precious ex-votos on the line of the imposts, or ran their soft and delicate lacework along the string-courses and into the window-embrasures, was the immediate predecessor of a Middle Age which expressed itself completely in stone, and whose sculpture and painting also were architecturally conceived.

It must, however, be acknowledged that the Carolingian ivory carvers, whose works are so various in composition, sentiment and handling, occasionally foreshadowed and perhaps pointed the way to certain decisive experiences of Romanesque monumental sculpture. They do at any rate display two principles which, when applied to monumental sculpture, endowed it with precision and originality—the principle of close adaptation of the design to its frame, and that of ornamental figure composition. On a comb from Cologne, pierced with rosettes and decorated on the reverse with foliage scrolls, figures are arranged and twisted so as to respect and even emphasize the very irregular outline and peculiar form of the field in which they are inscribed. Again, the ivory at St. Gall attributed to the famous artist-monk Tuotilo[2] has, in the upper part of a Crucifixion composition, figures of angels arranged precisely in the manner of ornamental foliage stems, a decorative conformation which recurs in its original guise in the band of foliage which runs along the top edge of the plaque. What we see here is no coincidence, but a conscious stylistic procedure.

II

AN acquaintance with these older forms is indispensable to the study of the Middle Ages proper, for just as twelfth-century art was not an abrupt efflorescence

[1] See J. Baltrusaitis, *Études sur l'art médiéval en Géorgie et en Arménie*, Paris, 1929. In Georgia, the tympana of Djvari and of Ateni (seventh century), of Ochque (ninth century), and of Koumourdo (946); in Armenia, the stelae of Haritch (fifth to sixth century), the reliefs of Zwarthnotz (seventh century), etc.

[2] A. Goldschmidt, *Die Elfenbeinskulpturen aus der Zeit der karolingischen und sächsischen Kaiser*, Berlin, 1914 etc., I, 163. *See E. de Wald, *Notes on the Tuotilo Ivories in Saint-Gall*, Art Bulletin, 1933, pp. 202 ff.

of culture on the morrow of a coarse and barbarous age, so the eleventh century also was no miraculous awakening. Incontestably, it inaugurated a new era in Western history, but it is abundantly clear that a division at the year 1000, as a strict chronological frontier, is a purely arbitrary one.[1] We should do better to treat our century convention with greater elasticity and begin the new period with the second half of the tenth century; but we remain the captives of our schematic view of historical time. It is, however, true that a remarkable conjunction of circumstances does give to the earliest years of the eleventh century a special significance, and that not only from the imaginative aspect. Certainly there can be no question of restoring its full sense and weight to Raoul Glaber's well-known phrase of the 'white robe of churches' with which mankind clothed the earth in gratitude for its deliverance from millenarian terrors. Fear and gratitude play only minor parts in the genesis of a style. But there occurred in fact at this time a number of interconnected events of fundamental importance, all of which contributed to the transformation of the West. First among these were the stabilization of the barbarians, their admission into the Christian community, their *volte-face*. The conversion of the Magyars, who turned to face the invaders from the steppes, and the constitution of the apostolic monarchy in Hungary (1000) completed on the eastern marches of Europe that process of crystallization which had begun in the West with the cession of Normandy to the Northmen by the treaty of Saint-Clair-sur-Epte (911). The conquests of Sicily and England prove that the Scandinavian settlers on French soil had lost nothing of their adventurous spirit, but at least it operated henceforth within the system, and not as an external impact or sudden irruption of the barbarian world. After a period of hesitancy and not without relapses into their earlier mood, they came to accept the framework and the rules of feudal society, and at the same time they forsook piracy for trade.

Islam was now receding. The reconquest of Spain, begun in earlier days by the Asturian chiefs who had succeeded Pelagius, developed into a Western crusade, foreshadowing the great movement of the late eleventh century which

[1]See Dom Plaines, *Les prétendues terreurs de l'an mil*, Revue des questions historiques, January 1893; R. Rosières, *Recherches critiques sur l'histoire religieuse en France*, p. 135, and *L'évolution de l'architecture religieuse en France*, p. 62; Revue critique, 1909, p. 107. It should be noted that none of the tenth-century councils concerned itself with millenarianism, that the discouraging formulae regarding the 'evening of the world' appear in the seventh century and continue until the twelfth, and that the relevant passages in the chronicles record such fears at various dates (909, 960, 992, 1010, 1032, 1095) but not in the year 1000. For R. de Lasteyrie, *L'architecture religieuse à l'époque romane*, p. 228, they nevertheless stimulated activity. For A. Choisy, *Histoire de l'architecture*, II, p. 139 they finally brought building work to a standstill. For C. Enlart, *Manuel*, I, p. 218, note, there has been exaggeration on both sides; too much importance should not be attached to such beliefs, nor should they be dismissed as legendary. *See also E. Pognon's introduction to *L'an mille* (a selection of texts), Paris, 1947, pp. VII–XLV, and H. Focillon, *L'an mil*, Paris, 1952.

was to establish the Western type of monarchy as far afield as Syria. On the death of Al-Mansour the caliphate of Cordova disintegrated into Berber, Slavonian and Andalusian principalities—the 'kingdoms of the taïfas'. The strength of Christian Spain was built up by leaders—Sancho the Great, 'rex Iberorum', Ferdinand I, Alfonso VI—who, with the collaboration of Cluny, reassimilated the country into the Western system, and who, despite rivalries and partitions, defined its political geography for centuries to come; their work was crowned in 1085 by the capture of Toledo, the ancient capital of the Goths. Meantime, Pisans and Genoese swept clean the Tyrrhenian Sea. The Saracens were defeated in the Strait of Messina in 1005, Sardinia was finally lost to them in 1022, the Pisans landed at Bône in 1034. At the other end of the Mediterranean basin the Bagratid princes were liberating Transcaucasia and marking the track of their victorious march against Islam with notable buildings expressive of a great monumental tradition. These facts are of capital importance. As Pirenne has shown, the Mediterranean was becoming once more, if not a European lake, at least a natural channel for travel and the interchange of ideas. The separation of East and West was at an end. The commerce of Byzantium, Venice, Genoa, Pisa, drew them still closer together. In the north, from the tenth century onwards, the Baltic played a similar role, lying open to the trade of the Flemings, who carried the coinage of their counts to Prussia and even into Russia.

The same period saw the appearance in the West of two new political conformations which changed the face of Christian Europe—the Holy Roman Empire and the Capetian monarchy. The Saxon Otto, King of Germany, was anointed Emperor at Rome in 962, thereby reasserting under entirely new conditions the imperial dignity which had been earlier revived for the benefit of Charlemagne. In 987, Hugues Capet was elected King of France, founding a dynasty which was to wear the crown for more than eight centuries without a break. He sprang from the line of those lords of Paris who had more than once repulsed the invading Northmen. His suzerainty covered the old Western Francia, from Flanders to the county of Barcelona. His personal domain, consisting principally of the Ile-de-France, was far from being the most important of the feudal states of which he was overlord; but he was king, and his posterity never ceased to labour for the increase of the royal lands.

Finally, within the feudal and monastic civilization, there had sprung to life an urban and mercantile civilization. The increase of population, the repulse of the barbarians, the freeing of sea-traffic, and the relative political stability all contributed to this renewal of urban life, a kind of life which had been interrupted since the eighth century and whose existence had been precarious even in the

preceding period. The colossal fragile silhouette of the Carolingian empire looms on a rural horizon. But gradually towns began to exert their powerful magnetism on the countryside. A class grew up which, before the era of charters and communal movements, acquired safeguards, a wall, a stronghold to shelter its property, and the protection of new legal rights—the 'ius mercatorum'—to regulate the new relationships.

Such were the circumstances of this great age, and such the forces engaged. And to these was added the force of the Church, which has never been wielded by stronger hands than it was at this time. Among the new men who gave the century its character, the monks of the West are vivid figures. The enterprises of the great abbots set the key for a whole period: at Montiérender, Adso, one of the first reformers of Saint-Bénigne and the builder of the church completed by Bérenger and consecrated in 998; at Hildesheim, Saint Bernward; at Dijon, William of Volpiano; at Ripoll, Abbot Oliba; at Fleury-sur-Loire, Gauzlin, a bastard of Hugues Capet and half-brother to King Robert; at Saint-Germain-des-Prés, Morart. Between 990 and 1030, there appears in the foreground of history a succession of monks who are church-builders, monastic reformers and prelate-politicians, a succession which includes Lanfranc, abbot of Saint-Étienne at Caen and primate of England, and the line of the great abbots of Cluny down to Saint Hugh, who founded the third church there, now demolished, which was one of the wonders of the Christian world. These grandiose figures loom at the entrance to the century like the stone precursors of the church portals.

Were men of this stature to be found among the political leaders also? And to what extent did their actions favour the genesis and propagation of a great art? Let us recall again briefly what they achieved. They imposed a stable authority and they extended the territories over which it was exercised. The first Capetians were rough and ready characters who, though they leaned on the Church, were not, like King Robert, enwrapped in the convolutions of priestly politics. But their sphere of action was still restricted, because it was dependent on the feudal principle; their power was bound up with the possession of their domain, which was itself small and scattered. To this power, monarchy added a heritage of memories, the prestige of its founders, and the authority of a moral magistrature which was a distant legacy from the Latin principate. It gradually acquired, and later fostered in its representatives, the least well endowed as well as the most kingly, an instinct of dynastic policy—a grasping policy, looking always to advantageous marriage or great inheritance, but one which, despite such errors as the repudiation of Eleanor of Aquitaine by which the whole of western France was forfeited to England, thus creating the century-long Plantagenet empire,

at last made the royal domain conterminous with France and welded its people into a profound unity. True, in the early days the great question was to get from Paris to Fleury without a fight and the fate of the monarchy turned on its possession of Étampes and Montlhéry. But the old dukes of France had no intention of ending like the last Carolingians, whom they had supplanted. They felt to the full the pride of the office with which they were invested. They had good towns and good stone-quarries. In the first half of the eleventh century notable buildings began to rise in their domains: Saint-Germain-des-Prés in Paris, the cathedral and Saint-Aignan at Orleans, the Romanesque cathedral at Chartres, and the second Saint-Rémi at Reims.

More formidable than the vassals of the enclaves were the great feudal states which formed the various provinces of Romanesque art. One of these is especially remarkable by reason of the circumstances of its origin, its precocious and harmonious development, and its sudden enormous expansion in the second half of the eleventh century. We have seen how Normandy sprang from the last barbarian invasion of Gaul and the weakness (or policy) of Charles the Simple. Once settled on French soil these insatiable harriers of the coasts and river valleys established in their vast fief institutions which were the admiration of contemporaries. They built castles and churches in a severe and measured style which they carried with them into England, there to displace the art of the Saxon architects. These sea-rovers turned feudal lords retained their taste for high adventure. The sons of Tancred of Hauteville expelled the Greeks from southern Italy and the Saracens from Sicily to found their own royal line. The evolution of their composite culture shows how they were beguiled by the blandishments of Byzantium and Islam, turning a complacent eye on mosaic pictures commemorating their investitures and on the imperial style of the bronze doors of churches and mausolea; but the Norman genius was to leave its imprint on the churches of Apulia.

The art of building was still more necessary to the rulers who, in the ninth century, from their little Christian states in the Asturias and the Pyrenean valleys, began a process of reconquest which was to lead them, towards the end of the eleventh century, to the heart of the Iberian peninsula. Churches and fortresses were their solid footholds in the reconverted territory. The Orientalizing style of the buildings of Oviedo gave way to forms imported through the collaboration of the French monastic orders, though the traces of the contact with Islam never entirely disappear from Spanish architecture. In the case of Spain, art was an indispensable agent of Western civilization, but Ottonian Germany, though employing it in this way in the organization of its eastern borderlands,

looked upon it also as the supreme symbol of imperial majesty. In politics and architecture, the Ottonians took up again the themes of Carolingian splendour, but treated them with grander, severer, power and richness. Finally, the entry of the Hungarians into the European community opened a new field of activity, first to the Lombard builders, and subsequently to the Cistercian architects and the exponents of the French style (which here appears mingled with a number of Italian survivals and elements from southern Germany).

But political geography and the aims of rulers, though they may help us in some degree to understand the extent of artistic movements and even certain aspects of the distribution of forms, cannot explain the origin, the character and the success of those forms. The political factors must not, on the other hand, be neglected, since they provided the broad framework within which the aesthetic forms had their existence and within which they drew on the new contacts, the new material resources and especially the new human reserves, which gave the century its peculiar impetus.

The earliest works of the new style were modifications of an obsolescent academism. From an early date, there appeared in the West an architecture which can be recognized by its systematic use of blind arcades and flat pilasters, the so-called Lombard bands, in a sober and unvarying decorative effect. It was long known as Lombard architecture—a conventional and restrictive term justified not only by the numbers and early dates of the Italian examples but also by the European celebrity of the Lombard architects—yet its territory extended far beyond the bounds of Lombardy. Its origins were probably Oriental. In rechristening it 'first Romanesque art',[1] J. Puig i Cadafalch rightly emphasized the historical importance of this style, its extension over a great part of Western Europe, and its place in the artistic development of the Middle Ages. But it should be noted that 'first Romanesque art' is principally characterized by its external decorative system and that the majority of its structural solutions (with the exception of its basilican high vaults) were simply taken over from Carolingian architecture. Again, 'first Romanesque art' was also 'second Romanesque art' in that it persisted throughout the twelfth century and even later. But on the other

[1]The term 'Romanesque' is of course a much older creation. In the French 'roman' it is happily linked with the parallel development of the Romance languages and literatures. The credit for this coinage is due to a Norman antiquary, M. de Gerville, who, in a letter to his friend Le Prévot, dated December 1818, wrote in connection with certain Norman churches: 'It is universally agreed that this heavy, clumsy architecture is *opus romanum* distorted or gradually debased by our rude ancestors. At the same time, from a similarly mangled Latin, there was emerging a Romance language (une langue romane) . . . ' The term is more valuable than the doctrine. See Ch. Gidon, *L'invention du terme d'architecture romane par Gerville* (1818), Bulletin de la Société des Antiquaires de Normandie, 1935.

hand, even in the eleventh century it did not represent the entire activity of the architects, nor, perhaps their most important contribution. It is really the Romanesque art of certain areas rather than of a certain period, and in using the term we must remember that its significance is primarily geographical.

Its extent was wide and well-defined, including conservative centres in which it persisted for a long period, and others which soon abandoned it for newer forms. It is found in northern and central Italy, in Catalonia, in Bas-Languedoc, in Provence; it pushed up the Rhône and Saône valleys, and spread to the Rhineland and Central Europe; it even reappeared at the end of the Middle Ages in Byzantine territory, in churches built by the Moldavian princes. In Catalonia it has left many well-grouped early buildings, forming an evolutionary series which time has preserved unmarred, complete with their remarkable wall-paintings. This area already possessed a long history; art had flourished there in the Visigothic era, as is shown by the baptistery of Tarrasa. Later, in the days of the spendours of Toledo, this little state on the fringes of Christianity played an intellectual role which was no less important than its political mission in the defence of the West. The contact with Islam was not without influence on the spirit of forms. Mozarabic art,[1] originally the art of the Christians in Muhammadan territory, was the first of the vigorous hybrids which developed in the Iberian peninsula. It had preceded first Romanesque art in Catalonia. But it occurs all over northern Spain, in the area bounded by the Douro and the Cantabrian Mountains, particularly in León. Here its monuments are distinguished by the use of the horseshoe form in the main arcades and even in the plans of apses, where the horseshoe sometimes comes near to being a closed circle; this characteristic, however, is not peculiar to the style since more than one earlier example can be found in the Visigothic territories. As at Cordova, the centre of this culture, the columns are surmounted by capitals of a dry, light style in which the stone is treated like wood. In conformity with the ritual of the Eastern Church, which was long observed over the whole Christian world, the choir was hidden from the faithful by a curtained portico. In addition, certain Mozarabic churches, such as San Miguel d'Escalada, have an elegant lateral gallery, which has sometimes been taken for the commencement or remains of a cloister, and which recalls the *liwan* of a mosque. One finds this art also in Castile, for instance at San Juan de Baudelio, whose palm-tree of stone shelters a cycle of Christian

9

[1] On Mozarabic art and culture, besides M. Gomez-Moreno's handsome book, see J. Puig i Cadafalch, *Le premier art roman*, ch. I, p. 11, and especially p. 28 and note (on the intellectual formation of Gerbert of Aurillac). For considerations affecting the number and shape of apses, see ibid., p. 57, and W. M. Whitehill, *Liturgical influence on pre-Romanesque apses in Spain*, Art Studies, 1927, p. 151.

paintings of great beauty, intermingled with Oriental hunting-scenes. A Mozarabic monastery, Liebana, gave to the West the *Commentary* of Beatus on the Apocalypse, which was destined to feed the visionary genius of the great twelfth-century sculpture and which inspired also the paintings of the Catalan oratory of Fonollar.[1] In Catalonia, the churches of Pedret, Marquet, Sant Féliu de Boada, Olerdola and Obiols are all in the Mozarabic style, and Saint-Michel de Cuxa (Pyrénées-Orientales) is one of the earliest and most important of this whole cycle of monuments.[2] They are superseded by the primitive forms of first Romanesque art and one is tempted to conclude that these little basilican churches, transeptless and, apart from apses and choir, roofed in wood, represent a popular rustic vein of Carolingian art—the more so since Sant Pere del Burgal has a western apse. But other sources must be found for the high vaulting of the naves, which was accomplished at Santa Maria d'Amer and Santa Cecilia de Montserrat probably in the second half of the tenth century, and is securely dated to the year 1009 at Saint-Martin du Canigou. The introduction of a dome over the crossing inaugurated, at Ripoll and Sant Vicent de Cardona, a series of basilicas on a grander scale.[3]

1

4

[1] The *Commentaries* of Beatus were composed in 784 at Liebana, near Santillane. Beatus was the antagonist of the adoptionism propagated by Elypandus, Archbishop of Toledo. It was no doubt in the scriptorium of San Miguel d'Escalada that they were first illustrated with miniatures, by a certain Magius Arxipictor (New York, Morgan, 644: this is at any rate the oldest known Beatus—according to the inscription on f. 293, it was executed in 926 for Abbot Victor). Copies were made by Magius himself, by his pupil Emeterius, by a female painter, Ende (975, cathedral of Gerona), and later, in the eleventh century (archives of La Seu d'Urgell), etc. The Beatus of Saint-Sever (Paris, Bibl. nat.) dates from the abbacy of Gregory (1028–72). *The dating of Saint-Martin at Fonollar (or Fenollar) has oscillated between the late tenth and the late twelfth centuries, but the wall paintings are now attributed to the middle of the twelfth century; see C. R. Post, *History of Spanish Painting*, Cambridge, U.S.A., Vol. I, 1930, p. 126; W. W. S. Cook and J. Gudiol Ricart, *Ars Hispaniae*, Vol. VI, Madrid, 1950, p. 80; P. Deschamps and M. Thibout, *La peinture murale en France. Le haut moyen-âge et l'epoque romane*, Paris, 1951, pp. 145–6.

[2] See F. Hernandez, *San Miguel de Cuixa, iglesia de ciclo mozarabe catalan*, Archivio español de arte y arqueologia, 1932; J. Puig i Cadafalch and G. Gaillard, *L'église Saint-Michel de Cuxa*, Bulletin monumental, 1935. Consecrated in 974, this old foundation of the counts of Cerdagne was altered and enlarged by Abbot Oliba. At the end of the tenth century, the Doge Pietro Orseolo, the builder of St. Mark's, came here to end his days, together with St. Romuald, the founder of the Carmaldolite Order. From Cuxa Oliba sent monks to build Saint-Martin du Canigou. The original plan comprised an aisled nave preceded by one projecting bay (as at Santa Cecilia de Montserrat), an extensive transept with two very deep chapels in each arm, and a square chevet, which was equal in width with the nave and which Oliba replaced by a larger one having three eastern chapels. All the tenth century arches are of the Islamic horseshoe form (diameter greater than the distance between the jambs, chord equal to a radius and a half). The masonry of piers and wall-angles is of Cordovan type. The use of monolithic members of Oriental character should be noted: the lintels of the lateral openings of the sanctuary and the arched window-heads. J. Puig i Cadafalch is at present (1938) engaged in preparations for the restoration of the timber-framed roof. *On Cuxa, add J. Puig i Cadafalch, *L'architecture mozarabe dans les Pyrénées françaises, Saint-Michel de Cuxa*, Mémoires de l'Académie des Inscriptions et Belles-Lettres, 1938, pp. 1–43.

[3] J. Puig i Cadafalch, *Le premier art roman*, passim, classifies the church-types of first Romanesque art in Catalonia as follows: (1) Triple-nave churches without transepts, terminating in three eastern

This architecture, the variety and evolution of whose unique external decorative system may best be studied in Catalonia, had a development no less early and remarkable in its other centres, which were always closely bound together, especially those in the Mediterranean area, by a constant interchange of ideas. In Italy, it produced its earliest manifestations and the greatest number of its monuments—Bagnacavallo (eighth century?), Agliate S. Pietro (824-59), Milan S. Vincenzo in Prato and S. Babila, and the Como churches. In Bas-Languedoc, it is exemplified by Saint-Guilhem-le-Désert (i.e. the old abbey of Gellone, founded by William of Orange) and by Saint-Martin-de-Londres. In Provence likewise, and still more in Burgundy, it has representatives whose stylistic purity does not preclude the most profound originality. Saint-Vorles at Châtillon-sur-Seine[1] may be dated round about the year 1000; standing on its shady knoll, the old church presents a complex silhouette, but among the alterations and additions one can still distinguish the volumes and gables of a double transept, wearing, like the walls of the nave, the familiar dress of shallow arcades and flat pilasters. The same decorative scheme is employed in the bell towers of the Mâcon district. Tournus, with its narthex covered with four different types of vaulting, its nave vaulted with transverse barrels, its ambulatory and rectangular radiating chapels, its solid lofty masses, would in itself be convincing testimony of a great architectural style. At Saint-Bénigne in Dijon, built by Abbot William of

apses, wood-roofed, and with arcades resting on square piers—Sant Pere del Burgal (late ninth–early tenth century, with western apse), Sant Vicent d'Estamariu, Sant Climent and Santa Maria de Tahull, and Santa Maria de Bohi, the last three dating from the twelfth-century and with columns in place of piers; this type also occurs in Savoie (Aime Saint-Martin) and in the Meuse area (Dugny). (2) Vaulted churches with plain longitudinal barrel-vaults—Santa Cecilia de Montserrat (tenth century), Saint-Martin du Canigou (1009)—or barrel-vaults with transverse arches—Sant Pere de Casseres (1010), Arles-sur-Tech (1046), Elne (1042–68). (3) Large basilican churches with transepts and dome at the crossing—Ripoll (1032), Sant Vicent de Cardona (1040), Sant Llorent del Munt (1066); this type is exemplified in France by Châtillon-sur-Seine Saint-Vorles (1000–10), Chapaize (1020), Saint-Guilhem-le-Désert (1076), Lons-le-Saunier Saint-Désiré (after 1085), etc.
*Refer also to A. M. Whitehill, *Spanish Romanesque Architecture of the Eleventh Century*, Oxford, 1941, reviewed by G. Gaillard in Bulletin monumental, 1945; and J. Gudiol Ricart and J. A. Gaya Nuno, *Arquitectura y escultura romanicas* (Ars Hispaniae, V), Madrid, 1948.
[1]Saint-Vorles was built by Bruno de Roucy, Bishop of Langres 980–1035. The church is remarkable for its double transept, which makes it one of the points of contact in Burgundy between Carolingian and Mediterranean forms. The western transept, which projects less than the eastern, is apparent only externally, from the north-west—the southern limb has been reduced to the level of the aisle-roof—and its mass is now dominated by a bell tower which, like the little porch in front of it, is of later construction. The interior of this transept is cut up by chapels and upper storeys. It seems to represent an intermediate stage between western transept and narthex. The extremely narrow and lofty nave is nowadays lit only by the aisle-windows. The main vault is seventeenth century; the groined vaults of the aisles are old, but one cannot say the same of the crossing-cupola and the barrel-vaults of the main transept. In the piers, half-columns project from each face of a rectangular block, entirely concealing it except for its angles, which are prolonged up the nave-wall as if to take the springing of the vanished vault. The external masses of the apse have been disfigured by later additions.

Volpiano (1007) about the time when the Tournus narthex was nearing comple-
tion,[1] the original five-nave church was replaced by a three-nave Gothic structure
in the thirteenth century; of the rotunda raised over the relics of the apostle of
Burgundy, there remains only the lower part, the present crypt, but its arrange-
ment and structure are known to us from the careful description of Dom Plancher.
The stair-turrets were decorated with pilaster-strips, and the regularly laid small
stones were the typical masonry of first Romanesque art in this region. The chief
difference between the Saint-Bénigne rotunda and the Aix chapel is that the
former does not stand alone but is part of a long church, as are also the later
rotundas of Canterbury St. Augustine, of Neuvy and of Charroux, which do not,
however, belong to first Romanesque art.[2] In the Jura, the Baume-les-Messieurs

[1]Authorities differ as to the dates of the work at Tournus. According to J. Virey, *Les dates de
construction de Saint-Philibert de Tournus*, Bulletin monumental, 1903, p. 532 ff., the choir
was begun by Abbot Aimin (928–46), after the destruction of an earlier church by the Magyars in
937; Abbot Hervé (946–70) and Abbot Étienne (980) continued the work; the lower storey of
the narthex was built from the debris of the destroyed church, and Étienne linked choir and
narthex by erecting the nave; a fire in 1007 or 1008 destroyed all except the ground storeys of
narthex and sanctuary; Abbot Bernier (1008–28) called in a group of Lombard masons who
covered the nave with a wooden roof and the aisles with groined vaults; a first consecration took
place in 1019; the transverse barrel-vaults of the nave date from the end of the eleventh century;
the choir was rebuilt, and consecrated in 1120 by Calixtus II. According to Ch. Oursel, *Art roman
en Bourgogne*, Boston, 1928, the great builder Étienne was responsible for the ambulatory with
radiating chapels, built on the model of the Clermont ambulatory to provide a worthy setting
for the relics of St. Valerian, who was to be resuscitated from the comparative neglect into which he
had fallen; the narthex is not earlier than the sanctuary and was built without interruption, the
two stages showing no specific differences (except that their pilaster-strips are not aligned)—
completed at about the time of the fire, it survived, thanks to the fortress-like stoutness of its masonry;
the nave-vaults are of the time of Abbot Pierre I (1066–1107) but the transverse and diaphragm
arches are earlier work reinforced. According to H. Masson, in his monograph *Tournus*, 1936, the
ground storey of the narthex is Aimin's original church, which was heightened by the addition of an
extra storey and transformed into a narthex under Abbot Ardain (1028–56).
[2]One hesitates to group with these the Syrian example of St. Simeon Stylites, at Kalaat-Seman, where
four basilicas radiate from a central court. H. Perrault-Desaix, *Recherches sur Neuvy-Saint-
Sépulcre et les monuments de plan ramassé*, 1931, p. 22, rightly observes that a distinction must be
made between an empty space and a solid structure. In addition to the rotundas connected with a
nave, isolated rotundas were still built (Saint-Léonard, Rieux-Minervoix). The fine rotunda of
Neuvy-Saint-Sépulcre is an example; though clumsily linked with an old and much altered church,
it is not an integral part of it. We know from four texts that a church of the Holy Sepulchre was built
at Neuvy between 1042 and 1046, and these are confirmed by a letter of Gregory VII dated 1078.
F. Deshoulières, Bulletin de la Société des Antiquaires de France, 1916, p. 190, and J. Hubert,
Bulletin monumental, 1931, p. 91, maintain that these texts relate to the church and not to the
rotunda. The analysis of structure and decoration, done again by Perrault-Desaix, *op. cit.*, supports
Viollet-le-Duc's view. The chapels of the knightly orders (octagons of the Templars at Laon, Paris,
London, Thomar, etc.) were modelled either on the Mosque of Omar or on funerary monuments.
The dodecagon of the Vera Cruz at Segovia belonged to the Order of the Holy Sepulchre, the
octagon of Montmorllion to the Hospitallers. See E. Lambert, *L'église des Templiers de Laon et les
chapelles de plan octogonal*, Revue archéologique, 1926,* and *L'architecture des Templiers*, Bulletin
monumental, 1954. On centrally planned buildings, see R. Krautheimer, *Introduction to an Icono-
graphy of Mediaeval Architecture*, Journal of the Warburg and Courtauld Institutes, 1942, pp. 1–33;
A. Grabar, *Martyrium*, 2 vols., Paris, 1946; E. B. Smith, *The Dome*, Princeton, 1950. A wooden
dome is now reconstructed at Kalaat-Seman, following D. Krencker's findings.

group, in Savoie, Aime Saint-Martin, and in Switzerland, Romainmôtier,[1] all
illustrate the stability of the style, and its consistency in very different localities
and periods, but at the same time suggest the great variety of planning and
structure which lay within its scope.

Indeed, when we try to come to close quarters with its more intimate charac-
teristics, behind the cloak of arcades and bands and the walls of small stones
roughly squared with the hammer, we realize that they are more complex than
could be imagined at first acquaintance. The plans are extremely varied, and in a
way which does not suggest that this is due merely to diversity of liturgical
requirements. Small and medium-sized churches, it is true, are normally planned
with eastern apsidal chapels, but the same scheme also occurs in some large
churches where the chapels form extensions of the choir-aisles, while at Ripoll
six apsidal chapels, in two groups of three flanking the main apse, open directly
on to the transept which cuts across the five naves.

First Romanesque art also adopted certain features of Carolingian architecture[2]
—the ambulatory with radiating chapels at Tournus (derived from Auvergne),
the western apse at Sant Pere del Burgal, the double transept at Châtillon-sur-
Seine—the two latter with no great future before them, rather the reverse, but
they are family traits which cannot be accounted for by any reference to
Mediterranean influences. Structure is likewise very varied, including churches
of the Carolingian type, wood-roofed except for apses and choir, and with or
without groin-vaulted aisles, churches with plain longitudinal barrel-vaults or
barrel-vaults with transverse arches, supported on columns or on rectangular
piers, and churches with domes at the crossing. A most remarkable feature is
the early date of the Catalan high vaults, which were certainly stimulated by
Oriental examples. From the same distant source came a method of constructing
arches and vaults, not with radiating voussoirs, but with flat stones following the
curve of the arch and in contact only at their edges; the same arrangement,
Mesopotamian in origin, is found in Transcaucasia, where churches are vaulted
with stone slabs in this way (Djvari). Domes on pendentives were likewise an

[1]This was a Cluniac priory, the church of which was built by St. Odilon between 996 and 1026.
Between 1080 and 1087, under Prior Étienne, with the encouragement of St. Hugh, the wooden
roof of the old basilica was replaced by plain barrel-vaults pierced by window-lunettes. This
remarkable experiment, successfully reconciling the demands of lighting and of equilibrium, has
been admirably treated by S. Brodtbeck, *Les voûtes romanes de l'église de Romainmôtier*, Bulletin
monumental, 1936.
*[2]On the survival of older features in early Romanesque architecture, see J. Baltrusaitis, *L'église
cloisonnée en Orient et en Occident*, Paris, 1941; L. Grodecki, *Le 'transept bas' dans le premier art
roman et le problème de Cluny*, à Cluny, Congrès scientifique, 9–11 juillet 1949, Dijon, 1950, pp.
265–69; P. Verdier, *Les transepts de nef*, Mélanges d'Archéologie et d'Histoire publiés par l'École
Française de Rome, 1952, pp. 179–215.

Asiatic invention. The transverse barrel-vaults erected over the nave of Tournus at the end of the eleventh century are reminiscent of ancient Iranian vaults; this system of vaulting, which was imitated at Mont-Saint-Vincent, had already been used between 979 and 1008, or possibly earlier, in the Tournus narthex, which is a veritable pattern-book of the vault-types of the time—in the lower storey the central vessel is covered with a stilted semi-circular groined vault and flanked by aisles vaulted with transverse barrels, while on the upper floor a longitudinal barrel is buttressed by half-barrels over the aisles. Similarly at Dijon Saint-Bénigne, the architect combined an annular barrel-vault, groined vaults inserted therein, half-barrels, and domes.

This art, so rich in resources and in the variety of its solutions, aiming at the extension of stone-technique into every part of the church (whereas the East and North were slow to abandon the timber-roof), is a fundamental aspect of the medieval achievement. By the severe distribution of masses and bold accentuation of volumes, first Romanesque art created effects of the utmost grandeur. Its strict regularity is enhanced by rugged, rocky settings. One of the oldest of the mountain abbeys, Santa Cecilia de Montserrat, seems raised of set purpose to dominate a convulsive landscape by the force of human intellect. In the gentler solitude of a little Pyrenean valley, coming down from the *col de Puymorens*, Oliba's Ripoll unfolds in mournful strength the seven half-cylinders of its apsidal chapels, ranged along the great transept-wall like the towers of a silo. And amid green alluvial fields beside the Saône, the solidity of the block is not diminished; one is impressed, not by an exterior elevation enclosing an interior elevation and standing on a plan, not by a combination of plane surfaces, but a system of solid bodies possessing mass and density, seated firmly on the ground, and powerfully defined in space. Everything proclaims the number, function and relationship of the parts, which make up a whole at once homogeneous and complex. Few openings pierce the thick walls; the bare surfaces reject all but the soberest ornament—those shallow vertical bands with little blind arcades running between them at cornice level, which are the sign-manual of first Romanesque art, repeated, with insignificant variations of proportion, in innumerable buildings. This slight frill serves to outline the gable-ends and to divide the storeys, it runs the length of the lateral façades and encircles the apses, it clarifies and embellishes the design of the towers. What was the source of these thickenings of the wall, the so-called Lombard bands, and the arcades which provide a kind of metrical scansion of the intervals between them? Were they derived from the heavy arches hung between the buttresses (or rather the arcades hollowed out of the wall-mass) of the Tomb of Galla Placidia at Ravenna? Whatever its

origins, the system appears fully formed at Bagnacavallo, before the opening of the eleventh century. In Italy, and in Germany also, it long remained in favour. Latterly, it assumed a lighter, more airy form; the apses of the Rhineland borrowed from Lombardy the more evolved type of open arcaded gallery with colonnettes, breaking up the wall-mass; and in Tuscany the dissociation of the wall and its arcaded dress was to become so marked that the block of the church proper is only dimly seen through the meshes of a second, openwork wall. But at the period which we are now considering, far from finding any premonition of the future dissociation of parts, what strikes us most about the plastic forms of first Romanesque architecture is their strength and unity.

Yet this Mediterranean, Oriental-born art was not, as we have already hinted, the universal formula of Western Europe. In another geographical area and a different moral climate, Carolingian art persisted, not as a decrepit survival but with remarkable vigour. In the British Isles, in the southern Netherlands, in northern and north-eastern France, on the Meuse and the Rhine, comprising altogether an enormous area, the art of architecture, in the last third of the tenth century and for the greater part of the eleventh, retained the programmes and techniques of the Carolingian empire. It was more or less affected by southern influences, more or less tinged with local tradition, but it was faithful to the timber roof, the vast programmes of the abbeys, the square, solid piers, and the arches cut cleanly through the nave walls with a truly Roman sobriety.

One may perhaps suggest that, but for the Norman invasion, Anglo-Saxon architecture might have experienced a period of grandeur comparable with that of the Rhineland. It is known to us, however, mainly from village churches which are very far from providing material for a complete evaluation. In addition, we learn something of the great vanished cathedrals from later evidence, like the seal of the Chichester chapter (fourteenth century), which shows a scheme resembling Saint-Riquier with a forest of towers, or from contemporary descriptions, such as those of Edmer the Precentor for Canterbury (altered at the end of the tenth century), of Wolstan for Winchester (consecrated 980) and of Reginald of Durham for the White Church at Durham (consecrated 999). The rapid succession of these dates indicates that in England also this was a period of efflorescence in architecture. The occurrence of western altars (Chichester, Abingdon) and the number and importance of towers, which were sometimes enormous (façade of Elmham Cathedral), underline the connections between this architecture and continental art. Was it also touched by Mediterranean influences and did the decorative arcades reach it indirectly by way of the Rhineland ? This may or may not have been so, but certainly something seems to have

been contributed by native techniques.[1] The very complex panelling which adorns the well-known tower of Earl's Barton and, in a rather simpler form, that of Barton-on-Humber, has been compared with half-timbered construction. But it is intriguing to discover, on the south face of Earl's Barton, above the slender pilasters, other sturdier shafts of much greater diameter, well fitted to exercise a supporting function. This bulkiness of supporting members, which in some of the porches are almost barrel-shaped, the beauty of the bare interiors of some parochial naves, and the notable variety of arch-forms, including three-centred and triangular arches, all contribute to the individuality of accent which colours and distinguishes the achievement of the Anglo-Saxon builders.

7

The true fulfilment, however, of the architectural traditions of the Carolingian empire was achieved in Germany, where a resurrected political system (962) now fell again into energetic hands[2]. It is here that architecture, often conceived on very ambitious programmes, may best be seen as a symbol of secular power and grandeur. Ottonian architecture knew the arcades and bands of first Romanesque art, but at the same time it retained the vastness of Carolingian monumental schemes, which were made possible by the relative lightness of the wooden covering, and that strength of wall, firmly based and built, which seems to preserve something of the Roman tradition. Hildesheim St. Michael, of the early eleventh century, has a double transept with a stair turret at the end of each arm and a tower over each crossing, while in the interior a bare wall rests on a plain arcade with alternating columns and square piers (each pier followed by two columns). The interior elevation of Gernrode (961) differs from this not only in its alternation of supports (one column to one pier) but also in its insertion of a sturdy gallery of colonnettes, in the grandest monumental style, between the main arcades and the clerestory windows. The great constructions of Conrad II, the abbey of Limburg a. d. Hardt, and the cathedral of Speyer, which derives from it, with the immensity of its scale and the majestic massiveness of its interior elevation, are probably the supreme expressions of the genius of this art. The imperial grandeur of Limburg is still further enhanced by ruin and desolation. It was founded by Conrad after his accession (1024), on a northern spur of the Vosges; the crypt was consecrated in 1035, the choir in 1042. The

19

20

*[1]On Saxon architecture the basic works are still G. B. Brown, *The Arts in Early England II. Anglo-Saxon Architecture*, revised ed., London, 1925, and A. W. Clapham, *English Romanesque Architecture before the Conquest*, Oxford, 1930; but on 'long and short work' see the three important articles by E. G. M. Fletcher and E. D. C. Jackson in the Journal of the British Archaeological Association, 1944, 1949 and 1951.
*[2]On Ottonian art and its political climate: H. Jantzen, *Ottonische Kunst*, Munich, 1947; on architecture, E. Lehmann, *Der frühe deutsche Kirchenbau*, Berlin, 1938, is now superseded by L. Grodecki, *Au seuil de l'art roman: L'architecture ottonienne*, Paris, 1958.

choir has the peculiarity of a square east end flanked by two apsidal chapels, a type which recurs later in Alsace, at Murbach. Moulding profiles and architectonic decoration run through the whole regional and period repertoire—Attic bases, cubic capitals, chamfers—with magisterial assurance. The most remarkable and rarest feature is the double storey of window-openings in choir and transept, and still more, the way in which the interior elevation knits them together in a unified and vigorous composition, framing the lower windows with pilasters and arches which, visually, support the upper window-register—a principle which was further developed by the architect of Speyer.

Speyer Cathedral is the expression of two consecutive ideas, each of which succeeds in realizing both the grandeur of the imperial project and the audacity of a new structural conception. The original cathedral, begun by Conrad II about 1030 and consecrated by Henry III in 1061, retained the scheme of wood-roofed nave and groin vaulted aisles. Its striking originality lay in raising the Limburg arcades to the full height of the nave, so that both main arcade and clerestory windows are enclosed in great arches which rise uninterrupted from the pavement to the summit of the wall. Thus there was achieved in Germany a colossal order which replaced the stage-superposition of the Gernrode-Hildesheim type by the systematic unification of the several storeys.[1] Other innovations of the greatest interest were to follow. At the end of the century, subsidences caused by the infiltration of the waters of the Rhine into the foundations necessitated extensive renovation, the scope of which was still further increased by the decision of Henry IV, the adversary of Gregory VII, to vault the nave. The piers were reinforced and the walls heightened in order to receive groined vaults of elliptical contour over square bays (1082–1106). But these vaults, being too flat and exercising a considerable and inadequately buttressed side-thrust, failed to withstand the fire of 1159.[2]

[1] In the light of the recent studies by E. Lehmann and H. Jantzen, it seems necessary now to clearly distinguish three main groups of buildings in Ottonian architecture: (a) the group of Saxony, represented by St. Michael at Hildesheim and by Oberkaufungen, where the alternation of piers and columns follows a dactylic rhythm (one pier, two columns); (b) the 'Imperial' group of the Middle Rhine valley, with Speyer and Limburg, whose origins have to be sought at Mainz (cathedral of 1009) and Strasbourg (cathedral of 1015); (c) the Cologne-Werden group on the Lower Rhine (St. Aposteln at Cologne, St. Lucius at Werden, etc.) where the alternation of piers and columns follows an iambic rhythm (double bays) and where the walls are covered by blind arcades. A particular importance must be given, in the history of Ottonian architecture, to the abbey-church of Nivelles, begun c. 1000 and partly completed for the dedication of 1045, which associated the characteristics of the 'Imperial style' of the Rhine with Mosan traditions: see F. Bellmann, *Zur Bau- und Kunstgeschichte der Stiftskirche von Nivelles*, Munich, 1941, and L. Grodecki, *op. cit.*, pp. 56–58.

[2] See S. Brodtbeck, *loc. cit.*, R. Kautzsch, *Der Dom zu Speier*, Städeljahrbuch, 1921; H. Reinhardt, *Die deutschen Kaiserdome des XI. Jahrh.*, Basler Zeitschrift, 1934. The history of groin-vaulted naves in Germany does not end with Speyer; a later example, over oblong bays, is that of Maria-Laach,

We are here witnessing the development of an architecture which, while drawing on a tradition which was already old, was able to renew it by virtue of its experimental spirit; and we shall find that the art of the plaster workers, the bronze founders, the goldsmiths, and perhaps most of all the art of manuscript decoration, present a comparable picture. In the case of architecture, at least, the same holds good for north-eastern France, particularly Champagne, the marches of Lorraine and the Capetian domain—an area impregnated with the Carolingian spirit, at no great distance from the Meuse centres, and generally antagonistic to the arcade-and-band system. The quality of its achievement at an early date may be estimated from what remains of the fasciculate piers of the nave of Saint-Rémi at Reims, which date from the building campaign of 1005–34. There are also several important churches still standing; such are Montiérender, begun by Abbot Adso and consecrated by his successor Bérenger (998), and especially a priory of Dijon Saint-Bénigne, Vignory,[2] the nave of which was built by Guy I, lord and patron of the place, in the early eleventh century, and the choir by his son Roger (consecration 1050–52).

8

At Montiérender, under a timber roof, the elevation—main arcades on rectangular piers with imposts, tribune with twin openings under relieving arches, and clerestory—has a solid beauty. This church of the old abbey of Le Der does not take us much beyond the traditional type of Carolingian structure. The nave of Vignory, however, presents a remarkable peculiarity, in the form of a range of openings above the main arcades which have no tribunes behind them and serve no purpose but to lighten, strengthen and enliven the wall. A rich ornament, mainly geometrical, is engraved rather than carved on the imposts of the rectangular piers and the columns which alternate with them in the eastern bays, and on the triforium capitals. But this summary can do no more than hint at the variety of resources and the originality of ideas displayed within a framework which is still fundamentally that of the old wood-roofed basilica.

which was in building from 1093 to 1156, though the vault form must have been determined in the 1090s, under the influence of the second building-campaign at Speyer. There is scope for an investigation of the relationships which may exist between these experiments, the vaulting of the Norman churches, and the so-called 'Martinian' type exemplified by Vézelay.

[2] From a charter of Roger de Vignory, published by d'Arbaumont, *Cartulaire de Saint-Étienne de Vignory*, Langres, 1882, we learn that the church was consecrated by Harduin, Bishop of Langres from 1050 onwards. But the abbot of Saint-Bénigne, Halinard, who received the donation, died in 1052. All would be clear, but that the chronicle of Saint-Bénigne expressly attributes the construction of the building to Guy, Roger's father, which would conflict with the charter, except that the latter does no more than refer to the church as *noviter aedificata*. Archaeological examination permits a reconciliation of the texts. In my view, Roger's work is the choir. This is vaulted throughout, and is indeed in a more up-to-date style, especially in the structure of the compound piers of its straight section and the capitals of the semicircular ambulatory. This opinion is developed at greater length in *L'église de Vignory, ses dates de construction*, Revue archéologique, July–September 1937. See also F. Deshoulières' studies in the Bulletin monumental for 1929, and in *Au début de l'art roman*, p. 78.

There existed, then, from the beginning of the eleventh century, a northern zone of Western architecture, whose productions, while radically different from those of first Romanesque art (the typical arcading was, however, adopted in some regions), were yet very far from being a mere monotonous and passive repetition of the Carolingian formulae from which they derived. Those formulae persisted over a very extensive area; western apses, for instance, occur in the Rhineland, in Catalonia (Sant Pere del Burgal) and in France (Nevers Saint-Cyr, 1029; Besançon cathedral).

Likewise of Carolingian origin are the towers which flank the east ends of Saint-Germain-des-Prés (1005), Auxerre cathedral (1030) and Morienval (1050). The notable narthexes of the eleventh century—Tournus, Lesterps (1040), and in Auvergne, Chamalières, Manglieu, Notre-Dame-du-Port—are clearly descended, at least as far as the more elaborate type with towers and first-floor chapels is concerned, from the porch churches of tenth-century abbeys.

But this great period is dominated by a much more significant factor. The apparent uniformity of 'Lombard' architecture begins to be replaced in eleventh-century France by distinctive regional styles which we shall find firmly established by the beginning of the twelfth century, and by the family of the pilgrimage churches. In the south-west there was early evolved a type of church without tribunes and having aisles almost equal in height with the nave, which was destined to develop towards the colonnaded hall. Of the eleventh-century style of Poitou there remain the greater part of Saint-Savin and not inconsiderable traces in the churches of Poitiers. Saint-Hilaire-le-Grand,[1] built by the English architect Walter Coorland and consecrated in 1049, was altered at the end of the century and again later when the nave was vaulted with domes, but the transept, the north tower, parts of the wall of the apse, and possibly the aisles and nave-walls, belong to the earliest period of building. Auvergne was both an asylum of old ideas and a focus of new. It remained untouched by the spread of

[1]Saint-Hilaire was rebuilt under the patronage of Emma, who married first Cnut, King of England, and later Guillaume Aigret, Count of Poitiers. E. Maillard, *Le problème de la reconstruction de Saint-Hilaire-le-Grand*, Bulletin de la Société des Antiquaires de l'Ouest, 1934, has put forward important suggestions regarding its relationship with Norman art. Fulbert (died 1028), treasurer of the abbey of Saint-Hilaire and builder of the first cathedral of Chartres, which owed much to the donations of Cnut, was doubtless Emma's adviser in the reconstruction of the monastery. Emma was a Norman princess, daughter of Duke Richard I. Moreover, Coorland must have known Bernay, which had been founded by the Duchess Judith (died 1017) and whose completion had been entrusted to William of Volpiano by Duke Richard II. The bell tower at the angle of nave and north transept seems to antedate the arrival of Walter, who was apparently responsible for the present nave-walls and aisles. The alternation of piers is Norman, but the absence of tribunes is characteristic of Poitevin art. Cf. the remarks of E. Lefèvre-Pontalis in the Congrès of Poitiers, 1903, and Angoulême, 1912. *On the buildings of Poitou and the forming of their type, there now exists R. Crozet, *L'art roman en Poitou*, Paris, 1948; see also Congrès archéologique de Poitiers, 1951.

Mediterranean and Ottonian forms, while at the same time the Saône valley was a meeting place of Carolingian and first Romanesque art. The cathedral of Étienne II at Clermont is the earliest dated example (946) of the ambulatory with radiating chapels; the even number, rectangular plan and archaic type of the latter are features which recur in Auvergne but are also found farther afield. The nave of Chamalières, in its original state, with its little narthex surmounted by a tribune and overtopping the church, its rectangular piers (later flanked by columns), and its modillions of the Cordovan wood-shaving pattern must be almost as early in date. The former choir of the church of Le Moutier at Thiers, affiliated to Cluny in 1011 and destroyed in 1882, had tribunes vaulted with half-barrels—one of the basic elements of Auvergnat structural science. And the dome over the crossing at Néris, with its pendentives intersected by lintels designed to facilitate the transition from square to octagon, exemplifies before 1078 a system which was to become general in Auvergne in the following century.[1] When one recalls that the architects of this region also played a great part in the elaboration of the pilgrimage-church—witness Conques, in Rouergue, begun in the middle of the eleventh century under Abbot Odolric—one is justified in the assertion that the elements of a new style were discovered and developed in central France between 950 and 1050.

And was Burgundy no more than the region of stylistic fusion and interaction for which it seemed destined by its geographical situation between South and North-East? At an early date it had produced buildings like Saint-Bénigne at Dijon and Saint-Philibert at Tournus. But, thus dignified by the authority and powerful tradition of its Mediterranean borrowings, was it at the same time capable of devising new forms in Western art or of foreshadowing the great Burgundian Romanesque which was to follow? St. Odo's Cluny,[2] built between 955, and 981, is known to us through a passage in the Customs of Farfa which permits us to interpret its general arrangement as one of the oldest known examples of the so-called Benedictine plan, with elongated choir and staggered apses. But enough buildings still survive to give us an idea of the persistence and ingenuity with which the eleventh-century architects of Burgundy sought to solve the problem of combining stone-vaults with direct lighting of the nave, both in churches

[1]See L. Bréhier, *Que faut-il entendre par le terme d'art roman auvergnat ?*, Bulletin archéologique du Comité des Travaux Historiques, 1930–31.

[2]The recent excavations of K. J. Conant have established certain facts. The church seems to have been about 60 metres long and the transept about 25–30 metres. It was possible to localize eleven altars in the main and subsidiary apses. *The results of the excavations have been published by J. K. Conant in Bulletin monumental, 1928 and 1929, la Revue de l'Art Ancien et Moderne, 1934, and Speculum 1934, 1942 and 1954; see also, by the same author, *Benedictine Contribution to Medieval Church Architecture*, Latrobe, 1950.

designed for vaulting from the start and in replacements of original timber-roofs by various types of vault. We have seen how they made the old walls of first Romanesque art carry the transverse barrels of Tournus and the longitudinal barrels, pierced by window-lunettes, of Romainmôtier. And we shall see later that the pointed barrel-vaults of Cluny III—whether we derive them, with Virey, from local antecedents or, with Conant, from Monte Cassino—and the groined vaults of Vézelay, also belong to the same field of research. But the boldest and most permanent solution had already been found at Nevers

10 Saint-Étienne (restored to Cluny 1068), by opening clerestory windows under a barrel-vault buttressed by half-barrels in the tribunes; with its three-stage elevation, its engaged columns rising uninterrupted to support the transverse arches, its chaste nakedness, and the sobriety of its sharp-cut angles, this church is both pattern and yardstick for the finest Romanesque proportions. The arcaded gallery of the apse is perhaps a vestige (much elaborated) of first Romanesque

15 art, but there is no other trace of it.[1]

The classical phase of Norman art coincides with the initial stage of its development.[2] Jumièges dates from the middle of the eleventh century, and the Caen churches—the Abbaye-aux-Hommes or Saint-Étienne and the Abbaye-aux-Dames or La Trinité—are not more than a generation later. This art is characterized in general by its frequent use of alternating supports and of tribunes, by frame-roofs, and perhaps also by groined vaults and early examples of the ribbed vault (all of which simplified the problem of piercing the upper walls for direct lighting of the nave, whereas under the barrel-vaults of Cluny and Nevers Saint-Étienne such a procedure was audacious in the extreme). But its natural vigour is amply demonstrated by its diversity. In plan, for example, La Trinité and Bernay exemplify the Benedictine system of staggered apses flanking an elongated choir, while ambulatories occur at Rouen[3] and Jumièges, the former with radiating chapels and the latter without. La Trinité

[1]On Saint-Étienne at Nevers, see F. Deshoulières, op. cit., pp. 119–22.

[2]If one takes into consideration the destroyed as well as the surviving buildings, their chronology is an insistent demonstration of the activity of the Norman architects during the first two-thirds of the eleventh century. There follows an abridged version of the list in E. Lambert, Caen roman et gothique, Caen, 1935. Cathedrals: Avranches, begun 1015 and rebuilt at the end of the eleventh century; Lisieux, begun 1035, consecrated 1055; Rouen, begun before 1037, consecrated 1063; Coutances, begun about 1030, consecrated 1056, completed 1091; Bayeux, begun before 1049, consecrated before 1077; Évreux, consecrated 1076. Greater Churches: Bernay, founded about 1013, completed about 1050; Mont-Saint-Michel, begun 1023, completed 1034; Jumièges, 1037–67; abbey of Bec, begun between 1045 and 1065, consecrated 1077; Caen Saint-Étienne, begun about 1064, consecrated 1077; Cerisy-la-Forêt Saint-Vigor, begun about the same time as Caen Saint-Étienne, and far advanced by 1083; Rouen Saint-Ouen, begun 1066, consecrated 1126. *On Normandy, see also J. Bony, La technique normande du mur épais à l'époque romane, Bulletin monumental, 1939.

*[3]G. Lanfry, La crypte romane ... de la cathédrale de Rouen, ibid., 1936.

and Caen Saint-Nicolas do not show the usual alternation of supports, and differences of interior elevation give rise to two distinct families. Of these the elevation of Jumièges, characterized by the diminishing height of the stages, recurs at Coutances, Bayeux and Durham, and Durham in turn leads on to Lindisfarne, the eastern bays of Selby, and Waltham Abbey, with their huge piers decorated with geometrical ornament, their depressed tribunes and low clerestories. The difference in height between the stages is likewise considerable in churches where the tribune is replaced by a triforium, as at Bernay, Caen La Trinité, Mont-Saint-Michel and Lessay. On the other hand, the elevation of Saint-Étienne and Cerisy-la-Forêt, with main arcades and tribunes of equal height, was followed in a whole group of Anglo-Norman churches of the eleventh century—Winchester (begun 1079), Lincoln (1073–92), Canterbury (1074–80). Is this not the very same distinction which is to be found in twelfth-century French Gothic and does it not help us to understand the two types of that period —Sens with its tall arcades compressing the upper storeys, and Laon and Paris with their less lofty arcades lending themselves to a number of equal stages? Methods of vaulting the various parts of the church show a similar variety of treatment—Jumièges received groined vaults over aisles and tribunes, while Saint-Étienne, in its original state, had groin-vaulted aisles and half-barrels over the tribunes. And in contrast with the façade of Jumièges, which indeed possesses two towers of much greater development than those of Tournus (and Nevers) but also has a projecting block which is something between a narthex and a tower-porch, Saint-Étienne presents the harmonic type of twin-towered façade; these towers do not yet spring directly from the ground—they seem as if set down on the top of a great square block—but they are prolonged downwards by massive buttresses which define their lower stages.[1]

If the differences between Jumièges and Caen Saint-Étienne and between the latter and La Trinité are to be interpreted as steps in an evolutionary series, it must be admitted that the evolution was extremely rapid. Moreover, it did not end with the eleventh century. The earliest forms of Norman Romanesque were followed by others. But this development proceeded on very stable and

26,
27, 28
29, 30

24

23

22

[1]See J. Vallery-Radot, *Églises romanes*, p. 97; J. Bilson, *La date de la construction de l'église abbatiale de Bernay*, Bulletin monumental, 1911, and *The Beginnings of Gothic Architecture*, Journal of the Royal Institute of British Architects, 1899, and Revue de l'art chrétien, 1901. Note that twin-towered façades are prescribed by the Customs of Farfa; see V. Mortet and P. Deschamps, *Recueil de textes*, I, p. 135. *A recent study has widened the geographical limits of the problem of the 'harmonic' twin-towered façade: H. Schaefer, *The Origins of the Two Tower Façade in Romanesque Architecture*, Art Bulletin, 1945, pp. 85–108. The Rhineland, Burgundy and Normandy adopt that type of façades c. 1000, on the basis of various earlier experiments, some of which went back to antiquity. See also L. Grodecki, *L'architecture ottonienne*, Paris, 1958, pp. 289–292.

well-defined lines. In England and on the Continent, Norman art with its variants is a homogeneous growth. What were the sources of this style which launched itself with such impetus, and was able within so short a time to produce so many monuments of the first importance? William of Volpiano and Lanfranc were Lombards, but there is nothing specifically Mediterranean here; no trace of first Romanesque art is to be found. The choirs of Bernay and La Trinité recall the Benedictine plan of Cluny II. The timber-framed roofs, the alternation of piers, the position and scale of the towers at the crossing and flanking the east end, the dry strength and uniform grandeur of the effects, are all reminiscent of Carolingian schemes and the art of the northern area. There was a tendency at one time to discover in the boldness of these architects a natural heritage from Scandinavian traditions of woodworking; but the significance, mass and function of stone have nowhere been better understood. Whatever the original models and sources may have been, the relationship of the parts was altered, and this new relationship, this new harmony of proportions, masses and effects, imposed its pattern over a wide area of Western Europe.

But in England and the Ile-de-France as well as in Normandy this art remained Norman art, whereas in other areas, the same period produced an art which may be called interregional, if not international.

The churches which, along the length of the pilgrimage roads, welcomed the faithful journeying towards Compostela, belong to an almost uniform type which was established in the eleventh century. Their characteristics—the vast programme, the complex east end, the barrel-vaults with transverse arches resting on columns which rise uninterrupted from the ground, the tribunes vaulted with half-barrels, the indirect lighting—we shall analyse later in connection with the great basilicas built in the early years of the twelfth century. Irrespective of whether their prototype is to be sought in Tours Saint-Martin or in Limoges Saint-Martial, neither of which survives, it is clear that Sainte-Foy at Conques, which still stands and may be accepted as the church begun by Abbot Odolric (1039–65), defines the type with remarkable breadth and authority.[1]

Thus on all sides we find not disjointed experiments but a great art. The

[1]The Cartulary of Conques is explicit: 'Odolric basilicam ex maxima parte consummavit.' See V. Mortet's *Recueil*, pp. 50 and 105. For the archaeological aspect, see A. Bouillet, *L'église et le trésor de Conques*, Paris, 1892, and F. Deshoulières, *Au début de l'art roman*, pp. 133–34. According to E. Mâle, *Art religieux du XIIe siècle*, p. 298, Saint-Martin was the earliest church of this type. But the church which the author of the *Guide des pèlerins* saw in the twelfth century and which he compared with St. James of Compostela, must have been that built by the treasurer Hervé 997–1014, and it is not easy to admit that a high-vault could have been constructed, in that area, at that period. It is more likely that the first Saint-Martin was comparable with Orleans cathedral, begun

later eleventh century is resonant with memorable consecrations, which, even when only partial, are nevertheless significant. On the eve of departure for the first crusade, when the West, long shaken by invasions, set forth itself to invade, in Christ's name—yielding in this not only to the demands of the faith but also to that principle of ebb and flow which underlies so much of its history—its culture may be said to have been organically complete. But it would be an error of perspective to seek to apprehend the eleventh century only in the light of the splendour of its closing years. From its commencement and throughout its course, great and original buildings testify to its creative urge, its spirit of invention and the breadth of its vision; such are the crypt of Saint-Bénigne (the remains of Abbot William's rotunda), the porch of Saint-Benoît-sur-Loire *14* (conceived by Abbot Gauzlin as an example for Gaul and certainly begun, if not finished, by him), Jumièges and Caen Saint-Étienne. On the banks of the Loire, in Theodulf's old diocese, now become so profoundly Capetian, the porch of Saint-Benoît—its enormous piers, its severely profiled arches, the capitals of Umbertus and his fellow-craftsmen, the nine groined vaults, with their plan a little awry—is a powerful evocation of the poetry of its period. The sanctuary is later, and the nave was not finished and roofed until the thirteenth century. But the group of masons concerned in the vital building-campaign were assembled in the last third of the eleventh century, before those of Cluny, whose colossal plan is prefigured in the double-transept plan of Saint-Benoît.[1]

III

IT would seem natural that architecture of such strength should be matched by an equally vigorous style in monumental sculpture. At least one might expect it to be so. But the problems presented by the working-out of a scheme of

between 987 and 1003 and roofed in wood. *The church of Saint-Martin at Tours has been studied recently by C. K. Hersey, *The Church of Saint-Martin at Tours* (903–1150), Art Bulletin, 1943, pp. 1–39; *Current Research on the Church of Saint-Martin at Tours*, Journal of the Society of Architectural Historians, 1948, pp. 10–12; and by F. Lesueur, *Saint-Martin de Tours*, Congrès archéologique de Tours, 1948, pp. 9–28; *Saint-Martin de Tours et les origines de l'art roman*, Bulletin monumental, 1949, pp. 7–84. But the chronological problems are not solved: C. K. Hersey places the vaulting of Saint-Martin c. 1050 and makes it the prototype of the series; for F. Lesueur, the high vaults were added at Saint-Martin after the fire of 1096, in imitation of Santiago and Saint-Sernin. As for Conques, M. Aubert, *L'église de Conques*, Paris, 1939, has shown that the upper parts of the church had been altered in the late eleventh and early twelfth centuries, so that it is more than ever difficult to arrive at any conclusion on this question.
[1]On Saint-Benoît-sur-Loire, see monographs by J. Banchereau, Paris, 1930, and Canon Chenesseau, Paris, 1931, and M. Aubert's article in Congrès archéologique d'Orléans, 1931.

monumental decoration are extremely complex, and their elements varied
from place to place. Tradition and experience differed in the three geographical
zones of the West in the eleventh century, and the various currents sometimes
intermingled. The essentially Romanesque areas, on the basis of a new influx
of foreign forms mainly from the Christian communities of the East, directed
their endeavours towards harmonization of the tasks of imager and mason. But
in the northern zone, especially on the Rhine, there existed a very great sculpture
which made no compromise with architectural materials and settings. It may be
said that Ottonian Germany respected above all things, the powerful integrity
of the wall-mass. Plaster, ivory, bronze, and the precious metals were worked
with admirable science. Church treasuries were assembled which enhance the
beauty of the buildings but are not incorporated in them. Moreover, at a time
when southern sculpture over most of France adhered—by a conscious adaptation
to the needs of architecture—to a relatively slight degree of modelling, still not
far removed from the arts of flat surface and low relief, the ivory carvers and
bronze founders of Germany were practising an art of generous modelling and
swelling volumes. This effect is already strikingly—and very subtly—used by
43 the bronze founders of Hildesheim. The impressive thing about St. Bernward's[1]
doors is not so much their relationship in scheme and composition with miniatures
like those of the Vienna Genesis, as a kind of perspective-modelling—in the
treatment of the ground, for example, with its suggestive difference in relief
between the clods of earth round the roots of the trees and the short grass a
little farther off, and this is still more marked in the various volumes of the
figures, whose heads detach themselves entirely from the background and are
frankly treated in the round. The same characteristic is no less manifest in the
famous column, a diminutive relation of Trajan's column, adorned with a spiral
band of very compact compositions; the scale of values here extends from
something close to that of a medal to that of high relief. It displays profound
knowledge—in composition (of a lively narrative vein), in the nude (Baptism
of Christ), and in drapery (of fascinating pictorial quality). How different are
the bronzes of the Amalfi doors which, at a later date, were imported from
Byzantium into southern Italy! The success of the Augsburg founder who, by

[1]Bernward, born in the middle of the tenth century, was consecrated Bishop of Hildesheim in 993.
His master had been Tangmar, dean of the chapter, and he had been chosen by the Empress
Theophano to be tutor to the young Otto III. The Annals of the Benedictine Order, which contain
a life of him written by Tangmar, depict him as an encyclopaedic spirit of indefatigable activity,
skilled not only in literature but also in the practice of the 'mechanical' arts. Traveller, architect,
military engineer and calligrapher, he kept a close eye also on the activities of his bronze-founders
and goldsmiths. 'Officina ubi diversi usus metalla fiebant circumiens singularum opera librabat.'
He died in 1023.

multiplying casts of his reliefs, was enabled to export complete doors is readily *42* understandable. This was a style, however, which did not extend to the other countries of the northern zone, France and England.[1]

What was happening in the Romanesque areas? Here we are embarking on a vital section in the history of medieval art, where a sound knowledge of the period and its creative centres is particularly necessary for the understanding of the subsequent development of sculpture. This is in fact an indispensable study. The broad lines I have sketched out in another place.[2] We could obtain more exact results if we possessed a corpus of eleventh-century reliefs. In the present state of our knowledge, several styles appear to exist side by side, and sometimes in contact one with another. These are not exactly local variants, nor yet chronological stages in a single series. Rather do they represent two fundamentally different types of approach. Firstly, it must be recalled that the Carolingian practice of applying a veneer of ornament—the heir of an older tradition and long surviving in the mosaic, stucco and painted decoration of churches—did not disappear overnight. When the taste arose for the representation of the human figure in stone and its inclusion in the monumental decorative system, the infant art of the imagers remained under the influence of this conception, plus the immediate and sometimes despotic influence which was exercised over their initial efforts by the available models, whether in stone or in other materials more or less foreign to the spirit of architecture. In this way the earliest Romanesque sculpture came to bear manifest traces of its derivation, not only from manuscripts, but also from textiles and objects of ivory, metal, wood, terra sigillata and plaster.[3] An applied art, not integral to the structure, an art which transposed

[1] Stone sculpture was not unknown to the Anglo-Saxons prior to the Norman conquest. The monuments are hard to date, but amid the tangle of traditions and influences one may discern the dawning of an original conception—the creation of a slender type which we shall find again later. In the north the art of interlace persisted till the middle of the eleventh century. At the beginning of the same period the Stepney Crucifixion is inspired by a Carolingian ivory. But the Romsey Rood goes beyond that formula in its plastic force and naturalism, while the St. Michael and the Dragon of the Southwell lintel (whose composition perhaps reproduces the lines of a panel of pure ornament) foreshadows the slender, charming figures of a later period. As for the Chichester Raising of Lazarus, if it is in fact early eleventh century, it can only be compared in skill of execution, beauty of draperies and stern purity of form, with the Ottonian masterpieces which (to judge from the arcaded canopies over the two figures on the left) must have inspired it. *The Chichester reliefs are now dated c. 1140 *139, 140* by G. Zarnecki, *The Chichester Reliefs*, Archaeological Journal, CX, for 1953, pp. 106–119, who stresses their connection with German works of the early twelfth century. On the presence of German craftsmen in Yorkshire on the eve of the Conquest see A. W. Clapham, *The York Virgin and its Date*, Archaeological Journal, 1948, pp. 6–13.

[2] *Art des sculpteurs romans*, p. 123. *Also: H. Focillon, *Recherches récentes sur la sculpture romane en France au XIe siècle*, Bulletin monumental, 1938, pp. 49–73, and L. Grodecki, *La sculpture du XIe siècle en France*, L'Information d'histoire de l'art, III, 1958, pp. 89–112.

[3] P. Deschamps, *Étude sur la renaissance de la sculpture en France à l'epoque romane*, gives numerous examples.

into stone designs conceived for other materials—such was one aspect of eleventh-century sculpture. This art was capable of progress; it might have advanced very far and evolved sooner into Gothic (of which certain types and movements are already foreshadowed in the superimposed registers of some Carolingian ivories)[1] or Renaissance sculpture, if its study of Roman remains had been more attentive and systematic; but we should not have had Romanesque sculpture as we know it. I have called sculpture of this type 'frieze-style'; for it is in friezes and isolated panels that its special characteristics are to be found. The uniform rectangular sections, like many antique reliefs, could be applied like pictures, or inset, at any point in the building, irrespective of the appropriateness of their style to their architectural position, aim and function. Reliefs conceived in this way draw a thin band of figures round the east ends of churches, adorn the faces of the towers, run like a temple-frieze across the façades, and are dotted over the gable-ends. It is true that some specimens are re-used. But this reservation confirms rather than weakens the force of our argument. More often than not it is impossible to discover their original position, and it would be profitless to search for it. Many of the re-used reliefs look well enough in their present places. They are in fact interchangeable. This characteristic is in conflict with the fundamental rule of Romanesque sculpture—that it is conceived for a particular position and defined by its architectural setting. A different emphasis, if not a different stylistic principle, must be sought in these applied friezes and reliefs. We find a feeling for narrative and also a certain aptitude for dramatic movement in the apse-frieze of Selles-sur-Cher, with its scenes from the life of St. Eusice,[2] and in the panels of Saint-Restitut.[3] We find a varied iconography, in which Oriental themes rub shoulders with Biblical compositions and scenes from the fabliaux. Here, too, appears the Siren, the inexhaustible motif of later Romanesque composition, tending already to adapt the curves of her fish-tail to the surrounding frame, but as yet isolated from other elements, and solitary on a wide expanse of background—an impersonal and as yet motionless and lifeless witness to those remote influences on which Romanesque sculpture was to bestow its prodigious gifts of metamorphosis.

40, 41

There must be a separate classification for a group of figure-reliefs of ancient lineage which recurred at various periods of medieval art—the figures in arcades. These were an inheritance from Hellenistic sculpture, which made great use of

[1]Including the lovely plaque with the story of David and Nathan (Paris, Bibl. nationale, about 870 ?) See A. Goldschmidt, op. cit., I, No. 40a.
[2]See M. Aubert, Congrès archéologique de Blois, 1926, p. 203.
[3]See É. Bonnet, Congrès archéologique d'Avignon, 1910–11, p. 251; L. Maître, La tour funéraire de Saint-Restitut, Revue de l'art chrétien, 1906.

them, especially in a group of tombs, the so-called Sidamara sarcophagi.[1] They are perhaps nothing more than a reduction and repetition of the monumental type of niche-statue. Between its pair of pilasters and beneath its arch or gable each figure remains isolated, even though its pose or gesture may denote participation in a general action. This type, so unlike the continuous style of imperial funerary art, with its tumultuous and plethoric mêlées of beasts and men, was adopted for a whole family of Christian sarcophagi, and it was doubtless these which inspired the eleventh-century sculptors, who were naturally attracted to a compositional procedure which adapted itself so readily to the treatment of elongated surfaces such as altar-frontals and lintels. The painted and carved antependia of Catalonia retained this form down to a late date, and arcaded lintels were common throughout the twelfth century. The form is found also in certain Romanesque capitals of the best period. But in general it was the depositary of a frozen academism rather than a principle of sculptural life. By penning the figure within so narrow a prison, it condemned it to a sterile solitude. It banned that dramatic force which attains movement by compositional continuity and the intimate interrelationship of parts. Only much later was it to regain its true and original significance, when, reintegrated with the funerary arts, it affirmed on tombs the final loneliness of death.

But eleventh-century art offers yet other aspects, a whole series of experiments which contributed powerfully to the formation of the true Romanesque style in sculpture and to the establishment of its architectural character. This last phrase requires special emphasis. The fields which a complex building offers for decoration are not mere indifferent bits of space. They will dominate living forms and refuse to be dominated by them. The antique solution of the frieze set in the wall, and the balanced diminution of the figures of the pediments, were appropriate to an art defined by the horizontality of lintels. With the introduction of arches this solution was no longer applicable; the rectangular frames were cut up by curves, and figures were forced to adapt their pose to these new fields. But Mediterranean respect for proportion, the cult of man as the universal measure, which survived in Roman art, set narrow limits to the researches of the sculptors in this direction, or indeed condemned them. Classical feeling had humanized even the beasts, in such monsters as the centaur. It long declined absolutely to admit human or animal forms in the decoration of capitals, in this breaking with the Oriental tradition which had produced the Persian capital

[1]See G. Mendel, *Catalogue des sculptures du musée de Constantinople*, Paris, 1912, Vol. I; G. Rodenwaldt, Römische Mitteilungen, 1923–24; Ch. Picard, *La sculpture antique, De Phidias à l'ère byzantine*, Paris, 1926, pp. 460–63.

with its addorsed bulls and the Hathor-headed capital of Egypt, and voluntarily
restricted itself to mouldings, volutes and foliage. It was sensitive of the extreme
difficulty, even impossibility, of introducing the human figure harmoniously
and without deformity into an inverted and truncated pyramid or cone. This
combination does, however, occur in late imperial art, and the monuments of
Rome and Gaul[1] can show more than one example; they include masks, busts,
half-lengths, and sometimes complete figures, these last standing out thin and
doll-like against a florid, fleshy foliage from which they are isolated by their
own movement. The art of the early Middle Ages, on the other hand, indifferent
to canons of proportion and the verisimilitude of its images, had multiplied
abstract patterns and begun to twist living forms to fit them. Carolingian
humanism was at home in the rectangle of the page of manuscript or the plaque
of ivory; but we have seen how, in the Cologne comb and the St. Gall ivory,
this humanism could be twisted in conformity with an order foreign to the balance
of human proportions. This is the principle whose development we shall follow
in the history of the classical period of Romanesque sculpture, indeed it is this
development which, by the variety and precision of its applications, will enable
us to penetrate to its sources.

The eleventh-century examples which we must examine first of all are those
composed of the very simplest elements. The block of masonry, as a unit in the
wall, begins to receive a carved decoration which is exactly conterminous with it.
It is simultaneously sculpture and wall-block. The progress of this conception
can be traced forward from the re-used reliefs of the porch of Saint-Benoît-sur-
Loire, those on the north wall of Selles-sur-Cher, and the frieze of Graville-
Sainte-Honorine. Normandy possesses other examples of this technique applied
to panels—for instance, the rectangular men of Saint-Georges-de-Boscherville.
Such work exemplifies the same conception of luxuriant, or rather of tight-packed,
composition, the so-called *horror vacui*, as the decorative art of the barbarians.
The style is often (but not always) allied with a technique of carving which leaves
large areas of the surface of the block untouched and circumscribed with narrow
troughs of shadow, with a strongly marked border surrounding the whole. It is
once again a translation from the compositional practices of drawing or engraving
imposed on a sculpture as yet unfamiliar with the idea and technique of plasticity.
The important point is that this strong, flat, limited art, so sparing of roundness
and relief, agrees perfectly with the compactness and homogeneity of the wall,
from which Romanesque sculpture was never to break forth in undisciplined

[1]E. Espérandieu, *Recueil général des reliefs de la Gaule romaine*, Paris, 1907, I, 70, 293, 493, 529, III,
2905, etc.

invasion of surrounding space. The problems set by the decoration of the capital were more complex, since here form was determined by function. The use of figures to underline and assist such functional activity was perhaps the greatest achievement of Romanesque sculpture. The eleventh century was heir to a long tradition of foliage capitals, grown dry and spindly in their passage through the hands of many an inferior and mongrel workshop.[1] It is wonderful to see how the earliest sculptors of the Saint-Benoît porch restore to the Corinthian *35* order its nobility and monumental grandeur, and at the same time insert on the central axis of each face figures whose heads replace the conventional decorative rosettes, and who, drawing up their knees to seat themselves on the first collaret of acanthus, assert categorically their architectural function. The role of the atlantes, bowed under the angles of the abacus, their hands on their bent legs, is clearly defined on certain archaic capitals from Auvergne, carved from the local arkose sandstone.[2] The striking capitals from Saint-Germain-des-Prés, in the *33* Musée de Cluny, sum up the uncertainties and experiments of the first years of the century.[3] Beneath the diversity of the models which inspired the artists, there is already apparent their concern to create and organize monumental style. One example is no more than a frieze curved to enwrap the capital; another follows the scheme of the arcaded antependia, but with the colonnettes set obliquely under the angles of the abacus; on one side of another the fauna of the steppes is reanimated in stone, the wild beast and its prey combined in a single compact group. This synthetic force, mixing one kind of life with another, breaking up individual creatures and composing monsters from the fragments, is at the core of Romanesque stylistic development. But something more than architectural fitness and an endless synthesis of motifs appears in the capitals of the crypt of Saint-Bénigne; for here we find two states of the same composition, one with *34* ornament and one with figures, as if Abbot William's sculptor, on the threshold of the new style, had wished to hand on to us its secret and its key. The ornamental pattern and the human figure are interchangeable. From this principle, a strictly logical system, recently rediscovered,[4] was able to evolve a universe of images. Other structural members, from other monuments of this century, show most remarkable examples of this submission of the human figure to a

[1] An extreme case of this dryness in the treatment of foliage can be observed at Bernay at the beginning of the eleventh century: L. Grodecki, *Les débuts de la sculpture romane en Normandie: Bernay*, Bulletin monumental, 1950, pp. 7–67.

[2] L. Bréhier, *L'homme dans la sculpture romane*, Paris, 1927.

[3] The date of the nave of Saint-Germain-des-Prés and of its capitals has been contested by J. Hubert, *Les dates de construction du clocher-porche et de la nef de Saint-Germain-des-Prés*, Bulletin monumental, 1950, pp. 69–84. They should perhaps be placed c. 1050.

[4] J. Baltrusaitis, *La stylistique ornementale dans la sculpture romane*, Paris, 1931.

pattern-idea; a cornice-modillion, in the Musée des Antiquaires de l'Ouest,[1] is composed of a sort of human wood-shaving folded and coiled round upon itself. Even in the arcaded lintels, we see the operation of this same law, which dominates Romanesque figure-sculpture. The Apostles who stand on each side of Christ at Saint-Genis-des-Fontaines (1020) have their heads closely gripped and defined by the arches which frame them, and the whole outline of their bodies follows that of the capitals, columns and bases on either side. A decorative mesh of triangles, spirals and concentric circles, reminiscent of the capricious geometry of Irish illumination, spreads its strange patterns over their garments and the limbs are lost in the labyrinth of ornament. An identical style is found in other monuments of the same region, including some of much later date—for instance, the antependium of Esterri de Cardos.[2] In this way the eleventh century prepared and, in certain directions had already defined, the future of a monumental sculpture which, dominated by architecture, created out of that very constraint the expressive image of a new life, rich in monsters and magical transformations, and with its figure-synthesis ceaselessly evolving on a basis of abstract schemes and ornamental compositions.

There existed, however, other groups and areas which remained untouched by these researches or allowed them only a strictly limited freedom. South of the Pyrenees, Mozarabic art continued faithful to the principles and spirit of the Cordovan capital, its ligneous flora, its refined dryness—a style which handles stone like wood and seems to cast over the forms of the capital a delicate net, sometimes broken by a narrow vertical panel. Perhaps from these Mozarabic masters came the earliest models for the capitals of León. And their influence was not limited to the north of Spain, for it can be traced also in Auvergne, in Le Velay and as far as the middle Loire, remaining distinct from the art which we call Romanesque and whose origins we have just outlined. Again, in the north and east of France other phenomena were appearing which were remote both from Mozarabic tradition and from Romanesque experiments. They illustrate the persistence (or the reawakening) of barbarian geometry and the pure linear tradition. In addition to the clerestory capitals at Vignory (if I am right in thinking that they date from the beginning of the eleventh century), there are important series in the departments of Oise and Aisne[3] whose significance was first recognized by Courajod—at La Croix and Oulchy-le-Château, and the astonishing capitals of Morienval, ornamented with spirals and volutes, which

[1]H. Focillon, *L'art des sculpteurs romans*, p. 128, note.
*[2]See G. Gaillard, *Premiers essais des sculpture monumentale en Catalogne*, Paris, 1938.
*[3]G. L. Micheli, *Le décor géométrique dans la sculpture de l'Aisne et de l'Oise au XIe siècle*, Paris, 1939.

seem to revive in stone the decorative repertory of the bronze age. These groups are not, however, entirely antagonistic to figure-art; the capitals of the sanctuary at Vignory, one of which is copied from an Oriental textile, prove that in the course of the second building campaign, about the middle of the eleventh century, Romanesque influences made themselves felt in the area—but as a contribution from an alien style. Thus, in the artistic geography of the eleventh century, of which only the main lines are as yet apparent to us, there are indications of three zones, which are not sealed off one from another but whose exact relationship is still undefined. Between the Islamic bracket and the northern bracket, the middle zone, the largest and the most intense, is the region of the great Romanesque experiments.

<div align="center">IV</div>

THESE various observations might suffice to justify the importance which I attach to the eleventh century in the general history of the Middle Ages, and especially as the indispensable and fruitful introduction to the classical period of Romanesque art. It must not be forgotten that the architecture of arcades and bands does not comprehend every variety of contemporary architectural style. 'Lombard' architecture, 'first Romanesque art', belongs indeed to the eleventh century and stretches on into the twelfth, but the art of the great pilgrimage churches, with their tribunes and their radiating plan, wherein the Romanesque spirit achieves the fullest expression of its maturity, also begins, as we have seen, in the eleventh century, with buildings which were completed only later, but whose altars were consecrated in the last years of that great period. Programme, plan and general scheme were fixed at that time, some of the churches were under construction, and some completed or nearly so. Conques Sainte-Foy, Limoges Saint-Martial, Toulouse Saint-Sernin, as well as Cluny and Saint-Étienne at Nevers, are of, or partly of, this eleventh century, whose declining years are marked by dates which are epoch-making in their period of civilization and constitute what one might call, in Taine's phrase, *un moment*.

At this moment, there appeared in architecture a new element, whose rapid development in France in the first half of the twelfth century was destined to bring about a radical transformation of the structural system—this was the strengthening arch set diagonally beneath the vault in order to reinforce it—the vault rib. The systematic use, firstly of the rib, then of the flying buttress, and

finally of the pointed arch, replacing the semi-circular arch in bay-design, was
the basis of Gothic art. But in the eleventh century, ribs were still a technique
of construction and not an element of style. Groined vaults, as compared with
barrel vaults, had the advantage of distributing and canalizing the thrust into
the four angles of the vault severy. The rib simplified and strengthened their
construction by supporting the weight and ensuring the independence and light-
ness of the cut-stone vault cells. By the progressive development of all its
potentialities it eventually replaced the homogeneous mural system by an armature
of arches. It is in the last quarter of the eleventh century that we find it used
for the first time in the Christian West.

It appears in various guises. Most often it is heavy, thick and angular—a
rounded profile also occurs, but the rectangular and toric sections do not seem
to correspond with any precise geographical division. Possibly it was used first
of all to reinforce vaults with an upper storey above, as in porches and bell-
towers, and its use extended to naves only later. Certain ribbed vaults of southern
France—Moissac, Saint-Guilhem-le-Désert—would seem to support this view.
We should then have a development analogous to that of Romanesque vaulting,
which was applied first to crypt, narthex and annular gallery, and subsequently
to naves. On the other hand it is not impossible that the ribbed vault may have
been utilized experimentally in various ways at one and the same time. One
58 thing is certain—that in the aisle of the Anglo-Norman cathedral of Durham,[1]
which is indisputably dated 1093–1104, it is handled with a technical mastery
which must presuppose considerable earlier experience.

What are its origins? Which are the earliest examples? These two questions
touch on the most delicate, the most bitterly contested point in the whole
history of architecture[2]. The Romans understood how to strengthen vaults
and domes by means of a stout skeleton, buried in the rubble masonry and
forming with it a single compact system; this was a procedure resembling that
of reinforced concrete. But they also, on occasion, laid bands of cut stones along
the groins and gave them projecting mouldings. Certain antique examples, like
those of the Palais de la Trouille at Arles[3] and of the Roman villa of Sette Bassi

[1]J. Bilson, *Durham Cathedral, The Chronology of its Vaults*, Archaeological Journal, LXXIX, 1922,
p. 108. *See also J. Bony, *Le projet premier de Durham. Voûtement partiel ou voûtement total?*
Urbanisme et Architecture, études écrites et publiées en l'honneur de Pierre Lavedan, Paris,
1954, pp. 27–35.
*[2]On the earliest rib-vaults, see the study by H. Focillon, *Le problème de l'ogive*, Bulletin de l'Office
international des instituts d'art et d'archéologie, 1935. The most recent summary of the question
will be found in P. Lavedan, *Histoire de l'art*, Vol. II, pp. 204–10; but the dating of Lombard
vaults has to be revised (see below).
[3]J. Formigé, Bulletin monumental, 1913.

(a groined vault with powerful ribs of vigorous projection), might lead to the conviction that it was among these vaults that the medieval architects found, if not models, at least useful suggestions for their own practice. But the intermediate stages are missing. Is it perhaps possible that the skilful Lombard builders, the Commacini, so expert in matters of technique and mechanical devices,[1] were able to profit by this element of the Roman tradition, drawing their inspiration from monuments more numerous than have come down to us? Some scholars (Dartein, Kingsley Porter) assume that the ribbed vault is of Lombard origin, and passed from Lombardy into the Anglo-Norman school. Milan S. Nazaro (1093–1112), now destroyed, certainly possessed ribbed vaults. Corneto S. Giacomo has been dated 1095, which is probable, but not certain. Sannazaro Sesia (1040–60) has remains of ribs but it is not known whether they formed part of the original building. At Asti S. Anastasia (1091), Aurona (1095), Rivolta d'Adda (1100) and Milan S. Ambrogio (early twelfth century) the Lombard school has left indisputably early examples—strongly projecting ribs of bricks or small stones beneath groined vaults of square plan. Yet it is equally indisputable that Italian art derived no advantage from this early experience. The great advances were made elsewhere.[2]

60

In another cultural area, Islamic Spain, at Toledo, small domes overspread with light ribs arranged in various geometrical patterns were constructed from the tenth century onwards.[3] But the charming cupolas of the mosque of Bib-al-Mardom are of limited span and light materials. Their ribs are decorative rather

[1] According to U. Monneret de Villard, *L'organizzazione industriale nell'Italia Longobarda*, Milan, 1919, the name Commacini is derived not from Como, but from machine. *This etymology has been contested by M. Salmi, *Maestri commacini e maestri lombardi*, Palladio, 1938.

[2] See A. K. Porter, *Lombard architecture*, 3 vols. and pl., New Haven, 1914–16, and *Construction of Gothic and Lombard vaults*, New Haven, 1911; C. Enlart, *Manuel*, II, p. 467, note 4, and *Avis au lecteur*, p. 932. *The dating of the early rib-vaults of Northern Italy has been altered by the studies of P. Verzone, *L'architettura romanica nel Vercellese*, Vercelli, 1934; *L'architettura romanica nel Novarese*, 2 vols., Novara, 1935–36; *L'origine della volta lombarda a nervature*, Atti del IV Convegno Nazionale di Storia dell' Architettura, Milano, 1939. Prof. Verzone has been kind enough to confirm to us his present view of the problem: the first rib-vaults of Italy appear in a group of churches built in or around Milan in the last years of the eleventh century and the first years of the twelfth. To this early Milanese group belong Rivolta d'Adda (begun between 1088 and 1099), the church of San Nazaro in Milan (which may have been begun shortly before 1093) and, again in Milan, Santa Maria di Aurona, of which only fragments remain (possibly begun c. 1095); at Sant Ambrogio the new work was started only after the earthquake of 1117. The Novarese group is a little later: San Pietro di Casalvolone seems to be the earliest (dedicated in 1118 or 1119), soon after came Sannazaro Sesia, San Giulio di Dulzago (dedicated between 1118 and 1148), and the cathedral of Novara (dedicated in 1132). The earliest examples appear contemporary with Durham.

[3] E. Lambert, *Les voûtes nervées hispano-musulmanes et leur influence possible sur l'art chrétien*, Hesperism 1928, II, pp. 147–75. In 1932 at the Musée Guimet in Paris photographs taken by Arthur Upham Pope were exhibited, showing ribbed vaults in the Jami mosque of Ispahan, in parts of the building which date possibly from the ninth to eleventh centuries. The ribs appear to project from a thick armature buried in the brickwork of the vaults: A. U. Pope, *A Survey of Persian Art*, IV, Oxford, 1938.

than functional. They may, none the less, have offered suggestions to Christian architects who saw them after the reconquest. But how, in what form, was it possible to adapt this delicate complex system, built under vaults of very narrow span, to the requirements of a massive structure? True, there are examples in certain churches in the region of the Pyrenees—Oloron-Sainte-Marie, Hôpital Saint-Blaise—and in Spain—San Miguel at Almazan, Eunate, Torres del Rio. But was this family really an intermediary, or only an isolated derivative group?[1] It would be interesting also to study in this connection the ribbed domes of western France, but in truth these may just as well be applications of a fashionable motif to the local vaulting-system as reproductions of hypothetical earlier models representing an intermediate stage. This latter hypothesis would find support in vaults of the type of Avesnières, near Laval, where the joints running at right-angles to the ribs are reminiscent of the annular courses of the domes.

But it must not be forgotten that a whole group of Christian buildings in Asia have ribs which exercise their full structural function and are stoutly made with a view to load-carrying. They are employed from the late tenth century in Armenia with a mastery which proves earlier experience and which allows of no confusion with the thin mouldings and decorative bands common in this region from the seventh century onwards. The recent investigations of M. Baltrusaitis[2] have thrown a flood of light on this question and have shown the Armenian ribbed vault applied in varied and subtle combinations: at the Shepherd's Chapel, a mausoleum outside the walls of Ani, six arches, used in conjunction with formerets, radiate from a central keystone to carry a kind of truncated dome which is cut through by a flat ceiling; in the porch of the Holy Apostles in the same town (about 1072), the structure is simpler and more powerful—a ceiling whose central portion opens into a cupola is carried on two sets of diagonal intersecting arches with walls mounted on their extrados; in one of the chapels of the dynastic necropolis at Khochavank two powerful arches spring from the mid-points of the sides of the square and intersect at right-angles, as in the vault of the north tower of Bayeux; the great hall in the same place is covered by a more complex system—the square vault is divided into nine compartments by four ribs which intersect at right-angles and carry the vault-cells in part directly and in part by means of walls erected on the extrados; the purest of these combinations is that of the porch at Hahpat, the most audacious at Haradess. In this homogeneous group, we see the architects

[1]See E. Lambert, *Les églises octogonales d'Eunate et de Torres del Rio*, Mémorial Henri Basset, II, p. 1. *Add E. Lambert, *La croisée d'ogives dans l'architecture islamique*, Recherche, I, 1939, pp. 57–71.
[2]J. Baltrusaitis, *Le problème de l'ogive et l'Arménie*, Paris, 1936. *Add J. Baltrusaitis, *La croisée d'ogives dans l'architecture transcaucasienne*, Recherche, I, 1939, pp. 73–92.

drawing every possible consequence from a logically established principle. It is an essentially structural system, and it is this, as much as the differences of scale, materials and compositional spirit, which distinguishes it from the Islamic vaults of the mosques of the Maghreb.

It is remarkable that the same types of plans and the same types of vaults recur in the West, in the upper chamber of the belltower of Cormery, at the crossing of Aubiac, and in the first floor of the belltower of Saint-Ours at Loches, and that ribs with walls built on the extrados are used in the same way in La Trinité at Vendôme, in the upper storey of the Moissac porch, in the Tour 50 Saint-Aubin at Angers, and notably in the Tour Guinette at Étampes and the porch of Saint-Mihiel. Moreover, in Lombardy, the narthex at Casale Monferrato 59 (slightly later than the church, which was consecrated in 1107) is a replica of the great hall at Khochavank. It is not inapposite to recall the remarkable role which Armenia played as the most ancient of the Christian communities of the East, as well as the most enterprising in architecture. And the resemblances and analogies between Armenian and Romanesque art, which are supported by the historical evidence,[1] are so remarkable in decorative sculpture that there is no improbability in the admission of relationships in structural science. There is also a precedent in the influence exercised by an Armenian prototype on Germigny-les-Prés. The simultaneous retreat of Islam in Transcaucasia and Spain was favourable to a new wave of influence.

So we are brought back to our point of departure, to one of the great expansive phenomena which characterized the eleventh century. But the Armenian structural rib (like the Muhammadan decorative rib), when transplanted to the West, had to adapt itself to the principles and processes of a quite different tradition from that into which it was born. In its native land it was applied to centrally planned buildings, square or rectangular halls; it was made to support both vaults and ceilings—with the aid of walls built on the extrados; it was combined with domes which might cover the whole area or only the central section. In the West, however, it had henceforth to work with and accommodate itself to the old groined vault, in long basilican churches. What the West took over—apart from the literal imitations—was the principle of individuality of treatment.

[1] In the sixth century, the travels of Simon the Armenian; in the seventh, the foundation of an Armenian monastery in Ireland; in the tenth, the retreat of St. Gregory, Armenian Bishop of Nicopoli, to Pithiviers, where the church, founded in 1080, remains a place of pilgrimage to his relics and has at the crossing a ribbed dome of Armenian type; in the same period, an Armenian-Latin conversation manual, appended to a manuscript of St. Jerome, etc. See J. Baltrusaitis, *Le problème de l'ogive et l'Arménie*, Paris, 1936, p. 65.

Are we to suppose a single model or numbers of parallel experiments based on various models, a direct line of descent or a complex of interrelated phenomena? Most probably we are here in the presence of one of the many Oriental elements which contributed so largely to the genesis of medieval Christian art and which are to be found not only in architecture but also in iconography and in the liturgy. The general diffusion of the stone vault and of the dome on pendentives over the crossing, from the first half of the eleventh century onwards, represents but a single chapter in the history of a current of influences which set in with the end of the Roman empire, slackened during the early Middle Ages, and was again intensified from the beginning of the Romanesque period. We have yet to see how there emerged from this a specifically Western thought. But we have seen enough to enable us to appreciate the grandeur of the eleventh century and the importance of the acquisitions which it bequeathed to the later Middle Ages. It was at once the source and the first stage in the evolution, of both Romanesque and Gothic art. It was the fruitful experimental phase of an age which was to find its full expression in the development of a twofold nature.

BIBLIOGRAPHY

GENERAL WORKS

L. Halphen, *Les Barbares*, Paris, 1928; L. Bréhier, *L'art en France, des invasions barbares à l'époque romane*, Paris, 1930; E. Mâle, *L'art allemand et L'art française du moyen âge*, Paris, 1917. Barbarian Art and Oriental influence: J. Strzygowski, *Altai-Iran und Völkerwanderung*, Leipzig, 1917; M. I. Rostovtsev, *Iranians and Greeks in South Russia*, London, 1923; *The Animal Style in South Russia and China*, Princeton Monographs, 1929; G. Borovka, *Scythian Art*, London, 1928; B. Salin, *Die altgermanische Tierornamentik*, Stockholm, 1904; N. Aberg, *Nordische Ornamentik*, Leipzig, 1931; C. Barrière-Flavy, *Les industries des peuples de la Gaule*, 2 vols., Paris, 1901; E. Molinier, *Histoire générale des arts appliqués à l'industrie*, Vol. IV, Orfèvrerie, Paris, 1900; L. Bréhier, *Les colonies d'Orientaux en Occident au commencement du moyen-âge*, Byzantinische Zeitschrift, 1903; J. Ebersolt, *Orient et Occident*, 2 vols., Paris, 1928.* E. Knögel, *Schriftquellen zur Geschichte der Kunst der Merowingerzeit*, Darmstadt, 1936; E. Salin, *La civilisation mérovingienne d'après les sépultures, les textes et le laboratoire*, 4 vols., Paris, 1950–1959; R. L. S. Bruce-Mitford, *The Sutton Hoo Ship-Burial*, Proceedings of the Suffolk Institute of Archaeology, XXV, 1, 1949, pp. 1–78.

MONUMENTS OF THE SIXTH TO EIGHTH CENTURIES

E. Le Blant, *Les sarcophages chrétiens de la Gaule*, Paris, 1886; E. Michon, *Les sarcophages chrétiens dits de l'école d'Aquitaine*, Mélanges Schlumberger, 1924; E. Réthoré, *Les cryptes de Jouarre*, Paris, 1889; M. Reymond, *La chapelle Saint-Laurent à Grenoble*, Bulletin archéologique, 1893; C. de la Croix, *Étude sommaire du baptistère de Poitiers*, Poitiers, 1894; L. Brehier, *Les mosaïques mérovingiennes de Thiers*, Mélanges de la Faculté des Lettres de Clermont, 1910.* J. Hubert, *L'art pré-roman*, Paris, 1938, and *L'architecture religieuse du haut moyen âge en France*, Paris, 1952; P. Verzone, *L'architettura religiosa dell'alto medioevo nel-l'Italia settentrionale*, Milan, 1942; T. D. Kendrick, *Anglo-Saxon Art to A.D. 900*, London, 1938; F. Henry, *Irish Art in the Early Christian Period*, London, 1940.

CAROLINGIAN ART

A. Kleinclausz, *L'empire carolingien, ses origines et ses transformations*, Paris, 1902; J. Strzygowski, *Der Dom zu Aachen und seine Entstehung*, Leipzig, 1904; M. Aubert, *Aix-la-Chapelle*, Congrès archéologique de France, Rhénanie, 1922; E. Jeannez-Audra, *L'église carolingienne de Germigny-les-Prés*, Institut d'art et d'archéologie de l'Université de Paris, Travaux du groupe d'histoire de l'art, 1928; W. Effmann, *Centula*, Münster i.W., 1912; *Die Kirche der Abtei Corvey*, Paderborn, 1929; L. Bréhier, *L'origine des chevets à chapelles rayonnantes et la liturgie*, La vie et les arts liturgiques, 1921; A. de Bastard, *Peintures et ornements des manuscrits, La Bible de Charles le Chauve*, Paris, 1883; A. Boinet, *La miniature carolingienne, son origine, son développement*, Paris, 1913; F. F. Leitschuh, *Geschichte der karolingischen Malerei*, 1894; A. K. Porter, *The Tomb of Hincmar and Carolingian Sculpture in France*, Burlington Magazine, 1927; J. Seligmann, *L'orfèvrerie carolingienne, son évolution*, Institut d'art et d'archéologie de l'Université de Paris, Travaux du groupe d'histoire de l'art, 1928; R. Hinks, *Carolingian Art, A Study of Early Medieval Painting and Sculpture in Western Europe*, London, 1935.* K. J. Conant, *Carolingian and Romanesque Architecture*, 800–1200 (Pelican History of Art), Harmondsworth, 1959; R. Krautheimer, *The Carolingian Revival of Early Christian Architecture*, Art Bulletin, XXIV, 1942, pp. 1–38, and *Introduction to an Iconography*

of Medieval Architecture, Journal of the Warburg and Courtauld Institutes, V, 1942, pp. 1–33; S. McK. Crosby, *L'abbaye Royale de Saint-Denis*, Paris, 1953; B. Taracena, P. B. Huguet and H. Schlunk, *Arte romano, Arte paleocristiano, Arte visigodo, Arte asturiano* (Ars Hispaniae, II), Madrid, 1947; E. Lehmann, *Der fruehe deutsche Kirchenbau, die Entwicklung seiner Raumordnung bis 1080*, Berlin, 1938, 2nd ed., 1949; H. E. Kubach and A. Verbeek, *Die vorromanische und romanische Baukunst in Mitteleuropa, Literaturbericht*, Zeitschrift für Kunstgeschichte, XIV, 1951, pp. 124–148, and XVIII, 1955, pp. 157–198; A. Grabar and C. Nordenfalk, *Le haut moyen âge* (Skira: Les grands siècles de la peinture), Geneva, 1957; A. Boeckler, *Abendländische Miniaturen bis zum Ausgang der romanischen Zeit*, Berlin, 1930; W. R. W. Koehler, *Die Karolingischen Miniaturen, I. Die Schule von Tours*, 2 vols., Berlin, 1932–34, *II. Die Hofschule Karls des Grossen*, 2 vols., 1958, *III. Die Gruppe des Krönungs-evangeliars, Metzer Handschriften*, 2 vols., 1960.

ELEVENTH CENTURY ART: THE EARLIEST FORMS OF ROMANESQUE
G. T. Rivoira, *Le origini dell'architettura lombarda*, Rome, Vol. I, 1901, Vol. II, 1907; P. de Truchis, Studies in the Volume of the Congrès Archéologique de France, *Avallon*, 1907, *Avignon*, 1909; J. Puig i Cadafalch, *L'aire géographique de l'architecture lombarde à la fin du XIe s.*, Actes du Xe Congrès international d'histoire de l'art, Rome, 1912; *Le premier art roman*, Paris, 1928; *La Geografia i els origens del primer art romanic*, Mémoires de l'Institut d'études catalanes, III, Barcelona, 1930, French translation, Paris, 1935; F. Deshoulières, *L'architecture en Catalogne du IXe au XIIe siècle*, Bulletin monumental, 1925; P. Verzone, *L'architettura romanica nel Novarese*, 2 vols., Novara, 1935–36; M. Gómez Moreno, *Iglesias mozarabes*, Madrid, 1919; W. M. Whitehill, *Tres iglesias del siglo XI en la provincia de Burgos*, Madrid, 1933; A. W. Clapham, *English Romanesque Architecture before the Conquest*, Oxford, 1930; F. Deshoulières, *Au début de l'art roman, Les églises du XIe siècle en France*, Paris, 1929, and *Eléments datés de l'art roman en France*, Paris, 1936; J. Virey, *L'architecture romane dans l'ancien diocèse de Mâcon*, Paris, 1928; M. Allemand, *Saint-Philibert de Tournus*, Institut d'art et d'archéologie de l'Université de Paris, Travaux du groupe d'histoire de l'art, 1928; P. Deschamps, *Étude sur la renaissance de la sculpture en France à l'époque romane*, Bulletin monumental, 1925.* E. Arslan, *L'architettura romanica milanese*, in Storia di Milano, III, Milan, 1954, pp. 397 *et seq.*, and *L'architettura romanica veronese*, Verona, 1939; E. Olivero, *Architettura religiosa preromanica e romanica nell'archidiocesi di Torino*, Turin, 1941; D. Thümmler, *Die Baukunst des 11. Jahrhunderts in Italien*, Römisches Jahrbuch für Kunstgeschichte, III, 1939, pp. 141–226; M. Gómez Moreno, *Arte califal hispano-arabe, Arte mozarabe* (Ars Hispaniae, III), Madrid, 1951; G. Marçais, *L'architecture musulmane d'Occident*, Paris, 1954; J. Gudiol Ricart and J. A. Gaya Nuño, *Arquitectura y escultura romanicas* (Ars Hispaniae V), Madrid, 1948; H. Jantzen, *Ottonische Kunst*, Munich, 1947; F. J. Tschan, *St. Bernard of Hildesheim*, 3 vols., Notre-Dame, Indiana, 1942–52; L. Grodecki, *Au seuil de l'art roman, L'architecture ottonienne*, Paris, 1958; L. Lemaire, *De Romaanse Bouwkunst in de Nederlanden* (Verhandelingen van de Koninklijke Vlaamse Academie . . . , Klasse der schone Kunsten, 6), Brussels, 1952; M. D. Ozinga, *De Romaanse Kerkelijke Bouwkunst* (De Schonheid van ons Land), Amsterdam, 1949; J. Baltrusaitis, *L'église cloisonnée en Orient et en Occident*, Paris, 1941; G. Plat, *L'art de bâtir en France des Romains à l'an 1100, d'après les monuments anciens de la Touraine, de l'Anjou et du Vendômois*, Paris, 1939; J. Vallery-Radot, G. de Miré and V. Lassalle, *Saint Philibert de Tournus*, Paris, 1956; M. Troiekouroff, *La cathédrale de Clermont du Ve au XIIe siècle*, Cahiers Archéologiques, XI, 1960, pp. 199–247; L. Lesueur, *Saint-Martin de Tours et les origines de l'art roman*, Bulletin monumental, CVII, 1949, pp. 7–84, and *Saint-Aignan d'Orléans, L'église de Robert-le-Pieux*, ibid., CXV, 1957,

pp. 169–206; G. Lanfry, *La cathédrale de Rouen dans la cité romaine et la Normandie ducale* (Cahiers de Notre-Dame de Rouen), Rouen, 1956, and *L'abbaye de Jumièges: plans et documents*, Rouen, 1954; J. Taralon, *Jumièges*, Paris, 1955; H. Swarzenski, *Monuments of Romanesque Art: The Art of Church Treasures in North-Western Europe*, Chicago and London, 1954; T. D. Kendrick, *Late Saxon and Viking Art*, London, 1949; H. Focillon, *Recherches récentes sur la sculpture en France au XIe siècle*, Bulletin monumental, XCVII, 1938, pp. 49–72; L. Grodecki, *Les débuts de la sculpture romane en Normandie: Bernay*, ibid., CXII, 1950, pp. 7–67, and *La sculpture du XIe siècle en France, état des questions*, L'information d'Histoire de l'Art, III, 1958, pp. 98–112; A. U. Pope, ed., *A Survey of Persian Art from Prehistoric Times to the Present*, 6 vols., Oxford, 1938–39; A. Godard, *Voûtes iraniennes*, Athâr é Irân, IV, 1949, pp. 201–238.

The Romanesque Church

I

EVEN the most homogeneous style is defined only by the sequence of its development. As early as the eleventh century, Romanesque architecture had taken on a characteristic form marked by the systematic use of wall-arcades and flat pilasters, but it was simultaneously elaborating, in the course of a long series of experiments, the classic Romanesque forms whose apogee fell in the first third of the twelfth century. Historically significant monuments, ambitious programmes, a single conception individually expressed by various regional groups and a beautiful and abundant sculpture dominated by the laws of the architecture—these were the main features of this superb moment of equilibrium, when images of God and of man, wrought from the building stone of the churches, mingled with the strangest fantasies of the human mind. The dreams of the most ancient East were reanimated, and embodied once more in figure-compositions; but the primacy of architecture imposed on them a logic, a profound harmony, which were the authentic expression of the West. This equilibrium, once achieved, was not overthrown by a sudden onset or insidious infiltration of new forms. Its stable principles and balanced clarity had emerged out of the flexible and many-sided researches of the experimental period, and they eventually lapsed again into a period of decline, marked by disorganization, ossification, and forgetfulness of the inherent laws of the style. We shall see that Romanesque art had its Baroque phase—using the word not in the limited sense of the historical period which followed the Renaissance, but as a designation for a state of mind whose recurrent manifestations appear in the lifetime of every style. It may be characterized on the one hand by academic dryness and the mechanical repetition of prototypes or, on the other, by forgetfulness of proper functions, profusion of ornament, and extravagant experiments, which call in question the value of acquired experience and the authority of the fundamental stylistic laws. But these destructive variations, these signs of weariness, incomprehension and forgetfulness, are in some sense a confirmation *a posteriori* (one might say, by *reductio ad absurdum*) of the value of the principles which they distort and deny. They are part of and they demonstrate the vitality of a style. If we were to content ourselves with a mere enumeration of the characteristics of Romanesque architecture and sculpture as if they were invariable data, neglecting the fact

that they were in constant development from the late tenth to the early thirteenth century and beyond, we should be unable to appreciate all their aspects, which would often seem contradictory, and we should fail to perceive how those contradictions were harmonized by the hidden links which were forged between them by the evolution of the thought and life of the time.

In the monuments of the last third of the eleventh century and the first third of the twelfth, the Romanesque style is seen at the height of its powers. It was no mere passive expression of its place and time. Romanesque man comprehended himself through Romanesque art. The spirit of a great system of architectural thought was the keynote to which poetry, science, philosophy and language were attuned. Then, as never before, the spirit of form determined the form of the spirit. This stylistic maturity coincided with an historical maturity, which furthered it by the consistency of its aims, the boldness of its policies, the abundance of its resources and the moral force of its institutions, particularly those of urbanism and monasticism. Both the latter are forceful illustrations of the twofold character of the Middle Ages, at once sedentary and nomadic, local and European. Each town acted as a focus and magnet of its surrounding countryside, distilled its qualities, and concentrated in itself the peculiar local traditions and experiences. But at the same time the towns were all linked together by trade, and by the identity of their statutes, brought about by copying each other's charters—a fact of which we shall find remarkable confirmation in the Gothic period and which was not without influence, for example, on Burgundian art. Monasticism favoured the interpenetration of localities to an even greater extent. By filiation, it propagated itself over enormous distances, and the monasteries were not only the refuge of exemplary Christians, detached from the life of their time, nor mere centres of meditation and culture, nor yet—in accordance with the spirit of their first foundation, renewed by the Cistercians—agricultural stations set up near a source of water for the purpose of tilling the virgin soil of desert places. For besides being planned, as they had already been in the Carolingian era, on the scale of towns, complete with schools, industrial and artistic workshops, scribes, blacksmiths and masons, they also intervened powerfully in the temporal destinies of the world, they cast a fine-meshed net over all Christendom, they were an organizing force and a focus of action. We should have a very inadequate understanding of the history of the early Middle Ages if we failed to take account of the expansion of Irish monachism. Similarly, in the Romanesque period, the political and moral stature of Cluny was outstanding.[1] It was a monarchy of

[1] E. Mâle, *L'art français et l'art allemand du moyen âge*, p. 93–4. Gregory VII, Urban II and Paschal II had been Cluniac monks. On the constitution of Cluny see V. Mortet, *Note sur la date de rédaction*.

monks, a monarchy of the spirit, ruled over by the abbot of Cluny, the abbot of abbots, whose moral authority was effective even beyond the organization of which he was head. The greatest of these abbots were both saints and leaders of men. Their community gave the Church several popes, numerous theologians, and a number of those great figures who, like St. Odo and St. Hugh, epitomize, and at the same time transfigure by their virtues, the age in which they live. Cluny, said Émile Mâle, was the greatest phenomenon of the Middle Ages. The modern development of orders vowed to contemplation or charity, and lying rather aside from the main currents of spiritual action (even when one takes into account the revival of institutions more exacting in their demands on the life of the spirit), provide no basis for our understanding of this immense priestly organization and its relations with the kings, emperors and popes, whom it often welcomed and entertained within the walls of its principal house. These great abbots were artists, not after the manner of princes enamoured of pomp and architectural splendour, but in a more profound and fundamental way. They loved music so greatly that when they came to decorate their church they caused the capitals of the sanctuary to be carved with figures symbolizing the various modes of plainsong. They loved nobility and dignity of form even as embodied in corruptible flesh, and one of them extolled a predecessor for the perfection of his beauty. These men stand in the foreground of the history of Romanesque art, not indeed as initiators of its morphology and style, for the roots of those lay deeper, but in the capacity of organizers. They it was who chose the sites of its activity, or at least it was they who animated the roads along which stand its most important monuments.

Cluny organized the pilgrimages, and thereby became the moving spirit of that nomadic middle age which rolled in wave after unceasing wave down the roads which led towards Santiago de Compostela and the oratory of San Michele on Monte Gargano.[1] This does not mean—far from it—that Romanesque

des Coutumes de Farfa, Mâcon, 1911. *More recently: G. de Valous, Le monachisme clunisien des origines au XVe siecle, Ligugé and Paris, 1936; J. Evans, The Romanesque Architecture of the Order of Cluny, Cambridge, 1938, and Cluniac Art of the Romanesque Period, Cambridge, 1950; to which must be added: Société des amis de Cluny (C. Oursel, ed.), A Cluny, Congrès scientifique . . . , 9-11 juillet 1949, Dijon, 1950.

[1] The Book of St. James, a fine copy of which is preserved in the chapter-library at Compostela, was written to assist pilgrims, probably by the monks of Cluny, at some date after 1139. See J. Bédier, Légendes épiques, III, p. 75; E. Mâle, L'art religieux du XIIe siècle en France, p. 291 and notes 3 and 4. The fourth book of the Compostela Codex was published by Père Fita, Paris, 1882. In addition, see Lavergne, Les chemins de Saint-Jacques en Gascogne, Bordeaux 1887; Dufourcet, Les voies romaines et les chemins de Saint-Jacques, Congrès archéologique de Dax et Bayonne, 1888; Abbé Daux, Le pèlerinage de Saint-Jacques de Compostelle, Paris 1898, cited by Mâle, op. cit., p. 289, note, and Ginot, Les chemins de Saint-Jacques en Poitou, Poitiers, 1912. The part played by the pilgrimage roads in the history of architecture was first studied by the Abbé Bouillet, the historian of Conques and Sainte-Foy, in Mémoires de la Société des Antiquaires de France, 1892, p. 117. The Via

art is exclusively Cluniac and that its leading features are to be traced back to Cluny itself, nor even that it was strictly dependent on the geography of these far-flung routes. The significance of the pilgrimage roads lay in the fact that they traversed various regions, beckoning always towards foreign horizons and inter-mingling the sedentary and the travelling populace; while acting as channels for the propagation of artistic types, they also attracted to themselves the forces and traditions of the localities through which they passed and these tended both to swell and to modify the character of the waves of influence. At the stages of the journey they fostered the dissemination of the *chansons de geste*,[1] and in doing so they mingled one aspect of the Middle Ages with another. They magnified local saints into saints venerated throughout the Western world, and by permitting the transmission of images over great distances, they enriched the universal language of iconography. The old Roman roads had been instruments of Roman penetration. The pilgrimage roads had a twofold action. They may have con-tributed to the unity of Romanesque art, but they also ensured its variety.

II

IN embarking on the study of the architecture which took its place in this system it is more than ever necessary that we should bear in mind the basic factors of the art of building[2]. A building is composed of plan, structure, composi-tion of masses, and distribution of effects. The architect is simultaneously and

Tolosana linked Provence with Languedoc, and leaving Arles, continued by way of Saint-Gilles du Gard, Toulouse, and the Somport pass. The stages of the Auvergne route were Le Puy, Conques, Moissac. A third route connected Burgundy and Aquitaine, from Vézelay to Saint-Léonard and Perigueux. The fourth and last, leaving Tours, traversed Poitou and Saintonge, and passed by way of Bordeaux to join the two preceding routes at Roncevaux, where they crossed the Pyrenees. Each route was an unbroken chain of sanctuaries. The pilgrimage road from France into Italy, crossing the alps by the Great St. Bernard or Mont Cenis passes, joined the Emilian Way via Modena, then the Cassian Way at Arezzo, reaching Rome by way of Viterbo. Influences travelled back and forth along the roads of St. Michael just as they did along those of St. James. On the relationship between Sant' Antimo in Tuscany and Conques, see J. Vallery-Radot. *Églises romanes*, p. 178, and on that between San Michele of Clusa and Le Puy, id., *ibid.*, pp. 176, 177, and the study by E. de Dienne, Congrès archéologique du Puy, 1904. *The most recent editions of the Guide for the Pilgrims of St. James are by J. Vieillard, Mâcon, 1938, and by W. M. Whitehill, Santiago, 1944. See also P. David, *Études sur le livre de Saint-Jacques*, Bulletin des Études Portugaises, Vols. 10–12, 1946–1948.

[1]It is well known that the *chansons de geste*, according to Gaston Paris, are the ultimate fruit of centuries of composition whereas for J. Bédier, *Les légendes épiques*, 2nd ed., Paris, 1914–21, they arose from the pilgrimages themselves. Note also the observations of G. Cohen, *La civilisation occi-dentale au moyen âge*, p. 211, where he indicates on the one hand the part played in the poems by geography and the northern abbeys, and on the other the continuity of poetic tradition attested by a ninth-century text such as the *Chanson de Saint-Faron de Meaux*.

*[2]H. Focillon has expressed the same views in *Vie des formes*, Paris, 1934, translated as *The Life of Forms in Art*, New Haven, U.S.A., 1942, and New York, 1948.

to a greater or less degree geometer, engineer, sculptor and painter—geometer in the interpretation of spatial area through the plan, engineer in the solution of the problem of stability, sculptor in the treatment of volumes, and painter in the handling of materials and light. Each type of talent and each phase of a style lays stress on one particular aspect of the art; the perfect harmony is attained only in the great periods. The importance of the plan is primarily sociological, for it is the diagram, the graphic representation, of the programme. The proportional relationships are indicative not only of the spirit of the style but also of the practical needs which the building is called upon to serve; the circlet of chapels radiating from the apse is not simply harmonious form but is necessitated by religious practice, while the curving ambulatory is designed to ensure a free flow of movement. For an eye accustomed to the study of architecture and the realization of the plan in space, the plan will suggest much more, and will even indicate the structural solutions. But one must remember that a building is not simply a matter of fitting a suitable elevation on to a pre-arranged plan, and the similarity of two plans does not necessarily and in every case entail the similarity of the composition of masses. Even though the plan is in some sense the abstract basis of these latter, yet they possess their own essential values, especially in a style which lays stress on the beauty of the masses, as does the Romanesque architecture of the twelfth century. They contribute to the stability of the building (here we are considering not a visual harmony, but actual resistance to thrust) and, arranged in order of size and of greater or less projection, they superimpose on the relationships of plane geometry a system of monumental relationships without which there would be no architecture, but only a diagram drawn out, like a flower-bed, on the ground. It is essential, particularly in Romanesque studies, to make the effort of considering a building as a collection of solids and of gauging the relationships between them. This manner of approach is doubly sound, since in Western architecture, at least in the period under discussion, the exterior masses invariably correspond with the internal distribution of parts and their three-dimensional relationships, so that the plan may be deduced from them, though the converse is not true. The truth of this observation may be demonstrated by a single example: a transept which does not project beyond the aisle-walls is hardly apparent on the plan. Finally the silhouette of a building, that most significant of values, results from the composition of masses.

The problems of structure and equilibrium, which are so important in large, complex, lofty, vaulted buildings such as those of the Romanesque period, arise mainly from the use of a stone covering, but this is not necessarily true in

every case, since lofty walls surmounted by a wooden roof also require buttressing, though to a lesser extent, and northern and north-eastern France, not to mention other areas, can show examples of this type of structure which are completely faithful to the spirit and style of their time in plan, mass and effects. A building is not carved or hollowed out of a monolith, but *constructed*, that is, composed of separate elements, assembled according to rules in which the architect figures as an interpreter of the force of gravity. The Greeks opposed the action of gravity in the vertical direction only. The medieval masters in most cases had to solve a problem involving oblique components and the counteraction of thrust, and, by an admirable process of reasoning, they progressively specialized each member of the structure according to its function, and devised for it a form which was at once the most suitable and the most expressive of its purpose. It is in this respect that their architecture is most truly an art of logical thought, whereas the Greeks, having adopted once for all the straightforward solution of verticals and horizontals, were thereafter interested only in melodic variations of the proportions.

Besides being an interpreter of gravity the architect is also an interpreter of light, by virtue of the calculation and composition of his effects. This question must not be limited to the problems of lighting, though they in themselves are of capital importance, and we shall see how intimately they were linked with the problems of structure and equilibrium, and how their solutions evolved throughout the Middle Ages in step with the structural solutions. But the study of effects is of wider scope. It concerns the relationships of void and solid, of light and dark, and—perhaps most important—of plain and decorated. Again, a building is not an architect's drawing or a photographic print, it is composed of solid matter. It is obvious that this fact has specific and far-reaching effects on every detail of the treatment. It is of fundamental importance for the structure, since the various kinds of material have their own peculiar qualities and requirements, and these determine the functions which they can perform, the types of masonry for which they can be used, and the extent of the programmes to which they can be applied. Materials, moreover, have texture and colour, and with these they make a pleasing and powerful contribution to the life of architecture, which is not intended merely for technical analysis and dissection but for the delight of the eye. They play their part within the system of relationships which we have just outlined, here stressing the solid, the broad luminous surface, the monumental economy of ornament, and there emphasizing the void, the equivocal effect of light and shade, and the profusion of carving; thus, though the vocabulary of forms may be constant, syntax, language and poetry are constantly recreated.

The elements can be isolated intellectually, but it must not be forgotten that they exist together, and that it is their organic interconnection, not their juxtaposition, which makes the building. We already have some idea of the inter-dependence of plan and structure, plan and masses, masses and equilibrium, and masses and effects. The architect conceives his building synthetically. Even in the first flash of an idea, his thought includes the diversity of the parts. Admittedly, of course, the genius of a school, a locality or a master may concentrate on one particular aspect. There are builders and there are decorators. But a medieval building is a harmony of living forces which mutually penetrate, amplify, restrain, modify and define each other. We shall see striking proofs of this when we examine the development of the vault-rib, its awkward early growth in the shadow of the Romanesque basilicas, its gradual procreation of useful ancillary members, its soaring upwards with increasing lightness to enormous heights, and finally its bursting asunder of the old shell and its proclamation of the new world of forms. The interrelationship of the masses, and the various relationships by which the effects are qualified, are transformed from top to bottom, from pavement to roof-tree, and in every dimension of the architecture. Each individual member shares in the life of the organism as a whole. And what is true of the Gothic skeleton of arches and ribs is no less so for the massive Romanesque structure of compact vaults and thick walls, as a more detailed examination will show. We are compelled to deal with the elements one by one, but we must never lose sight of the fact that these elements are all functions of each other. And when we analyse the regional varieties of Romanesque architecture, which testify so strikingly to its historical vigour, we shall find that they owe their individuality not so much to what may perhaps be called their superficial features, or to the treatment of details, as to modifications of the interrelationship of parts. In this respect they constitute dialectal varieties comparable with the various romance idioms.

The programme of the Romanesque basilicas was that of an enormous reliquary open to all comers. The monastic church of the time served both monks and pilgrims. It sheltered the bodies of the saints and attracted the devotion of the faithful. Renowned relics, the miracles wrought by them, the pious legends which surrounded them, the cult which exalted their virtues, the enhanced value of prayer uttered beside them—all this intense spiritual fervour created the prosperity of the great abbeys, and at once necessitated and made possible the grandeur of their scale. As in the progress of cities, demand created supply. The plan of the pilgrimage churches is as if drawn by the immense throngs which passed through them, by the order of their going and of their standing

still, the places where they stopped and the places where they moved onwards. Sometimes a great narthex, a survival of the old church of the catechumens, precedes the church, and serves as its vestibule, though large enough, with its central nave, aisles and upper storey, to form a separate church. The church proper has three, and sometimes five, naves. It was thus enabled to impose order on the multitudes within, by cutting parallel furrows in the moving mass. One or two transepts, with oriented chapels opening off them, form two or four projections on the plan, each one so large that it seems an additional church set at right angles to the first. But they did not interrupt the progress of the pilgrim. They provided the throng with auxiliary entrances and exits, and they formed part of that architectural topography of pilgrimage which permitted of uninterrupted circulation within the building, from the west front to the chapels of the apse and from the chapels of the apse back to the west front. Sometimes, as in Saint-Sernin at Toulouse, a continuous aisle surrounds the transept arm, extends along the choir, makes the circuit of the apse, and so returns. The long choir favoured the development of ceremony. But it was the east end which, in both plan and elevation, in both the establishment of the programme and the treatment of the masses, was the vital part of the church. Here are disposed the chapels which sheltered the relics of the saints, in addition to those which in some cases were preserved in the crypt, as in the martyrium of the primitive basilica. The most frequent arrangement is that in which small apses radiate from the ambulatory, a scheme whose earliest examples we have already noted in the second half of the tenth century; this was the best arrangement from the point of view of circulation. But a whole family of churches preserved the orientation of the apses by disposing chapels of diminishing scale in echelon; and this plan was best from the point of view of presentation, the chapels being parallel to one another and opening directly on to choir and transepts. This scheme is known as the Benedictine or Berry plan, though it is not confined to that province. The finest and most characteristic example is perhaps that of Châteaumeillant. But it was the radiating plan which prevailed, and Romanesque art, which had received it from the Carolingian tradition, bequeathed it in due time to its Gothic successor.

The exact adaptation of plan to programme is noteworthy. Another feature which should be emphasized is the legibility of the parts. Each one was designed not only to fulfil a function but also to proclaim it both inside and outside the church. In this respect the Romanesque East, by which I mean that which comes closest to Romanesque art proper, diverged from the Western practice. There is no doubt that certain features of Western architecture are found at a very early

date in the East Christian communities—for instance, the general disposition of the Syrian naves of the Hauran, and the continuous aisle, used in the Egyptian basilica of St. Menas; and it is apposite here to recall that the Carolingian double-apse plan occurs also in certain Roman buildings in North Africa. But however great the importance and interest of these analogies (and in studying the masses and the architectural sculpture we shall come upon many others), the subsequent development of architecture in Asia Minor, especially in Transcaucasia, between the ninth and twelfth centuries, displays a characteristic tendency to combine two types of plan, the centralized scheme of rotunda or quatrefoil and the longi-tudinal scheme of the basilica, and, more generally, to conceal the interior plan within a totally dissimilar exterior plan by the interposition of enormous masses of masonry—so that a building which appears to be round or square may actually contain a quatrefoil, made still more complex by subsidiary lobes. A kind of secretive genius seems to have delighted in multiplying and concealing these complexities of the interior. We have here a conception diametrically opposed to that of the West. So also with Islamic art. As is well known, the plan of the mosque is composed of numerous naves of identical dimensions. By isolating one of these narrow elements plus the transverse portico into which they issue, but which can hardly be called a transept, and adding the minute projection of the mihrab, one can obtain a sort of attenuated version of the basilican plan. But this mental operation, which results in an architectural monstrosity, is at variance with the facts. The originality of these enormous halls and their number-less colonnades resides in the principle of unlimited extension and the impressive monotony of repetition. Equilibrium, masses and ornament likewise obey rules foreign to Western art.

The development and organization of the basilican plan represented a funda-mental aspect of Romanesque architecture, but the central plan, which earlier Christian builders, copying antique funerary monuments, had used for bap-tisteries and dynastic chapels, enjoyed a renewed lease of life thanks to imitations of the Constantinian rotunda of the Holy Sepulchre.[1] The palatine chapel of Aix traced its descent indirectly, through San Vitale at Ravenna, to the funerary type from which all these buildings ultimately derived, and it inspired in its turn a family of similar monuments at Nijmegen, Ottmarsheim (1045) and Mettlach. The rotunda which the abbot of Saint-Bénigne erected in Dijon in the early eleventh century we have already noticed as exhibiting a novel alliance of central and basilican planning. Neuvy, erected after the return of Eudes de Déols from a pilgrimage to the Holy Land, and other related monuments,

[1] On the complexity of this development and related topics cf. *supra*, p. 33, n. 2.

demonstrate the potent fascination exercised by the tomb of Christ before the commencement of the Crusades. Rotundas were built throughout Europe (e.g. Prague St. Cross and St. Mary of Vyscherad) and the rib-vaulted crossing of Ferrière-en-Gâtinais is a late application of the same idea. But this type of plan belonged to the past rather than to the Romanesque period itself.

The same may be said of the trefoil plan, which can be thought of (without committing ourselves to a theory of its origin[1]) as a quatrefoil with one of its lobes replaced by a nave. Another type of plan is that in which the transept ends are rounded and the apsidal chapels omitted from the chevet. This is a scheme which was commonest in the Rhineland, and which continued to enjoy a certain vogue in the areas where Carolingian influence had been strongest; we shall come across the rounded transept again in some twelfth-century Gothic churches. But the unbroken walls which this plan entailed conflicted with certain indispensable requirements of the pilgrimage churches—many entrances, and numerous conveniently placed chapels. These basic demands were satisfied, however, by the plan of the sanctuary and chevet as defined in the basilica of Hervé at Tours, in the cathedral of Étienne II at Clermont and in Saint-Philibert at Tournus.

The structure of vaults and piers responded to the needs of the vast programmes with which the geometry of the plans has made us acquainted. The eleventh century had already experimented with the main solutions of the problem of stone-vaulting. The twelfth gave them their strict classic forms, used them boldly over wider spans, and employed a new profile for the barrel vault. It abandoned transverse vaulting, which was, however, revived in the aisles of certain Gothic churches, no doubt for purposes of abutment—for instance, the Cistercian church of Fontenay, and a small group in southern Champagne. The barrel vault, with or without transverse arches, was the rule for naves, and the groined vault for aisles, where it long resisted the advance of the ribbed vault, as, for example, in Cistercian architecture. But the architect of Speyer, he of Maria-Laach, the Burgundian builders, and perhaps the Normans also, constructed groined vaults over their naves[2], and profited from the distribution of thrusts to raise the height of the wall, to open windows in the lunettes (theoretically with less risk than under a vault of continuous thrust), and hence

[1]But note the plan of the crypt of Saint-Laurent at Grenoble, where one lobe of the quatrefoil is separated from the other three by a complete bay, suggesting an intermediate stage between the quatrefoil and trefoil plans.

*[2]It seems very unlikely that Norman architects ever contemplated vaulting a nave before c. 1115–20. After that date they used generally the rib-vault, but some examples of groin-vaulted naves can be found in England: see C. Lynam, *The Nave of Chepstow Church*, Archaeological Journal, 1905, p. 270.

to obtain direct lighting. They also utilized the pointed barrel vault, whose profile is composed of two arcs struck from different centres and without keystones at the crown (except in some Islamic examples, where they are nonsensical). At intervals, directly beneath the transverse arches, the walls are buttressed. The system is completed by the armature of supports which is, to some extent, articulated.

In the earliest types of basilica the wall was carried on columns and lintels. In the next stage, arches were bitten out of it, and it was supported sometimes by columns, and sometimes by rectangular piers which were themselves part of the wall, so that the latter now rose uninterrupted from floor to roof. The first sign of an evolution of the supports appeared when these pieces of wall assumed a cruciform section: the rectangular block was decomposed into four pilasters, of which two appear to carry the arch mouldings, while two rise to support certain elements of the roof. By combining the column and the rectangular or cruciform pier, the Middle Ages created a type of support of profound originality, the logical development of which was to lead to a system of architecture based entirely on structural functions. The various members are not independent, but they are specialized, and each one contributes a particular function to the activity of the whole. In the support, the transverse arch of the vault is linked with the wall, which is thickened to receive it and to conduct it down to the ground. The separate bays which make up the powerful rhythm of the nave are each echoed by the adjacent bays of the aisles. It is a strong and noble language, metrically scanned. At Saint-Sernin, the engaged columns soar uninterrupted to the springing of the vault and the equal strophes succeed each other down the vista of the nave, while the pier retains its austere mural strength in the plain pilasters of the arcades. The pier of Poitou assembles closely round its central core elements which are elsewhere more or less dissociated, but its quatrefoil section is very marked. The Cluniac architecture of Burgundy furrows its pilasters with classical fluting, and its superposed orders and the cornices which divide, or rather emphasize, the separate stages present a visible analysis of the interior elevation into its component parts. In Normandy and Germany, on the other hand, the rhythmic continuity is modified by an alternation of strong and weak stresses.[1] The main supports are composed of heavier or more numerous elements, while the secondary ones are weaker or simpler

[1]On the origin of the alternation of supports, of which the early examples are Hagios Demetrios at Salonika (fifth century) the basilica of Rusafa in the neighbourhood of Edessa (pre seventh century) Gernrode (961), and SS. Felice e Fortunato in Vicenza (985), see Mâle, *Art allemand et art français du moyen âge*, pp. 71-3. *Add E. Lambert, *L'ancienne église du prieuré de Lay-Saint-Christophe et l'alternance des supports dans les églises de plan basilical*, Bulletin monumental, 1942, pp. 225-253.

in construction. This difference of form reflects a difference in the amount of work done. In wood-roofed churches the main pier supports a main truss of the roof while the subordinate pier carries some lesser member. By doubling the size of the main bays, this arrangement breaks the unity of the bay system, each bay of the nave now corresponding to two bays of the aisles. The vista of the church thus becomes more varied. Over these alternating supports and double bays were raised the first Gothic vaults, in which a secondary transverse arch springs from the lesser pier and, in conjunction with the diagonal ribs, divides the vault not into four, but into six cells, whence the name sexpartite vaulting.

To what extent were these ingenious forms, this co-ordination of vault and support, capable, even with the assistance of buttresses, of ensuring the equilibrium of these gigantic structures? It is in studying this question that one comes to realize how intimate are the links between the various aspects of thought which together make up this architecture. The distribution of masses plays a part in the stability of the building. The apsidal chapels lend support to the main apse, and the nave is buttressed by the aisles. The aisles may be of one storey only, or they may be surmounted by tribunes. To obviate the instability of the upper walls in churches without tribunes, the architects of Poitou raised their aisles to the level of the imposts of the nave and covered the whole building with a single roof. In Auvergne and in the pilgrimage churches, the tribunes counteract the thrust of the main vault, while the danger of their own thrust towards the exterior is minimized by the relative lowness of the wall. Such a system of equilibrium is effective only with indirect lighting. If the nave walls are raised considerably above the level of the tribunes in order to permit the piercing of windows, there are two possibilities. If the tribunes are groin-vaulted, they contribute nothing to the equilibrium; if, on the other hand, they have half-barrel vaults, they may be positively harmful to the stability of the wall, since they will exercise a thrust upon it at a point much below that exercised by the main vault, and in the contrary direction.[1] For this reason we find churches which have no clerestory and are lit only by windows in the aisles and tribunes. The tribunes have thus a triple function, which, though it makes no showing on the plan, responds to the demands of equilibrium, to the distribution of light and also to a programme-idea. For despite the inadequacy of the means of access

[1] Note, however, that in the upper storey of the narthex of Tournus, in the nave of Saint-Étienne at Nevers and in Norman churches, we find such half-barrel vaults surmounted by pierced walls which have stood for centuries. According to H. Masson, in his study of Tournus quoted above, the upper part of the church may simply be treated as an aisleless building provided that it is firmly seated on the piers.

in both number and scale, one can hardly admit that they are mere circulation galleries; forming as they do a kind of upper church, and often making a complete circuit of the nave, they seem calculated to receive a multitude within their spacious bays. The capitals with which their columns are adorned convey a message which was assuredly not intended to languish unseen. The faithful were not confined to the pavements of the pilgrimage church; life and prayer were admitted also to the heights. We are justified in imagining the lovely volumes of these openwork galleries thronged with pilgrims, at least on days of solemn feast; and at the same time they served the church as props and as sources of light. In Auvergne they were vaulted in a way which makes plain their structural significance, using the half-barrels which at an earlier date had served to buttress the dome of the rotunda of Saint-Bénigne at Dijon. The profile of this vault foreshadows the flying buttress. Was it perhaps its progenitor?

To identify the flying buttress with a section or slice of a half-barrel vault may be purely theoretical. But it is logical, and it is certainly true that in the two cases the same form solves the same problem. The tribunes of Auvergne are notable for this vigorous element of structure; those of Normandy are equally so for their beauty as architectural composition, for the harmonious proportions of their arcades, and for their survival in the Gothic architecture of the twelfth century, when the cathedrals of Laon and Paris adapted the vault rib to the old structural form characterized by alternating supports and two-storeyed aisles.

The masses, whose role in the equilibrium of parts and the counteraction of thrusts we have just examined, are also plastic form. The Romanesque architecture of the eleventh century is a composition of volumes in the same way as first Romanesque art had been, but its methods were more varied and skilful. Once again we must station ourselves outside the church, at the east end, to appreciate 62-66 the progressive building-up and interrelationship of the separate masses. From this aspect, the compositions of the Auvergne masters are invariably magnificent. Up from the chapel-roofs to the roof of the main apse, from thence to the higher level of the rectangular block[1] which supports the lantern, and finally to the point of the spire, the eye ascends a kind of staircase of which each step is a calculated volume. The ample coronet of minor apses lends variety and a perspective of swinging curves to the base from which this impulse springs. The combination of cylindrical and rectangular volumes, of polyhedron and pyramid,

[1]According to C. Enlart, *Manuel*, I, 3rd ed., p. 228, n. 1, these oblong blocks on which the lanterns rest are a survival of a Carolingian arrangement visible in the old drawing of Saint-Riquier (*ibid.*, p. 187). In fact the superposed lantern-stages at Saint-Riquier are supported on a circular base.

undoubtedly attains its perfection in Auvergne, and the strictness of this classic form, once achieved, has left its imprint on a great number of buildings, even those of secondary importance, so that there are few regional groups or schools which appear so homogeneous. In Normandy the masses are differently disposed; again they include the lantern-tower over the crossing, but a greater and more influential destiny was reserved for the innovation of the harmonic façade, in which the western gable is clasped between a pair of towers. Rectangular volumes predominate, with square belfries. The Norman lantern-tower is no airy tapering crown set over the crossing. Despite its fenestration, the mass retains a somewhat military aspect. Its weight, loading the unyielding flanks of the church, its thick-set authority, its harsh junction with the main structure, without the transition afforded by the rectangular block of the Auvergne system, are features which outlived Romanesque art and persisted in many Gothic buildings in England and Normandy, though in conjunction with newer methods which ensured not a stronger, but a more economical and technically more advanced construction. The lantern of Coutances—which was admired amid the full flood of classical taste by the unprejudiced technician's intellect of Vauban—is the most celebrated example. In the Norman east end, one finds sometimes an ambulatory, with or without chapels, and sometimes a lofty apse pierced by three stages of windows, an arrangement inherited perhaps from an Ottonian scheme and which recurs in Gothic architecture, in the lovely chapel of the north transept at Laon, and later in Notre-Dame at Dijon.

The composition of the masses of the main façade had been treated in various ways during the preceding period and continued to be so; in small and medium-sized churches it was often no more than a simple gable-end, that is, a wall masking the interior and presenting a kind of cross-section of the nave. But the buttresses which uphold it on either side, emphasizing the distribution of thrust, the cornices which sometimes intersect it, indicating the division into storeys, the introduction of one or more windows, and, in western and south-western France, the addition of ranges of wall-arcades, are sufficient to give it the characteristics of an architectural composition, albeit a simple one. Arcaded façades were exploited particularly by the architects of Poitou and Saintonge; the system which employs several registers of small wall-arcades belonged rather to Saintonge, though in Poitiers itself Notre-Dame-la-Grande has this type of design; the 95 system of large arches is mainly Poitevin, but is often found in Charente. The façade of Angoulême cathedral has superposed registers of large arches. For the most part the main lines of the gable are respected, and in some cases, as at Saint-Jouin-de-Marnes, a decorative arrangement of masonry above a cornice 94

or string-course is used to emphasize the gable-form. The gable is no less well defined when clasped between the slim stair turrets with their imbricated caps—turrets which are no larger than the splendid column clusters which the architects of Charente loved to place at the angles of their façades. But there are also examples, as at Échillais, of the replacement of the gable by a rectangular wall decorated with blind arcades, so that the façade gives the impression of a screen placed in front of the church, and almost of an independent structure.

At this point it will be apposite to discuss some other treatments which, from an early stage of Romanesque art, accorded an independent existence to this part of the building. Of these the tower-porch is the simplest type and the one which, under certain conditions, was to survive the longest. It calls to mind an earlier age when the tower had been a campanile at some distance from the church. We possess examples of naves which were built westwards to link up with an earlier tower (Saint-Savin-sur-Gartempe) though there is no doubt that in this particular case the tower was already a tower-porch. Many of these towers are of normal proportions and are exceptional only by reason of their situation, as, for instance, that of Saint-Martin-d'Ainay at Lyons, though this unfortunately has been ruined by Pollet's restoration, which has hemmed it in between a pair of lateral chapels instead of allowing it to project. Some, on the other hand, are so large that they absorb the entire façade, or rather they themselves become the façade, as in the churches of Le Dorat (Limousin) and Cunault (Touraine).

We have already indicated the importance of the porch, derived from the Carolingian porch-church, in many buildings of the eleventh-century. Sometimes it may be classified as a more spacious variety of the façade tower. Sometimes it forms a kind of portico, either open and carried on columns as at Saint-Benoît-sur-Loire, or raised on powerful wall masses pierced with openings as at Ébreuil. Sometimes it is large enough to form a separate church preceding the main building. Of this type Tournus is the notable example and Burgundy long remained faithful to it. The narthex of Vézelay, the Gothic porch of Cluny, and with less ambitious programmes, those of Semur and Notre-Dame at Dijon, show the persistence of the tradition in this region. Tournus, with its tower-stumps which hardly overtop the narthex block, provides a kind of first sketch of the elements of the harmonic façade. But it was at Saint-Étienne at Caen that this scheme received its authoritative monumental definition. It is true that even there the towers do not spring directly from the ground, nor do they project forwards from the wall. They are, as it were, set down on the façade block, of which they constitute an upper storey. But the silhouette is established with

clarity, for centuries to come. While the façade of Jumièges butts against a tower porch, that of Saint-Étienne displays its majestic strength between and beneath the bold masses of its twin towers. Later the towers were no longer set down on the wall block, but framed it, descending to take root in the ground. From Normandy this splendid composition of masses was taken over by the twelfth-century cathedrals of the Ile-de-France; it persisted through the thirteenth century, determining the physiognomy of the church; it belongs to the Middle Ages as a whole and is one of their most characteristic shapes and embodiments. Was it elaborated out of native Norman traditions? Or suggested by the façade of Tourmanin in Syria? The relationship between the latter and the church of Pontorson has gained adherents for this view, and might take its place among a whole series of links between Syrian and Romanesque art, such as the columns of the apse of St. Simeon at Antioch, which recur in Cluniac apses. But there are marked differences between Tourmanin and Pontorson, which is moreover an exceptional case, while on the other hand the stages in the internal evolution of the treatment of masses, both in Normandy and elsewhere in the West are much too apparent to allow a theory of imitation to usurp the role formerly assigned to independent research[1].

We must apprehend, beyond the vigorous life of these forms, a force more coherent and compelling than mere accumulation of archaeological detail, an underlying logic which took advantage of the circumstances of time and place to become historical reality. The study of effects as the interpretation of light and materials, and as the relating of plain to decorated wall-surface, will provide an equally cogent demonstration of the ascendancy of this style, which remained loyal, through all the varieties of handling, to the great wall-masses, and respected their coursed masonry even when disguising it beneath the profusion of blind arcades (which do not undermine or penetrate them) or the polychromy of decorative stone-setting (which does not disturb their equipoise). The decoration is itself wall. It does not exceed the strict limits imposed by the block of building stone. Even in its most passionate moods it is held in check by a discipline which forbids it to flourish and posture about the church or to launch itself turbulently into space. It builds up an artificial third dimension by subtle gradations of relief within the volume of the wall. It exists as a function of the wall-mass, which its images adorn but do not compromise, and by the same token it is the servant of architecture, which determines its location, arrangement and style. Some groups of churches, built of soft stone responsive to the chisel, admit a rich and, at a later stage of evolution, an overladen decoration and indulge in

*[1]On this type of façade, see p. 43, n. 1.

effects which are pictorial rather than strictly plastic—tricks of chiaroscuro and simulated shadow; this is the case in south-western France. Other groups, of harder and less easily worked material, are almost bare of ornament. Aulnay is covered with relief-carving. Saint-Paul at Issoire is barren, and its façade gives the impression not of a wall, but of one plane of a solid body. The human figure is almost entirely banished from Norman churches for the benefit of a vocabulary of geometric ornament, whereas in Languedoc and Burgundy human dreams and passions are violently revived in the drama of the Gospels and the apocalyptic vision of the Last Day. But the effects both of sobriety and of luxuriance are in every case determined by the wall-mass. The detailed analysis of the sculpture, considered not as a collection of museum pieces but as a part of an organic whole, will prove the validity of this rule. When it was contravened, the style was already in dissolution and the same symptoms of degeneracy appeared in both the decoration and the architectural members.

III

W E are now in a position to examine individually the various local types, and to trace the broad lines of the geography of Romanesque architecture. Something of this has already appeared in our technical analysis, which necessarily included some reference to regional conditions. But if our general picture, our panoramic view, of the various aspects of the style is to have positive value, it must observe three conditions. It must take account of the historical deposits laid down in the Romanesque territory after the end of the tenth century, which were not every-where of the same value and duration; furthermore, in making use of the conventional term 'schools', it must avoid the error of envisaging them as confined to limited areas circumscribed by the frontiers of the great feudal states; and thirdly, it must take cognisance of the fact that within these groups the idea of influence and the stylistic genealogy of churches depend on the principle of filiation—this we have already seen operating over long distances, transmitting the basic features of a type along the pilgrimage roads, and it was equally effective within the various groups, of which even the most uniform produced several distinct stylistic currents. The Normandy of Caen is not the Normandy of Jumièges. The Burgundian style derived from Vézelay differs from that derived from Cluny. Auvergne is more unified, but the Velay group stands quite apart from the rest. The Midi, which long remained faithful to the tradition of first Romanesque art, also inherited or revived the cornices of the antique temple,

and sometimes its bulk and proportions also. Absolute localization of styles is likewise impossible; those of Poitou and of Saintonge exchanged their characteristic types, while Limousin gives its name to a class of tower which recurs in the Rhône valley. On the other hand such localizations may be more cogent when they depend, like the domes of Aquitaine, on a geological factor—in this case the zone of excellent surface materials extending from Périgord to Angoumois, which was, as Vidal de La Blache was the first to note, so liberally sprinkled with castles. With these reservations, it remains true that this universal art was also a local art, and this in fact was the twofold principle of its greatness. The applications of its rules were everywhere modified, yet these very variations tended to make it more generally intelligible and to facilitate the acceptance of one or several models, which were then followed, but not slavishly imitated.

The great Romanesque architecture of Burgundy comprised two main divisions, or rather three if we include the eleventh century, which was so prolific in great buildings—Saint Bénigne at Dijon, Saint Philibert at Tournus (the standard type of first Romanesque art in composition and architectonic decoration of the masses, but of such daring originality in vaulting) not to mention the churches of the regions of Mâcon and Châtillon-sur-Seine (where rise the solid and austere volumes of Saint-Vorles, with its dome over the crossing, its piers without capitals, and its exterior walls metrically scanned with arcades and bands). The influence of Cluny II,[1] which is still traceable in the plan of some Burgundian churches, spread far and wide, especially in Germany and Switzerland. On the other hand we have seen how already in the eleventh century the Burgundian architects were studying the problem of the direct lighting of vaulted naves, and this study was also characteristic of the two great families of buildings of the next century, one of which was the progeny of Cluny III, while of the other the chief representative is Vézelay.

[1]Saint-Pierre le Vieux, completed by St. Odo and consecrated in 981, was embellished by St. Odilon. According to Dehio, I, p. 273, this church was demolished to make way for the erection of the church of St. Hugh. According to J. Virey, Congrès du millénaire de Cluny, 1910 and Congrès archéologique de Moulins et Nevers, 1913, a plan made in the seventeenth century still shows traces of it. According to Mettler, Die zweite Kirche in Cluni ..., Zeitschrift für Geschichte der Architektur, 1909, the abbey of Hirsau, which was built after the introduction of Cluniac customs, was a reproduction of Saint-Pierre le Vieux and itself inspired a group of churches, including notably that of Paulinzella. See E. Mâle, Art et artistes du moyen âge, p. 167. The description given in the Consuetudinary of Farfa and the first results of Conant's excavations are mentioned above, p. 37, n. 2. It may be added that Romainmôtier, Saint-Fortunat at Charlieu, and Anzy-le-Duc have choirs reminiscent of the 'Benedictine' plan of Cluny II, with the nave-aisles prolonged on the farther side of the transept by the aisles of the sanctuary. *On Cluny II, see K. J. Conant, Benedictine Contribution to the Mediaeval Church Architecture, Latrobe, 1950; also L. Grodecki, Le 'transept bas' dans le premier art roman et le problème de Cluny, A Cluny, Congrès scientifique, 9–11 juillet 1949, Dijon, 1950. (See supra, p. 41, n. 2.)

To treat the basilica of St. Hugh[1] as the culmination of the whole of the Romanesque experience of the preceding period would be as erroneous as to consider it the fountain-head of all subsequent development. But from the scanty remains which have come down to us, from the relevant texts, and above all from its surviving daughter churches, we can understand the awestruck admiration of contemporaries. In the grandeur of its programme it can be compared only with Speyer, from which however it differs profoundly. Its five naves, its many great towers, its pair of eastern transepts, are less characteristic features than the innovation of the pointed barrel-vault over the directly lit nave, the elegant audacity of the three-storey elevation without the reinforcement of tribunes, and the noble composition of pilasters and colonnettes reminiscent of the antique —as are also the design of the triforium gallery and the amplitude of certain interior volumes, which recall those of Roman thermae.

93 Vézelay is of a quite different character. Built by a commune of warlike burghers, on a hill-spur of harsher aspect than the gentle valleys among which stood the metropolitan church of the Cluniacs down to the beginning of the nineteenth century, the church of La Madeleine[2] is conceived more modestly, yet not without grandeur, and by limiting its elevation to two storeys it avoids raising the walls to dangerous heights without lateral support. Nothing intervenes between the main arcades and the clerestory windows, neither the tribunes of Saint-Étienne at Nevers, nor the triforium of Cluny. Overhead, a groined

[1]In addition to *Congrès du millénaire de Cluny*, see the monograph by J. Virey, Paris, 1927; C. Oursel *L'art roman de Bourgogne*, *p. 57 seq.;* K. J. Conant, *La chapelle Saint-Gabriel à Cluny*, Bulletin monumental, 1928, and *Les fouilles de Cluny, ibid.*, 1929. Work on Cluny III was begun in 1088; a first consecration by Urban II took place in 1096 and was followed by a second of uncertain date by Bishop Peter of Pamplona, who died in 1115; the nave was certainly completed before 1125. *The most important article on the subject is now K. J. Conant, *The Third Church at Cluny*, Mediaeval Studies in Memory of A. K. Porter, Cambridge, U.S.A., 1939, II, pp. 327–357.
[2]According to C. Oursel, *Art roman de Bourgogne*, p. 116 and C. Porée, *Vézelay*, p. 14, Abbot Artaud (1096–1106) was responsible for the bulk of the church, which was consecrated in 1104 and completed about 1110; the fire in the town in 1120 was without serious consequences for the building; the 'ecclesia peregrinorium' which is traditionally thought to be the narthex, was consecrated in 1132. According to R. de Lasteyrie. *Architecture religieuse à l'époque romane*, p. 425, and J. Vallery-Radot, *Églises romanes*, p. 89, the nave was rebuilt after the fire, and there is some confirmatory evidence of this in the difference of style between some capitals of the earlier nave, re-used in the two bays next to the transept, and those of the other bays. F. Salet, *La Madeleine de Vézelay et ses dates de construction*, Bulletin monumental, 1936, takes the view that the eleventh-century church was that consecrated in 878, with some alterations. The afflux of pilgrims, which was considerable from 1050 onwards, led Abbot Artaud to begin a great church, whose choir and transept were consecrated in 1104. Work was interrupted by the death of Artaud in 1106. The destruction wrought by the fire of 1120 was confined to the old timber-roofed Carolingian nave. Abbot Renaud de Semur, 'reparator monasterii', rased the burned nave and built the existing one, which was completed between 1135 and 1140, while the narthex (which, contrary to the traditional belief, is not the 'ecclesia peregrinorum') was finished about 1150; the consecration of the chapel of St. Michael in the eastern tribune of the narthex took place between 1145 and 1151, and its vault-ribs are of that date. *On Vézelay, see now F. Salet, *La Madeleine de Vézelay*, Melun, 1948.

vault of flattened form (which had later to be propped with flying buttresses) is carried on stout compound piers. An aisled narthex gives access to the three naves of the church, and its upper storey communicates with the main building by a tribune dedicated to the cult of St. Michael, the vault of which shows the earliest use of the vault rib in Burgundy. At Vézelay as at Cluny, despite the divergence of their solutions, the primary aim was the reconciliation of the rival claims of direct lighting and the stone vault. It has been rightly said that Burgundian architecture was, as it were, impatient of the Romanesque formula and tended to anticipate Gothic solutions. The ribbed vault which covers the Romanesque nave of Langres, and the Gothic choir which was added to the Romanesque nave of Vézelay, both appear as logical conclusions of what had gone before. In this way a style was formulated which, in one place following Cluny, in another Vézelay, but with mixtures and exchanges which indicate the flexibility of the filiation principle, produced many magnificent buildings in the course of the twelfth century. The columns set against the buttresses of the apsidal chapels, the lovely flat pilasters with their antique fluting, and the horizontal string-courses which divide the storeys, are characteristic Cluniac features of this superb language of stone, which is further embellished by sculpture representing all three periods of Romanesque carving, from the earliest capitals of the Cluny choir, preceding those of the Liberal Arts and of Music, down to the latest workshop at Charlieu. The basilica of Paray-le-Monial,[1] Saint-Lazare at Autun, Saint-Andoche at Saulieu, Notre-Dame at Beaune, the cathedral of Langres, Saint-Hilaire at Semur-en-Brionnais and in England the ruins of the Cluniac priory of St. Pancras at Lewes, demonstrate the importance of the filiation of Cluny.[2] The Vézelay type recurs in Saint-Lazare at Avallon[3] and in the churches of Pontaubert and Anzy-le-Duc.[4]

We have already dwelt sufficiently on the structural characteristics peculiar to Auvergne—in particular, the abutment by means of the half-barrel vaults

[1]See J. Virey, *Paray-le-Monial et les églises du Brionnais*, Paris, 1926. The choir was certainly built before 1109.

[2]See J. Vallery-Radot, *Églises romanes*, p. 80 ff.

[3]See P. de Truchis, Congrès archéologique d'Avallon, 1907.

[4]The plan of the choir of Anzy-le-Duc with its aisles prolonging those of the nave, was held to be unique in Burgundy, but J. Vallery-Radot, *Les analogies des églises Saint-Fortunat de Charlieu et d'Anzy-le-Duc*, Bulletin monumental, 1929, has shown that it was almost identical with that of Saint Fortunat, and that both derived from Cluny II. This fact necessitates certain reservations with regard to Oursel's 'Martinian' theory. It may be admitted that the Vézelay type belongs to the diocese of Autun and that it originated in that town, at the abbey of Saint-Martin, of which Anzy-le-Duc, Bragny-en-Charolais, and Saint-Martin at Avallon were all dependencies. But is it legitimate to look for its origin in the antagonism between Bishop Norgaud and Cluny? In any case, Renaud de Semur, the 'reparator' of Vézelay, was a nephew of St. Hugh and was buried at Cluny. *J. Hubert, *L'art préroman*, Paris, 1938, has shown that the abbey church of Saint-Martin at Autun was not rebuilt in the Romanesque period and that the old Merovingian basilica was still standing in the eighteenth century. This put an end to the 'Martinian' theory.

of the tribunes, the two-storey elevation, and the indirect lighting—to dispense us from the necessity of further discussion, except to notice a uniformity of style which, as far as this province is concerned, sufficiently justifies the use of the idea and term 'school'. It preserves archaic features in its unribbed barrel vaults and flat piers. It had been one of the centres of Celtic resistance, one of the regions where Gallic traditions had survived, mingled with elements of the culture of the invaders; but later its senatorial families had given men of merit to Church and State, it had become Romanized, and the memory of this phase was present in its iconography in figures such as the personifications of the vine-harvest or the sacrificing priest long after the fall of the Empire. In the middle of the tenth century Étienne II had chosen the scheme of ambulatory and radiating chapels for his cathedral, and had commissioned a golden reliquary Virgin, which doubtless served as the model for the many wooden Virgins of the same type, which we shall see again, translated into stone, in the tympana of a group of North French churches of the second half of the twelfth century. The great basilica of Conques, in Rouergue, its austere masses piled one upon another amid a desert calcined by the sun, with its pediment-shaped lintels, the marvels of its treasury, and its barbaric idol of St. Foy, illustrates the close connections which exist between the pilgrimage churches and the architecture of Auvergne. Superimposed on the more general characteristics of the monumental idiom of this architecture are peculiarities which give it some original inflexions; for example, the sombre tints of the volcanic rocks, Volvic stone, and arkose sandstone, which make the churches seem outcrops from the underlying strata. The diversity of these materials was often utilized by the architects for polychrome effects, as in the apse of Notre-Dame-du-Port at Clermont and in the cloister of the cathedral of Le Puy. The pediment-shaped lintel, the so-called Auvergne lintel, provides in its figure carving an elementary example of the architectural conformity of Romanesque sculpture. The Auvergne churches—Saint-Saturnin, Saint-Nectaire, Orcival, Saint-Julien at Brioude—are impressed with a powerful uniformity of style, and as with all homogeneous groups, the influence of this style is apparent in the neighbouring districts, in Berry, and in the Rhône valley, where it clashed with survivals from first Romanesque art and where it coalesced with Burgundian influence in the church of Saint-Martin d'Ainay at Lyons[1].

On the borders of Auvergne, in Limousin and Velay, the same period saw the production of some curious forms of varying importance. The Limousin tower differs from the Auvergne lantern; supported by four stout columns in

*[1]See J. Vallery-Radot, *La limite méridionale de l'école romane de Bourgogne*, Bulletin monumental 1936, pp. 273–316.

the lowest storey, it rises in diminishing stages, square below and octagonal above, with the transition between the two masked by gables of acutely pointed form. It is found in Limousin, at Saint-Léonard and Uzerche, in Périgord at Bergerac, in Provence at Valence and in Velay at Le Puy. The prototype has been identified successively as the tower of Brantôme, those of the cathedral and Saint-Martial at Limoges, and that of Le Puy.[1] Certainly the name by which it is traditionally known indicates the area of its most frequent occurrence and not that of its origin. The architecture of Velay is of wider interest, not so much for its influence, which was very restricted, as for the relationships with distant centres which provide the only possible explanation of its distinctive characteristics. Its Islamic connections, which are readily seen in the silhouette and colouring of Notre-Dame at Le Puy, were first pointed out by M. Mâle.[2] The celebrity of this Christian pilgrimage in the Muhammadan lands provides a confirmation of the art-historical diagnosis. It may perhaps one day be possible to prove that the architect of Le Puy had seen in their native setting the models which must have inspired him. The polychromy of the masonry would not in itself attract attention, for the Auvergne architects had a predilection for polychrome stonework (though it nowhere comes closer than this to Islamic prototypes). But the multifoil arch, which may be found everywhere, here retains its purest form—not the shape remaining after a foliate composition has been cut out from it, but a true compass-drawn half-circle. Again, the Kufic inscriptions which adorn the portals seem at first sight to belong to the common fund of those widely diffused Oriental borrowings which may be found throughout the Middle Ages, but the beauty and regularity of their style betrays the direct copy, adding a kind of guarantee of provenance to the other evident proofs of Islamic influence. Moreover, the decoration of Le Puy offers extensive and exact analogies with the Islamic decorative system. It is, however, in the structure that these connections are most apparent. The domes of Le Puy are unlike both the pendentive domes of Aquitaine, to which they are quite unrelated, and the domes which cover so many crossings. Instead of pendentives, they have squinches consisting of niches with semidome vaults; these are of skilful workmanship, but decorative rather than functional, after the fashion of a type which is common in southern Spain and in regions still further afield. In the heart of Western Europe, on a fantastic

[1]See R. Fage, *Le clocher limousin à l'époque romane*, Bulletin monumental, 1907; J. Vallery-Radot, *Églises romanes*, p. 143.

[2]E. Mâle, *Les influences arabes dans l'art roman*, Revue des Deux Mondes, 1923; *La mosquée de Cordoue et les églises d'Auvergne et du Velay*, Revue de l'art ancien et moderne, 1911, and *Art et artistes du moyen âge*, p. 81. A book by A. Fikry, *L'art roman du Puy et les influences islamiques*, Paris, 1934, contributes many new observations.

rock-strewn site, Notre-Dame at Le Puy and the oratory, different in programme and much more modest in scale, of Saint-Michel d'Aiguilhe, perched with its polychrome bands and multifoil arches on the summit of the rock-pinnacle to which it owes its name, represent an incrustation of Islamic techniques and patterns on a Romanesque scheme. It is a unique phenomenon, and rendered all the more striking by the geological circumstance which has surrounded it with a landscape of legend.

South-east of these mountains, beyond the horizon of the Cévennes, Provence formed one of the most homogeneous regions of twelfth century Romanesque art[1]. By way of the Rhône, and the traffic between Syria and the port of Arles, from which the ships of ancient trading-companies sailed to Beirut, it lay open to the east, to the new faith, to the Christianity of Asia, including its Gnostic forms, and to the Christianity of Egypt as propagated by the saintly and ascetic founders of the first monasteries. Having been the earliest Roman possession in Gaul, the Provincia *par excellence*, and preserving on its soil so many monuments of Roman antiquity, it retained an essentially Latin tone, tinged with Hellenistic elegance. This tradition persisted among the tomb sculptors of the early Middle Ages. But the tomb of Izarn, abbot of Saint-Victor at Marseilles, with the face exposed and carved with wild and rugged grandeur, while all the rest of the body except the feet remains hidden by the stone, betrays a harsher spirit, and perhaps some influence from Coptic models. In the eleventh century, on both sides of the Rhône and up the lateral valleys to the regions of the Drôme and the Ardèche, Provence had cultivated the architecture of arcades and bands; its taste for these features persisted, and was confirmed and fortified by its relations with the art of Lombardy, which are equally apparent in iconography. But twelfth-century architecture used these within a framework which was specifically Provençal, especially in the composition of masses and the system of equilibration—lofty naves buttressed by high aisles and directly but feebly lit by windows which are sometimes pierced through the lower part of the barrel vaulting (Vaison), while the tile roofs are laid in Roman fashion on the extrados of the vaults. Imitation of antique models is apparent in the mouldings, and the cornice of a triumphal arch or a nymphaeum may be found reproduced almost to the last detail on a church wall; the same imitation is equally plain in those fine compositions of columns which, at Saint-Trophime at Arles and Saint-Gilles du Gard, form statue-decked porticos resting on bases of vigorous projection. Some of the smaller buildings have the rectangular compactness of an antique cella. Among these is the lonely golden church of Saint Gabriel,

*[1] J. Vallery-Radot, *Le domaine de l'école romane de Provence*, Bulletin monumental, 1945, pp. 5–63.

with its delightfully chaste portal, and its pediment carried on shallow pilasters,
which stands between a pair of cypresses, amid a grove of vines and olives,
raised on a podium of reddish stone. This reawakening of classical forms several
centuries before the Italian Renaissance is but one of several modes adopted
by Romanesque art in the area of the western Mediterranean.

The Midi of Languedoc was not the Midi of Provence. Here was the junction
of the routes of St. James, which came down from northern and central France
and continued by way of the passes and depressions of the Pyrenees. From the
Loire, through western Gaul, from Saint-Martin at Tours to Compostela, these
several axes of spiritual life are signposted with lofty churches. By them
Languedoc was drawn forcibly into the multiplicity of Western life. By them the
programme and type of the pilgrimage church was propagated in both directions.
By them Aquitaine was linked with Spain; the mountains were no barrier, for
though the high crests lie between, cols and valleys connect the contrary slopes.
In studying first Romanesque art we observed how Catalonia, as far as the region
of the Hérault, formed a single stylistic province. Similarly, at the end of the
eleventh century, the impact of Cluny was felt on both sides of the Pyrenees
and as far off as Galicia. The little Asturian churches with their fluted pilaster
buttresses, the younger sisters of Germigny-les-Prés, the foundations of the
kings of Oviedo, were succeeded by great abbeys and basilicas dominated by
Compostela, the goal of the pilgrims. Programme, plan, composition and
decoration (though this last will require to be estimated and interpreted with
special care) show how close were the connections between Santiago and Saint-
Sernin. The characteristics of the latter have already been indicated, but it must
be imagined beneath its native sky, with the pinkish tone of its bricks, spreading
wide its many chapels, above which soars the great lantern-tower with its clean-
cut angles and its many stages, the prototype of numerous towers in the comté of
Toulouse. But the greatness of the genius of Languedoc is seen more clearly
in its sculpture than in its architecture, which owed so much to Auvergne, to
Provence and to first Romanesque art.

Though near neighbours of Languedoc or connected with it by the roads,
Périgord, Gascony, and farther north, Saintonge and Poitou practised an entirely
different architecture. From Cahors to Angoulême the domed churches of
Aquitaine superimpose Oriental silhouettes on Gallic horizons. Beneath the great
stone caps and between walls adorned with blind arcades, the interior volumes
are handled with remarkable power and sobriety. The conception of the dome
over the crossing was here extended to cover the whole church, as at Le Puy,
though marked differences of structure make it impossible to include the latter

within this group. Nor are the domes of Aquitaine Byzantine; they are of stone, not brick, and the masonry of their pendentives is in *tas de charge*. In a region where the single-nave church is very common[1] this type of vaulting, already widely used in other circumstances—over crossings and in centrally planned buildings—was the only one which permitted the covering of large superficial areas. Geology,[2] moreover, explains the distribution of the churches along a zone of surface rocks exactly conterminous with the area in which they occur; but it does not explain their origin. Is it permissible to include in their genealogy, in addition to an unknown Oriental model, a local popular architecture of round huts covered with rude domes, such as those observed by Bertaux in southern Italy? This may well be relevant. It suggests—in so far as it is possible to assign a date to these little buildings—an ancient structural practice. But the domes of the rustic churches which are typologically intermediate between these and the monumental domes are probably in fact copies of the latter. Three buildings have been put forward in turn as the prototype of these great domed churches— Saint-Front at Périgueux[3], copied like St. Mark's at Venice, from the church of the Holy Apostles at Constantinople, the cathedral of Cahors[4] and, again at Périgueux, the church of Saint-Étienne-en-La-Cité.[5] Saint-Front is so restored as to be hardly accessible to analysis; moreover, it is almost certain that it was built after the fire of 1120. The cathedral of Cahors was consecrated in 1119, but it is uncertain whether this consecration applied to the whole church or to the sanctuary only. In any case, Cahors founded an important family of domed churches possessing radiating chapels but no ambulatory—Souillac, Solignac, Saint-Pierre at Angoulême and Saint-Caprais at Agen. As for Saint-Étienne at Périgueux (or at least its oldest dome), it was the model for Saint Avit-Sénieur, a church built prior to 1117. It would seem therefore to be the progenitor of this whole line, which includes also Cognac and, at Fontevrault, the old foundation of Robert d'Arbrissel which became the funerary church of the Plantagenets, a magnificent nave of four domes.

In the churches of Poitou and Saintonge, of a type which is found also in Gascony, along the Gironde, we return to the normal characteristics of Romanesque vaulting. We have already examined the novel system of equilibrium used in Poitou, in which the stability of the nave is guaranteed by high aisles,

67

68

[1]E. Lefèvre-Pontalis, *L'école du Périgord n'existe pas*, Bulletin monumental, 1923.
[2]P. Vidal de la Blache, *Principes de géographie humaine*, p. 163.
[3]F. de Verneilh, *L'architecture byzantine en France*, Paris, 1851, and *Les influences byzantine, lettre à M. Viter*, Paris, 1855. Cf. M. Aubert, *Notice sur Saint-Front*, Congrès archéologique de Périgueux, 1927.
[4]R. Rey, *La cathédrale de Cahors et les origines de l'architecture à coupoles d'Aquitaine*, Paris, 1929.
[5]Marquis de Fayolle, *Notice sur Saint-Étienne*, Congrès archéologique de Périgueux, 1927, and J. Vallery-Radot, *Églises romanes*, p. 123.

and we have noted the quatrefoil form of the pier and the compositions of large and small arcades on the façades, which are flanked by column-clusters carrying lanterns with imbricated spires.[1] The chapels of the east end are crowned with steep masses of masonry, and they are often pierced with openings at ground-level. But these generalities and details give no idea of the power, colour and variety of this architecture, which sprang up in an area where the existence of abundant Gallo-Roman remains—the vanished greatness of Saintes has left some relics of them—must, as in Auvergne, be taken into account; these may have inspired the fine columns of the façades, which retain antique proportions and entasis.

A town such as Poitiers, with buildings ranging in time from its Baptistery to Saint-Hilaire, epitomizes the whole history of the earlier Middle Ages, through Merovingian times, when it gave shelter to Radegonde and Fortunatus, down to the late eleventh century, which has left many traces of its activity.[2] Romanesque architecture scattered masterpieces over the whole area; besides the admirable churches of Poitiers we may mention Airvault, Chauvigny, Parthenay, Saint-Jouin, and Saint-Savin, with its longitudinal barrel vault adorned with a painted epic. The Charentes and Vendée colour both sculpture and the composition of masses with their own peculiar spirit: Sainte-Marie-des-Dames and Saint-Eutrope at Saintes, Aulnay, Châteauneuf, Pérignac, Pont-l'Abbé, Corme-Royal, Foussais and many other churches display the skill and increasing luxuriance of the sculptural decoration, in which an admixture of Arab elements (a reflection of the part played by the counts of Poitiers in the Spanish crusade) is found in association with an architectonic law which produces some remarkable effects, especially in the treatment of archivolts[3]. The art of south-western France, like that of Auvergne, extended beyond its regional boundaries; one finds it for instance in complete and intact form as far away as Berry.[4] Purely geometrical motifs, such as the zigzag, are found in the decorative

[1] In addition to Notre-Dame-la-Grande, 'the conical imbricated spires are found at Montierneuf, at Saint-Nicolas at Civray, and on the stair-turrets of Saint-Pierre at Chauvigny, and Notre-Dame at Lusignan.' A. de la Bouralière, *Guide archéologique* of the Poitiers congress of 1903, p. 27. They are also common in Angoumois and Périgord.

[2] At Poitiers, as in many other areas, the main period of building fell in the late eleventh century. Saint-Jean at Montierneuf was consecrated in 1096 by Urban II, and Sainte-Radegonde in 1099; Saint Hilaire-le-Grand was rebuilt at the same period.

[3] See C. Daras, *L'orientalisme dans l'art roman en Angoumois*, Bulletin et Mémoires de la Société archéologique et historique de la Charente, 1937; P. Héliot, *Les portails polylobés de l'Aquitaine et des régions limitrophes*, Bulletin monumental, 1946.

[4] In south-western Berry, often even in single-nave churches, the façades have three openings in the ground-storey, of which two are false doors—a typical arrangement in Poitou and Saintonge. It occurs, for instance, at Saint-Genès in Châteaumeillant, La Berthenoux, Fontgombaud, and Selles-sur-Cher. There are also examples of façade buttresses with the lower section in the form of a half-column (Chouday, Fontgombaud, Paulnay). See R. Crozet, *L'art roman en Berry*, p. 148. C. Enlart, *Manuel*, I, 3rd ed., 1927, p. 227, gives other instances of Poitevin influence. To these may be added the façade of Sanguesa, in Spain.

vocabulary of this area and also in that of the north French groups, especially Normandy and the Ile-de-France. They belong to the common fund of all these regions, but while they are preponderant and, as it were, in their pure state, in the two last-named, Poitou and Saintonge utilized them also for curious figure-compositions. Perhaps no style has more audaciously moulded the human figure into conformity with an architectural setting, yet at the same time no twelfth-century style was more respectful of its harmony and proportions under certain conditions, as when statues were set directly against a wall. This region, too, offers the most complete series of examples of the way in which Romanesque sculpture became thoroughly Baroque, forgetting its structural functions and tending towards luxuriant and picturesque effects.

IV

THESE were the main centres. But the domain of Romanesque thought extended farther, both in the north and in the Mediterranean basin. In France, the regions which lie north of the Loire, and those to the east, were Romanesque by virtue of their conception of masses and effects rather than by the system of covering; some areas long remained faithful to the wooden roof, though in Normandy this was replaced at an early date by the ribbed vault. It would be only seemingly paradoxical to say that the Romanesque architecture of these regions was characterized by the use of this new element, for at first it respected the general economy of the building, which a little later it was to transform from top to bottom. It must not be forgotten that the initial application and development of the ribbed vault took place between 1093 (Durham) and 1144 (consecration of the choir of Saint-Denis), that is, in the golden age of Romanesque art, to which, in many respects, the great cathedrals of the second half of the twelfth century also belong. The Norman school took an active part in the development of the ribbed vault from the first, but it was the architects of the Domaine Royal who made it the basis of a style. Thus the passage of time does not in itself explain the evolution of forms. The eleventh century displayed almost simultaneously the principles of all the resources upon which the Middle Ages lived. But the subsequent development of these resources was very irregular.

We have seen how Normandy very early established a great architectural style, and of this the main features persisted, though with modifications and additions. The homeland of timber construction was not ignorant of the art

of stone-vaulting, at least for certain parts of its churches. The choir of Saint-Étienne at Caen may have possessed groined vaults, as did those of La Trinité and Saint-Nicolas. But the new technique of the ribbed vault soon replaced earlier systems by the six-branched armature used in the nave of Saint-Étienne, or, as in that of La Trinité, by the so-called 'false sexpartite' vault, which is in fact quadripartite, but possesses a supplementary transverse arch carrying a diaphragm wall. In the first third of the twelfth century the use of the ribbed vault became widespread in Normandy,[1] stimulated no doubt by the conquest of England, where it was used not only at Durham, but also in the transept of Winchester (1110) and the aisles of the choir at Peterborough (about 1120). The *23* treatment of the upper walls was enriched by an ingenious and pleasing composition in which the supplementary transverse arch is flanked by two pairs of unequal openings forming an airy portico in front of the circulation gallery, which is situated above the tribune and on the same level as the clerestory. At the same time the scalloped capital made its appearance and the style of the geometric decoration grew more severe.

The geographical extent of the Norman school was immense. It included the Ile-de-France and it penetrated into Champagne[2]. It occupied England at the time of the conquest[3] and built great churches there, with tribunes and alternating supports, dominated by a gigantic tower over the crossing, and with a pair of western towers flanking a harmonic façade of considerable breadth; Lincoln is exceptional in having a façade hollowed out in niches and arcades and set against the church like an enormous screen[4]. It introduced the plan of oriented apses at Westminster, Lincoln and Durham, and at the same time that of the ambulatory with radiating chapels at Winchester (1079), Worcester (1084) and Norwich (1096). The geometric decoration of chevron and zigzag overran even the shafts of the *27-30* massive columns. It is hard to decide whether Saxon art was able to infiltrate

[1]Chapter house of the abbey of Jumièges (between 1101 and 1109), tower of Duclair, Rouen Saint-Paul, possibly the covered-walk of the monks at Mont-Saint-Michel (between 1106 and 1136?), Montivilliers, Lessay, etc., see E. Lambert, *Caen roman et gothique*, Caen, 1936, pp. 34-5.

[*2]See M. Anfray, *L'architecture normande, son influence dans le nord de la France aux XIe et XIIe siècles*, Paris, 1939, who rather overstates the case for Normandy and does not seem to entertain the possibility of parallel developments out of a common source.

[*3]On English architecture, the two essential works are A. W. Clapham, *English Romanesque Architecture after the Conquest*, Oxford, 1934, and T. S. R. Boase, *English Art 1100–1216* (Vol. III of The Oxford History of English Art), Oxford, 1953. See also J. Bony, *La technique normande du mur épais à l'époque romane*, Bulletin monumental, 1939, who gives a somewhat different accent to a problem already studied by E. Gall, *Niederrheinische und normannische Architektur im Zeitalter der Frühgotik*, Part I (*Die niederrheinischen Apsidengliederungen nach normannischen Vorbilde*), Berlin, 1915.

[*4]On the west front of Lincoln cathedral, F. Saxl, *Lincoln Cathedral: The Eleventh-Century Design for the West Front*, Archaeological Journal, 1946, pp. 105–118.

anything of its own resources into this hard compact style which was so trium-
phantly carried forward by the successful politics of the Norman kings. The
Saxons were not unacquainted with vast programmes, nor even with Romanesque
planning, as is shown by the plan of the old abbey of Westminster; the powerful
plainness, thick supports and massive towers of the architecture of the reign
of Edward the Confessor were elements of style which might have endured;
the technique of great timber constructions has left a solitary testimony in the
wall-ornament at Earl's Barton[1]. But the churches which rose on conquered soil
and, with the aid of the ribbed vault, advanced towards the Gothic system with
unusual speed, consigned these traces of an older culture to unmerited oblivion.
The new architecture passed on into Ireland where it is found alongside or in
combination with the traditional forms of the old Celtic Christian community,
such as the stone vault shaped like an inverted boat. Composite monuments, on
which each generation seems to have left its mark, with some memento of its
travels, are found next to the high crosses with their scenes carved in relief,
and the ancient towers, very tall and slender, which stand like petrified trees
in the solitary landscapes. In Scandinavia also, Bergen, Stavanger and the
transept of Trondheim (1161) are Anglo-Norman[2], while wooden churches such
73 as Borgund and Fantoft recall, especially in their Norse decoration, an older
technique.[3] In Sweden, on the other hand, the cathedral of Lund (1145) derives
its style from Germany.

 The links between England and Normandy on the one hand, and the county
of Flanders and neighbouring territories on the other, do not in themselves
suffice to explain all the aspects of the architectural style which was evolved
in the latter area during the eleventh and twelfth centuries. The great northern

[1]See the series of very important articles by E. D. C. Jackson and E. G. M. Fletcher, *Long and
Short Quoins and Pilaster-Strips in Saxon Churches*, Journal of the British Archaeological Association,
1944; *Further Notes on Long and Short Quoins in Saxon Churches*, ibid., 1949; *Constructional
Characteristics in Anglo-Saxon Churches*, ibid., 1951.

[2]Recently studied by G. Fischer, *Nidaros Cathedral in Trondheim*, The Norseman, 1953.

[3]Denmark, converted to Christianity in the eleventh century, was divided between English and
German influence, a division which was from an early date reflected in a profound difference of
spirit, extending even to the choice of materials. The union of England and Denmark under Canute
was no doubt favourable to contacts with Anglo-Saxon art, which appear notably in little granite
churches, timber-roofed and with semidomes over the apses. Later one finds the Norman scheme
of the façade flanked by a pair of towers (Tvege-Malrose) and a typically English style in a group of
tympana (Œrsted). But the Danish bishops were suffragans of the archbishopric of Bremen;
German influence resulted in a certain aridity of style and the use of foreign materials (importation
of Andernach tufa for Ribe cathedral, and later, of bricks). A rather important group of round
churches should be noted, some with a single central pier (Bornholm), some with four (Bjernede,
Thorsager). See B. Fay, *L'art roman en Danemark*, Gazette des Beaux-Arts, 1936. *On Danish
churches the exhaustive survey *Danmarks Kirker*, Copenhagen, 1933 *et seq.*, published by The
Danish National Museum, is in course of publication. Summaries in English are also issued under
the title *Danish Churches*, Copenhagen, 1940 *et seq.*

zone extending from the valley of the lower Seine to the lands of the Meuse and
the Rhine had its own historical pattern, shaped by the vigour of its commercial
and industrial enterprises, and maintained and enriched by prosperous towns
trading with distant places, and by old and powerful abbeys. It had its own
materials—the yellowish sandstone of Saint-Vincent at Soignies and Braine-le-
Comte, and the blue stone of Tournai. Like the art of the Mosan goldsmiths and
of the font sculptors, its architecture, situated between the examples of Normandy
and the traditions of the Empire, retained strongly marked inflexions of its own.
It possessed important foundations at an early date, as is proved by the oldest
parts of Soignies, where the rectangular choir and the transept with its square
chapels may go back to the early eleventh century. The nave was completed
about the middle of the twelfth century. By its stout arcades opening into
groin-vaulted aisles and its tribune arches resting on rectangular piers with
imposts, it recalls northern types like Gernrode and Vignory; by its alternation
of columns and composite piers, it connects with Jumièges.[1] About the same
time, there was rising at Tournai a great church combining Norman, Rhenish *74*
and Gothic features, which was destined to exercise a much wider influence,
extending to a whole group of French churches, by virtue of its transept plan
and the disposition of its towers. Considered by themselves, the rounded transept
arms with their vigorous wall shafts might be dated to the early twelfth century.
The timber-roofed nave was unfinished in 1140; the four-storey elevation, a
theme enunciated in England at Tewkesbury,[2] has each storey slightly recessed
from the one below so that the walls diverge slightly as they rise. The disposition
and scale of the towers is equally noteworthy. At the crossing, a gigantic square
tower with an octagonal spire seems, not to soar into the air, but to weigh
monstrously on the unyielding church. A pair of towers, overtopping the central
one, rise at each extremity of the transept. Each component is a self-sufficient
architectural composition, each transept a great choir clasped between its pair
of towers. But the inter-relationship of the whole is still more striking. The four
subsidiary towers, which are of considerable height and breadth, seem to hem in

[1]See Chanoine R. Maere, *Les églises de Chaussée-Notre-Dame, de Horrues et de Saint-Vincent à
Soignies*, Mons and Frameries, 1930. The tribunes which were also present in the transept of
Floreffe Abbey, at Saint-Nicolas in Ghent, and in other churches now destroyed, such as Saint-
Donatien at Bruges, recur only in the choir of Saint-Léonard de Léau and at Tournai, Canon Maere
adopts the hypothesis of G. Lanfry, *Fouilles et découvertes à Jumièges*, Bulletin monumental, 1928:
it is not impossible that the piers of Jumièges may have supported groined vaults. So also at
Soignies. *Add R. Maere and L. Delferrière, *La collégiale Saint-Vincent à Soignies*, Revue belge
d'archéologie et d'histoire de l'art, 1938. On the Romanesque churches of Belgium, S. Brigode,
Les églises romanes de Belgique, Brussels, 1943, is a convenient summary.
[2]J. Bony, *Tewkesbury et Pershore, deux élévations à quatre étages de la fin du XIe siècle*, Bulletin
monumental, 1937.

the great bulk of the lantern tower, across which runs all day long one or other of their colossal shadows. The scheme at Cluny was perhaps analogous, though with a different arrangement. The verticality of the Gothic cathedrals, when inspired, like Laon and Chartres, by Tournai, entailed sharper, slimmer forms. And the enormous compositions of the Rhineland failed to attain the force of this design.

In the latter area architecture was equally homogeneous in both space and time. There was no discontinuity between the Carolingian, the Ottonian, and the Romanesque styles in Germany. The examination of plan and mass shows the persistence of Carolingian solutions, especially in the disposition of towers and the double apses, at St. Emmeran and the cathedral of Regensburg, at Augsburg,
75 at Bamberg, and especially in the Rhineland, at Speyer, Mainz, Worms and Trier. Nor must it be forgotten that important structural researches had been initiated, though not consistently pursued, in the Rhineland, among them the groined vaults thrown across the vast span of Speyer by the architect of Henry IV
77 (1082–1106), those of Mainz (before 1137), and those of Maria-Laach over oblong bays. But the true greatness of German art lay in the beauty of its volumes and the amplitude of its programmes, and not in its structural solutions. The arcaded
78, 79 galleries and doubtless the cushion capitals also (likewise the trefoil plan of St.
76 Maria im Kapitol at Cologne, which was followed at St. Aposteln and Gross St. Martin in the same town, and at St. Quirin in Neuss) were borrowed from Lombardy. In Alsace, the church of Murbach (1155–75) which is related to Romainmôtier, Rosheim and Lautenbach, retained the square east end of Hirsau, the Cluniac arrangement of towers over the transept arms, and, most significant, the two storeys of windows which we noted at Limburg. Its choir inspired the slightly later choir of Worms cathedral.[1] Here, on the threshold of the Gothic period, we find early Western formulae still surviving in planning, window arrangement, and especially in the ordering of the masses.

Cushion capitals are found, not only in the heart of Germany, but also in the other regions of central Europe, and even in Normandy. An inverted hemisphere[2] cut down to a square section lacks the organic quality of the capitals descended from the Corinthian type, in which the various parts—collarets of acanthus, angle-volutes, and central medallions—boldly declare their structural functions

[1]See E. Fels, *L'église abbatiale de Murbach*, Archives alsaciennes, 1929.
[2]On the various types of cushion capitals, see C. Enlart, *Manuel*, I, p. 394; E. Durand, *Églises des Vosges*, p. 33; R. de Lasteyrie, *Architecture religieuse en France à l'époque romane*, p. 611, with the following excellent theoretical definition: a spherical mass intersected by two horizontal planes, at the levels of astragal and abacus, and four vertical planes corresponding with the edges of the abacus. Four, or even as many as a dozen, small cushion capitals are sometimes found grouped round the top of a pier, as in Alsace, at Rosheim and Marmoutier. Cf. the piers of the choir aisles at Durham.

and control the distribution of ornament. It is hardly possible nowadays to maintain that the form of the cushion capital was hewn out of a billet of timber by the creative spirit of the carpenters of the North, but it is true that it is responsible for a good part of the power, the aridity and the monotony of German architecture, and that it does not belong to the same class of forms as those to which the spirit of Western Europe preferred to devote its energies. In Germany, as in Italy, the evolution of Romanesque architecture was extremely slow. The Gothic style invariably appeared late and as an importation from without.

This, then, is the geographical framework within which the buildings stand. In Burgundy and south of the Loire, France was producing varied interpretations of Romanesque architectural forms, of which some were new, others inventions of the eleventh century, but all now quite distinct from first Romanesque and imperial art. In the north, in the Anglo-Norman area, the ribbed vault was rapidly coming into currency over naves of the Jumièges or Caen types, while Germany provided a grandiose continuation of an art with small capacity for self-renewal, which long resisted the entry of the ribbed vault. What, meantime, was taking place in the Mediterranean countries ? The West was already indebted to them for much experience. They had transmitted Oriental influences, which they had been the first to receive. Spain had produced Asturian art, Mozarabic art, and the Catalan forms of first Romanesque art. Lombardy had been a pioneer in the treatment of the arcade-and-band system, and though it long remained attached to the wooden roof, it can also show very early ribbed vaults. Southern Italy had been no less active. Under the rule of Desiderius, Monte Cassino had been one of the focal points of Christianity in the eleventh century.[1] Of the vanished church there we know no more than is contained in the description of Leo of Ostia and the drawings of San Gallo, but that is sufficient to make us ask whether it may not have exercised some influence on St. Hugh's Cluny. What did these ancient and prolific countries bring forth in the twelfth century ? Spain, a half-Arab land, and Italy, clasped between Byzantine Venice and the astonishing Sicilian empire—were they capable of new developments ? In what directions ? And to what extent do they belong to the story of the West ? Their

[1]See H. M. Willard, *A Project for the Graphic Reconstruction of the Romanesque Abbey at Monte Cassino*, Speculum, 1936. Conant considers the church of Desiderius to have been a direct or indirect source of Cluny III. The plan comprised a nave with two aisles, a projecting transept, and three parallel eastern chapels. To the west lay an atrium whose western façade formed a portico flanked by two towers, of which one was dedicated to St. Peter and the other to St. Michael. To the south was a large cloister, having the chapter lodgings on the east, the refectory on the west, and the dorter on the southern side. Cf. Leo of Ostia, *Chronica monasterii Cassinensis*, in *Monumenta Germaniae historica*, *SS*, VII, p. 716; J. von Schlosser, *Die abendländische Klosteranlage des frühen Mittelalters*, Vienna, 1889, pp. 67–75; A. Jahn-Rusconi, *Monte Cassino*, Bergamo, 1929.

historical positions were dissimilar, for Spain was crusading territory, like the Latin East, whereas the historical and cultural situation in Italy was entirely different.

A prime factor was the weight of great traditions. The memory of classical architecture was never quite lost. To say that Tuscany retained the basilican plan is to understate the case. In fact its delicate linear genius was completely satisfied by those very old and simple volumes which trace their descent from the Early Christian box-basilica. Beyond the Alps, the synthesis of parts was a long-established fact; baptismal chapel and bell-tower were incorporated in the main block, and central and basilican plan had combined to produce apses with radiating chapels and the lovely compositions of the terraced east ends. Tuscany retained the isolated campanile and baptistery, and the ambulatory with radiating chapels is of the rarest occurrence in Italy. These masters were concerned with the interpretation of surface rather than of mass. They panelled the walls and veneered the façades with coloured stones—as at S. Miniato al Monte, and the Badia at Fiesole—a practice foreign to the architecture of the West, which invariably proclaimed the dignity of the masonry itself. The forms of the temple lived on in the church. A mid-twelfth-century church in Rome, Santa Maria in Trastevere (1140–48), has columns with Ionic capitals supporting an architrave, with a panelled ceiling above and a pavement of polychrome marble below. Even in a rib-vaulted nave such as that of Sant' Ambrogio at Milan, with its tribunes and its alternating piers, the interpretation of space and the treatment of the masses are Early Christian rather than Romanesque.[1] Romanesque forms still clashed with the old Lombard style, and first Romanesque art continued to produce work of the highest quality, not only in the north, in the Como district, but also in the heart of Roman territory. So at Tivoli, above the bronze-green leafage of the gardens of the Villa d'Este, there rises like a rose-tinted tower the half-cylinder of a brick apse, delicately inscribed with the pattern of wall-arcades and shallow pilasters. To the south and east, Romanesque art was opposed by the splendid tradition of the second golden age of Byzantine art. The Norman princes of Sicily, who, in fighting against the Byzantine Emperors, came face to face with their own compatriots enrolled in the Varangian guard, lived in

82, 84

83

[1] The minor supports consist of columns surmounted by colonnettes—a system of Syrian origin, found also in the nave of Tournus. The foundation of the monastery goes back to 789. The apse and apsidal chapels are said to have been built under Abbot Anspert, in 859, while the choir is of the eleventh century. Porter and Toesca assign the nave, including the ribbed vaults, to the close of the same century: the bodies of SS. Gervais and Protais are said to have been discovered in 1098, on the occasion of the reconstruction. This chronology is contested by Biscaro, Lasteyrie and Frankl, who consider that all the major rebuildings of Italian churches are later than the earthquake of 1117. According to Rivoira and Cattaneo, the nave of S. Ambrogio is of the early twelfth century.

palaces and churches in which the fascinations of the art of Islam and the art of Constantinople were commingled. But northern and central Italy were traversed by the roads of St. Michael, as France was by those of St. James, and these formed an iconographic axis along which an illustrated version of the deeds of Arthur and his knights travelled as far as Modena. In the Susa valley, San Michele of Clusa still possesses a monumental stairway such as once gave access to the choir of the cathedral of Le Puy. The few ambulatories with radiating chapels— Sant Antimo in Tuscany, Venosa in Basilicate—lie on the pilgrim roads. But despite such intrusions, architecture remained loyal to the older schemes and handled them in novel and impressive ways, as, for instance, in the development of the wall-arcades so as to envelop the masses of the building in a mesh of arches and colonnettes and to conceal the poverty of the gables behind their airy screen. This was a characteristic feature of Pisan art, whose influence was very extensive. It can be traced at Benevento and Siponto (consecrated 1117) in the heart of Byzantine territory, while San Nicola at Bari[1] (1089–after 1132) in this respect, *85* as also in its interior elevation, recalls the cathedral of Modena (begun 1099).

This profound diversity, which succeeded the uniformity of the old Lombard style, was doubtless the reflection of different intellectual patterns, whereas the Romanesque schools of France, for all their strongly marked individuality, were varieties of a single system of thought. Its clearly defined types became widely diffused; and its distinctive shapes and forms contributed to the organization of conquered territories. This was true of Romanesque Spain, the crusaders' country. It was perhaps this continuous historical function of crusading (which, after the fall of Granada, was to transfer itself to the new world) that developed the national genius of Spain. In this respect, its situation was totally unlike that of Italy, which was absorbed in the struggle of two universal polities, the Papacy

[1]The importance of S. Nicola at Bari was appreciated by Porter, but it should not be considered the source of an international type. The relics of St. Nicholas were found in 1087. The concourse of pilgrims necessitated the construction of a large church, and building operations were in progress by 1089. A consecration took place in 1105, but the church was still unfinished in 1132; already in 1098, however, it was possible for a council to meet 'in ecclesia'. The plan comprises a wood-roofed nave with groin-vaulted aisles, and a transept into which open an apse and two apsidal chapels of slight projection, which were subsequently masked by a straight wall. The elevation is of three storeys—a main arcade of columns and pointed arches, tribunes with triplets of arches beneath a relieving arch, and a clerestory of small windows with long intervals between. The galleried elevation of the nave bears only a remote relationship to the system of Saint-Étienne at Nevers. There are no supporting members other than the columns of the main arcade, above which a bare expanse of wall extends between the tribune-openings and up to the roof; compared with the French churches, whose supports rise from the pavements to the summit of the wall, this system seems inorganic. The broad low western façade is not of the harmonic type, although it is framed between two towers; only the southern tower is in the same plane as the wall, while the older northern tower projects considerably from it. On the building campaigns, see R. Krautheimer, *San Nicola in Bari und die apulische Architektur des 12. Jahrhunderts*, Wiener Jahrbuch für Kunstgeschichte, 1934.

and the Empire. It was in Spain, not in the Holy Land, that over the centuries the great retreat of Islam took place; but the influence of Islam continued to affect the culture and even the destiny of the race. We have seen already to what an extent it had penetrated the architecture of the little Christian mountain-kingdoms, which was so remarkable for the variety of its schemes and the science of its stone-vaulting. Except for Catalonia, Spain looked, not towards Italy, but first towards Andalusia, and then to France. Mozarabic art had constituted a barrier against first Romanesque art and Mediterranean influences. It was the earliest amalgam, the first harmonization, of Islamic and Western culture. Expanded to meet the requirements of more ambitious programmes, it would have been worthy and capable of survival, but it became submerged beneath elements imported from France. By settling Cluniac monks at San Juan de la Peña, Sancho the Great oriented the peninsula towards a new destiny. It became the largest and most active sphere of Cluniac operations.[1] The organization of the network of routes which led towards the old Galician pilgrimage centre was but one aspect of this activity, just as Compostela was but one aspect of Spanish Romanesque architecture. Early in the eleventh century, a Frenchman, Bishop Pons, rebuilt the church of Palencia, including a crypt in which Asturian elements are combined with a Romanesque apse. The cathedral of Jaca, founded in his capital by Ramiro, King of Aragon, shows traces of changes of design in the alternating piers and the masonry of the walls. The aisle vaults are groined; the form of the nave vault can no longer be determined; the dome over the crossing has ribs of Mozarabic type. Under construction in 1063, it was still unfinished in 1094. Jaca lies at the exit from the Somport pass. Likewise on the 'French Way' is San Martin at Fromista, a slightly later and stylistically more unified church; its three naves, almost equal in height, belong to the type of south-western France[2]. And at the end of the pilgrimage road, at the farthest

91, 92 point of distant Galicia, the architects of Santiago de Compostela (begun 1075 and finished for the most part by 1122) raised a church which, if not the daughter of its contemporary, Saint-Sernin, was certainly the direct descendant of the French pilgrimage churches, Sainte-Foy at Conques (begun under Odolric,

[1]A few facts and dates may serve to demonstrate this: in 1008 the Cluniac reform was introduced at Ripoll by Oliba; in 1025 at San Juan de la Peña by his disciple Paterno; in 1030 at San Millan de Suso in the upper Ebro valley; in 1032 and 1033 at Oña and Cardona in Castile. About the middle of the century Spanish monasteries began to attach themselves to the French daughter-houses of Cluny—in Catalonia, Camprodon was attached to Moissac and Ripoll to Saint-Victor at Marseilles. See P. Guinard, in *Histoire du moyen âge*, coll. G. Glotz, IV, Bk. II, 1937, *La péninsule ibérique*, p. 301.

*[2]See A. M. Whitehill, *Spanish Romanesque Architecture of the Eleventh Century*, London, 1941, and G. Gaillard, *Notes sur la date de quelques églises romanes espagnoles*, Bulletin monumental, 1945.

1030–65) and Saint-Martial at Limoges (consecrated 1095), whose features it exactly reproduces. San Isidoro at León is more complex. The existing church replaced an earlier building whose narthex had been intended from the first to serve as a mausoleum (about 1065); enlarged about the end of the eleventh century, this Pantheon of the Kings, with its sturdy piers, belongs to the well-known series of French porches, but the fine capitals which are its most original feature derive in part from Mozarabic types. The church which now adjoins this, and which supplanted the earlier structure, was consecrated in 1149; it was originally projected as a transeptless church with a wooden roof. These ancient and illustrious monuments bear witness to a stream of influence which had become irresistible and which, from the reign of Alfonso VI (1072–1109) onwards, overspread the whole of Christian Spain. About the same time the see of Compostela was re-established by Raymond of Burgundy, Count of Galicia. The Romanesque style of many Spanish monuments proclaims its origin clearly. We have already seen a Poitevin composition at Fromista; the façades of south-western France, with their multiple arcades, are not lacking; and the half-barrel vaults of Auvergne recur in the cathedral of Lugo. The creative originality of Spain was active in other spheres of architecture and in the establishment of new compromises with Islamic art. And it must be added that very often the treatment of Romanesque forms is coloured by local feeling; we shall see many examples of this in the sculpture. The specifically Hispanic tonality is still more apparent in the later architecture, as if the intrusive forms had been assimilated and subdued by the native genius.

At the other end of the Christian world a somewhat similar situation had arisen; the same factors were involved, but in a very different setting. The Latin kingdom of Jerusalem was a feudal monarchy of French type, transported lock, stock and barrel to the Near East. The builders of political systems, and the builders of castles and churches likewise, proceeded to colonize the area. They were not impervious to influences emanating from the vigorous local culture,[1] nor were they averse from the acquisition of hitherto unsuspected science[2]—for instance, in military architecture—but their principles and their prototypes they had

[1]Note, for instance the following passage by Foucher of Chartres, chaplain to Baldwin I: 'The Lord has transformed West into East; he who dwelt in Reims or Chartres is become a citizen of Tyre or Antioch. One man possesses here houses and servants, another is wedded with a woman of the country, a Syrian, or even a Saracen who has received the grace of baptism. . . . The most remote races grow together in mutual trust. . . . The pilgrim remains in the Holy Land and is become one of its people. Daily our kinsfolk come to join us. Those who were poor in their own country, here God has made them rich. Why should a man return to the West when he has found the East so propitious ?'
[2]See G. Rey, Étude sur les monuments de l'architecture militaire des Croisés en Syrie et dans l'Ile de Chypre, Paris, 1871; M. van Berchem and E. Fatio, Voyage en Syrie, 3 vols., Cairo, 1914–15; P. Deschamps, Les châteaux des Croisés en Terre Sainte. I. Le Crac des Chevaliers, Paris, 1934.

brought with them.[1] It is true that transepts are rare and invariably of slight projection, and that the commonest form of east end is that in which an apse is flanked by a pair of oriented apsidal chapels—in a word, it is true that programmes are simple. But the structure reproduces the Burgundian solutions; the Cluniac pointed barrel vault is found in Saint-Jean at Beirut, Notre-Dame in Tortosa and the cathedral of Djebel, and naves with groined vaults occur at Saint-Pierre in Gaza and Sainte-Anne and Sainte-Marie-Latine at Jerusalem. The transverse arches spring sometimes from columns corbelled out of the wall and sometimes from consoles, which again recalls Burgundian types. In one church one may find a Poitevin doorway, and in another a North French doorway of the second half of the twelfth century. In that very region which had been the point of departure of so many influences, by a strange turn of fortune, East and West found themselves once more face to face. Yet there was nothing here of the uniformity of an architecture mass-produced for export. Romanesque art, at the height of its powers, was well able to take on new inflexions and nuances. And on this ancient Syrian soil this was demonstrated, for instance, by the characteristic envelopment of the apses within square blocks of masonry, as at Saint-Jérémie, and Saint-Pierre in Jerusalem. The Romanesque art of the Holy Land behaved in the same way as the other French groups.

Thus the geography of the Romanesque art of the twelfth century comprises both sub-division and interpenetration. It combines the static strength of localities, as defined by their possession of special traditions, their own political and moral life, their own resources and materials, with the active force exercised by prototypes and influences. Transmission of style took place in several ways; by direct or indirect filiation, by local imitation creating homogeneous groups, and by propagation of a programme and a type along the great routes. In addition, currents of influence from other civilizations deposited exotic forms on the basic Romanesque material; these were adapted to a greater or less extent to their new environment, but they always remain distinct and recognizable, and never became a characteristic or fundamental element of the grand style of the Western builders. In the tenth century, Islam had set its mark on Mozarabic art and in the same area it was later to create Mudejar art; it left equally decisive traces in

[1]The Holy Sepulchre is a building of exceptional character. The ancient rotunda of Constantine had been rebuilt between 1010 and 1048 with chapels and tribunes. According to Enlart, the Crusaders constructed an apse, and opposite it a second apse having an ambulatory and three radiating chapels. Between the two they built a transept with a narthex. The church is groin-vaulted; the ambulatory has barrel vaults pierced by window-lunettes. See L. H. Vincent and F. M. Abel, *Jérusalem, recherches de topographie, d'archéologie et d'histoire*, Paris, 1914–26. C. Enlart, *Les monuments des Croisés dans le royaume de Jérusalem, architecture religieuse et civile*, Paris, 1925–28.
*See also W. Harvey, *Church of the Holy Sepulchre*, Jerusalem, 1935.

the churches of Velay, but its deeper influence did not extend beyond that point. Byzantium and Cyprus inspired the domes of Aquitaine. But Romanesque architecture, which in its origins was a combination of Oriental forms with Christian classical forms, was neither Oriental nor Roman, but the expression of a purely Western thought.

BIBLIOGRAPHY

J. Quicherat, *Mélanges d'archéologie et d'histoire*, Vol. II, Paris, 1886; R. de Lasteyrie, *L'architecture religieuse en France à l'époque romane*, 2nd edition, Paris, 1929; C. Martin, *L'art roman en France*, Paris, 1909; M. Aubert, *L'art français à l'époque romane*, 4 vols., Paris, 1930–1950; J. Vallery-Radot, *Églises romanes, filiations et échanges d'influences*, Paris, 1931; C. Oursel, *L'art roman de Bourgogne*, Dijon, 1928; L. Micheli, *Vézelay et Avallon*, Paris, 1932; H. Revoil, *L'architecture romane du Midi de la France*, 3 vols., Paris, 1873; H. Labande, *Études d'archéologie romane, Provence et Bas-Languedoc*, Paris, 1902; W. Rabaud, *Arles*, Paris, 1932; M. and C. Dickson, *Les églises romanes de l'ancien diocèse de Chalon (Cluny et sa région)*, Macon, 1935; A. de Rochemonteix, *Les églises romanes de la Haute-Auvergne*, Paris, 1902; N. Thiollier, *L'architecture religieuse a l'époque romane dans l'ancien diocèse du Puy*, Le Puy, 1902; A. Fikry, *L'art roman du Puy et les influences islamiques*, Paris, 1934; F. Deshoulières, *Les églises romanes du Berry*, Bulletin monumental, 1909 and 1922; R. Crozet, *L'art roman en Berry*, Paris, 1932; J.-A. Brutails, *Les vieilles églises de la Gironde*, Bordeaux, 1912; R. Rey, *La cathédrale de Cahors et les origines de l'architecture à coupoles d'Aquitaine*, Paris, 1925; C. Enlart, *Les églises à coupoles d'Aquitaine et de Chypre*, Gazette des Beaux-Arts, 1926; J. George and A. Guérin-Boutaud, *Les églises romanes de l'ancien diocèse d'Angoulême*, Paris, 1928; Abbé G. Plat, *La Touraine, berceau des églises romanes du Sud-Ouest*, Bulletin monumental, 1913; V. Ruprich-Robert, *L'architecture normande aux XIe et XIIe siècles*, 2 vols., Paris, 1884; G. Huard, *L'art en Normandie*, Paris, 1928; C. Enlart, *Monuments religieux de l'architecture romane et de transition dans la région picarde*, Paris, 1895; E. Lefèvre-Pontalis, *L'architecture religieuse dans l'ancien diocèse de Soissons au XIe et au XIIe siècle*, 2 vols., Paris, 1894–98; G. Durand, *Églises romanes des Vosges*, Paris, 1913; E. Bertaux, *L'art dans l'Italie méridionale*, Paris, 1904; A. K. Porter, *Lombard Architecture*, 3 vols., and plates, New Haven, 1918; C. Enlart, *L'art roman en Italie*, Paris, 1923; C. Ricci, *Romanische Baukunst in Italien*, Stuttgart, 1925; R. Menéndez Pidal, *La España del Cid*, 2 vols., Madrid, 1929; M. Gómez Moreno, *El arte romanico español*, Madrid, 1934 (Cf. G. Gaillard, *Les commencements de l'art roman en Espagne*, Bulletin hispanique, 1935); K. J. Conant, *The Early Architectural History of the Cathedral of Santiago de Compostela*, Cambridge, Harvard University Press, 1926; J. Puig i Cadafalch, A. de Falguera, J. Goday y Casals, *L'arquitectura romanica a Catalunya*, 3 vols., Barcelona, 1909–18; A. W. Clapham, *English Romanesque Architecture after the Conquest*, Oxford, 1934; P. Frankl, *Die frühmittelalterliche und romanische Baukunst*, Potsdam, 1926; L. Réau, *Cologne*, Paris, 1908; R. Kautzsch, *Die romanischen Dome am Rhein*, Leipzig, 1922; H. Weigert, *Die Kaiserdome am Mittelrhein*, Speyer, Mainz und Worms, 1933; Chanoine J. Warichez, *La cathédrale de Tournai*, 2 vols., Brussels, 1934; L. Gal, *L'architecture religieuse en Hongrie du IXe au XIIe siècle*, Paris, 1929; P. Francastel, *Les relations artistiques entre la Pologne et la France*, Revue des Études Slaves, 1937; J. Roosval, *Die Steinmeister Gotlands . . .*, Stockholm, 1918; C. J. M. de Vogüé, *Les églises de Terre-Sainte*, Paris, 1860; C. Enlart, *Les monuments des Croisés dans le royaume de Jerusalem*, Paris, 1925–28. *K. J. Conant, *Carolingian and Romanesque Architecture, 800–1200* (Pelican History of Art), Harmondsworth, 1959; J. Evans, *The Romanesque Architecture of the Order of Cluny*, Cambridge, 1938; E. Lambert, *Études médiévales*, 4 vols., Toulouse-Paris, 1956; M. Aubert, ed., *L'art roman en France*, Paris, 1961; K. J. Conant, *The Third Church at Cluny*, Medieval Studies in Memory of A. Kingsley Porter, Cambridge, U.S.A., 1939, II, pp. 327–357, and *Medieval Academy Excavations at Cluny*, VIII, Final

Stages of the Project, Speculum, XXIX, 1954, pp. 1–12; F. Salet, *La Madeleine de Vézelay*, Melun, 1948; R. Tournier, *Les églises comtoises, leur architecture, des origines au XVIIIe siècle*, Paris, 1954; J. Vallery-Radot, *Les églises romanes du Rouergue*, Bulletin monumental, IC, 1940, pp. 5–68, and *Le domaine de l'école de Provence*, ibid., CIII, 1945, pp. 5–63; M. Aubert, *L'église Saint-Sernin de Toulouse*, Paris, 1933, and *L'église de Conques*, Paris, 1939; J. Secret, *La restauration de Saint-Front au XIXe siècle*, Les Monuments historiques de la France, 1956, pp. 145–159; R. Crozet, *L'art roman en Poitou*, Paris, 1948; E. Lambert, *Caen roman et gothique*, Bulletin de la Société des Antiquaires de Normandie, XLIII, 1935, pp. 5–70; J. Bony, *La technique normande du mur épais à l'époque romane*, Bulletin monumental, XCVIII, 1939, pp. 153–188; R. Grand, *L'art roman en Bretagne*, Paris, 1958; G. de Angelis d'Ossat, *Le influenze bizantine nell'architettura romanica*, Rome, 1942; R. Wagner-Rieger, *Die italienische Baukunst zu Beginn der Gotik*, 2 vols., Graz, 1957; M. Salmi, *L'architettura romanica in Toscana*, Milan, 1927; W. W. Horn, *Romanesque Churches in Florence. A Study of their Chronology and Stylistic Development*, Art Bulletin, XXV, 1943, pp. 112–131; W. Paatz, *Die Kirchen von Florenz*, 6 vols., Frankfurt-am-Main, 1940–1955; R. Krautheimer, *San Nicola in Bari und die apulische Architektur des 12. Jahrhunderts*, Wiener Jahrbuch für Kunstgeschichte, IX, 1934, pp. 5 et seq.; H. M. Schwarz, *Die Baukunst Kalabriens und Siziliens im Zeitalter der Normannen*, Römisches Jahrbuch für Kunstgeschichte, 1942–44; S. Bottari, *L'architettura della Contea*, Catania, 1948, and *I rapporti tra l'architettura siciliana e quella campana nel medioevo*, Palladio, 1955, pp. 7–28; S. Bettini, *L'architettura di San Marco*, Padova, 1946; O. Demus, *The Church of San Marco in Venice* (Dumbarton Oaks Studies, VI), Washington, 1960; J. Gudiol Ricart and J. A. Gaya Nuño, *Arquitectura y escultura románicas* (Ars Hispaniae, IV), Madrid, 1948; J. Vieillard, *Le guide du pélerin de Saint-Jacques de Compostelle*, Mâcon, 1938; J. Vazquez de Parga, J. M. Lacarra and J. Uria Riu, *Las peregrinaciones a Santiago de Compostela*, 3 vols., Madrid, 1948–49; J. Secret, *Saint Jacques et les chemins de Compostelle*, Paris, 1955; T. S. R. Boase, *English Art 1100–1216*, Oxford, 1953; G. F. Webb, *Ely Cathedral*, London, 1951; F. Saxl, *Lincoln Cathedral: The Eleventh Century Design for the West Front*, Archaeological Journal, CIII, 1946, pp. 105–118; N. Drinkwater, *Hereford Cathedral: The Bishop's Chapel of St. Katherine and St. Mary Magdalene*, ibid., CXI, 1954, pp. 129–137; J. Bony, *La chapelle épiscopale de Hereford et les apports lorrains en Angleterre après la conquête*, Actes du XIXe Congrès International d'Histoire de l'Art, Paris, 8–13 Sept. 1958, Paris, 1959, pp. 36–43; W. A. Pantin, *Durham Cathedral*, London, 1948; H. G. Leask, *Irish Churches and Monastic Buildings, I. The First Phase and the Romanesque*, Dundalk, 1955; E. Gall, *Dome und Klosterkirchen am Rhein*, Munich, 1956; W. Hoffmann, *Hirsau und die Hirsauer Bauschule*, Munich, 1950; W. Meyer-Barkhausen, *Das grosse Jahrhundert Kölnischer Kirchenbaukunst*, Cologne, 1952; R. Lemaire, *De Romaanse Bouwkunst in de Nederlanden*, Brussels, 1952; S. Brigode, *Les églises romanes de Belgique*, Brussels, 1943; P. Rolland, *La cathédrale romane de Tournai et les courants architecturaux*, Revue belge d'archéologie et d'histoire de l'art, VII, 1937, pp. 229–280, and *La technique normande du mur évidé et l'architecture scaldienne*, ibid., X, 1940, pp. 169–180; J. Gantner, *Histoire de l'art en Suisse, I. Des origines à la fin de l'époque romane*, Neuchâtel, 1941; G. Fischer, *Nidaros Cathedral in Trondheim*, The Norseman, 1953; E. Lundberg, *Den äldsta stenkatedralen i Skara*, Festskrift till Martin Olsson, Rig, 1936; E. Cinthio, *Lunds Domkyrka under Romansk Tid* (Acta Archaeologica Lundensia, series in 8°, No. 1), Bonn and Lund, 1957.

CHAPTER III

Romanesque Decoration

I

THE history of Romanesque sculpture is animated by the same spirit. Yet at first sight how remote from us it seems! Is it possible that this is ours—this strange vision, entwined so mysteriously with the stone and inscribing the walls of the buildings with fancies which are often indecipherable, like the characters of a lost language? Can it be that our conception of man, life and the world is divided by such an abyss from that of our forebears? In Gothic sculpture we recognize ourselves, we find our own kind of humanity; it remains our contemporary, almost our neighbour—much more so than Renaissance sculpture, which was based upon the resuscitation of an earlier age for which we can no longer feel more than an intellectual sympathy and admiration. The endless ranks of images which fill the Gothic cathedrals evoke in us a kind of spiritual kinship, which we freely acknowledge; in many ways even, they are like a vivid recollection of our past life, our own past, and that of our towns, our suburbs and our countryside. We can name the animals and the plants, and the saints with their working-men's faces who stand in the doorways are of the same race as our own fathers. But wherever we turn, the images of Romanesque art disconcert us by their composition and their sentiment. It is an art abundant in monsters, visions, and enigmatic symbols. It seems at first sight much older than the age which it so faithfully expresses and the architecture to which it so exactly conforms.

Let us study it first as a system of signs before we attempt to interpret it as a system of forms. Every art is language, in two ways—once by its choice of subjects, once by its treatment of them. Iconography floodlights the life of the spirit. It is not a collection of symbols, a vocabulary, or a key; the novelty of M. Mâle's studies[1] consists in the widening of its horizons and the deepening of its perspectives, both historical and moral, to form a broad and detailed panorama of the spiritual life of the past. Romanesque iconography was epic. It bestowed superhuman proportions on God-made-man and man-in-the-image-of-God; sometimes even it gave them an appearance divorced from humanity. It surrounded them with a cortège of monsters which entwine them in their coils. To expound and present them to the people it chose, as a terrible warning, the most extraordinary

[1] *L'art religieux du XIIe siècle en France, Paris*, 1924, chaps. I, IV.

page of the whole Bible. The story of the Last Days, foretold in words of fire by an enthusiast filled with the afflatus of the Jewish Bible, inspired it with majestic terror. The seer roused the visionaries. The faithful entering the church were not welcomed by the evangelic Christ of the thirteenth-century *trumeau*, but compelled to file beneath the tympanum of the Last Judgment as if they themselves were about to hear their sentence from the mouth of the inflexible Judge. At La Lande de Cubzac, the sword of the Word flashes from the lips of the Apocalyptic Christ, who stands beside the symbolic candelabrum, holding in his hand the book sealed with seven seals. In a less strange guise, alone or flanked by two angels who seem to fan the flames of the glory which surrounds Him, it is this same God of the Apocalypse who figures on the old Aragonese tympana, at Perrecy-les-Forges in Burgundy and Mauriac in Auvergne, and who finally, in the second half of the twelfth century, appears again and again in monotonous profusion, accompanied by the tetramorph of Evangelists, above the portals of northern France. But it was particularly in the tympana of Languedoc, in the first half of the century, that the theme was developed with the full amplitude of the epic. Christ the Judge, whose kingdom is founded on the destruction of the universe and the punishment of sinners, emerges from the mystery of the end of time like an apparition suddenly risen before the eyes of His terror-stricken followers. Surrounded by convulsive shapes, He is accompanied by the twenty-four Elders carrying lamps and viols. At Beaulieu there appears behind Him the cross of His sacrifice, and of the redemption of mankind. Even when, as at Vézelay, He is the Christ of Pentecost, charging the Apostles with their mission[1], He is still a terrible God. The Oriental Potentate of Moissac is Lord of a world from which the Good Shepherd of the catacombs, the Christ of Psamathia, and all those figures of Hellenistic Christianity who still combined divinity with youth and harmonious beauty have passed away. One might believe that the Romanesque Apocalypse trembled still with millenarian terrors, passed on by Beatus' illustrated commentary, which served as its guide through this Divine Comedy in stone. There is a breath of the East in these strange figures, this fearful conception of the Master of Days. Yet the same epic spirit, the same legendary disproportions, the same superhuman quality, are characteristic of the tales of knightly prowess created, at the same time and often at the same places, out of the recollection and imagination of the peoples of the West. The God of the sculptors and the heroes of the poets are ornaments of the same horizon of thought: the visionary theology of

102

[1] On the iconographic meaning of the Vézelay tympanum, see A. Katzenellenbogen, *The Central Tympanum at Vézelay*, Art Bulletin, 1944, pp. 141–151.

Scotus Eriugena, if it did not directly inspire the iconography, helps us at least to understand its intellectual climate. The unity of the period is not founded on a congeries of completely heterogeneous borrowings; unfamiliar elements were welcomed because they responded to a need, and we shall see how they were subsequently elaborated.

The stories of the Gospels and the lives of the saints, and still more the representation of the world, are touched with the same strangeness, and many details betray the remoteness of their origin. Sir Arthur Evans has recently shown that the theme of the Adoration of the Kings goes back to the remotest antiquity[1], and it should be observed that already on Sumerian monuments it is accompanied by the motif of the guiding star. In Syria, Mesopotamia, Transcaucasia and Egypt the East Christian communities were the heirs of an iconographical tradition built up over thousands of years; they in turn devised new elements and established stereotypes which fixed the images for the future. The three cycles of Nativity, Passion, and Parables, the essential chapters of the iconography of the Gospels, are full of Oriental features, whose history and diffusion can be followed from the throne of Maximian and the ampullae of Monza down to Romanesque times. The Byzantine drama *Christos Paskon*,[2] whose influence is vouched for by numerous manuscripts, spread the knowledge of the *mise en scène* of the Resurrection and the other episodes centred on the Tomb. The prophets of the Coming of Christ were born of the Biblical East and insinuated themselves into still older Oriental forms. Daniel standing between the lions who lick his feet is Gilgamesh, the master of animals in Assyrian art. An Oriental silk at Saint-Maurice d'Agaune in Valais, the national sanctuary of the Burgundians, shows the manner in which these themes were able in the early Middle Ages to penetrate the West and to become invested with a Christian significance, before they made their appearance on Romanesque capitals. Thus we find the Biblical and Gospel figures intimately linked with the oldest images of Asia[3], and even when they are of more recent origin, they have very often been composed and fixed in the East. Hence the indisputably exotic tonality in the choice and treatment of subjects.

This quality of Romanesque iconography strikes us still more forcibly when we consider the number and the strangeness of the monsters which inhabit it. Man himself loses his identity and, obedient to the law of metamorphosis by which this universe is constantly created, broken down and recomposed, he also

[1] A. J. Evans, *The Earlier Religion of Greece in the Light of Cretan Discoveries*, London, 1931.
[2] See V. Cottas, *Le théâtre à Byzance*, Paris, 1931, and *Le drame Christos Paskon*, Paris, 1931.
[3] See J. Baltrusaitis, *Art sumérien, art roman*, Paris, 1934.

assumes a monstrous guise. Even when probability is respected, the animal life is of bewildering variety. The bestiary of the steppes, which had been diffused by the invasions, and the Asiatic fauna which had filled Visigothic manuscripts such as the Sacramentary of Gellone and now reappeared, often in copies after Arabic ivories, introduced into the churches the menagerie, the 'paradise' of the Oriental monarch. But, seized by that hidden power which remoulded living creatures to its own needs, and conferred on them a multiple existence more mobile and passionate than life itself, the animals are subdivided, reunited, acquire two heads on one body or two bodies for one head, gripe one another, devour one another, and are again reborn, all in an indecipherable tumultuous *mêlée*. What name can we give, what meaning assign to these fancies, which seem to emanate from the caprice or delirium of a solitary visionary and which yet recur throughout Romanesque art, like the images of some vast collective nightmare? Of what virtues, what sins are they the incarnation? At times we seem on the point of penetrating these symbols, but immediately they flicker away into the monstrous inanity of the compositions.

Such are the general characteristics of this iconography. It is rich in Oriental elements. It is epical and teratological. It gives us the epic of God, the epic of the end of the world, and the epic of chaos. Is there not a singular contradiction between the order of the churches and the tumult of these images, between the rules of an architecture whose strength, stability and logic we have been at pains to demonstrate, and the rules of an iconography between whose transfiguration of God and deformation of His creatures one may scarcely find a middle term, between structures dominated by a conception of plan and masses which is purely Western, and an iconography which derives most of its resources from the East? Only the study of the forms permits us to resolve this apparent contradiction; it will likewise assist us to make a true assessment of influences, and it will also demonstrate the profound harmony of thought between the technique of the Romanesque decorative artist and the intellectual technique of his period.

II

THIS technique had a twofold character: it was architectural, in that the figures were made to conform to their architectural setting and it was ornamental, in that the figures were drawn and composed in accordance with ornamental schemes. In our brief study of the experiments carried out in the

course of the eleventh century we have already caught a glimpse of some of the earliest applications of these principles and of the manner in which they tended—in opposition to the academic forms of antique art and in alliance with the abstract repertory which had become diffused through Europe—to substitute for the verisimilitude of the images their just adaptation to a surrounding frame, and to replace the harmony and proportions of life by the harmony and proportions of an abstract system. The forms of architecture and the forms of life being fixed, what compromise could be established between them? Romanesque architecture did not offer indifferent fields to the decorator, but fields whose shape and function were clearly defined. The genius of the style lay in its association of sculpture with these functions. By adopting once for all the frieze-system, which had flourished in the eleventh century alongside more adventurous lines of research, it would have renounced its fundamental originality. It might also have allowed sculpture to flow indifferently over the wall-surfaces, and assimilated it to those severe and powerful masses in truly monumental beauty: but sculpture in architecture and for architecture demanded a much stricter economy. Where is it found, in a twelfth-century church? On capitals, tympana and archivolts. True, it did not altogether abandon the friezes and the arcades, but its development depended on the more tyrannical constraint exercised by frames which were ill-adapted to receive the image of life. Yet these frames seized upon sculpture, bestowed on it a new passion, imposed on it movement, mimicry and drama. To enter the system of the stone, man was forced to bend forward or lean backward, to stretch or contract his limbs, to become a giant or a dwarf. He preserved his identity at the cost of unbalance and deformation; he remained man, but a man of plastic material, obedient—not to the caprice of an ironical idea—but to the exigencies of a system which comprehended the entire structure.

We have noted among the capitals of Saint-Benoît-sur-Loire remarkable examples of the transition from the Corinthian (which was never treated with greater breadth than here) to the figured capital. The solidity and complexity of these powerful architectural compositions became in some sense the basis and inspiration on which the Romanesque decorators were to build. They respected the fundamental forms—collerets of acanthus, angle-volutes and medallions—but they gradually introduced among them men, animals, and figure compositions. Romanesque art was to make the church 'speak'; space had to be found for an abundant iconography, without disturbing the architectural masses and their functions. It was necessary to set on top of the columns, at the same time avoiding the appearance of meagreness and insignificance, not one or two figures

—Christ in Majesty, St. Anne and St. Elizabeth, Adam and Eve—which could easily be disposed axially or confronted, but the more numerous actors of the Nativity, the Flight into Egypt or the Last Supper. We must remember that it *119* was in the Corinthian capital that human figures first began to be inserted; they were abducted from the charms of continuous narrative, the storyteller's dispersal of effects, and wedded to architecture, grouped in a colleret of figures or assigned the role of atlantes. In the course of this treatment the living organism was twisted out of shape and out of proportion, but it gained thereby an unexpected eloquence. Bound by every limb to the block of stone, and bound by the continuity of the movement to its companions, which are a prolongation and multiplication of itself, it gave rise to compact systems from which the removal of a single element would entail the ruin of the massive unity of the whole. The loose narrative of the frieze-style was succeeded by the complex strength of drama, with its concentrated impact, and its mimicry accentuated by the deformation of the actors. This architectural conformity did not operate only within the framework of the Corinthian capital. The cushion capital also, when it accepted figure decoration, submitted it to the same discipline. So too, did the capital formed like a truncated and inverted pyramid; and when the capitals of conjoined or adjacent columns were adorned with a single composition, the bridging of the gap between the two masses produced some unexpected but logical applications of the same principle.

A similar problem, but with rather different data, was set by the decorations of the archivolts. How could the image of man, and, in a more general sense, the image of life, be accommodated within the arch-mouldings which curve around the semi-circular tympanum? The art of Poitou is notable for the abundance and strictness of the solutions it offered to this problem. It seems almost as if it sought to compensate by the beauty of its treatment of this member for the absence of the tympanum over the doorways—for the great stone panel on which the workshops of Languedoc presented the supreme vision of the Apocalypse was generally omitted in Poitou. The decoration of the mouldings is sometimes disposed radially, while at other times it follows the curve of the arch. In the former case, each voussoir is treated as a unit and closely contains the figure or ornament which it receives—bearers of offerings following one another in procession up to the keystone and down again on the other side, horses' heads, and ornamental frets worked in the stone as in ivory or ironwork. In the latter case, the figure occupies several voussoirs, bending with the arch; a body may cross the keystone, or the heads of two symmetrical bodies may be confronted there; the living creature becomes an architectural curve and is identified with the

moulding itself. The whole of south-western France is rich in these surprising con-
figurations. The Virtues and Vices, derived from the *Psychomachia* of Prudentius,
are drawn up in this strange array; one enters the church beneath an arch
of triumphant Virtues. One of these, at Aulnay, offers us the finest example of
architectural conformity to be found in the whole of Romanesque art: the mailed
128 figure is almost entirely hidden behind a tall shield whose spine exactly coincides
with the arris of the rectangular moulding, creating a species of moulding-man.
At Castelvielh (Gironde), the profiles are rounded, the figures no longer coincide
with the voussoirs or mouldings, and the execution is of a somewhat rough and
rustic character, yet the flexion, function, and effect of the figures is not dis-
similar. Human figures sometimes try to escape to some extent from this narrow
bondage. Instead of the radial or circumferential position, they take up a tangential
one, forming with the curve of the arch an angle which hardly ever varies. The
elongated bodies stand erect or bend over within the arch, their bellies slightly
prominent, and punctuated by a spot of shadow between the thighs. But this
semi-freedom, which satisfied the statuesque instincts of the Poitevins, was
opposed by the hegemony of architecture, which, here as elsewhere, continued
to define the essential aspects of Romanesque sculpture.

The composition of a tympanum is not determined by a vague symmetry. Its
elements must be both deployed and concentrated. Its lower and wider part
extends to very nearly the same length as the lintel on which its rests. The upper
segment narrows rapidly. The two parts are held together by the radii of the
arch. A fan-shaped composition would seem to be the most favourable and
harmonious solution, but the Romanesque sculptors by no means restricted
themselves to that alone. Sometimes they made it more complex by the insertion
of a triangular pediment, which is not outlined by projecting mouldings, but is
visible in the lines of heads which rise towards the central axis (and emphasized,
as at Vézelay, by the fiery rays emanating from the hands of Christ), or may be
suggested, in less elaborate compositions, by the movement of the mandorla-
carrying angels as they bow down before the glory of God. Sometimes they sub-
divided it so as to obtain, with the help of some curvilinear triangles, a collection
99 of rectangular frames, as at Cahors, and Carennac. Sometimes the composition
blossoms like a flower or a palmette, with living figures forming the lobes. It
was the special function of the monsters to contort themselves to suit these various
schemes, but man also conformed. In accordance with a kind of morphological
perspective, which, though equivalent with hierarchic perspective, yet precedes
it in the structural and logical order, and is more insistent in its demands, the
witnesses and actors of these impressive scenes, the attendants of the throne of

heaven, increase in scale in proportion to their nearness to the Deity, who alone occupies the centre and towers up to the full height of the tympanum.

In the lintel the Apostles, the enthroned Elders and the dead, awaking from their funereal sleep and already, at Autun, shrinking in horror under the talons of the demons, seem to be allowed greater freedom of action within their rectangular frame, which is identical with that of the frieze. But the Auvergne lintel, which at Conques is introduced into the composition of the tympanum itself, 98, 103 bears down upon them and progressively diminishes their stature beneath its double slope. Finally, we may mention a class of rectangular panels, decorating *trumeaux* and door-jambs, which reveal to us one of the most curious aspects of this technique. The principle of exact conformity to the frame, strictly applied, results (there are many examples) in creatures of absolutely geometrical shape— the circle-men, like the delightful acrobat on the keystone of the archivolt at 120 Vézelay, above the Zodiac, the lozenge-men, and the rectangle-men. But this last shape, once defined, could never satisfy the manifold demands of the iconography, which required other heroes than these massive witnesses, and especially they were unfitted to share in that restless movement with which Romanesque art is filled. Hence the figure conterminous with its frame was displaced by the figure which touched its frame at the greatest possible number of points. With elbow, shoulder, knee, and heel the body, whose parts are disposed on multiple 121 axes, makes contact with the limits of the enclosing field, and thus describes a whole series of triangles. In this way there was produced a family of figures which, even in their immobility, enliven the firm and ponderous masses of Romanesque architecture with ceaseless movement; this sculpture, though dominated by the laws of a massive equilibrium, presents itself in the guise of a series of experimental studies in motion. It may have taken over from Oriental models the motif of the crossed legs, whose classic examples are the Zodiacal signs and the Apostles in the Toulouse museum. But it multiplied the flexions of the limbs to produce the types to which, for the sake of convenience, the names of dancer, climber, and swimmer have been assigned. The prophet of Souillac, 108 and the St. Paul and Jeremiah on the sides of the Moissac *trumeau*, move to the rhythm of the dance; the Apostles who stand on either side of the doorway seem to haul themselves up some mountain-chasm; The Eve of Autun rests on elbow 109 and knee and crawls in the attitude of swimming—a delightful figure, perhaps the most feminine and insidious of this great epoch. The damned of Autun bend their knees, and even God seated in glory and the Apostles in the majesty of their mission are represented as if in violent motion. To a superficial observer this interpretation might seem a product of vain ingenuity, and this geometric grid

a device to support a preconceived system. But the album of Villard de Honnecourt[1] provides, *a posteriori*, a brilliant confirmation. This Picard master-mason, whose notebook testifies to an insatiable curiosity, fed by wide experience, and foreign travel, resurrected some aspects of the 'lost art', whose rules had been forgotten by his contemporaries and of which, after him, there seems to be no trace. By insisting on the interest of what he calls the 'art de jométrie' and by divulging the secret of the triangulation of figures, he confirms the historical importance, the authenticity, and the systematic character of the processes which we have analysed.

Architectural conformity and the use of geometric schemes, even if they are the fundamental characteristics of Romanesque technique, do not in themselves account for all its aspects. This essentially architectural sculpture was devised for particular positions and for frames which determined its arrangement and movement; but it is also ornamental—it established or rather modelled its image of life in accordance with the forms of ornament. The man, the beast and the monster are not only volute, medallion, moulding, wall-mass, or function, they are not assembled only in accordance with the broad lines of a geometric scheme; they are also palmette and foliage-scroll. Recent research,[2] the point of departure for which was provided by the juxtaposition of a design composed of ornament in the pure state, and a figure composition in which its main lines are exactly reproduced, as if the sculptor wished to leave beside his work the key to its understanding, has brought to light the prodigious decorative 'underpainting' of Romanesque sculpture. Moreover, if we envisage the ornament not as a static vocabulary or a collection of invariable formulae but as a dialectic or multiple development in which each term may be deduced from its predecessor, we find that the dialectic of the figure sculpture reproduces, in its movement and variety, that of the ornament. Three primary motifs—the foliage-scroll, the heart (with or without a palmette), and the motif formed by setting two foliage-scrolls back to back about a central axis—give rise to a large number of ornamental variations whose forms and interrelationships reappear in many of the figure compositions of Romanesque sculpture. If it were merely a question of explaining in this way the symmetries of confronted and addorsed objects, or the genesis of the monsters with two heads or two bodies, this fact would amount to no

[1] Bibliothèque Nationale, ms. fr. 19, 093. First published by Lassus and Darcel (1858), then by H. Omont in the series of phototype albums issued by the department of manuscripts, and most recently by Hans R. Hahnloser, Vienna, 1935.

[2] J. Baltrusaitis, *La stylistique ornementale dans la sculpture romane*, Paris, 1931, chap. 5, VII, p. 273, L'animal (genèse des monstres); VIII, p. 301, Le personnage. The method followed in this remarkable book has revolutionized the subject.

more than evidence of a very common and widespread habit, though it would still be noteworthy, since it was abandoned by European art after the twelfth century. But in fact there is a complete system, an immense variety of forms which can only be explained by the dialectic of ornament. An inexhaustible vitality, differing from organic life, and of even greater richness and multiplicity, but as highly organized, arises out of, and owes its diversity to, these abstract devices, and modulates its variations according to their variations. Very ancient motifs, such as the sea-siren with the double tail, were also admitted to this realm of forms, not as alien elements arbitrarily inserted or passive recipients of influence, but because they, too, had originated in an ornamental idea, whose shape and aptitude for life they still preserved, and were ready participants in the play of metamorphoses. In the setting within which this process of transformation operates, it links together all the movements, leaving no single gesture unconnected, and ensures that all the parts interlock and interpenetrate, so that each block of ornament in pictorial guise is like a small separate world, close-knit and compact, a law unto itself. The great complex compositions of the tympana are very often the expanded and diversified, yet quite regular, version of an ornamental motif which runs through the whole, controlling and influencing every detail. The epic of the Last Day, the Adoration of the Kings, and all the other stories and visions, adorned the stones of the churches with a mysterious flora, with the characters of a hidden language, by which their own poetic content was enhanced. Thus the study of the technique of Romanesque sculpture has revealed to us a poetry and a psychology. The feeling and subtlety of the dialectical process as applied to these forms runs parallel with the dialectic of pure thought. It is not without significance that both church-decoration and the scholasticism of the period were equally dominated by the philosophy of abstraction, and that both groups of purist logicians were given to the spinning of elegant formal patterns. But whereas the dialectician lost himself in a labyrinth of unprofitable composition, the sculptor, in conjunction with the architect, was creating a new world, extending the limits of man's experience, and giving shape and form to his wildest fantasies.

In our insistence on these features, we are not speculating on the aesthetics of the style, but we are defining it for the purposes of archaeology and history. Just as the architecture could only be approached and understood through its formal details, so it is by the analysis of forms that we comprehend the sculpture. The facts which we have just established will enable use to recognize, if not to solve, the historical problems posed by the evolution of the sculpture of the Romanesque period. It was necessary first of all to define it, or rather to examine

it at the moment in which, following on the significant experiments of the twelfth century, it so completely defined itself. It now becomes possible to study the question of sources, and this study, brief as it will be, will bring to our notice a whole series of treatments analogous to, and yet different from, those of the Romanesque style. The assessment of these relationships and differences will render the originality of that style still more apparent.

III

THE art of the East Christian communities, of Islam, of Ireland, and of the Carolingian era enter into the study of these origins by virtue of a number of correspondences and relationships of varying importance. All of them were combinations, or perhaps rather attempts to harmonize, various forces and elements. The East Christian communities claim our attention first of all for many reasons, of which the most important is the persistence and significance of the relations which connected some of them with Western Europe. Syria provided the early Middle Ages with some of those elementary motifs, such as the rosette, which were adopted, though as foreign bodies, into the meagre decorative repertory of the period; I have indicated above the close analogies in composition and treatment of masses between the great stone-built basilicas of Syria and certain Romanesque churches; finally, the monuments of Constantinian Palestine stood for centuries on the skyline of the West, not only as the goal of the most holy of all the pilgrimages, but also as models to be imitated, so that the Holy Sepulchre became the direct or indirect progenitor of a whole family of rotundas[1]. From an early period the Christianity of Egypt was spread far and wide by the diffusion of monasticism; the feature of the continuous aisle, which is noteworthy in certain pilgrimage churches, made its appearance much earlier in the monasteries of the Nile valley; the variations of the interlace pattern are there limited in number, but of a definition which may be called classic, and it may well have been from Egypt that they were transmitted to the art of the Lombards; but at a yet earlier period, while still to a great extent under the influence of the Hellenistic spirit, Coptic art had attempted a combination of living and abstract forms; the ruins of Ahnas[2] show them side by side, while the evolution of ornament in

[1] R. Krautheimer, *Introduction to an Iconography of Mediaeval Architecture*, Journal of the Warburg and Courtauld Institutes, 1942, pp. 1–33.
[2] See U. Monneret de Villard, *La scultura ad Ahnas, note sull'origine dell'arte copta*, Milan, 1923.

wood and textiles illustrates the progressive drying-up and reduction to geometric regularity of that rich Alexandrian flora which had been the earliest ornament of the Christian pastorals; the human figure likewise, though it long continued to follow the models of late Greco-Roman paintings and mosaics, may be seen growing schematic and decorative, if not ornamental, enveloping itself, for instance, in interlacing strips, which tend to become reduced to an interlace pattern.

Still closer attention should perhaps be paid to the Asiatic Christian communities, to the art of Armenia and Georgia.[1] Certainly it was in Armenia that Christianity first became a state-religion. But it was no doubt to the proximity of the old Sassanian empire that this region owed its inspiration, its models, and its taste for the application of sculpture to monumental decoration, in which field colossal examples were to be seen in the Sassanian rock-carved reliefs depicting the investiture of the rulers, where plastic force and respect for the human figure are combined with strict symmetry and with ornamental treatment of detail, especially in the treatment of the animals; furthermore, Armenia was acquainted earlier than Byzantium and the West with Sassanian textiles, wherein the schematic rendering of flora and fauna, accentuated by the technique of weaving, gives a uniform vigour, in its most complex medallion patterns, to the confronted and addorsed motifs, the fire-altar, the tree of life, and the reincarnations of the hero Gilgamesh. But in its own territory also it possessed the remains of age-old civilizations which offered it a repertory of abstract forms, especially the interlace, which was used extensively in church decoration by both Georgia and Armenia, though in different ways. Nor must it be forgotten that Transcaucasia had been in the area of influence of the ancient Mesopotamian and Iranian cultures, whose lion-hunters and bull-tamers had created an animal style, which was admittedly remarkable for its naturalistic

[1] See J. Baltrusaitis, *Études sur l'art médiéval en Géorgie et en Arménie*, Paris, 1929, chap. III, p. 43; IV, p. 69. In another of his works, *Art sumérien, art roman*, Paris, 1934, the same author has brought to light not only new and striking relationships between the medieval West and the ancient East (in many comparisons of Sumerian seals with the reliefs of French churches), but also the identity of the morphological reasoning which produced and developed the ornamental dialectic of the two groups, despite their historical and geographical remoteness. In other words, the influences were not imported as a heterogeneous collection in bulk, but they set in motion and reconstituted an identical system of thought. This is the typical example of *correspondence*. In this current of influence, the role of Armenia was the enlargement of the figurines of the seals, the jewellery and the ceramics, to a monumental scale and their incorporation in stone. The West made them an integral part of architecture and bound them to it in a regular system. Among the most remarkable comparisons, see p. 21, *Fig.* 8, detail of a seal-impression from Susa in the Louvre and the ornament of a capital at Moissac; p. 22, *Fig.* 10, detail of a seal-impression from Kirkuk and a relief at S. Michele at Pavia; p. 52, *Fig.* 32, detail of the front of a harp from the Tomb of the King at Ur and detail of a capital of the old cathedral at Nantes (the donkey with the hurdy-gurdy); p. 53, *Fig.* 33, detail of the impression of a Cappadocian cylinder in the Louvre and the Virgin of the tympanum of Neuilly-en-Donjon, etc.

vigour and its feeling for life, but in which the musculature is distinguished and emphasized for its ornamental effect. It was again an ornamental style, stricter and more complex, but following similar principles and sometimes even reproducing the old Assyrian forms, which dominated the monumental sculpture of Armenia and Georgia. This sculpture was ornamental and monumental, but was it architectural? At this point the differences which distinguish this art from Romanesque art became apparent, for the sculpture is as indifferent to structural functions as is the architecture, which, for example, uses spheres as bases and capitals, and sets the enormous window-sills on ridiculous horizontal columns. At Akhtamar, colossal figures seem to flow all over the façade. Romanesque in the plenitude of its masses, its insistence on the frame, and its ornamental rhythm, Transcaucasian sculpture is Asiatic in its indiscriminate wanderings about the church. Yet it is impossible to dismiss as pure coincidence such striking analogies as that between the sculptured figures in the pendentives at Conques and Armenian figures in the same style and the same position, which are so completely exceptional in Western art.[1] The Armenian inscription[2] which appears round the little juggler, now in the museum at Lyons, from one of the mouldings of Saint-Pierre-le-Puellier at Bourges, reinforces the notion of direct historical contacts, which we have touched on in connection with Armenian ribbed vaults. The great pilgrimages of Western Europe attracted the faithful from Transcaucasia; and even before relations were established between the crusaders and the Armenian barons of Cilicia, it was possible for pilgrims to the Holy Land to visit the churches built by the Georgian princes at the various stages of their victorious advance against Islam.

The art of Islam stood on the frontiers of Romanesque art, not only in the Frankish kingdom of Jerusalem, but also in Spain, where it had left its mark on the composite form of Mozarabic art, and in southern and south-western France, where the ribbed dome of Oloron-Sainte-Marie reproduces the domes of Toledo, where certain doorways in Vendée, Saintonge and Poitou recall the lacy filigree of the stucco-decoration of the mosques, and where a multitude of capitals give shelter to an exotic menagerie; we have seen, too, that Notre Dame at Le Puy was indebted to a still greater extent. But what exactly was its share in the elaboration of monumental sculpture in the West? Certainly it carried with it

[1] J. Baltrusaitis, *Études*, pl. 140, Koumourdo, pendentive of the dome (964), and pl. 141, Conques, Sainte-Foy, pendentive of the dome.

[2] I am indebted to M. Marr for the information that Longpérier, Revue archéologique, 1846, p. 702, considered it an imitation of Arab epigraphy and compared the Bourges archivolt and the casket of Bayeux cathedral. Cf. Spencer Smith, *Précis d'une dissertation sur un monument arabe du moyen âge en Normandie*, Caen, 1828.

many motifs of that vast common store in which the spirit of the ancient East was combined with debased Hellenistic survivals, that Mediterranean κοινή which was transported hither and thither for centuries by trade and invasions. But a style is not only a vocabulary, it is an articulated language, a way of treating materials, a more or less successful adaptation to the principles of architecture. Two important features of the plastic arts of Islam must be emphasized: their geometrical tendency, and their filigree treatment. The geometrical tendency was an aspect of a more general predisposition, the taste for abstract pattern, whose ascendancy we have already noted among all those nomadic forces which were precipitated on to Western Europe by the decline and fall of the Roman empire—the barbarians of the great migrations, the Northmen, and the Arabs. Were these latter naturally inclined in this direction, and towards that exclusion of living forms which was enforced by the Koranic veto ?[1]

In many areas to which their domination extended, and especially in the various regions of Hellenistic culture, they accepted a heritage which included living figures. But it is true that they submitted these to special conditions, isolated them by analysis, and emphasized most strictly such prominences and contours as might reduce them to void and regular shapes. At the same time the Oriental taste for concealment, hiding beginnings and ends within sinuous convolutions, led them to conceive ornament as a kind of labyrinth in which the eye is both deceived and led on by repetitions, symmetries and entanglements. The progress of mathematics led the polygonists of Cairo to the most astonishing displays of geometrical virtuosity. The ornamental transposition of the scripts, in process of which they were simultaneously beautified and rendered unrecognizable, is another very important aspect of this psychology and style. It may be admitted that certain procedures of measurement and spatial division, as invented and expounded in the Arab *Perspectives*, may have been known in the workshop practice of northern Spain and southern France. The recipes which were subsequently formulated by Villard de Honnecourt may have been well known by the end of the eleventh century to artists who had learned the 'art de jométrie', indirectly, from the great geometers of the period. Thus, as mathematicians and ornamental designers, the Arabs conceived certain regions of the life of forms in the same way as the Romanesques. Cutting their material as engravers or filigree goldsmiths rather than sculptors, they seem to fling an airy mesh over an intact surface, or rather their compositions seem to be inserted between two inviolable planes, one of darkness and one of light, the black ground-plane

[1]On the question of the prohibition of images, see the important chapter devoted to the subject by G. Wiet, in *Les mosquées du Caire*, by L. Hautecoeur and G. Wiet, Paris, 1932, Part 1, X, p. 163.

appearing through a lacy pattern which is likewise in a single plane or very slightly undulating. On the façade of the Palestinian palace of Mshatta[1] (Berlin Museum) the relief is extracted by cutting back the negative parts of the design and leaving the rest of the surface intact. Romanesque sculpture likewise frequently shuns prominent volumes, strong projections and deep-cut hollows; it exercises restraint in confining itself within the volume of the wall; and in south-western France, particularly in certain voussoir-carvings, the designs, with their strong, deep shadows, are seen as if against a background of black velvet. But Romanesque art had need of the image of man and the tumult of life. Though it organized its compositions by means of a geometrical system, this was never uninhabited, and the human and animal forms which accepted its embrace emerged magnified, multiplied, and enhanced in their powers of mimicry and expression.

Ireland[2] was by no means exclusively dependent on its Celtic background. It had received iconographic elements and certain features of style from the monks of Egypt. Its debt to the Scandinavian raiders and the relative contributions of the two cultures are more difficult to estimate. Finally, the sculptors of the astounding stone crosses were perhaps not unacquainted with Carolingian ivories. But however complex its sources, the logic of Irish art is all its own, and its creations are among the most original, not only of the Middle Ages, but of all periods. There can be no doubt that it was in the manuscripts that this singular genius found its richest and most intense expression. It is true that there are different schools and different manners; the Book of Dimma, for instance, is quite unlike the Book of Kells, and the Book of Kells itself is not homogeneous, but is probably the work of several masters working towards the close of a fairly long evolution. But there are few styles which are more definite and categorical as expressions of an inner life. It submits living figures to the spiral and interlace, with a concealed logic which at first sight seems pure caprice. Like Muhammadan art and, in certain respects, like Romanesque art, it rests on a discipline of involution, which, instead of describing or narrating, envelops patterns one within another, cunningly concealing their beginning and their end. The composition of forms is essentially ornamental, but the motifs on which it prefers to base itself are not identical with those which serve as a framework for Romanesque sculpture, though they are often related and seem to foreshadow them. It was no gratuitous hypothesis

[1]See Tristram, *The Land of Moab*, London, 1874; Strzygowski and Schulz, *Mschatta*, Berlin, 1904; Herzfeld, *Die Genesis der Islam. Kunst und das Mschatta-Problem*, Der Islam, Strasbourg, 1910. *Add K. A. C. Creswell, *Early Muslim Architecture*, Vol. I, Oxford, 1932.
[2]See H. S. Crawford, *Handbook of Carved Ornament from Irish Monuments of the Christian Period*, Dublin, 1926; J. Vallery-Radot, *La sculpture française du XIIe siècle et les influences irlandaises*, Revue de l'Art, 1924; Françoise Henry, *La sculpture irlandaise dans les douze premiers siècles de l'ère chrétienne*, Paris, 1933, with which cf. J. Baltrusaitis, *Stylistique ornementale*, Paris, 1931.

which led Viollet-le-Duc[1] to reproduce a band of illuminated ornament of Irish type in his study of Romanesque sculpture, but rather a presentiment inspired by the just appreciation of form. The Irish experience was all the more significant in the history of the origins of Romanesque sculpture in that, during the ninth and tenth centuries, Ireland was linked with the Continent by well-known historical connections which affected not only the expansion of the monastic system but also the characteristics and development of Carolingian art. The ivory of Tuotilo already opens the way to Romanesque stylization. There would be scope here for a re-examination of the continental manuscripts of the period, especially from the point of view of the canon-tables: these beautiful porticos would show us an initial exercise, freer and less hampered by the limitations of material, in architectural decoration, and we should find there, among the classical reminiscences and other more remote elements, a kind of preview or first draft of Romanesque schemes.

These then, in broad outline, are the several styles which were spiritually related to, and which prepared the way for, Romanesque sculpture; we have indicated the various ways in which they resembled or influenced it, but we have also pointed out the ways in which they differed, and differed sometimes very considerably. Romanesque art did not, far from it, invent the ornamental style. It was not even the first to apply it to the decoration of buildings. But it did give it its firm basis by associating it with the structural functions; and by this it not only became architectural—it became architecture. This was the fundamental advantage which it possessed over the art of the East Christian communities, even when the latter, in Transcaucasia, under conditions similar to those in which the Romanesque culture developed, built great and resourceful stone structures in which abstract patterns provided the framework for figure sculpture.

But our examination, however cursory, would be incomplete without some mention of those resources of local genius, those examples from the past, those traditions, which in all the regions of Romanesque art contributed, if not to the elaboration of the style of the sculpture, at least to its particular flavour. Was Spain not the possessor of the ancient Iberian sculpture, and did not Gaul have, interspersed with Gallo-Roman art, examples of a folk-art which imbued its rude and stumpy proportions with vigorously grimacing life? Bréhier[2] stresses the significance of these latter monuments, and rightly considers them indicative of a regional revival, if not an ethnic renaissance, and an ancestral

[1]*Dictionnaire raisonné de l'architecture*, art. *Sculpture*, vol. VIII, 1866, p. 186.
[2]*L'Art en France, des invasions barbares à l'époque romane*, p. 9.

form of medieval art. Provence and Italy were still museums of classical antiquity. The Normans who had settled on French soil retained their taste for purely abstract pattern, and enshrined its geometric repertory in the stones of their churches, whilst the men of Poitou and Saintonge, faithful to the spirit of a style which they had helped to found and of which they have left such fine examples, still loved sculpture for its own sake, for the harmony and strength of the naturalistic human figure, and placed equestrian statues of Constantine beneath their great arcades, and statues of saints against the background of the walls. But these varieties of historical life leave intact the unity of the definition.

IV

WHERE and when did this style first appear in Western Europe? The study of the eleventh century has widened the scope of both these questions and has caused the data relevant to the second to be looked for at a much earlier date than it was formerly. We can no longer consider the first years of the twelfth century as the point of departure of a movement *ex nihilo*, an unheralded renaissance. It is not to be denied that the genius of certain masters, working in privileged centres, took up, with greater accomplishment and a finer sense of form, researches which had already been carried on over a long period. But to begin the study of the sculpture with the beginning of the century would be as grave an error as to adopt for the 'revival' of architecture the fateful date of the year 1000. It is also essential to remember that a style does not suddenly die and leave the field vacant for another; the frieze-style did not vanish completely and for ever before the onslaught of Romanesque art—Saint-Paul-lès-Dax and Saint-Paul de Varax prove the contrary. But, having made these reservations, in what region of the West did Romanesque sculpture begin to produce its masterpieces?—and by this I mean, not pieces corresponding to our modern conception of taste or our idea of the beautiful, but ensembles which admit of interpretation as conscious and regular expressions of a system of thought. Was it in Burgundy, in Spain, or in Languedoc? Burgundy[1] means Cluny, the tradition of its holy

[1]On the Burgundy-Languedoc problem, besides Kingsley Porter's books on Lombard architecture and the sculpture of the pilgrimage roads, see also his articles, *Les débuts de la sculpture romane*, Gazette des Beaux-Arts, 1919; *La sculpture du XIIe siècle en Bourgogne*, ibid., 1920; P. Deschamps, *La sculpture romane en Lombardie d'après Kingsley Porter*, Le moyen âge, 1919; *La sculpture romane en Bourgogne*, Gazette des Beaux-Arts, 1922; E. Mâle, *L'architecture et la sculpture romane en Lombardie*,

abbots, the power of a monastic order, the breadth of a monumental conception. The organization of the pilgrimages radiated from Cluny. Before St. Hugh, from the early eleventh century, monastic Burgundy had shown its aptitude for greatness by the boldness and the novelty of its enterprises. After St. Hugh, it enriched sculpture with memorable pages—the tympanum of Vézelay and the tympanum of Autun. It drew inspiration from the many monuments of antiquity which existed within its boundaries. And would not the Cluniac workshops, where so many manuscripts were produced, also have provided sculptors for the decoration of the basilica ? In addition to these arguments in support of Burgundian primacy, there is also the evidence of the capitals preserved in the Musée

à propos d'un livre récent, ibid., 1918; Abbé V. Terret, Saulieu, Autun, 1919; La cathédrale Saint-Lazare d'Autun, Mémoires de la Société Éduenne, XLIII, 1919; La sculpture bourguignonne aux XIIe et XIIIe siècles, I. Cluny, II. Autun, 3 vols., 1914–15. C. Oursel, L'art roman de Bourgogne, Dijon and Boston, 1928, chap. V, summarizes the various views and supports Kingsley Porter's theory of Burgundian origins; cf. the reply by Deschamps, La sculpture romane en Languedoc et en Bourgogne, Revue archéologique, 1924, supporting the traditional view of the primacy of Languedoc, and, by the same author, Les chapiteaux de Cluny, Revue de l'Art Ancien et Moderne, 1931. The theories and chronologies of the disputants may be summarized as follows: for Kingsley Porter, everything came from Cluny, and not from Moissac and Toulouse; the capitals of the Cluny ambulatory were executed between 1089 and 1095; the earliest sculptures of Saint-Fortunat at Charlieu in 1094; the majority of the nave-capitals at Cluny before the death of St. Hugh in 1109; the nave capitals at Vézelay between 1104 and 1120; the Saulieu capitals about 1119; the Autun capitals between 1120 and 1132; the lost tympanum of Cluny in 1113—and on this were based the tympana of Vézelay and Autun, 1132; Moissac and its derivatives are later. For Deschamps, the lintel and tympanum of Saint-Fortunat at Charlieu are contemporary with the church consecrated in 1094; in the series of capitals from Cluny, two groups are to be distinguished: (a) the capitals of the eight columns of the apse; (b) three capitals from another part of the building, earlier in style, and related to the style of the Saint-Benoît-sur-Loire capitals, before 1108, and those of Saint-Martin-d'Ainay at Lyons, consecrated in 1107; only group (b) is contemporary with St. Hugh, who died in 1109; the two groups are separated by a long interval; group (a) is of too high a quality to date from St. Hugh's time, and dates between 1122 and 1156, under Abbot Peter the Venerable, whose wish to embellish the church is known from certain letters, and who is also known to have had a taste for music (capitals with the modes of plainsong); the sculpture of Saulieu dates from 1119, that of the nave of Vézelay from 1120–38, and that of Autun from 1132–47. For Oursel, the argument of 'too high quality' recoils against the sculpture of Languedoc; Peter the Venerable was not the only Cluniac abbot with a taste for music; moreover, it was during his abbacy that St. Bernard reacted against the 'monstrous' art of Cluny (Apologia to Guillaume de Saint-Thierry, 1124); finally the quality of the Saulieu capitals is as high as that of the capitals of the Cluny ambulatory, and everyone is agreed that they are of 1119. If it is admitted that the consecration of Cluny in 1095 took place in a completed choir, with the capitals in place, they cannot have been sculptured later, since their upper surfaces show traces of cutting, where no tool could have reached once the superimposed masonry was in position. In this learned controversy the only element lacking is a stylistic analysis. See my L'Art des sculpteurs romans, p. 152. *To the controversy on the Cluny capitals must be added K. J. Conant, The Date of the Ambulatory Capitals, Speculum, 1930, and Le problème de Cluny d'après les fouilles récentes, Revue de l'Art Ancien et Moderne, 1931. On the west doorway, J. Talobre, La reconstitution du portail de l'église abbatiale de Cluny, Bulletin monumental, 1943–44. Vézelay has now been closely analysed: F. Salet, La Madeleine de Vézelay, Notes sur la façade de la nef, Bulletin monumental, 1940, and La Madeleine de Vézelay, Melun, 1948; A. Katzenellenbogen, The Central Tympanum at Vézelay, Art Bulletin, 1944. On later works: R. Hamann, Das Lazarusgrab in Autun, Marburg, 1935; L. Schürenberg, Spätromanische und frühgotische Plastik in Dijon und ihre Bedeutung für die Skulpturen des Strassburger Münster Querschiffes, Jahrbuch der preussischen Kunstsammlungen, 1937.

Ochier. They were the capitals of the columns of the choir. But were they contemporary with the consecration? If they were, then the Romanesque style began in Burgundy with its decadence. Or rather, the precocity of such a stylistic development, even if one postulates an exceptional genius (all things are possible), is hard to explain. Whatever date one assigns to them, one must admit that they are not yet, or they are no longer, Romanesque, by reason of their complete and unparalleled divergence from all earlier or contemporary capitals. The elegant personifications of the modes of plainsong and the liberal arts are isolated within their appliqué medallions, and not incorporated in the structural mass; they are self-sufficient and unrelated to their surroundings, objects made for their own sake, with every technical refinement. They are, in fact, *objets d'art*. On the other hand some adjacent capitals, which also come from the sanctuary, and are decorated with figures of Adam and Eve and the Sacrifice of Abraham, must be accepted as contemporary with St. Hugh. They belong to the series of experiments which were carried on throughout the eleventh century, both in Burgundy and elsewhere.

Spain[1] means Compostela, the goal of the pilgrimages, the spiritual focus, the great masons' yard with its sculptors working on the Puerta de las Platerias and on the capitals of the nave. But, besides the great Galician basilica, it also means, at an earlier period, a series of foundations and experiments which must be taken into account and which are of importance for the history of sculpture in the peninsula—the great Iberian art, which was not the stumbling speech of a primitive race but the considered expression of a strong and refined culture. Asturian art, which, with its tubular style, created an individual interpretation of form, and Islamic art, which, by its capitals with their veils of fretted stone, and more particularly by its ivories on which animals pursue each other through forests of foliage scrolls, influenced Christian Spain and south-western France. These antecedents were significant. One can detect their characteristic imprint in later styles. But were they responsible for the formation of Spanish Romanesque sculpture? And was Romanesque sculpture as a whole the creation of the building-yards of Galicia, Castile and León? That Catalan sculpture was precocious is proved by the lintels of Saint-Genis-des-Fontaines and Saint-André de Sorède; but we know that Catalonia was a province apart, that, despite Mozarabic

[1]See A. K. Porter, *Romanesque Sculpture in Spain*, Pantheon series, 1930, and the review by G. Gaillard, Bulletin monumental, 1931. The reliefs of the choir at Saint-Sernin and those of the cloister at Moissac date from the closing years of the eleventh century; the tympana of Moissac and Saint-Sernin, from the first two decades of the twelfth century. *A date c. 1080 has been claimed for the earliest series of capitals from la Daurade, Toulouse: M. Lafargue, *Les chapiteaux du cloître de Notre-Dame la Daurade*, Paris, 1940.

influence, it was a march of Romanesque France, that its links were with Languedoc and Provence, and that it was pre-eminently the territory of vaulted churches with arcade-and-band decoration, a style which never penetrated into north-western Spain. Moreover, if we recall that Romanesque architecture proper literally overran non-Catalan Spain, and that, from Sancho I down to the great foundations of the late eleventh century, the French monks, from San Juan de la Peña to Sahagun, were the constant collaborators of the princes, and if one admits, finally, that an architectural style carries with it to some extent its decorative style, then one must at least confess that the problem is not a simple one. The 'Hispanists' and the Spanish historians are also too much inclined to underrate the logical sequence of experiments by which eleventh-century France gradually defined, as we have seen, an art which is monumental throughout, and in which sculpture is the expression of a system of architectural thought—one of the fundamental principles of Western culture. This is not so much a dispute of nationalities as a debate regarding the logical order of ideas. Whatever its conclusions may be, they cannot in any way detract from the force and originality of Spanish Romanesque sculpture.

But we must look at the monuments, their historical situation, and their style. At León, the Panteón de los Reyes is the sole surviving part of the church built by Doña Sancha and Ferdinand I, which was consecrated in 1063. It is a 'west work', belonging to that type of the porch with an upper storey, which was derived from Carolingian architecture and of which French examples from the eleventh century are to be found at Tournus, Saint Benoît and Lesterps. This was intended from the first to serve as a mausoleum, in accordance with a long established Spanish tradition. In the shadow of this old royal necropolis, beneath the groined vaults of its three low naves, there is an array of sculpture whose origins lead back, in part at least, to the neighbouring Mozarabic monasteries. The Corinthian acanthus, the rosettes, the palmettes and the broad leaves are *133* wrought into varied patterns which observe the rules of the ornamental style and *134* finally subject the human figure to it also. The majority of these capitals are products of a homogeneous workmanship active about 1070. The church which now adjoins this narthex was begun by the Infanta Urraca and consecrated in 1149. Its extensive sculptural decoration comprises several phases of Romanesque art. At the main door, the astonishing statues of SS. Isidore and Pelayo have a richness *142, 143* of substance, a fullness of volume, an authority, which distinguish them from the art of Toulouse, with its greater emphasis on profile. With their plump cheeks, their heavy locks and their tunics tormented with folds (St. Isidore's suggests an amplified version of the Asturian tubes), the old Spanish saints on their

bull's-head consoles look like tribal gods. The Aragonese cathedral of Jaca, begun in 1063, the year in which its founder, King Ramiro, died, but not finished till much later, and a whole group of churches, including Santa Cruz de la Seros, Huesca and Fromista, testify to the continuing vigour of a style which, from an early date and on the basis of local resources, carried on a series of experiments analogous to those of the French centres, with which, moreover, it was not without contacts.[1]

Clearly the drama was played out at other places besides Compostela. Silos, in Castile, is another of the vital spots in the controversy.[2] St. Domingo settled there in 1041. He built there. He was buried there. On the abacus of a capital in the cloister there is an inscription which reproduces part of his epitaph— but it is a commemorative inscription, intended to mark his burial-place in the cloister (1073–76) pending the removal of the body into the church. In 1088 a great new building was consecrated, which had been undertaken under the impetus of the existence of the great building yards, then in full activity, at Compostela, Sahagun, León and Arlanza. In the middle of the twelfth century work on the cloister was still going on.

Besides eight reliefs on the four angle-piers, its decoration comprises numerous capitals. Of the latter, some show Arab influence, but the majority, by their compositional procedures, the refined quality of the surfaces and the virtuosity of the undercutting, betray their late date; those which portray scenes from the life of Christ have Gothic characteristics. As to the reliefs, it seems likely that one workshop executed five or perhaps six of them: Crucifixion, Pentecost, Ascension, Incredulity of St. Thomas, Christ at Emmaus, and Entombment. The last-named may be slightly later; Christ on the funerary slab and the sleeping soldiers are rendered with the assurance of the fully developed Romanesque style, while the figure of the angel goes even beyond it. As to the Annunciation and Tree of Jesse reliefs, their late date is no longer in dispute.

But the earlier series is very remarkable. The figure-type is fairly constant— short, stiff arms, knees set too low down, and legs crossed, beneath the carefully

[1] See G. Gaillard, *Les débuts de la sculpture romane espagnole. Leon, Jaca, Compostelle*. Paris, 1938.
[2] See E. Bertaux, *Santo Domingo de Silos*, Gazette des Beaux-Arts, 1906 (the capitals are of 1075 and the reliefs later); A. K. Porter, *Spain or Toulouse*, Art Bulletin, 1924 (all eleventh century); P. Deschamps, *Notes sur la sculpture romane en Languedoc et dans le Nord de l'Espagne*, Bulletin monumental, 1928 (the inscription is commemorative, and not contemporary); Baron Verhaegen, *Silos*, Gazette des Beaux-Arts, 1931; G. Gaillard, *L'église et le cloître de Silos*, Bulletin monumental, 1932, reconsiders the building-history: the eastern parts of the church were enlarged by Abbot Fortunius, while St. Domingo merely repaired the pre-Romanesque church of Asturian type. Cf. Dom Marius Ferotin, *Histoire de l'abbaye de Silos*, Paris, 1897; Dom Roulin, *Les églises de l'abbaye de Silos et les cloîtres de l'abbaye de Silos*, Revue de l'Art chrétien, 1908–10; J. Pérez de Urbel, *El claustro de Silos*, Burgos, 1930. *Also M. Schapiro, *From Mozarabic to Romanesque in Silos*, Art Bulletin, 1939.

arranged and rather clinging tunics. The ground is sometimes rendered as a collection of rounded clods of earth, like fruit, and engraved with a kind of ornamental fold which curls round like a short volute. In the Pentecost and the Incredulity of St. Thomas there are many figures, packed closely together and arranged in parallel ranks, one above the other; deep channels of shadow divide the clusters of figures; each body is calmly and solidly modelled—the relationship with Moissac and Toulouse is manifest. The Christ at Emmaus is strangely beautiful. He does not walk towards the disciples, but is leaving them, towering over them and turning back his head—a head like that of a young Eastern king, with long, thin nose, smooth cheeks, and curled beard falling in parallel strands. He moves forward, like the Toulouse Apostles, with a slightly dancing step. It is enough to glance at the nervous execution of the feet in order to be convinced that this is not a work of the eleventh century. In the spandrels of the Incredulity of St. Thomas there appear, along with anecdotal figures, the aedicules with colonnettes and imbricated roofs which are common in the later phases of Spanish Romanesque sculpture. Possibly these reliefs are contemporary with the second generation in Languedoc. In any event neither the secret of the composition of the tympana nor, generally speaking, their continuity and their calculated play of movement, could have emerged from the juxtaposition of figures of this kind, however skilful and moving they may be. Nor do the heterogeneous statues set over the Puerta de las Platerias at Compostela, fragments from an earlier scheme of decoration, give any hint of them, and the tympana there seem a random assemblage of sections of frieze.

But is this not perhaps a too rigorous application of the principle of stylistic conformity? Certainly there is here a new and powerful humanity, animated by a strange passion and the mystery of a profound spiritual life; there is also the substance of flesh. The woman holding a skull at Compostela, who appears again, monstrously deformed, as a dwarf with an enormous head on a console of the Porte Miégeville at Saint-Sernin, is human and feminine, with her dishevelled hair and the supple, almost liquid, modelling of her body, but is at the same time inhuman by reason of the fixed and dreadful intensity of her expression and the legend which she illustrates. On either side of the Pyrenees, linked by the pilgrimage roads, the workshops of Galicia and those of Languedoc certainly collaborated, though it is not always possible to estimate the extent of their individual contributions[1]. In any event, it was the second Moissac workshop

*[1]On Languedoc sculpture, see a short but important article by G. Gaillard, *De la diversité des styles dans la sculpture romane des pèlerinages*, Revue des Arts, 1951, pp. 77–87. The most complete study of Moissac is by M. Schapiro in the Art Bulletin, XIII, 1931.

which, about 1115, orchestrated for the first time in stone, with a breadth and coherence which were definitive for a whole style, the terrible cantata of the Apocalypse, on a theme enunciated, with variations, by a monk in a Spanish monastery. But how remote, both in form and inspiration, are the figurines of the manuscripts, traced with the point of the reed pen, brightly coloured and invariably graphic, from the actors of this superhuman drama carved in stone! The suggestion of modelling by decorative folds, the rhythmic swirl of the hems of the robes, and all the arabesques which run calligraphically over the surfaces of the bodies, in Languedoc as in Burgundy and all the other regions inhabited by the Romanesque spirit, are not so much a residue of the draughtsman's modelling on bodies which have acquired their own mass and volume, but rather a kind of surface-eddy of the hidden system by which the composition is held together.

The part played by Auvergne, Poitou and Saintonge in the definition of the style was of great significance; but neither Poitou nor Auvergne (except at Conques, which connects with the Auvergne group) composed these vast tympana which epitomize and amplify the Romanesque idea. It is not that the artists of Aquitaine never utilized sculpture in the upper parts of the false doors which are characteristic features of the architectonic decoration of the façades in Angoumois, Poitou and Saintonge. They produced tympana of unusual form—crescent-shaped (Lichères, Champagne-Mouton) or composed of two arches (Vouvant). Nor must we forget certain tympana of normal type, grouped in the neighbourhood of Angoulême, of which the best-known is that of Saint Michel d'Entraygues, depicting the archangel fighting the dragon (after 1137). But these are late works, some of which, like the tympanum of Champniers (after 1150) where the treatment of the tetramorph is touched by a spirit of anecdote, escape altogether from the Romanesque style.[1] Despite the beauty of certain examples, it is not in the tympana that the essential qualities are found. But our technical analysis has shown us with what mastery the south-western sculptors bent the archivolt-figures and persuaded them into the narrow frame of the voussoir. We know too the richness of modelling—held strictly within the limits of the wall—of the sculptural decoration of Poitou and Saintonge, a modelling which acts to some extent by linear suggestion, combining the labyrinth of ornament and image with the delicate mesh of deep shadow, close-knit and continuous. Excellent examples of this may be seen in Saint-Pierre at Aulnay, Saint-Marie-des-Dames at Saintes, Corme-Royal, Pont-l'Abbé and Rétaud. On the other hand,

129

[1] See T. Sauvel, *Tympans de l'Angoumois*, Bulletin monumental, 1936.

in the figures grouped beneath arcades or set against the bare wall (Châteauneuf-sur-Charente, Matha), the art of south-western France also foreshadows a new type of sculpture and prepares the way for Gothic art. The horsemen who trample on the enemies of the Church, inspired either by the Capitoline Marcus Aurelius (wrongly supposed to be Constantine) or by some Roman model in Gaul, are sometimes simply a 'piece of sculptured wall' (Parthenay-le-Vieux, Saint-Jouin-de-Marnes)—but elsewhere they have the balance and volume of independent statues.[1] Certainly the Romanesque sculpture of Poitou was not proof against influences from Languedoc: those archivolt figures of Virtues which are not circumferential or radial but tangential to the curve of the arch have the characteristic proportions and drapery system of Toulouse and Moissac[2]. In addition, Muhammadan Spain, during the crusade of reconquest, introduced into the iconography and even into the style recognizable touches of Oriental influence: the great lions which leap around the doorway of Chadenac are perhaps derived from a hunting-scene on an Arab ivory, but they describe a course which follows and repeats the curve of the arch. Without ever leaving this area it would be possible to write a history of continuous and varied development from the earliest sculpture of Saint-Hilaire at Poitiers and the modillion-man of the Musée des Antiquaires de l'Ouest down to the Baroque phase.

Auvergne is old in sculpture, with the plaques of Thiers and Saint-Alyre, and the capitals of Chamalières. In the eleventh century Guinamundus, a monk of La Chaise-Dieu, was known far and wide for his works of architecture and sculpture. In Auvergne we find some of the earliest examples of the atlantes which underline so powerfully the structural function of the capitals. And certainly some of the Auvergne workshops were most forceful composers of those superb figured blocks. Men, beasts and monsters are packed energetically together and assimilated to the shape of the bell. The art of Master Robert, at Notre-Dame-du-Port, about 1130, is characterized by compactness and vigorous plasticity. In Saint-Julien at Brioude, at Saint-Nectaire and, later, in Notre-Dame at Orcival, and at Besse-en-Chandesse, the capitals are more concentrated, wilder, and perhaps more skilful than in the other groups. But the master of the capital of the Holy Women at Mozac bathes his lovely figures in a serener light. The Auvergne *115*

[1]The 'baronial' theory, according to which these figures represent the local nobility, the benefactors of the various churches, is now discarded. Cf. E. Mâle, *L'art religieux du XIIe siècle en France*, p. 248, and T. Sauvel, *Les hauts-reliefs romans de Surgères*, Revue de Saintonge et d'Aunis, 1936. Surgères is exceptional in having two horsemen, one on either side of the central door. *On the statues of Constantine, see J. Adhémar, *Influences antiques dans l'art du Moyen-Age français*, London, 1939.
*[2]The connection with Moissac is also stressed by T. Sauvel, *La façade de Saint-Pierre d'Angoulême*, Bulletin monumental, 1945.

masters were also sculptors of lintels, and under the double slope of the charac-
teristic pediment-shape they create figures of massive breadth; the compactness
of the compositions recalls the style of the sarcophagi rather than the geometry
of Languedoc (Mozat, Le Chambon, Thuret). But in Notre-Dame at Le Puy,
alongside foliage capitals of Gallo-Roman inspiration and some Romanesque
figured capitals, Islam has left its imprint on a sculpture which overlays Moorish-
style panelling with a veil of openwork ornament, while the wooden doors,
decorated with flat figure reliefs, bear a Kufic inscription.[1] Mozarabic influence
also made itself felt in Basse-Auvergne, not only in the wood-shaving modillions,
but also in capitals carved after the Cordovan fashion, which are found as far
away as the Loire.

Thus the Romanesque style arose from the collaboration of the workshops
of the Spain-Languedoc group, and those of Burgundy, Auvergne, Poitou and
Saintonge, and its massive unity was naturally subject to a variety of local
colourings. The Romanesque transformations were by no means unknown to
Norman art;[2] on the contrary, it can show examples of the strict application of the
ornamental style to tympanum-compositions without iconography, in which
confronted beasts are combined with interlacing foliage scrolls to form a palmette-
pattern, as at Wordwell and Knook, which are closely related to two tympana
at Beauvais (those of Saint-Étienne and the old church of Saint-Gilles), while
the motif of Wynford Eagle recurs in France at Villesalem—a few examples from
the many which link Normandy with the Domaine Royale and western France.
As to the monsters which adorn the spandrels in Bayeux cathedral, their resem-
blance to certain western Asiatic forms is very striking. Their situation in the
architecture, which has been chosen purely for effect, as well as their peculiar
style, suggests outside influence rather than native inspiration[3]. Again, it may be
asked whether there was not, in northern France and Belgium, a survival of an
earlier style, in fonts for example, side by side with the true Romanesque forms.

By these latter Germany remained largely untouched. Its greatness in the
plastic arts lay in its stuccos and bronzes, and not in monumental sculpture: the

[1]The same technique is found also at La Voûte-Chilhac, at Blesle, and at Chamalières-sur-Loire.
In his important review of A. Fikry's book, in Journal des Savants, 1936, L. Bréhier notes the frequent
occurrence at Le Puy of the Adoration of the Lamb, a subject derived from Mozarabic Spain, where
it appears on tympana and in Apocalypse manuscripts. It is uncommon in the adjacent provinces.
*[2]Our information on Romanesque sculpture in Normandy is still very limited. On the other hand the
diversity of style in English Romanesque sculpture can be appreciated from C. E. Keyser, *Norman
Tympana and Lintels*, 2nd ed., London, 1927, and from the two small volumes by G. Zarnecki,
English Romanesque Sculpture 1066–1140, London, 1951, and *Later English Romanesque Sculpture
1140–1210*, London, 1953, and from T. S. R. Boase, *English Art 1100–1216*, Oxford, 1953.
*[3]Recent study by E. Lambert, *Les écoinçons de la cathédrale de Bayeux*, Särtryck ur Studies tillägnade
Henrik Cornell, Stockholm, 1950.

Ottonian workshops had inherited these traditions and passed them down to the thirteenth century. Stone-sculpture presents a composite picture, coloured in the Rhineland by the classical tradition, at Basle by Burgundian influence, and in Alsace and a good deal of the rest of Germany by contributions from Lombardy. The impressive (late) figures in the choir of Bamberg reflect Roman art as seen by a Romanesque master. But the colossal Deposition cut in the living rock at Extern, near Detmold, suggests a troglodyte version of Romanesque art. In this old imperial tradition on the one hand and this coarseness of scale on the other, there was no doubt a more authentic instinct than appears in the importations from the west and south. Yet in the astonishing reverie in stone of San Michele at Pavia there existed a purity and over-refinement of ornamental composition, together with a teeming vitality and a quality of mystery which were profoundly sympathetic to the German taste. The diffusion of Italian style took place along the lines of the Roman roads, through the passes of the Alps and across the ancient kingdom of Arles.[1] It introduced column-bearing lions beneath porches of Lombard type at Reichenau and Salzburg. From Borgo San Donnino, the scene of the Flight of Alexander travelled to Basle, Freiburg-im-Breisgau, and Remagen, and the classicizing medallions of Ferrara recur at Oberpleiss. Alsatian sculpture includes numerous southern elements in its severe façades. Murbach, Rosheim, and most of all Andlau, seem to reflect, though fragmentarily and without unity, Sant' Ambrogio at Milan, San Zeno at Verona and the cathedral at Modena. These somewhat heterogeneous and ill-assimilated influences are in line of descent from the earlier travels of Lombard masons and architects along the high roads of Western Europe.

Other regions also contributed an important and individual share to the history of this movement, which, by its forms, so profoundly affected the life of the spirit. We no longer believe that Provence was the fountain-head of the North French portal-sculpture of the second half of the twelfth century, nor that it upheld an unbroken classical tradition. Instead it seems remarkably complex. At an early date, if we are to credit the reputation of the workshops of Saint-Ruf at Avignon, of which nothing survives, it possessed sculptors of repute. The frieze-style has left remains, in association with first Romanesque architecture, at Saint-Restitut and Cruas. And the same style and technique characterize

[1] René Jullian has thrown light on the subject of these movements and influences: *Le portail d'Andlau et l'expansion de la sculpture lombarde en Alsace à l'époque romane*, Mélanges d'Archéologie et d'Histoire publiés par l'École de Rome, 1930. St. Richarde, the foundress of Andlau, had travelled in Italy, as had her friends. One of them, Liutward, was Bishop of Vercelli. The lintel (Adam and Eve) is more or less inspired by the Modena Genesis. The tympanum is more Alsatian in its iconography—Christ handing the book to St. Paul and the keys to St. Peter, a subject which recurs at Marienheim and Sigolsheim—but in composition recalls the tympanum of Nonantola.

89 the tympanum of the delightful church of Saint-Gabriel, as well as the relief let into the triangular pediment—no more lively contrast could be imagined than that between this architecture and this sculpture. An archaistic Romanesque maintains in Provence the art of the eleventh century. On the other hand, on the middle Rhône, at Vienne and Valence, in the area of immediate Burgundian influence, a much more accomplished sculpture subjects everything to Romanesque stylistic principles, including even the reminiscences of Roman art, which are few and inconspicuous. Saint-Gilles du Gard and Saint-Trophime at Arles display extensive ensembles representing three phases of Provençal sculpture in the twelfth century. Saint-Gilles, with its handsome colonnade built out at the front, was begun in 1116, but the sculpture is assumed to be subsequent to that date,[1] and the tympana still later. Under the luminous shadow of the portico, between piers and architraves forming, as it were, rectangular niches, the Saint-Gilles figures appear in a Roman setting, but they are not Roman, nor are they essentially Romanesque; independent of the architecture, in which their role is purely decorative—and this is the most 'antique' thing about them—they bear the marks of Languedoc influence, as do the statues of Saint-Denis, which were not inspired by them, though there was perhaps some connection. But there exists between them and the column statues a profound and unbridgeable gulf, especially in the treatment of the shadows, which are here seen with the eye of the painter, rich and deep, whereas a sober ornamental modelling leaves intact the volumes of the figures of Chartres and Étampes. In any case, the tympanum depicting Christ and the tetramorph belongs to the iconography of the second half of the twelfth century. It reappears

[1]Two funerary inscriptions of 1142 have been remarked on the western wall of the crypt, a wall which was built to support the sculptured façade. See R. de Lasteyrie, *Études sur la sculpture française au moyen âge*, Monuments Piot, vol. VIII, 1902, pp. 96–102. M. Schapiro, *New documents on Saint-Gilles*, Art Bulletin, 1935, observes that this hardly provides a reliable basis for dating, since there is nothing to prove that the inscriptions were placed there immediately before the construction and immediately before the execution of the sculpture. He has, moreover, discovered three funerary inscriptions relating to persons who, according to the obituary of Saint-Gilles, died in 1129. The date of the reliefs may therefore be put back. The chronology of Saint-Gilles has oscillated widely. For R. Hamann, *Geschichte der Kunst*, Berlin, 1933, and Burlington Magazine, 1934, pp. 26–9, work on the church was begun about 1096. For A. Fliche, *Aigues-Mortes et Saint-Gilles*, Paris, 1925, p. 75, the sculpture dates from the first half of the thirteenth century. Except for the tympana, there is no reason why the decoration of Saint-Gilles should not go back to the first third of the twelfth century. *The problem of Saint-Gilles has been revised by M. Gouron, *Dates des sculptures du portail de l'église de Saint-Gilles*, Bulletin de la Société d'Histoire et d'Archéologie de Nîmes, 1935. Petrus Brunus, 'artifex in opere ligneo et lapideo,' appears as a witness to various documents: at Saint-Gilles in 1157 and 1171, at Nîmes in 1165 and 1186. As two of the statues at Saint-Gilles are signed Brunus, this part of the decoration is now commonly dated in the 1150's. But the lower parts of the façade are certainly older and the upper parts are later than 1185; the side doorways may even be as late as c. 1210. The present condition of the west front at Saint-Gilles is the result of many alterations which have not yet been completely elucidated.

at Saint-Trophime, whose façade is still later in date; the cloister is dated 1180 by an inscription on the north-west pillar; the capitals, moreover, show a very evolved stage of the Romanesque style, in complete control of all its resources.

We cannot examine in detail the importance of the connections between Provence and Italy; iconographically they are striking, and they appear also in the style. Of the wide diffusion of southern forms we have already seen numerous examples in Germany and Alsace. Italy, moreover, was as various in sculpture as it was in architecture during the Romanesque period. It was Byzantine and classicizing in the south, where we find the art of imperial Capua inspiring the beginnings of Nicola Pisano. In Tuscany, polychromy was at odds with sculpture, which concentrated on lintels at Pistoia (1166–67) and Lucca, and created one richer and nobler ensemble in the doorway of the baptistery at Pisa, facing the cathedral. It is in Lombardy that we find a genuinely Romanesque sculpture, often showing a remarkable stylistic energy.[1] Its first (and certainly its most curious) aspect is exemplified in the churches of Pavia, San Pietro in Ciel d'oro (1132) and San Michele, with a luxuriance, vitality and variety which savour, not of crude beginnings but of feverish mannerism. Monsters and ornament cling together in identical convolutions. The great portals of Master Guglielmo and Master Nicolo are of another inspiration. Sheltered by flimsy porches whose slender colonnettes rest on the backs of a pair of crouching lions, they display, on either side of the door, reliefs let in flush with the façade wall and still recalling (like the Catalan portal at Ripoll) the facing-slab or the ex-voto. This taste for a pictorial treatment of the wall-surfaces long remained characteristic of Italian art. There is a fine example at San Zeno in Verona, where the old bronze doors, memorials of the art of the 88 German bronze-founders whose reputation and handiwork travelled as far as Novgorod, are flanked by a system of arcades and shallow pilasters enclosing tiers of reliefs by Guglielmo and Nicolo. The first of these two artists was also responsible for the great portal of Modena, whilst it is mainly at the cathedrals 80 of Verona, Piacenza and Ferrara (1135?) that the second must be studied: his doorways, with statues of prophets accompanying those of the old paladins, Oliver and Roland, are in some respects reminiscent of the art of the transition in France. It is at Modena (not in Guglielmo's porch, but on the doorway by the campanile) that the deeds of Arthur are depicted, along with episodes from

*[1]On Romanesque sculpture in Northern Italy, see G. de Francovich, *Wiligelmo da Modena* , Rivista del Reale Instituto d'Archeologia e Storia dell'Arte, 1940; T. Krautheimer-Hess, The *Original Porta dei Mesi at Ferrara and the Art of Niccolo*, Art Bulletin, 1944; R. Jullian, *L'éveil de la sculpture italienne*, Paris, 1945; R. Salvini, *Wiligelmo e le origini della scultura romanica*, Milan, 1956. Many points of chronology are still controversial.

the *Roman de Renart*. While the homely, stocky forms of the façade reliefs, with their breadth of feeling, suggest the eleventh-century frieze-style, with some reminiscences of antique sarcophagi (funerary genius of Modena), the Lombard capitals show the patterns of the Romanesque style-system in all their purity. But the charmingly youthful nudes of Modena introduce into them a very human poetry. At the cathedral (1178) and baptistery (1196) at Parma, and at Borgo San Donnino, Benedetto Antelami displays a rich and learned iconography, of Gothic inspiration, while his figures, at first treated rather inflexibly but later becoming more supple, are poised, weighty and nobly monumental. The Deposition,[1] let into the south wall of the transept of Parma cathedral, is strangely stiff. It seems to exaggerate the compositional formulae of half a century earlier. The group on the left, without any flexion of the body, all lean over, as if by magnetic attraction, in the same direction as Joseph of Arimathea leans to receive the body of Christ. The strictly horizontal wings of the angels are extensions of the arms of the cross. The figures of Sun and Moon are set like cabochons in the upper register, and the whole scene gives the impression of having been drawn out with a ruler. But the parting of Christ's raiment, on the right, is an anecdote which is already Gothic in feeling. This Janus-headed art is nearer to Provence than to Modena. Its unity lies in its serene modelling and full volumes. But works like the seated prophets, and the Solomon and the Queen of Sheba of the baptistery no longer belong, either in date or in style, to Romanesque art.

The interest of the peripheral centres which extend from England, through northern France, Belgium and the Rhineland down to Lombardy, forming a wide fringe round the workshops of central and south-western France and northern Spain, lies in their exhibiting, apart from the diffusion of the clearly defined, architecturally dominated Romanesque style, elements of earlier traditions together with the first fruits of a new art. The Anglo-Norman territories show the vocabulary and sometimes the compositions of northern Europe with some traces of influence from farther afield; to the East, Carolingian forms and techniques persisted; in Mediterranean France and Italy, first Romanesque sculpture held its ground, side by side with classical reminiscences; while the Ile-de-France, about the middle of the twelfth century, created a new iconographic theme and a

[1] A fragment of an ambo, to which another relief, representing Christ in Majesty, and three capitals also belonged. The latter are disputed. According to R. Jullian, *Les fragments de l'ambon de Benedetto Antelami à Parme*, Mélanges d'Archéologie et d'Histoire publiés par l'École de Rome, 1929, they are by a master very close to Antelami, but of a more amiable and facile spirit. *G. de Francovich, *Benedetto Antelami, architetto e scultore, e l'arte del suo tempo*, 2 vols., Milan-Florence, 1952, dates the Parma ambo c. 1175–78 and attributes it to Antelami's youth (he was born c. 1150).

new monumental style whose influence was soon felt as far away as Provence, Italy, and even Spain, where the portal of Sanguesa displays column-figures on a façade of the Saintonge type. Romanesque art and Gothic art were not successive chronological stages. The essential fact is that a subsidiary centre became the main centre.

Our technical analysis of Romanesque sculpture and our study of its origins and its earliest manifestations in the twelfth century—that is, the moment at which, enriched by the discoveries of the eleventh, it attains its classic complete-ness and stability—have already made us acquainted with its regional varieties. There remains for us to indicate briefly the manner of its further development and its ending. Its decline is heralded by a number of symptoms which rarely appear singly, though their appearance is not necessarily synchronized: these are overabundance, neglect of structural functions, the pursuit of pictorial effects, a taste for anecdote, and increasing aridity. By spreading itself with a lavishness which disregarded architectural discipline, and by overrunning members for which it was ill-adapted or whose function it obscured or enfeebled, the decoration escaped from the strict regime which had confined it to definite situations and definite frames. The patterning of colonnettes with guilloche-ornament, especially in south-western France, is an early example, which is followed up by the related treatment of the short columns which serve as bases in some Burgundian portals. The pursuit of effects also invades the composition and modelling of the actual plastic forms, or rather we see in these one of its elementary applications. A network of flickering shadows, a scattering of exces-sively numerous and varied accents, compromise the balance and unity of the monumental block. The churches of Poitou and Saintonge lent themselves, by reason of the relatively soft stone of which they are composed, to technical displays in which virtuosity is the controlling principle, and at the same time to an illusionism which replaces the full, compact volumes of the sculpture, even when entirely ornamental, with the values, the devices, and almost the very brush-strokes of the painter. Shadow ceases to be the natural projection of illuminated bodies, a calculated progression into light, and becomes a zone arbitrarily hollowed out behind them. The taste for anecdote, detail, pictorial realism and truth to nature, together with a touch of wit or humour, in the representation of accessories, usurps the place of the old hierarchic organization, and slackens and enfeebles the quality of the style. The demand for story-telling and the interest in the accuracy of the detail were in line with popular feeling; but they were at odds with a more exigent regime. Burgundy, in the capitals of the nave at Vézelay, provides in this respect an example of the way in which a

great school was able to combine opposing tendencies, by introducing the familiar scenes of rural life without adulterating the economy of the style. But it was through this crack, so to speak, that the spirit of Gothic art first became visible, and its development was rapid.[1]

But if in some places the style disintegrated, or tended to disintegrate, as a consequence of these new aims and interests, it also tended, in areas of less rapid evolution, to persist and harden. The rules whose character and effectiveness we have observed, were not in the first third or even the first half of the twelfth century a code whose rigorous logic was applied inflexibly to every case and provided the solution of every problem. It must not be forgotten that life was never excluded: Romanesque sculpture, based on an architectural idea and an ornamental composition, was not a sapless sculpture. But it became so, through too great a reliance on the formulae, and as an inevitable consequence of industrialization and mass-production. In the places where it survived longest, in Catalonia, the cloister of the cathedral of Gerona and, not far from Barcelona, that of Sant Cugat del Valles[2] allow us as it were to witness several phenomena which enable us to classify and date the groups of capitals—not only, in the latest period, the elegance and the pursuit of detail in disjointed compositions which follow no principle but that of narrative charm, but also, in the initial stage of purely ornamental designs, the thinness of the volumes, the crabbed angularity of the silhouettes, and the crumbling dryness of the increasingly slender plant-stems. The law of the conservation of types, which, by fixing and restricting invention, ended by impoverishing all the varieties of the style, introduced the same moulds and the same models everywhere. A curious case of the misdirection

145

[1]There are interesting examples of the Baroque phase of Romanesque art even in Basse-Auvergne, in the chevet of Saint-Pierre de Blesle, on the edge of the Cantal. Its capitals were carved between 1150 and 1180, possibly by pupils of the artists who, a generation earlier, were working on the southern chapels of the same church and on the cloister of Lavaudieu. This sculpture is not unrelated to the great Catalan workshops of Galligans, Elne, and Estany, which, about the same time, though faithful to the old Romanesque tradition which was still vigorous in those regions, were nevertheless giving it a very novel accent. The characteristics of the second workshop at Blesle recur in the chevet of Saint-Julien at Brioude and in the church of Chanteuges. M. Bréhier, who brought this series to the general notice, regards it as the development of a local school. But the phenomenon is typical. The capitals of the quintain and of Fertility, with their figures corbelled out so as to project beyond the line of the shaft, and their deeply undercut masses, are characteristic of the Baroque phase. The same distinction may be made at Brioude, between the capitals of the chevet and those of the rest of the church. See L. Bréhier, *Les chapiteaux de Saint-Pierre de Blesle*, Almanach de Brioude, 1929.
[2]See J. Baltrusaitis, *Les chapiteaux du cloître de Sant Cugat del Valles*, Paris, 1931. In addition to the internal evolution, external influences also play a part in certain cases. The masons' yards of Lerida and Agramunt were in contact with the late Toulouse workshops. Moorish elements (already apparent in certain capitals of the same area in the eleventh century) are notable in the cloister at Estany, where the motifs of the pottery of Paterna are found (lecture delivered by J. Puig i Cadafalch, Institut d'art et d'archéologie de l'Université de Paris, February, 1933).

of functions and forms occurs, at Sant Cugat, in association with these signs of degeneracy, but it is also found in very many capitals of the second half of the twelfth century: the volutes, which Romanesque art had transformed into crockets and atlantes, become a species of hanging boss at the four corners of the abacus. They do not support; they aggravate the weight. These fragile suspended aedicules, like stalactites, are a categorical denial of the structural logic of Romanesque sculpture, enunciated by the Baroque spirit of its decline.

But the world of forms which it had invented retained the silhouette and the mimic power produced by the frames within which it had come to birth, even after those frames had been shattered. The syntax had created a vocabulary, but the vocabulary outlived the syntax. The twilight of Romanesque art is full of these aberrant forms, born, at an earlier period, from the vigour of its dreams. Some were inherited by Gothic art, but their vitality was transformed and en-feebled: the monsters became grotesques. The enigmatic subjects on the bases at Sens and the Portail des Libraires at Rouen, are not so much evidence of a capricious liveliness, as remains of an art which has lost its actuality. But at the close of the Middle Ages it regained—with an almost explosive force—all its old virulence. As soon as the Gothic system began to disintegrate, the monsters awoke, and swarmed once again on to stone, wood and parchment. And it is difficult to decide whether this singular phenomenon is in truth a 'revival' or an intensified expression of an uninterrupted subterranean existence.[1]

V

IN this way Romanesque architecture extended its laws into the sculpture which adorned it. No period or style ever created a more intimate unity between constructed stone and sculptured stone. But the patterns of light and shade were not the only ones which brought the life of colour into the buildings. The Romanesque church utilized polychromy for sculpture and welcomed mural painting. The study of the first of these subjects is rendered difficult by the extreme rarity and the poor state of the surviving examples. The delicate appli-cations of paint which clothed the stone with a thin skin of colour have almost entirely disappeared, but the traces which here and there remain testify to the importance of its practice, so widespread in antiquity, though they do not provide us with a basis for a precise estimate of its role and extent in the twelfth century. Was polychromy used for the sake of emphasis—for instance, to make

*[1]H. Focillon has further developed these ideas in *Quelques survivances de la sculpture romane dans l'art français*, Mediaeval Studies in Memory of A. K. Porter, Cambridge, Mass., 1939; reprinted in H. Focillon, *Moyen-âge, Survivances et réveils*, Montreal, 1945.

the reliefs stand out more sharply against the backgrounds ? It is hard to believe that masters so highly skilled in the architectural and plastic interpretation of space and, as we shall see, so sensitive to the optical values of painting, would risk the disorganization of a system which had been built up with such ingenuity. More probably the polychromy of the sculpture was in their eyes an adornment of the same kind as the polychromy used in horizontal courses or in patterned setting of the masonry. But it is also possible that, by intruding it into the processes of ornamental composition, they took advantage of it to point or imitate certain effects and movements.

We are better placed to judge of the wall-painting. Its importance strengthens the suppositions inspired by the remains of polychromy proper, and suggests that the latter was the connecting link in the harmony of architecture, sculpture and painted decoration. This great middle age of stone was also a middle age of painters, and, although the main development of stained glass took place within the wider Gothic windows, the rich hues of glass also played their part in this universal harmony. We must picture the Romanesque basilicas, not in that state of majestic bareness to which they have been reduced by the ravages of time and in which they nowadays hold our affections, but with a richness of colour, ranging, as required, from a few touches of polychromy to the amplitude of the great narrative cycles painted on the walls or worked in textiles. From an early date Romanesque art had utilized for the decoration of palaces and religious buildings the figured textiles, tapestries or embroideries which had continued the tradition of large-scale historical painting. Of these we possess one remarkable example, the 'telle du Conquest d'Angleterre' (cloth of the conquest of England), traditionally attributed to Queen Matilda, which was formerly hung up on St. John's day in the cathedral of Bayeux. In this curious masterpiece, the Oriental bestiary, reduced to a few motifs, accompanies in two parallel bands the narrative of the military and naval operations of the Normans.[1] We must also, by an

[1]The treasury of the abbey of Saint-Denis is reported to have possessed at one time an embroidery worked by Queen Bertha, which celebrated the fame of her family. Gonorra, wife of Richard I, is extolled in the *Roman de Rou* for her skill in this art. The Duchess of Northumberland presented to the cathedral of Ely an embroidery recording the exploits of her husband. The apartment of Adela, the daughter of the Conqueror, was decorated with hangings of biblical and historical scenes. See A. Levé, *La Tapisserie de Bayeux*, Paris, 1919, p. 7. The tapestry, or rather the embroidery, of Queen Matilda, is more than 230 ft. long, by about 19½in. deep. It is made up from eight pieces of linen, joined by fine seams. The wools are of eight colours—three shades of blue, two of green, a red, a yellow tending to buff, and a dove-grey. The various sections, which differ in certain respects, particularly in the proportions of the figures, were perhaps begun simultaneously by several groups of workers. According to some writers, the embroidery was ordered and directed, not by the wife of the Conqueror, but by another Matilda (daughter of Henry I of England and wife of the emperor Henry V), who died in 1167. Others consider it to have been made the behest of Odo, Bishop of Bayeux and half-brother of William. See Émile Travers, Congrès archéologique, Caen, 1908, p. 182. *The basic work now is Sir Frank Stenton, ed., *The Bayeux Tapestry*, London (Phaidon Press), 1958.

effort of thought, take from the museums and treasuries and replace in the life of the church the liturgical textiles, still bearing the medallions and symbols of the East, and the reliquaries, enamelled by the Limoges and Mosan masters, in the shape of heads, arms, coffers and buildings, in which the relics of the saints were displayed for the veneration of the faithful. The treasury of Conques, with the golden figure of St. Foy seated stiffly on her throne, her jewels flashing like apocalyptic eyes, with the A of Charlemagne and the reliquary of Pepin of Aquitaine, glitters in solitude: we must imagine it shining over bowed heads, as in the days when two scholars of Chartres, come to the great pilgrimage of Rouergue, were scandalized by the idolatrous fervour of a southern crowd worshipping the images.

Metalwork, illumination and wall-painting were interrelated, and all more or less dependent on architecture. Often the manuscript painter was a goldsmith in illumination and the goldsmith was an illuminator in metals, not only by virtue of vague analogies such as the use of gold in painting, but also for more definite reasons, which prove, moreover, that it would be profitless to hold up one of these arts as the source of all the others and that, on the contrary, they constantly exchanged resources. The large initials of the Merovingian zoomorphic alphabets are subdivided internally by little bars in the same way as compartments of enamels. Some of the ornamental pages of the manuscripts of the Irish style are composed like an arrangement of enamelled plaques. Ottonian art offers a striking example of these exchanges in the Gospel-book of St. Bernward (treasury of Hildesheim cathedral): the three kings in the Adoration scene are divided up into broad bands edged with lighter lines which look very like cloisons. The method of drawing is also similar in the two techniques: the dark line in the miniature circumscribes and isolates the zone of colour, just as the gold strip of cloisonné or champlevé[1]

[1]The most remarkable feature of Western enamelling is the replacement of cloisonné by champlevé. Instead of a thin metal thread soldered to the ground, the ground itself rises to the surface. The enamel is thus incorporated in the material of the object and the design becomes more vigorous. This technical revolution was doubtless effected at Conques, in Rouergue, after 1107, under Abbot Boniface. The lands of the abbey of Saint-Martial at Limoges extended into this area. We do not know whether it possessed a workshop of goldsmiths. It exercised its influence, thanks to its manuscripts, through the legend of its patron saint, especially the episode of St. Valérie, after decapitation, bringing her head to St. Martial. Traces of this influence may be found even in the Romanesque sculpture of Roussillon. Again, we are unaware whether a workshop existed at the abbey of Grandmont, whose famous altar, destroyed at the Revolution, is known to us from the dispersed fragments in the Louvre, the Musée de Cluny, and the treasury of Orense in Galicia. At the end of the twelfth century lay goldsmiths and silversmiths replaced the abbey-workshops. The trade in 'Limoges work' spread all over Europe. Industrialization exercised a regressive influence on the style—mass-produced appliqué figures, juxtaposition in place of composition, and reappearance of figures beneath arcades. See P. Lavedan, *Léonard Limosin et les émailleurs français*, Paris, 1913, p. 16; J.-J. Marquet de Vasselot, *Les émaux limousins à fond vermiculé*, Revue archéologique, 1905, and, regarding the later development of this art, the excellent studies by the same author in Gazette des Beaux-Arts, 1904, 1911, etc., as well as his *Bibliographie de l'orfèvrerie et de l'émaillerie françaises*, Paris, 1925.

isolates the enamels. The same may be said of stained glass—manuscript in its network of lead-lines, enamel in its coloured material.

The logic of Romanesque architecture dominated the decorative arts. Obviously the application of this rule varied according to circumstances, but even metalwork was dominated by it. When the goldsmith was not a sculptor of cult-images, heads or limbs, he was an architect of reliquaries. He gave to the shrines the form of chapels, adorned with arcades and covered with pitched roofs, while the pyxes were little turrets with perfectly conical roofs. The Cologne masters gave a magnificent development to the motif of the basilica of Greek-cross plan, surmounted by a cupola.[1] Thus there was installed within the church another tinier church, not necessarily of the same type, but invariably conceived as architecture, like a microcosm surrounded by the vastness of the universe. A similar meaning must be read into the decorative architecture of the manuscripts, the canopies sculptured in stone or ivory, the arcades and pillars of carved wooden furniture. But such small-scale replicas are only one form of a much wider harmony. This reacts characteristically upon wall-painting. Nor does the painting of the manuscripts escape it. Like the reliquaries, most of the latter were conceived with a view to the broad spaces of the church. They were designed to accord with the scale of the building. They formed part of the liturgical furnishings, and have the necessary shape and format for being held by strong hands or laid on tall lecterns before which a man stood upright, between massive columns and beneath immense vaults. The parchment on which the images rest is of the same colour as the wall and seems to frame them within a broad border of stone. The figures with which they are adorned often possess the amplitude, the dignity and the calm strength appropriate to mural decoration. Were they perhaps copied for that purpose? But the unity of style needs no such explanations. The manuscripts of Ottonian art can show examples of large-scale historical paintings: the Otto II of the *Registrum Gregorii* (Chantilly), the Otto III of the Bamberg Gospels (Munich), calm, massive and colossal, and the coronation of Henry II between SS. Ulrich and Emmeran, in the Sacramentary of Henry II (Munich). A similar correspondence of style, still more exact and striking, may be found later, on a different level and in quite another area. During the second

[1]For instance, the reliquary of the Guelph treasury exhibited in Berlin in 1930, No. 22 of the catalogue (1175). Each arm of the cross is terminated by a pediment below which a segmental arch frames a scene from the Gospels. In the centre rises the cupola, each side of which is hollowed out below to form a niche containing a seated figure. Around the drum are figures of Christ and the twelve Apostles. Prophets beneath arcades occupy the lower part of the reliquary. See W. A. Neumann, *Der Reliquienschatz des Hauses Braunschweig-Lüneburg*, Vienna, 1921, No. 23, and O. von Falke, R. Schmidt, and G. Swarzenski, *Der Welfenschatz*, Frankfurt-am-Main, 1930. *An almost identical work, the Eltenberg Reliquary, is preserved at the Victoria and Albert Museum in London.

half of the eleventh century, in southern Italy, the art of Monte Cassino, while retaining an abundant repertory of monsters, seems to have striven to purge painting of its surfeit of riches, to purify it, to induce in it a noble quality of line. The same development made itself felt in monumental painting, especially among the Roman studios, in the so-called Master of the 'Translations' at Anagni, in the great artist who painted the second cycle at San Clemente, and also in the master of the triptych in the cathedral of Tivoli.[1] In turn, the great Bibles of central Italy submitted to this regime of delicate economy and predominantly graphic poetry, of which accomplished examples, contemporary, but following the Monte Cassino style more closely, may also be found in certain manuscripts executed in the monastery of S. Giorgio at Lucca.[2] Nothing could be farther from the richness and violence of the Ottonian groups, even when the southern art illustrates the luxuriant and highly-coloured prose of the *Exultet* rolls.[3] The Mozarabic East of the Beatus manuscripts belonged to a still more remote climate of the mind, peopled with visions of the seven churches of the Apocalypse, of the great whore of Babylon and of the last days of the world. Saxon England continued to practise the keen, lively, picturesque style of the Utrecht Psalter, while Norman England, in the second half of the twelfth century, distilled from the luxuriant compositions and fantastic genius of the Winchester school a thin, violent style, and a tall, contorted figure canon which later passed into Gothic art.[4]

150

But there was one sphere in which it was natural that illumination should influence wall painting—that of iconography. For this the manuscripts were a sort of practice ground or great laboratory. It was in them that the creative imagination found the widest scope and the most tractable instruments. Neither gold, nor ivory, nor stone, nor wall, were so ductile as parchment and reed pen. Out of pure ornament an image was born. It created a world of figures; it animated the abstractions. Tirelessly it evolved new forms, for some of which

[1]See P. Toesca, *Miniature romane dei secoli XI e XII, Bibbie miniate*, Rivista del R. Istituto di Archeologia e Storia dell' Arte, 1929. A group of manuscripts executed in or near Rome, notably the Gospel-book E. 16 of the Valicelliana, connects both with the art of Monte Cassino (*Vita S. Benedicti*, Vat. lat. 1202) and with the paintings of San Clemente, Anagni and Tivoli. The exquisite linear quality is found in another group of Bibles, that of Santa Cecilia in Trastevere (Vat. cod. barb. lat. 487) and that of Santa Maria della Rotonda (Vat. lat. 1258), etc., evolving towards a more plastic handling, which becomes dominant in the frescoes of San Giovanni a Porta Latina (about 1191).
[2]Morgan Library, M. 737. Cf. Morgan 492, Latin Gospels from N. Italy.
[3]See E. Bertaux, *Iconographie comparée des rouleaux d'Exultet*, Paris, 1909. *The best study is now M. Avery, *The Exultet-Rolls of South Italy*, Oxford, 1936.
*[4]English illumination has been the object of many important studies in recent years. Of these, see F. Wormald, *English Drawings of the Tenth and Eleventh Centuries*, London, 1952; *Decorative Initials in the English Manuscripts from 900 to 1100*, Archaeologia, 1945, *The Survival of Anglo-Saxon Illumination after the Norman Conquest*, Proceedings of the British Academy, 1944, *The Development of English Illumination in the Twelfth Century*, Journal of the British Archaeological Association. 1943; and T. S. R. Boase, *English Art 1100–1216*, Oxford, 1953.

this first appearance was also their last. Others spread far and wide. Nothing transmitted influences more rapidly and conveniently than the manuscripts. Travelling monks carried them from place to place. The 'peregrini Scotti' of the preceding period planted the art of Ireland and Northumbria in the heart of Europe, in the workshops of St. Gall and Reichenau.[1] When Judith, countess of Flanders and daughter of Edward the Confessor, bequeathed manuscripts to the abbey of Weingarten, she created a whole school of illumination.[2] The diffusion of the Beatus manuscripts in Aquitaine and as far as the Loire (at Saint-Benoît) introduced a novel and brilliant iconography. From the scriptorium of Saint-Martial at Limoges came images whose influence was felt not only in the immediate environment, in the Limoges enamels, but also in the art of Languedoc and Roussillon[3]. The favourite motifs of the Cluniac manuscripts are found far beyond the Mâcon region.

The history of the development of monumental painting is closely linked with that of the early Church. It formed the sole decoration of the catacombs, where, in the eternal shadows of the sepulchral chambers, the gay painting of Alexandria lives humbly on, with its birds, its branches of vine, its repeating patterns of little flowers, its romantic landscapes, and, among these, a few symbols whose sense is veiled by the discipline of secrecy, a few biblical or Gospel scenes, some funerary portraits, and the earliest motifs of the iconography of the sacraments. The paintings of Santa Maria Antiqua, in the Forum, show how extensively this art had been enriched with images and figures in the course of the first three centuries after the recognition of Christianity, notably through the influence of Greek popes, by drawing on the repertory of those East Christian communities which already, in the Nilotic monasteries, were displaying the majesty of the theological hierarchies—God, the saints, and the exemplary abbots. The iconoclastic dispute had two important results: on the one hand it brought about a return to pastoral themes and tended to favour secular painting at the expense of sacred iconography; on the other, it scattered over Western Europe persecuted painter-monks, who brought with them from the eastern shores of the Mediterranean the motifs and types of the Rabula Gospels (composed by a monk of that name in the monastery of Zagba on the Euphrates), a dramatic violence, and a feeling for lively narrative and for apt comment,

[1]See G. Micheli, *Recherches sur les manuscrits irlandais décorés de Saint-Gall et de Reichenau*, Revue archéologique, 1936, *L'enluminure du Haut Moyen-Age et les influences irlandaises*, Brussels, 1939.
[2]Latin Gospels of Thorney Abbey (Morgan 708) and New Minster (M. 708). The masterpiece of the Weingarten school is the Berthold Missal (beginning of the thirteenth century, M. 710).
[*3]See T. Sauvel, *Les manuscrits limousins. Essai sur les liens qui les unissent à la sculpture monumentale, aux émaux et aux vitraux*, Bulletin monumental, 1950.

both by image and gesture, which profoundly affected Western painting. We shall come across this accent again in certain fresco cycles which run parallel with the Byzantine art of Tuscany and the pontifical art of Rome, when we investigate the origins of the Giottesque style. In the barbarian kingdoms, especially Merovingian Gaul, chroniclers and poets testify that the churches were adorned with paintings. From texts, we may guess the importance of the historical cycles in the Carolingian palaces. Concurrently with the Byzantine-inspired technique of mosaic, there was probably in the same period a parallel development of sacred painting, doubtless inspired by the artists who, in many monastic studios, were creating masterpieces of illumination.

In the Romanesque period, the extent of the development becomes apparent. On the vaults, on the intrados of the arches and on the vertical wall-surfaces, the painter disposed his compositions like the ornamental pages or bands of book-decoration. On semidome, tympanum and arcade-spandrel, he collaborated with the architect, arranging his figures to suit the place which they occupied. There is no evidence that the compositions were created, sustained and developed by the ornamental technique: painting had a long tradition behind it, whereas sculpture was forced to invent its own procedures. But the symmetrical systems, even though they had no part in the story-telling of the painted friezes, reappear in the harmonies of the tympana, and the drapery style, with its swirling, fan-shaped, shell-shaped and spiral folds, is itself an ornamental style. Romanesque painting was also a function of Romanesque architecture by virtue of another, more general characteristic. It respected the plane of the wall; space is not hollowed out behind the figures but simply cancelled by means of a homogeneous dark background or alternating decorative bands, while the figures themselves have no thickness, and are composed of large areas of flat colour, separated by regular dark lines. These tall solemn personages seem to have been cut up and reassembled like pieces of stained glass on the designer's bench. But the material of which they are composed is not very different from the wall itself: it consists of one or several applications of plaster, painted with distemper—earth colours mixed with water—or with several layers of paint, which react on each other to produce the brilliancy of tone of a transparent glaze. The *Schedula diversarum artium*, by the monk Theophilus,[1] gives us details of the composition of the

[1]Published by Comte de Lescalopier, Paris, 1845. See E. Berger, *Beiträge zur Entwicklungsgeschichte der Maltechnik*, Munich, 1897, vol. III; W. Theobald, *Technik des Kunsthandwerks im zehnten Jahrhundert, Theophilus Presbyter, Schedula diversarum artium . . .* , Berlin, 1935; D. V. Thompson, *The Schedula of Theophilus Presbyter*, Speculum, 1932, and *The Materials of Mediaeval Painting*, London, 1936; E. Mâle, *La peinture murale en France*, in *Histoire de l'art* by André Michel, vol. I, part 2. An exhaustive analysis of painting 'in the Greek manner' has been made by F. Mercier in his study of *La peinture clunysienne*, Paris, 1932.

palette, the choice of colour, according to whether a face, hands, dress, earth or trees were to be executed, and the conventions of drawing, by which the articulation of the limbs, and the movement of the draperies were graphically emphasized. This affords invaluable evidence of stylistic formulae and workshop recipes, but it must not be allowed to conceal from us the subtlety of the masters and the variety of their handling. Viollet-le-Duc observed that they do not place two tones of equal intensity side by side, but introduce between them a zone of quieter colour to keep the harmony in balance. One may also see, in a certain type of meander ornament, how, by an alternation of light and dark, they were able to create a kind of colour perspective which avoids the tyrannous illusion of a third dimension and leaves intact the unity of the wall. Perhaps similar methods, applied to the polychromy of sculpture, contributed a further effect to the ornamental style.

We have already touched on the Romanesque paintings of Catalonia,[1] and the Mozarabic paintings of San Baudelio[2] in Castile. The first are important by reason of their number, their early date, and the relationship of their colouring with that brilliant and insubstantial liveliness of tone of the Beatus manuscripts, which in an earlier age had already distinguished the manuscripts of the Visigothic group; they demonstrate the importance of painted decoration (and polychromy) in first Romanesque art. Many have now been detached from the walls and assembled in the Barcelona Museum, where it is possible to make a systematic study of this great school. The second group decorated the walls and tribune of a chapel whose vault is supported and ramified by a central pier; it includes Gospel scenes, influenced by French art, and of a new richness of conception, with astonishing still-lifes, and figures instinct with the authority of a great style; these are accompanied by Oriental hunting-scenes, and animals rendered with a

[1]In addition to the works of J. Gudiol i Cunill, see Folch i Torrès, *Catalogue de la section romane du musée de Barcelone*, Barcelona, 1926, and J. Puig i Cadafalch, *op. cit.*, p. 147. The simplest type of decoration is an imitation of cut-stone masonry. In the apse there is a representation either of the Pantocrator surrounded with seraphim and Evangelist-symbols (Sant Miquel d'Angulastres, Sant Climent de Tahull, Esterri de Cardos) or the Virgin surrounded with archangels (Santa Maria de Tahull, Santa Maria d'Aneu). In Saint-Martin de Fonollar, the iconography is more comprehensive: in the vault, God between angels and the Evangelist-symbols; on the rear wall, the Virgin in prayer; below, in two registers, one above the other, the twenty-four Elders of the Apocalypse, the Annunciation, and the Adoration of the Magi. Sometimes the whole of the interior is covered with paintings (Sant Climent and Santa Maria de Tahull), and, in other regions of first Romanesque art, the exterior as well (Lombardy, Switzerland, and, later, Moldavia). First Romanesque art was an art of colourists. The liturgical furnishings (antependia, predelle, ciboria), the pavements, the carpets and the hangings all played a part in the total effect. *On Spanish painting in the Romanesque period, add C. L. Kuhn, *Romanesque Mural Painting of Catalonia*, Cambridge, U.S.A., 1930; C. R. Post, *History of Spanish Painting*, vol. I, Cambridge, U.S.A., 1930; and more recently W. W. S. Cook and J. Gudiol Ricart, *Pintura y imaginería románicas* (Ars Hispaniae, vol. VI), Madrid, 1950.
[2]Published by W. W. S. Cook, Art Bulletin, 1930.

remarkable synthetic power. But though, in their combination of influences and their Islamic elements, they belong to Romanesque art, or at least to one of its strangest backwaters, they are probably of rather late date.

As in architecture, so in painting, the diversity of the French groups is surprising, but their geography does not coincide with that of architecture and sculpture.[1] They may be divided into two regions: one, which consists mainly of Burgundy and part of Auvergne, with paintings of the 'brilliant' type, on dark grounds; the other, extending from the Loire to Languedoc and towards the western provinces, with dull colours on light grounds. But this division conceals the profound originality of the various local schools. If the first group seems fairly coherent, the second abounds in workshops of widely differing characters which reject the monotony of a formula. Painting is found there not only in the great buildings, but in little parish churches, priories deep in the country, and narrow crypts, which are filled with the mysterious life of the images. Burgundy was heir to a long tradition in this art, as is shown by the remains dating from Carolingian times which were recently discovered in the crypt of Auxerre. Cluny possessed a painted decoration of some magnitude in the colossal Christ in Majesty of the apse. And on the walls of the little priory of Berzé-la-Ville it is still possible to study, in excellent examples, the style and technique of Cluniac painting, its compositional resources, and the way in which it combined the narrative and the monumental styles. The Majesty of the semidome, the saints who—like a sculptured lintel, but curving round with the apse—form a human footstool for the glory of the Lord, and the dramatic scenes which frame the composition on either side, are both steadfast in pose and lively in movement. The colour is often rich and daring—for instance, the purple, tending to violet. The application of several coats of plaster, in accordance with Greek technical practice, the Byzantine cast of some of the faces (of elongated oval shape, with large staring eyes, and narrow mouth beneath a thin nose), and the presence in the lower register of the apse of several representatives of Eastern hagiography, such as SS. Abdon and Sennen, indicate one current of influence which, without prejudice to other traditions, was active at this time in the Cluniac workshops. This art was not confined to Burgundy, for in the paintings of Le Puy and

*[1]H. Focillon has given a complete account of his views on Romanesque mural painting in France in *Peintures romanes des églises de France*, Paris, 1938. Since then, C. P. Duprat, *Enquête sur la peinture murale en France à l'époque romane*, Bulletin monumental, 1942 and 1943–44; P.-H. Michel, *Romanesque Wall Paintings in France*, London and New York, 1950; P. Deschamps and M. Thibout, *La peinture murale en France. Le Haut Moyen-Age et l'époque romane*, Paris, 1951. On English mural painting, see E. W. Tristram, *English Medieval Wall Painting: I. The Twelfth Century*, London, 1944; and A. Baker, *Lewes Priory and the Early Group of Wall Paintings in Sussex*, Walpole Society, 1942–43 (published 1946).

Brioude, which are technically similar, we again find great austere figures rising up against a nocturnal sky. It may have descended even farther, to Dauphiné, in the abbey of Saint-Chef.[1]

The paintings of western France are lighter in tone. The dominant colours are yellow ochre, red ochre, black and white, with a few touches of cinnabar for the flesh tints. Green is rare, and blue is generally reserved for the garments of Christ. The characteristic absence of lustre is due to the use of earth colours and the distemper technique. Frequently, broad alternating bands behind the figures form a barrier which prevents the eye from piercing through the wall into an imaginary space beyond. The most comprehensive scheme is found in Poitou, in the paintings of Saint-Savin-sur-Gartempe. This church, whose construction occupied several distinct campaigns, as is shown by the change in the form of the piers—quatrefoil in the western bays, but cylindrical elsewhere —has its main nave covered with a continuous barrel vault uninterrupted by transverse arches, which was clearly designed with a view to painted decoration. Upon it, in compartments which run down the church on either side of the line of the keystones, the stories of the Bible are unfolded with homely majesty. The Creator throws the stars into the heavens with a gesture of the hand; contemporary life performs with epic grandeur the eternal motions of work and war in the various scenes from Genesis, the Passage of the Red Sea and the Building of the Tower of Babel. The two Majesties of Christ, the Virgin as keeper of the door (over the entrance-bay), the Apocalyptic scenes of the porch, and the episodes from the lives of the saints in the crypt, round off this remarkable cycle. In the same region are many other churches possessing schemes of painting —for instance, at Poitiers itself, the Temple Saint-Jean, with its decoration of several different periods and its cross-legged dancing figures, reminiscent of the sculpture of Languedoc. The style of Romanesque painting here persists beyond its chronological limits: the Virgin of Montmorillon, with the mystic marriage of St. Catherine, is probably of the thirteenth century. This pheno-menon of stylistic inertia is paralleled in the same period by the conservation of the Romanesque style in Limoges enamels and certain types of ivories—the Virgin in Majesty, for example—as if the Divine image, in painting and the precious materials, continued to be cast in the same moulds.

But the intensity of the feeling for drama renewed the forms in certain scenes *148, 149* showing human figures in violent action. In Berry, the church of Vicq—with its figures wearing stiff yet mobile tunics, composed of a fan of long conical

*[1]P. Deschamps and M. Thibout, *op. cit.*, pp. 49–52, place Saint-Chef before the Cluny group and connect it directly with Monte Cassino.

folds which are displaced by movements of the legs and arms—in the Loir valley, Montoire, Artins, Poncé and Saint-Jacques-des-Guérets, and many another church in the neighbouring areas show the vigour with which this style approached the life of forms, took possession of it, and in each place gave it extraordinary individuality. A recently discovered ensemble, that of the crypt of Tavant,[1] near l'Ile-Bouchard, in Indre-et-Loire, says perhaps the last word *152-154* concerning this inspirational force which, far from enslaving itself to a formula, constantly renewed the style with motifs and influences from the past. Like the Jonah of Saint-Savin, who, erect and with arms outstretched, holds sway over the spandrel which he occupies, some of the figures (atlantes, orants, and lamp-bearers), painted between the low arches, are more or less servants and interpreters of architecture. They wear the short tunic and close-fitting breeches of the Carolingian miniatures. Others, clothed with an Oriental magnificence and drawn with a more capricious freedom, recall those strange half-human, half-ornamental creatures which are trapped in the nets of Irish interlace. A woman, transfixed by a lance, serpentine in the wonderfully rich and harmonious flexions of the body, is doubtless a remnant of a Poitevin Psychomachia, whilst a Harrowing of Hell, of compact yet mobile composition, belongs to an older region of iconography. Painted on a white ground, with a vehemence of brush-work which excludes all idea of detailed reproduction of an existing pattern, these figures seem strange indeed, in the depths of their underground chamber, amid the countryside of Touraine! The Romanesque spirit gives here the measure of its poetry and of that inherent strength which was able, out of elements drawn from many centuries and many civilizations, to create, in its reasoned architecture, in its sculpture (likewise architectural) and in the varieties of its monumental painting, an art both homogeneous and vital, defined by the intimate interaction of the laws of the style, the activity of the historical settings, and the genius of the individual workshops.

[1]Published by M. Webber, *The Frescoes of Tavant*, Art Studies, 1925. *Add H. Moyrand, *Les fresques de l'église de Tavant*, Tours, 1938; and P.-H. Michel, *Les fresques de Tavant*, Paris, 1944. On Saint-Savin: I. Yoshikawa, *L'Apocalypse de Saint-Savin*, Paris, 1939; G. Gaillard, *Les fresques de Saint-Savin*, Paris, 1944; P. Deschamps, M. Thibout and A. Grabar, *Observations sur les fresques de Saint-Savin*, Cahiers Archéologiques, 1949.

BIBLIOGRAPHY

SCULPTURE

E. Mâle, *L'art religieux du XIIe siècle en France*, Paris, 1922, 4th edition, 1940; R. de Lasteyrie, *Études sur la sculpture française au moyen âge*, Monuments Piot, VIII, 1902; A. K. Porter, *Romanesque Sculpture of the Pilgrimage Roads*, 10 vols., Boston, 1923; P. Deschamps, *La sculpture française à l'époque romane*, Paris, 1930; J. Baltrusaitis, *La stylistique ornementale dans la sculpture romane*, Paris, 1931, and *Art sumérien, art roman*, Paris, 1934; H. Focillon, *L'art des sculpteurs romans*, Paris, 1931; L. Lefrançois-Pillion, *Les sculpteurs français du XIIe siècle*, Paris, 1931; R. Rey, *La sculpture romane languedocienne*, Toulouse and Paris, 1936; R. Bernheimer, *Romanische Tierplastik und die Ursprünge ihrer Motive*, Munich, 1931 (cf. the review by J. Baltrusaitis, in Revue de l'Art, 1933); R. H. L. Hamann, *Das Lazarus-grab in Autun*, Marburg, 1935; A. K. Porter, *Spanish Romanesque sculpture*, Paris, 1928 (cf. G. Gaillard, Bulletin monumental, 1930, and E. Lambert, Revue critique, 1931); G. Beenken, *Romanische Skulptur in Deutschland*, Leipzig, 1924; E. Panofsky, *Die deutsche Plastik des elften bis dreizehnten Jahrhunderts*, 2 vols., Munich, 1934; A. Goldschmidt, *Die deutschen Bronze-türen des frühen Mittelalters*, Marburg, 1926; E. S. Prior and A. Gardner, *English Mediaeval Figure-Sculpture*, London, 1904–05; M. Devigne, *La sculpture mosane du XIIe au XVIe siècle*, Brussels and Paris, 1932.* J. Gantner, *Romanische Plastik. Inhalt und Form in der Kunst des XI. und XII. Jahrhunderts*, Vienna, 1941, 3rd ed., 1948; P. Pradel, *Sculptures romanes des musées de France*, Paris, 1958; L. Grodecki, *La sculpture du XIe siècle en France, état des questions*, L'Information d'Histoire de l'art, III, 1958, pp. 98–112; F. Garcia Romo, *La escultura romanica francese hasta 1090*, Archivo español de arte, 1957, pp. 223–240, and 1959, pp. 121–141; J. Adhémar, *Influences antiques dans l'art du moyen âge français*, London, 1939; R. W. Koehler (editor), *Medieval Studies in Memory of A. Kingsley Porter*, 2 vols., Cambridge, U.S.A., 1939; H. Swarzenski, *Monuments of Romanesque Art*, Cambridge, U.S.A., 1955; A. Katzenellenbogen, *The Central Tympanum at Vézelay*, Art Bulletin, 1944; F. Salet, *La Madeleine de Vézelay*, Melun, 1948; D. Grivot and G. Zarnecki, *Gislebertus, Sculptor of Autun*, London, 1961; M. Lafargue, *Les chapiteaux du cloître de Notre-Dame la Daurade*, Paris, 1940; G. Gaillard, *De la diversité des styles dans la sculpture romane des pèlerinages*, Revue des Arts, 1951; M. Durliat, *La sculpture romane en Roussillon*, 4 vols., Perpignan, 1948–54; E. Mendell, *Romanesque Sculpture in Saintonge*, New Haven, 1940; C. Daras, *L'orientalisme dans l'art roman en Angoumois*, Bulletin et Mémoires de la Société archéologique et historique de la Charente, Angoulême, 1937; R. Crozet, *Nouvelles remarques sur les cavaliers sculptés ou peints dans les églises romanes*, Cahiers de civilisation médiévale, I, 1958, pp. 27–36; G. Gaillard, *Les débuts de la sculpture romane espagnole, Leon, Jaca, Compostelle*, Paris, 1938, and *La sculpture du XIe siècle en Navarre avant l'influence des pèlerinages*, Bulletin monu-mental, 1955; J. Gudiol Ricart and J. A. Gaya Nuno, *Arquitectura y escultura romanicas* (Ars Hispaniae, V), Madrid, 1948; R. Jullian, *L'éveil de la sculpture italienne. La sculpture romane dans l'Italie du nord*, Paris, 1945, and *Les sculpteurs romans de l'Italie septentrionale* (plates), Paris, 1952; G. de Francovich, *Wiligelmo da Modena e gli inizii della scultura romanica in Francia e in Spagna*, Rivista del Reale Istituto di archeologia e storia dell'arte, VII, 1940, and *Benedetto Antelami, architetto et scultore, e l'arte del suo tempo*, 2 vols., Milan and Florence, 1952; T. Krautheimer-Hess, *The Original Porta dei Mesi at Ferrara and the Art of Niccolo*, Art Bulletin XXVI, 1944, pp. 152–174; G. H. Crichton, *Romanesque Sculpture in Italy*, London, 1954; R. Salvini, *Wiligelmo e le origini della scultura romanica*, Milan, 1956;

C. D. Sheppard, *Romanesque Sculpture in Tuscany*, Gazette des Beaux-Arts, 1959, and *A Chronology of Romanesque Sculpture in Campania*, Art Bulletin, XXXII, 1950; P. Rolland, *La sculpture tournaisienne*, Brussels, 1944; P. Francastel, ed., *L'art mosan*, Paris, 1953; T. S. R. Boase, *English Art*, 1100–1216, Oxford, 1953; A. Gardner, *English Medieval Sculpture*, Cambridge, 1951; F. Saxl, *English Sculptures of the XIIth century*, London, 1954; L. Stone, *Sculpture in Britain: The Middle Ages*, Harmondsworth, 1955; G. Zarnecki, *English Romanesque Sculpture*, 1066–1140, London, 1951, *Later English Romanesque Sculpture*, 1140–1210, London, 1953; *The Early Sculpture of Ely Cathedral*, London, 1958, and *English Romanesque Lead Sculpture*, London, 1957; F. Henry and G. Zarnecki, *Romanesque Arches Decorated with Human and Animal Heads*, Journal of the British Archaeological Association, 3rd series, XX–XXI, 1957–58, pp. 1–34.

PAINTING AND DECORATIVE ARTS
Ph. Lauer, *Les enluminures romanes des manuscrits de la Bibliothèque Nationale*, Paris, 1927; P. Gelis-Didot and H. Laffillée, *La peinture décorative en France*, 2 vols., Paris, 1890; F. Mercier, *Les primitifs français. La peinture clunysienne*, Paris, 1932; L. Giron, *Les peintures murales du département de la Haute-Loire du XIe au XVIII siècle*, Paris, 1911; E. Maillard, *L'église de Saint-Savin*, Paris, 1926; Chanoine Ch. Urseau, *La peinture décorative en Anjou du XIIe au XVIIIe siècle*, Angers, 1920; G. Swarzenski, *Die Regensburger Buchmalerei des X. und XI. Jahrhunderts*, Leipzig, 1901, and *Vorgotische Miniaturen*, Leipzig, 1927; P. Clemen, *Die romanische Monumentalmalerei in den Rheinländern*, Düsseldorf, 1916; H. Karlinger, *Die hochromanische Wandmalerei in Regensburg*, Munich, 1920; F. X. Kraus, *Die Wandgemälde der S. Georgskirche zu Oberzell auf der Reichenau*, Freiburg, 1844; P. d'Ancona, *La miniature italienne du Xe au XIVe siècle*, Paris-Brussels, 1925; *Paleografia artistica di Montecassino*, 4 vols., Montecassino, 1872–77; R. van Marle, *La peinture romaine au moyen âge*, Strasbourg, 1921; J. Wilpert, *Die römischen Mosaiken und Malereien vom IV. bis XII. Jahrhundert*, Freiburg, 1917; P. Toesca, *La pittura e la miniatura nella Lombardia*, Milan, 1912; W. Neuss, *Die Apokalypse des Hl. Johannes in der altspanischen und altchristlichen Bibelillustration; das Problem der Beatus Handschriften*, Münster, 1931; J. Gudiol i Cunill, *La pintura mig-eval Catalana*, Barcelona, 1927; E. G. Millar, *English Illuminated Manuscripts from the Xth to the XIIIth century*, Paris and Brussels, 1926; J. Marquet de Vasselot, *Bibliographie de l'orfèvrerie et de l'émaillerie françaises*, Paris, 1925; F. de Lasteyrie, *Histoire de l'orfèvrerie*, Paris, 1875; O. von Falke and H. Frauberger, *Deutsche Schmelzarbeiten des Mittelalters*, Frankfurt-am-Main, 1904; O. von Falke, *Geschichte des Kunstgewerbes*, Berlin, 1907; H. d'Hennezel, *Histoire du décor textile*, 3 vols., Lyons, 1928, G. Migeon, *Les arts du tissu*, Paris, 1929*. A. Grabar and C. Nordenfalk, *La peinture romane du XIe au XIIIe siècle*, *Peintures murales. L'enluminure* (Skira: Les grands siècles de la peinture), Geneva, 1958; W. R. W. Koehler, *Byzantine Art in the West*, Dumbarton Oaks Papers, I, 1941, pp. 63–87; A. Boeckler, *Abendländische Miniaturen bis zum Ausgang der romanischen Zeit*, Berlin and Leipzig, 1930; E. Van Moe, *Illuminated Initials in Mediaeval Manuscripts*, London and New York, 1950; Bibliothèque Nationale, *Les manuscrits à peintures en France, I. Du VIIe au XIIe siècle* (Catalogue of Exhibition), Paris, 1954; J. Porcher, *L'enluminure française*, Paris, 1959 (*Medieval French Miniatures*, New York, 1960); H. Focillon, *Peintures romanes des églises de France*, Paris, 1938; C. P. Duprat, *Enquête sur la peinture murale en France à l'époque romane*, Bulletin monumental, 1942 and 1943–44; P. H. Michel, *Romanesque Wall-Paintings in France*, London and New York, 1950; P. Deschamps and M. Thibout, *La peinture murale en France. Le haut moyen âge et l'époque romane*, Paris, 1951, and *Apropos*

de nos plus anciennes peintures murales, Bulletin monumental, 1953; M. Rickert, *Painting in Britain: The Middle Ages*, Harmondsworth, 1954; F. Wormald, *The Survival of Anglo-Saxon Illumination after the Norman Conquest*, Proceedings of the British Academy, XXX, 1944, and *The Development of English Illumination in the XIIth Century*, Journal of the British Archaeological Association, 1943; C. R. Dodwell, *The Canterbury School of Illumination*, Cambridge, 1954, and *The Great Lambeth Bible*, London, 1959; C. R. Dodwell, O. Pächt and F. Wormald, *The Saint-Albans Psalter* (Studies of the Warburg Institute, 25), London, 1960; O. Pächt, *Hugo Pictor*, The Bodleian Library Record, III, 1950, and *The Rise of Pictorial Narrative in Twelfth Century England*, London, 1962; W. Oakeshott, *The Artists of the Winchester Bible*, London, 1945; E. W. Tristram, *English Medieval Wall-Painting, I. The XIIth Century*, London, 1944; A. Boutemy, *La miniature, VIIIe–XIIe siècles*, in E. de Moreau, Histoire de l'Eglise en Belgique, II, 2nd ed., 1945, pp. 311–362; E. B. Garrison, *Italian Romanesque Panel-Painting*, Florence, 1950; C. R. Post, *History of Spanish Painting*, Vol. I, Cambridge, U.S.A., 1930; W. W. S. Cook and J. Gudiol Ricart, *Pintura y imagineria románicas* (Ars Hispaniae, VI), Madrid, 1950; W. W. S. Cook, *La pintura mural romanica en Cataluña*, Madrid, 1956; O. Demus, *The Mosaics of Norman Sicily*, London, 1949; H. Buchthal, *Miniature Painting in the Latin Kingdom of Jerusalem*, Oxford, 1957; S. Gevaert, *L'orfèvrerie mosane au moyen âge*, Brussels, 1943; S. Collon-Gevaert, *Histoire des arts du métal en Belgique*, Mémoires de l'Académie Royale de Belgique, VI, Brussels, 1951; F. Röhrig, *Der Verduner Altar*, Vienna, 1955; G. Oman, *The Gloucester Candlestick*, London, 1958; M. M. Gauthier, *Emaux limousins champlevés des XIIe, XIIIe et XIVe siècles*, Paris, 1950; M. Chamot, *English Medieval Enamels*, London, 1930; F. M. Stenton, ed., *The Bayeux Tapestry*, London, 1957; P. de Palol, *Une broderie catalane d'époque romane, la Genèse de Gérone*, Cahiers archéologiques, 1956.

ACKNOWLEDGEMENTS

The Publishers wish to thank all who have helped with the selection of the illustrations. They are grateful to all who have provided photographs, in particular to Messrs. Alinari, Florence; Archives Photographiques, Paris; Bibliothèque Nationale, Paris; British Museum, London; Courtauld Institute, London; Pierre Dévinoy, Paris; Walter Dräher, Zürich; Giraudon, Paris; Foto Mas, Barcelona; Foto Marburg, Marburg-an-der-Lahn; Jules Messiaen, Tournai; National Buildings Record, London; Jean Roubier, Paris; Soprintendenza ai monumenti del Piemonte; Victoria and Albert Museum, London.

ILLUSTRATIONS

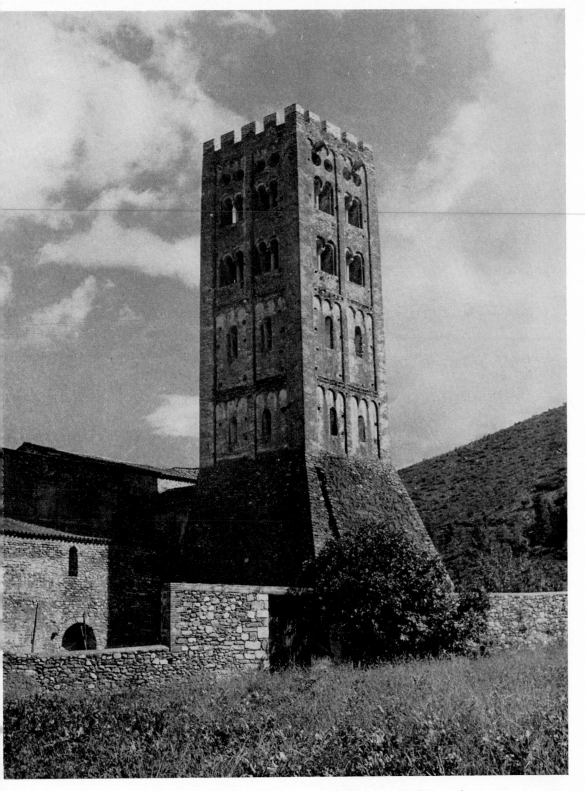

1. Saint Michel de Cuxa (Pyrénées Orientales). Church: tenth century; tower: eleventh century.

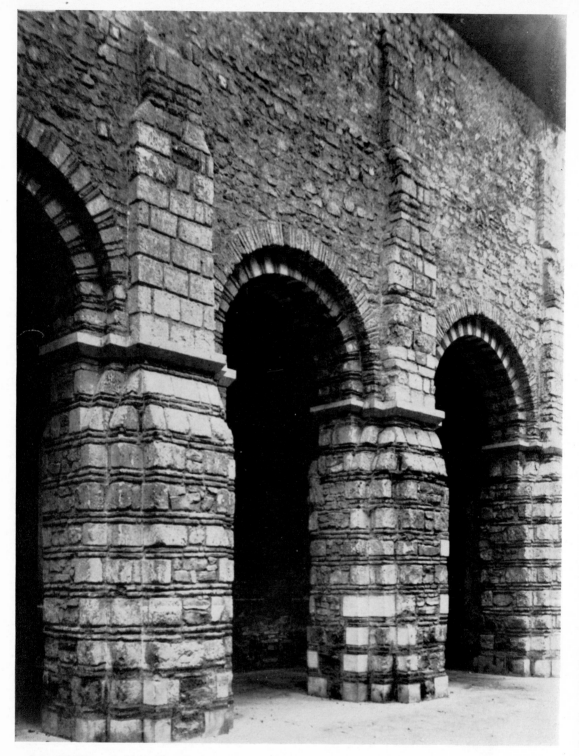

2. Saint-Philibert de Grandlieu (Loire-Atlantique). Piers in the nave, early eleventh century.

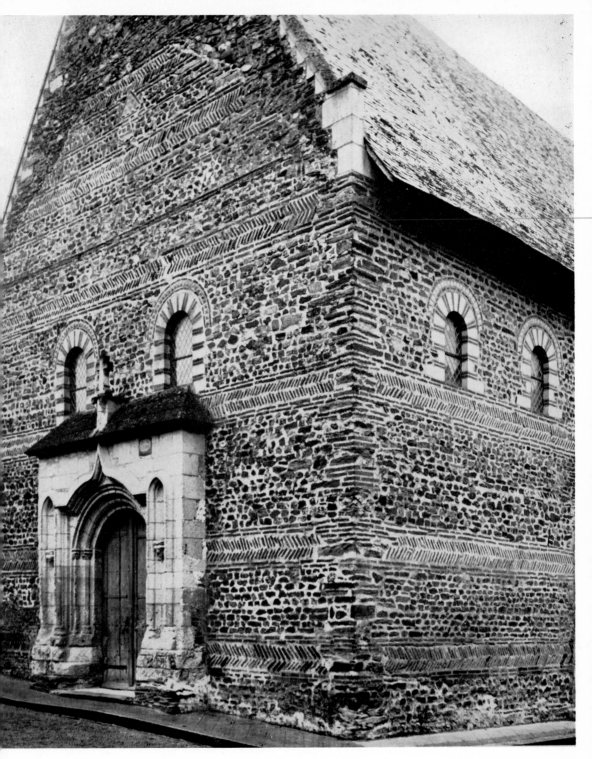

Savenières (Maine-et-Loire). Ornamental arrangement of masonry.

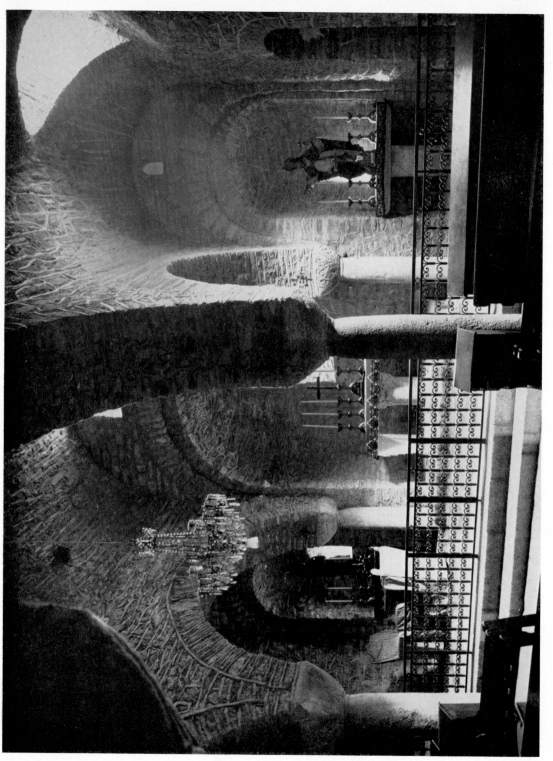

4. Saint-Martin du Canigou (Pyrénées-Orientales). East bays of upper church, between 1009 and 1026.

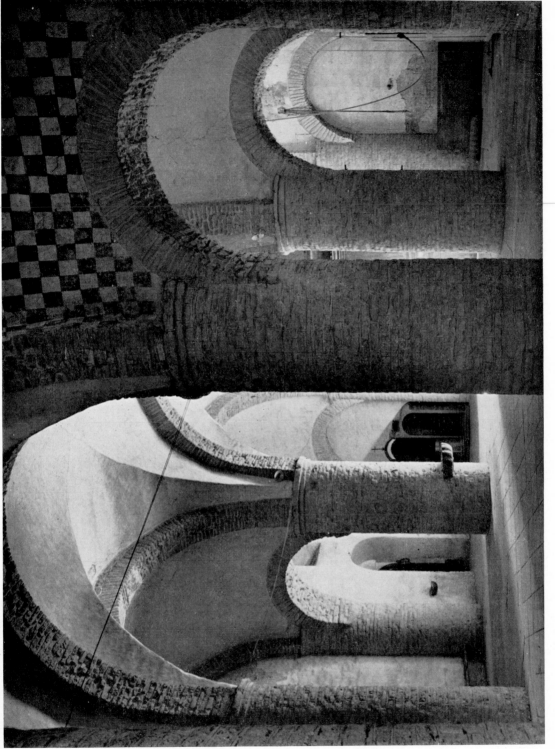

5. Tournus (Saône-et-Loire), Saint-Philibert. Narthex, lower storey, about 1020.

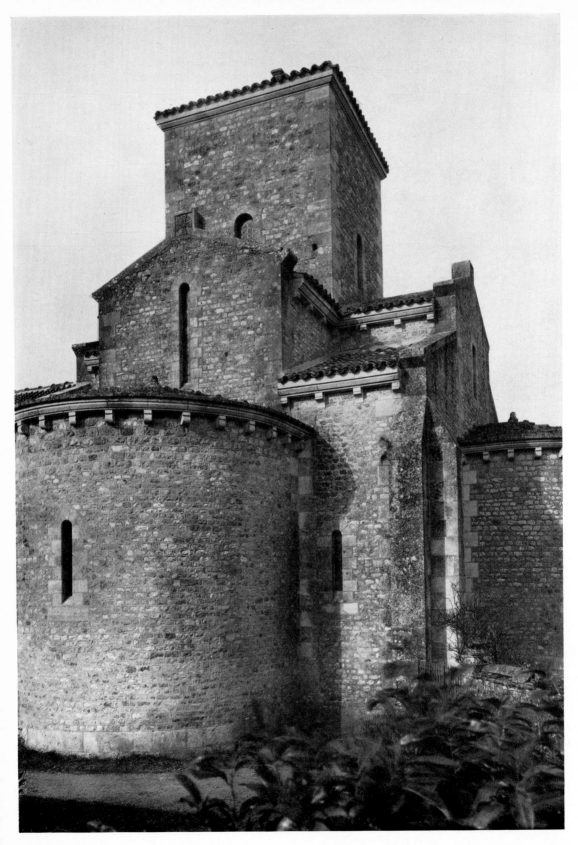

6. Germigny-des-Prés (Loiret). Chapel from the south, about 810, heavily restored
in the nineteenth century.

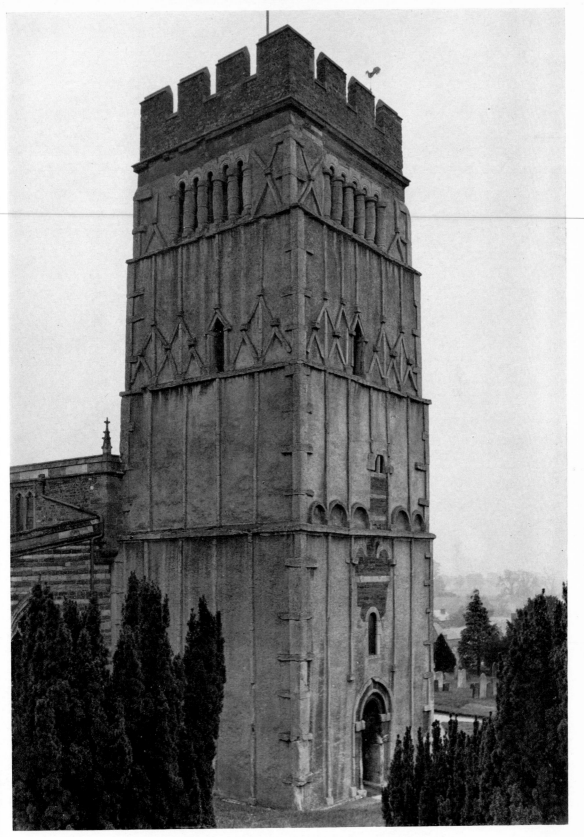

7. Earl's Barton (Northamptonshire). Tower, first half of the eleventh century.

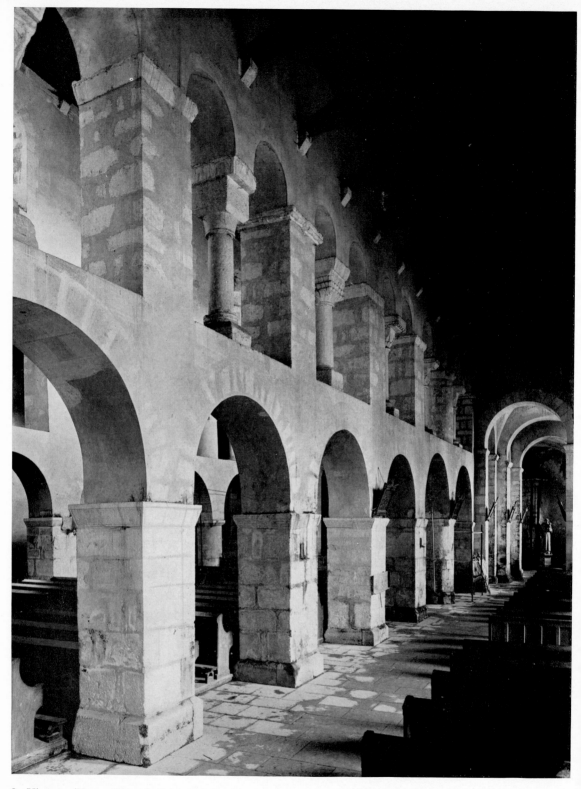

8. Vignory (Haute-Marne), Saint-Etienne. South aisle of nave, early eleventh century.

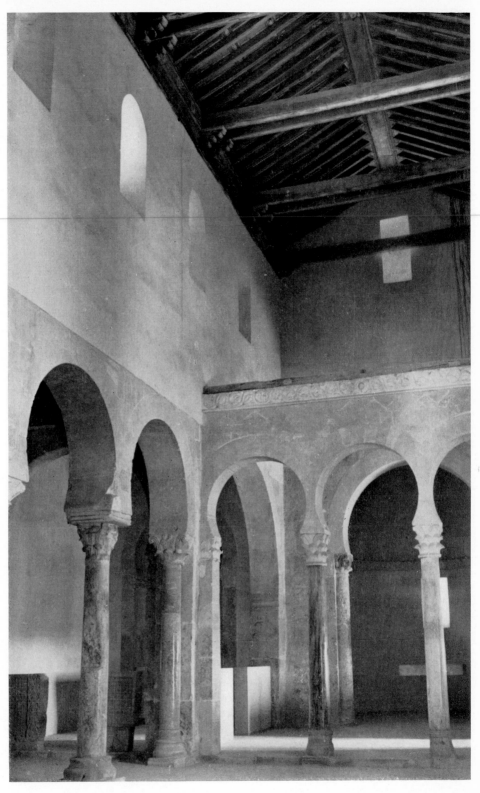

9. San Miguel de Escalada (León). Dedicated 913.

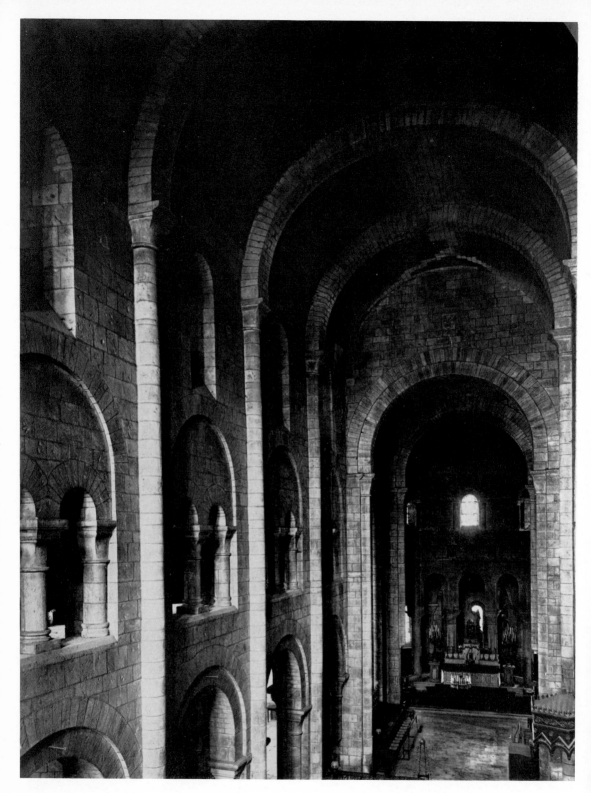

10. Nevers (Nièvre), Saint-Etienne, 1083–1097.

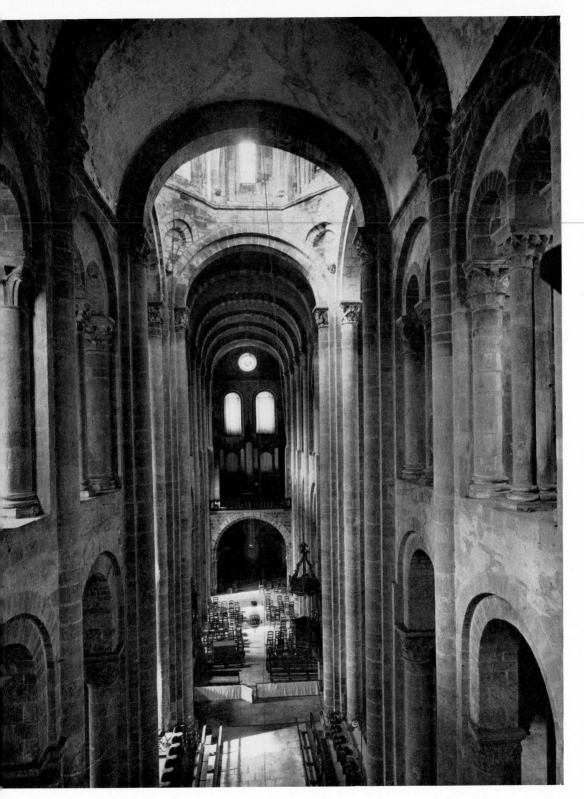

11. Conques (Aveyron), Sainte-Foy. Begun between 1041 and 1052; largely rebuilt after 1080.

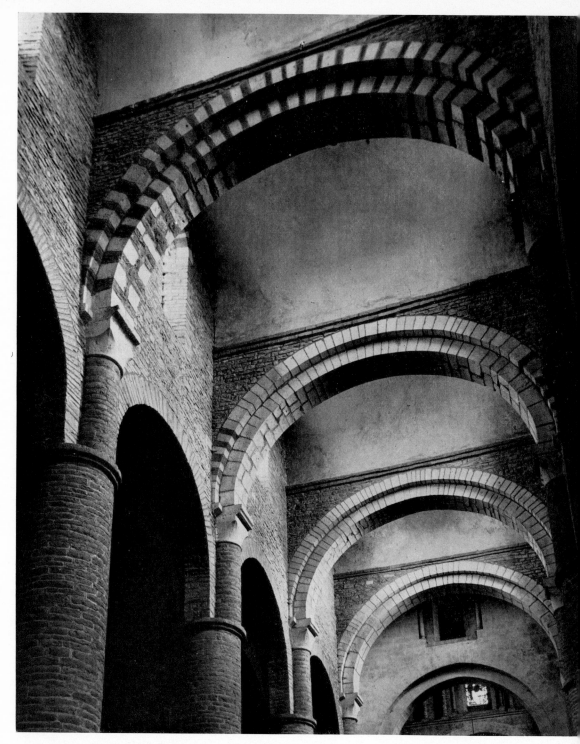

12. Tournus (Saône-et-Loire), Saint-Philibert. Nave vaulting, between 1066 and 1107.

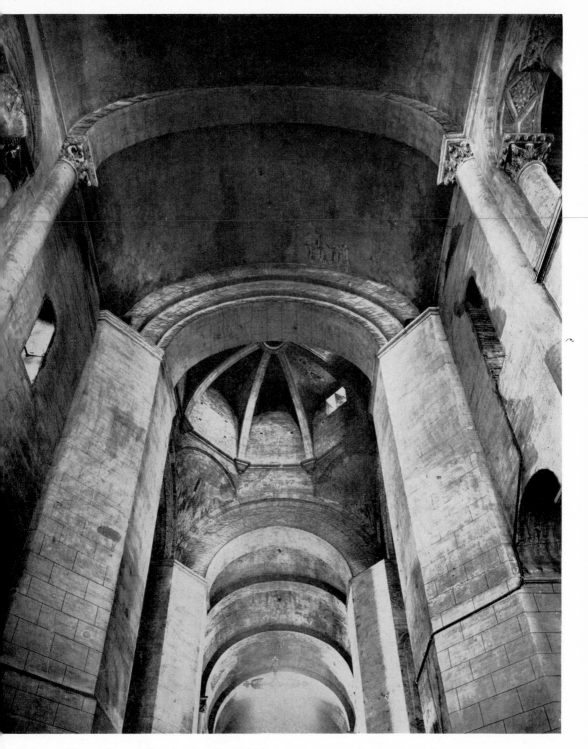

Toulouse (Haute-Garonne), Saint-Sernin. Vaulting of transept, early twelfth century; dome, thirteenth century.

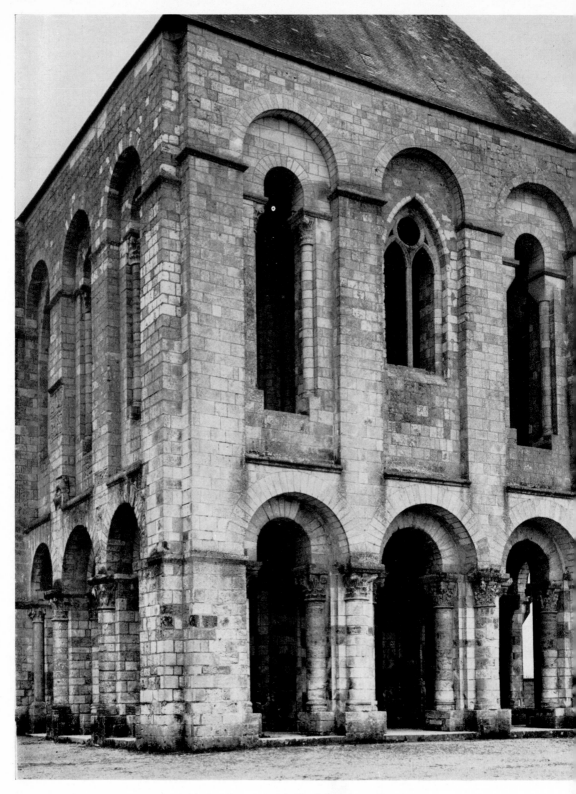

14. Saint-Benoît-sur-Loire (Loiret). Porch, second half of the eleventh century.

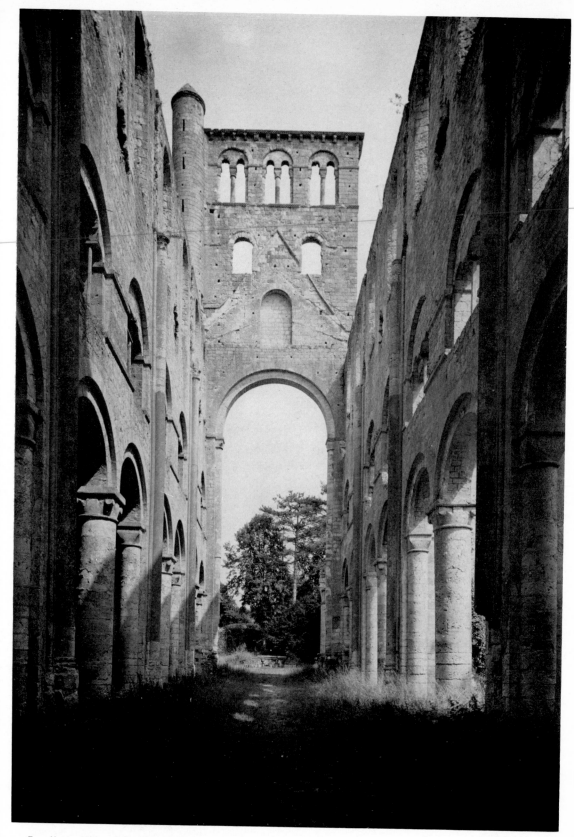

15. Jumièges (Seine-Maritime). Ruins of nave, 1052–1067.

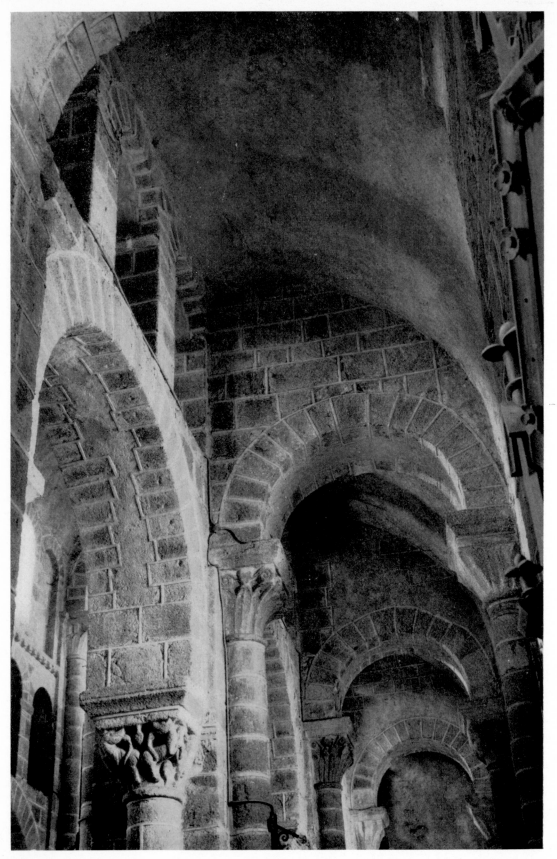

16. Châtel-Montagne (Allier). Aisle vaulting, first half of twelfth century.

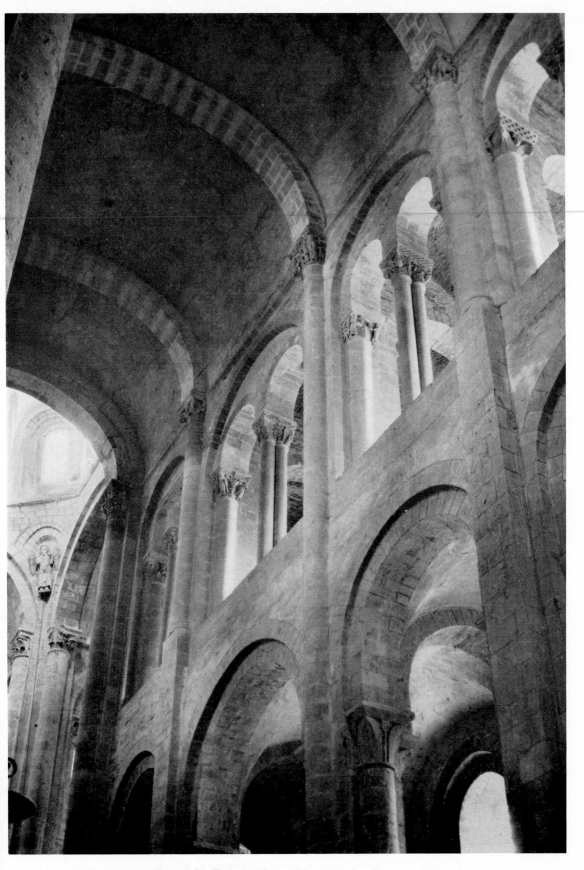

17. Conques (Aveyron) Sainte-Foy. Tribune and nave vaulting, mostly late eleventh and
early twelfth centuries.

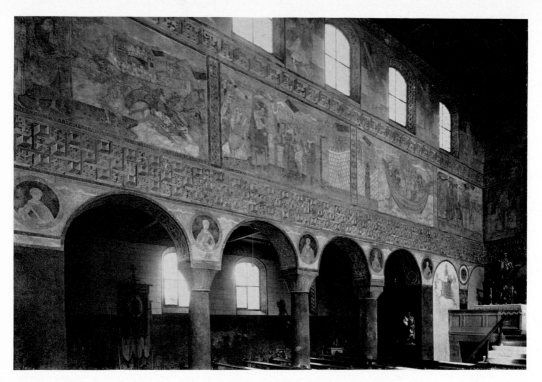

18. Reichenau-Oberzell (Germany), St. Georg. North wall, tenth century.

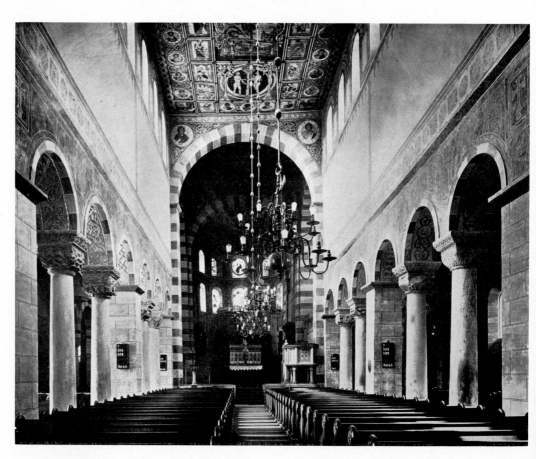

19. Hildesheim, St. Michael. Early eleventh century; restored after a fire at the end of the twelfth century.

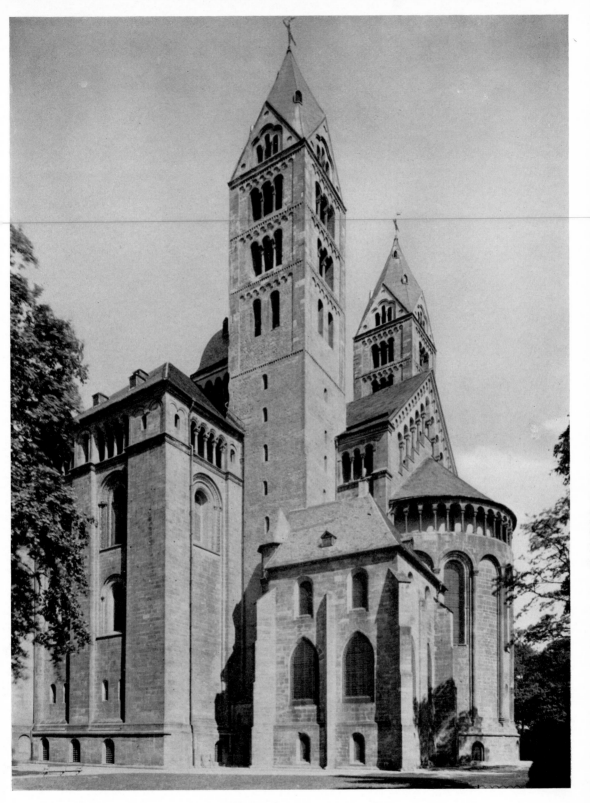

20. Speyer Cathedral. Begun about 1030, remodelled after 1081.

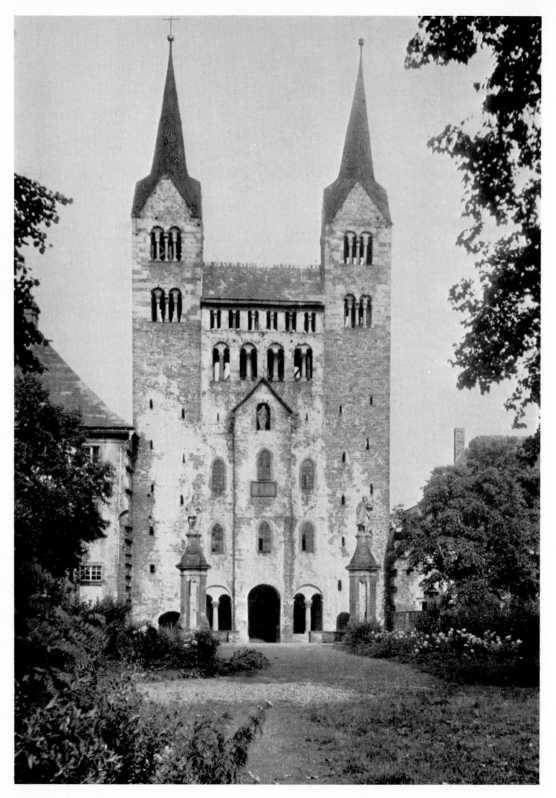

21. Corvey (Westphalia), former Benedictine Abbey. West façade, ninth and twelfth centuries.

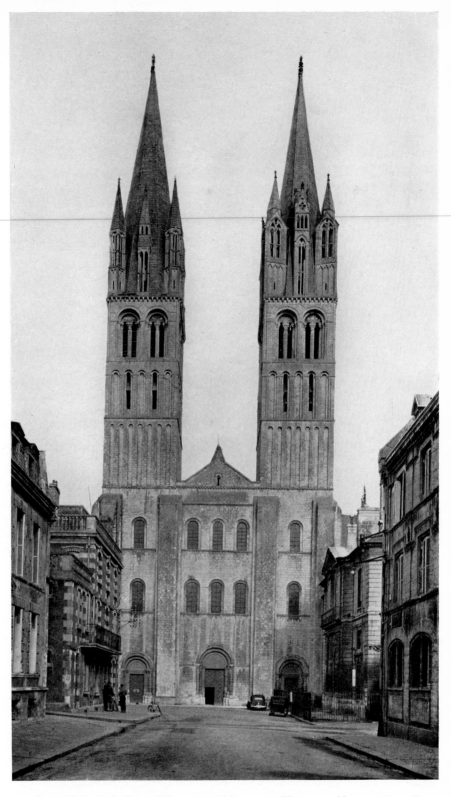

22. Caen (Calvados), Saint-Etienne or Abbaye-aux-Hommes. About 1067–1085.
Gothic spires added at the beginning of the thirteenth century.

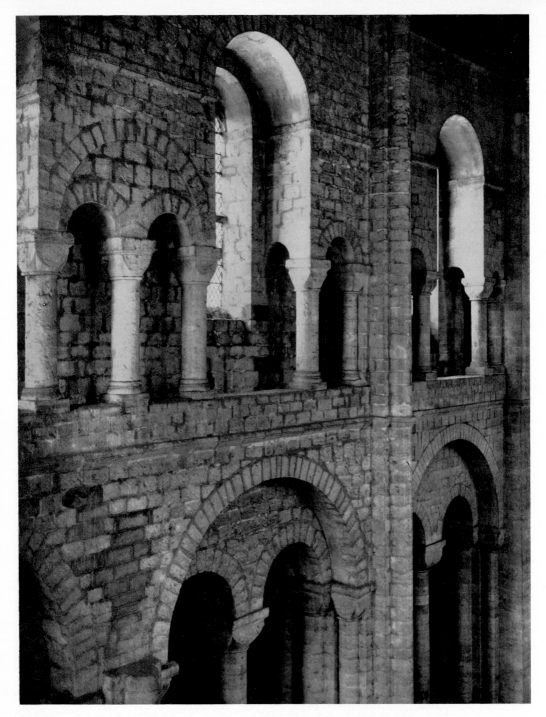

23. Winchester Cathedral. Clerestory passage in transept, about 1080–1107.

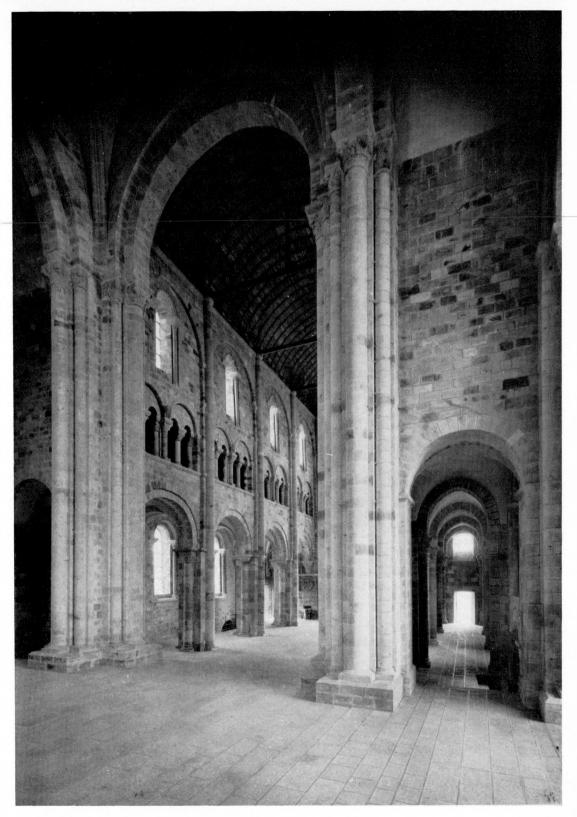

24. Mont-Saint-Michel (Manche). Nave of monastery church, begun soon after 1060.

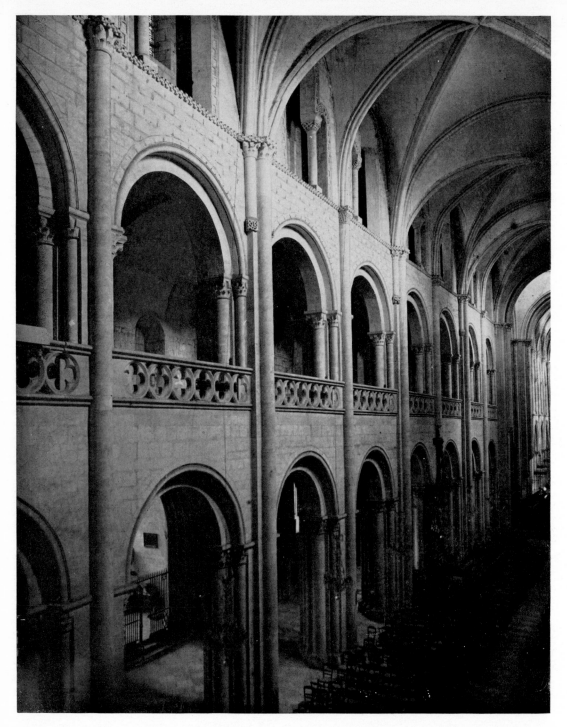

25. Caen, Saint-Etienne. Nave, north side, begun about 1067 (quatrefoil balustrade added later).

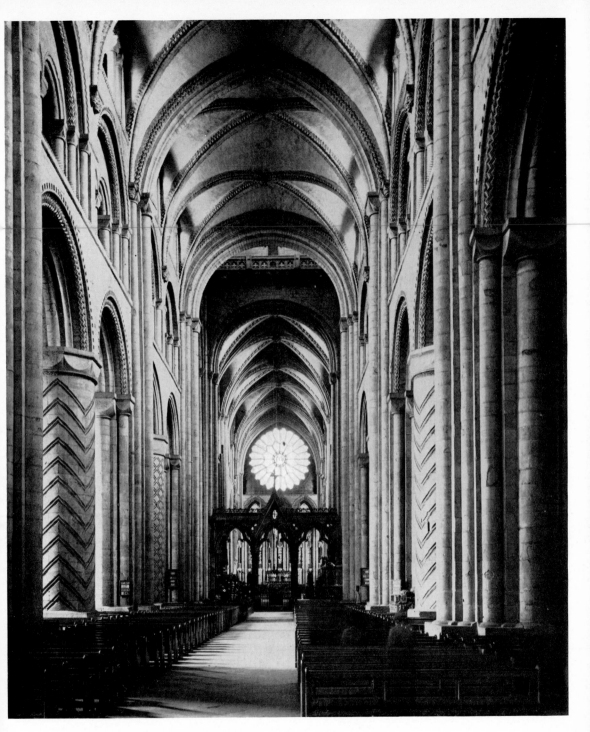

26. Durham Cathedral. Begun 1093, completed 1133.

28. Waltham Abbey (Essex). Decorated pier in the nave, early twelfth century.

27. Lindisfarne Priory (Holy Island, Northumberland). Decorated pier in the nave, early twelfth century.

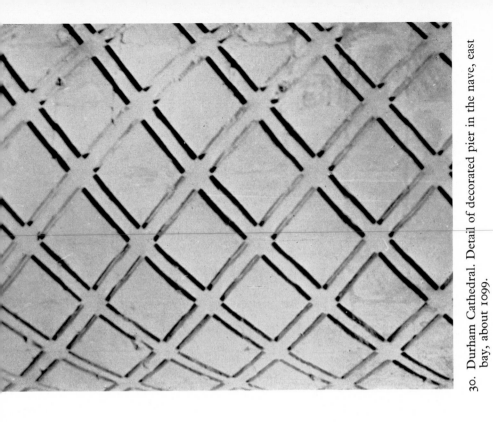

30. Durham Cathedral. Detail of decorated pier in the nave, east bay, about 1099.

29. Waltham Abbey. Pier decoration, early twelfth century.

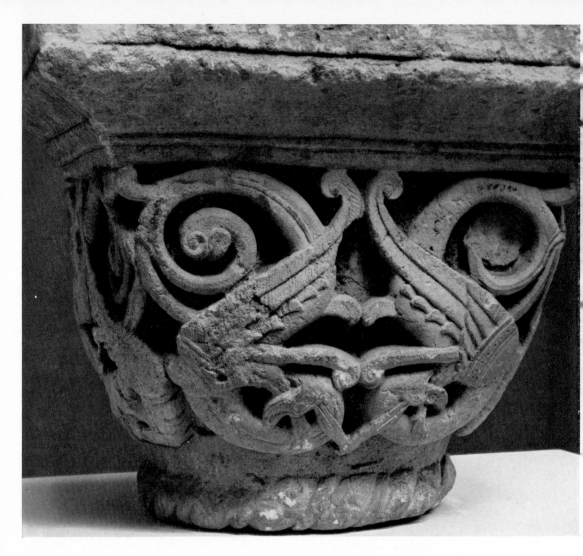

31. Capital from Reading Abbey, second quarter of the twelfth century. Reading Museum.

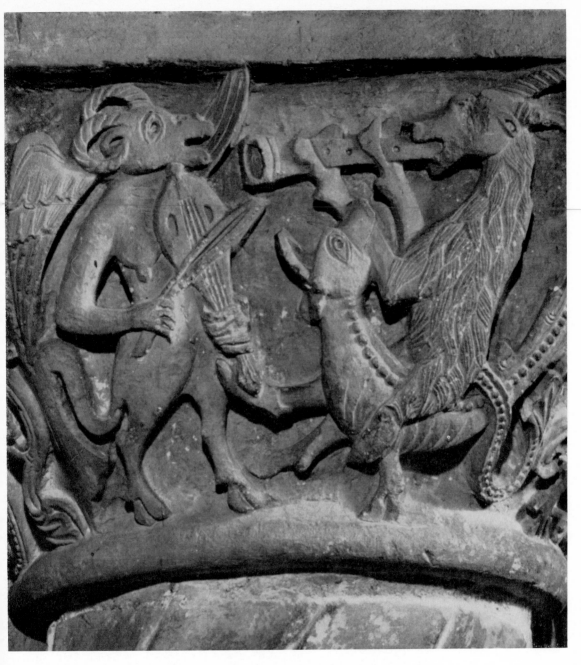

32. Canterbury Cathedral. Capital in St. Gabriel's Chapel in the crypt, about 1120.

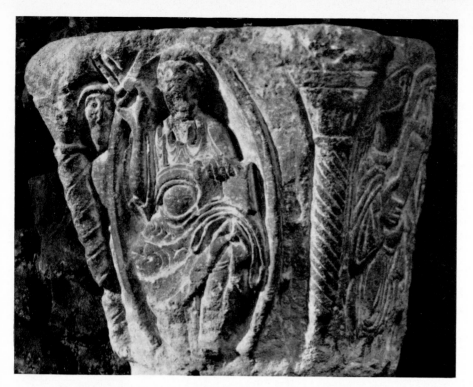

33. Capital from Saint-Germain-des-Prés, early to mid-eleventh century. Paris Musée de Cluny.

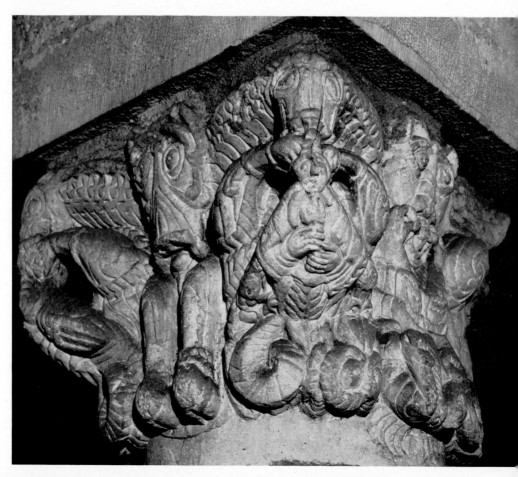

34. Dijon (Côte d'Or), Saint-Bénigne. Capital in the crypt, early eleventh century.

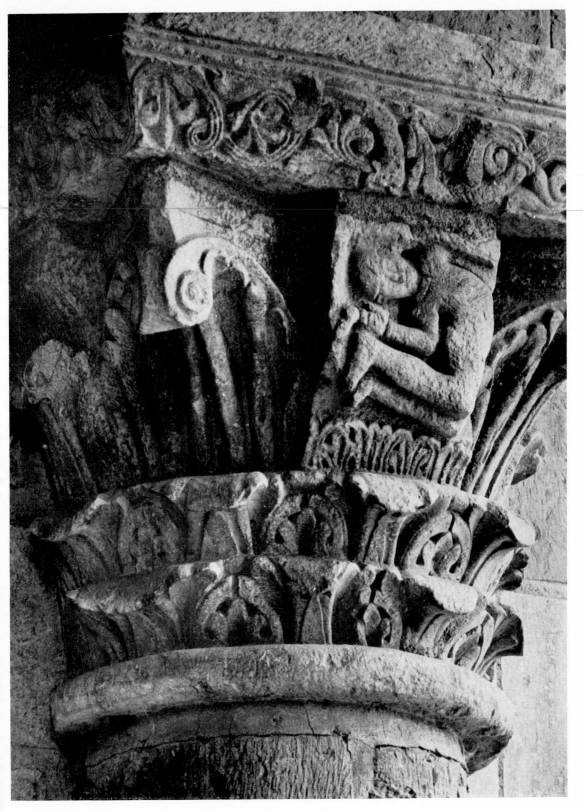

35. Saint-Benoît-sur-Loire (Loiret). Capital in the west porch, second half of the eleventh century.

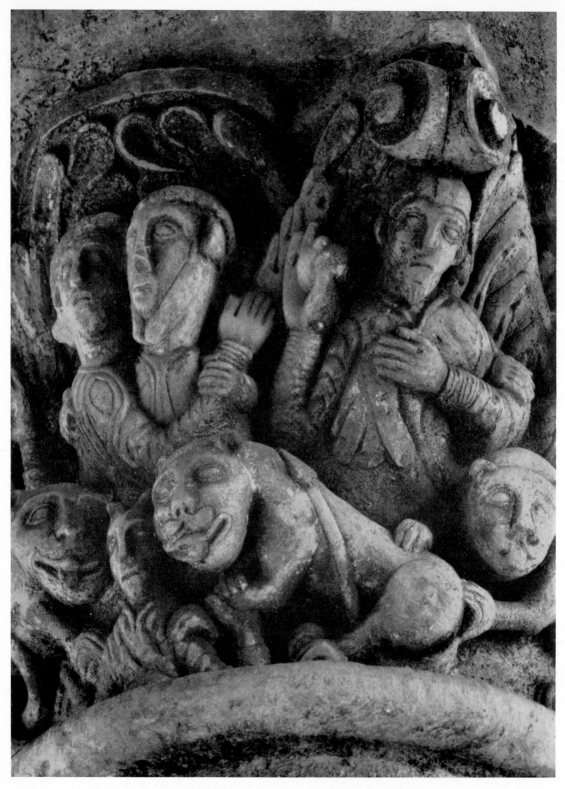

36. Saint-Benoît-sur-Loire (Loiret). Porch capital, second half of the eleventh century.

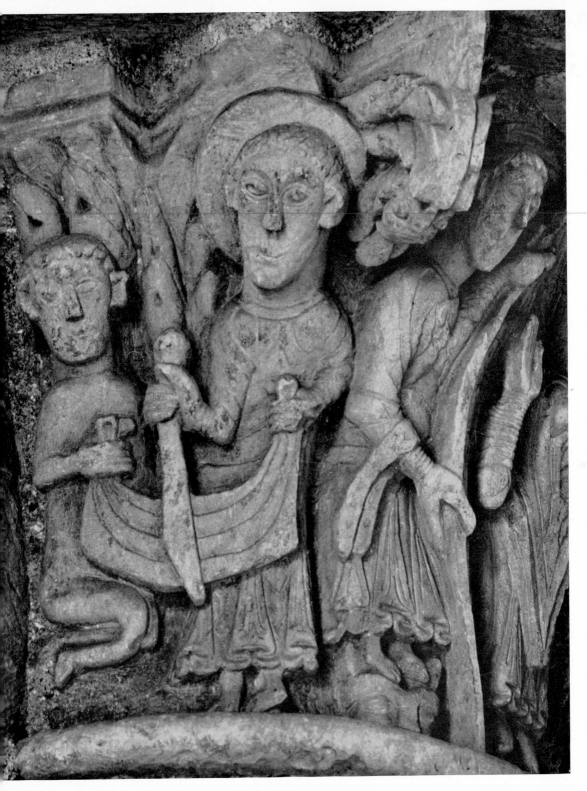

Saint-Benoît-sur-Loire (Loiret). Porch capital, St. Martin, second half of the eleventh century.

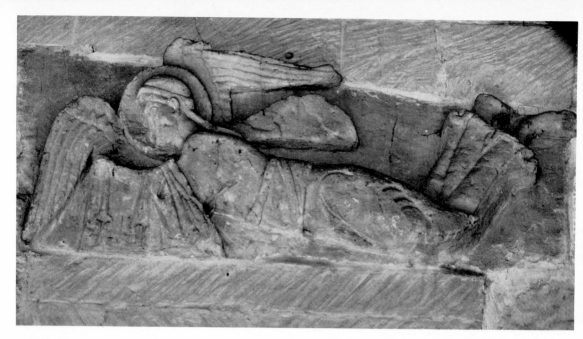

38. Bradford-on-Avon (Wiltshire), St. Lawrence. Angel on the east wall of the nave, about 980.

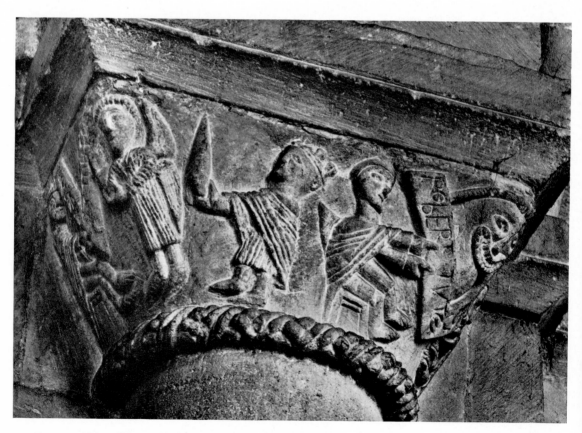

39. Romsey Abbey (Hampshire). Capital in the south choir aisle, about 1125.

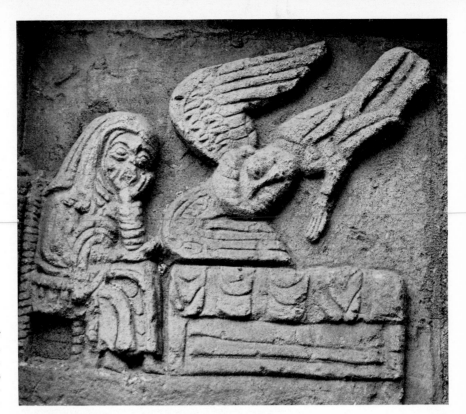

40. Selles-sur-Cher
(Loir-et-Cher).
Detail of apse frieze.
The Annunciation,
d of eleventh century.

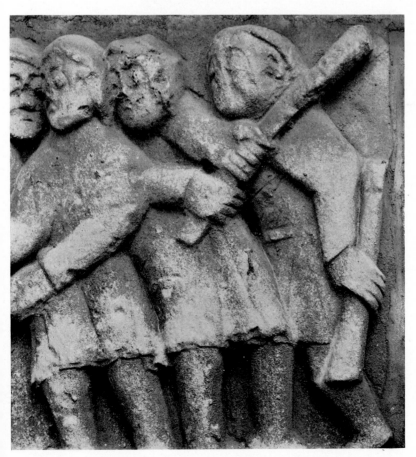

41. Selles-sur-Cher
(Loir-et-Cher).
Detail from the apse frieze
of the *Life of St. Eusice*,
mid-twelfth century.

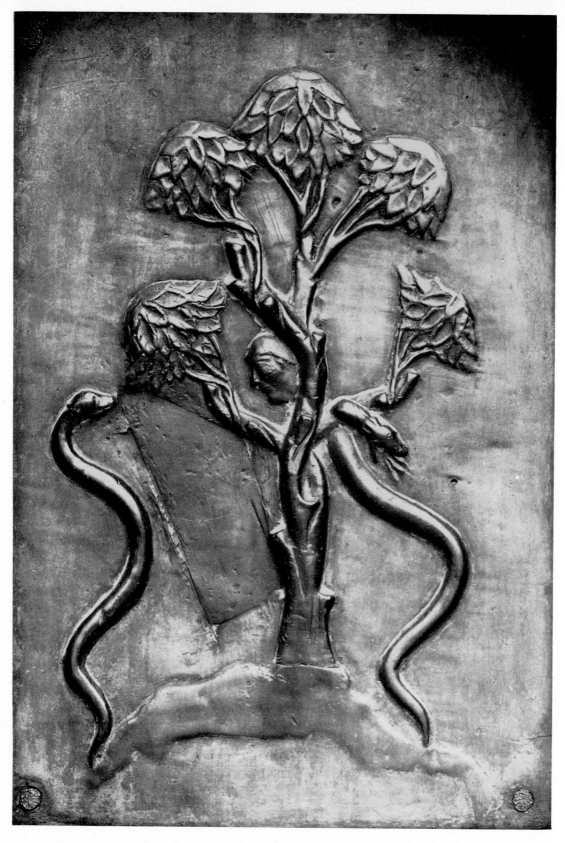

42. Augsburg Cathedral. Bronze door relief, *The Tree of Knowledge*, mid-eleventh century.

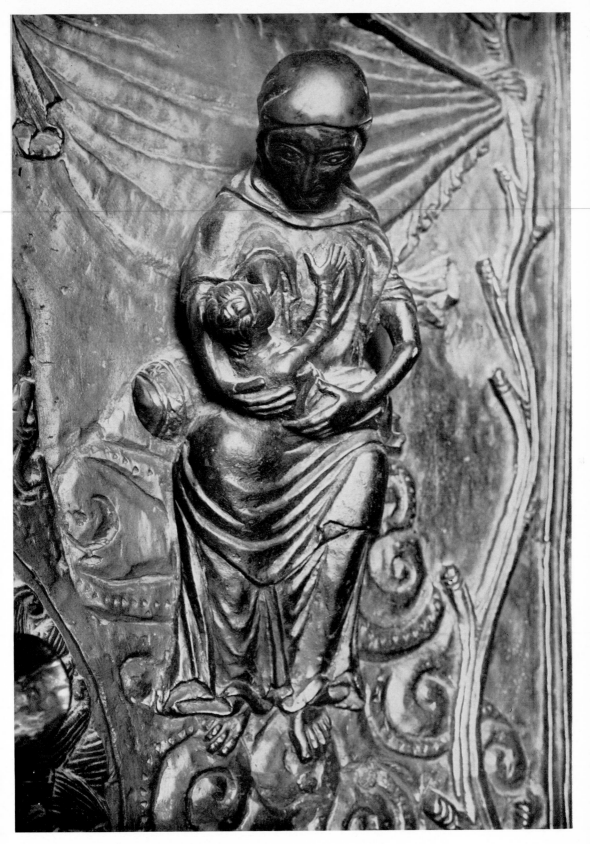

43. Hildesheim Cathedral. Bronze door relief, *Eve nursing her first born*, about 1015.

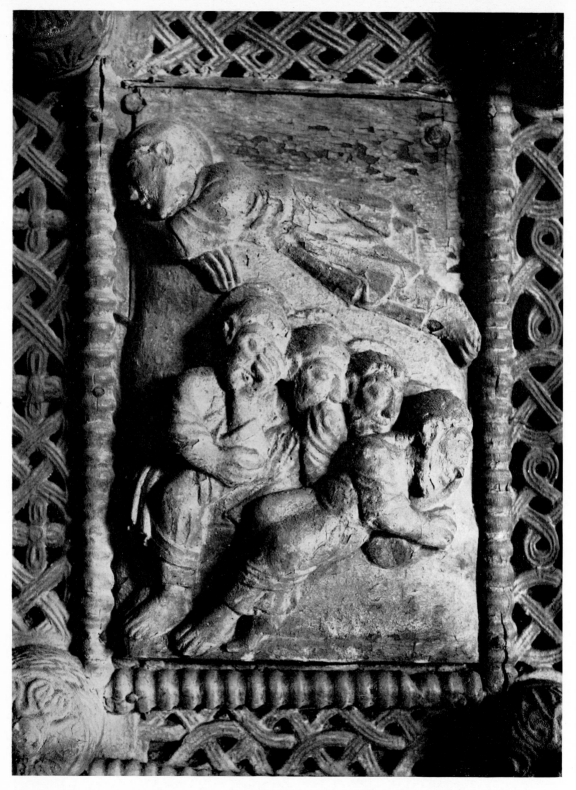

44. Cologne, St. Maria-im-Kapitol. Wooden door relief, *Christ on the Mount of Olives*, second half of eleventh century.

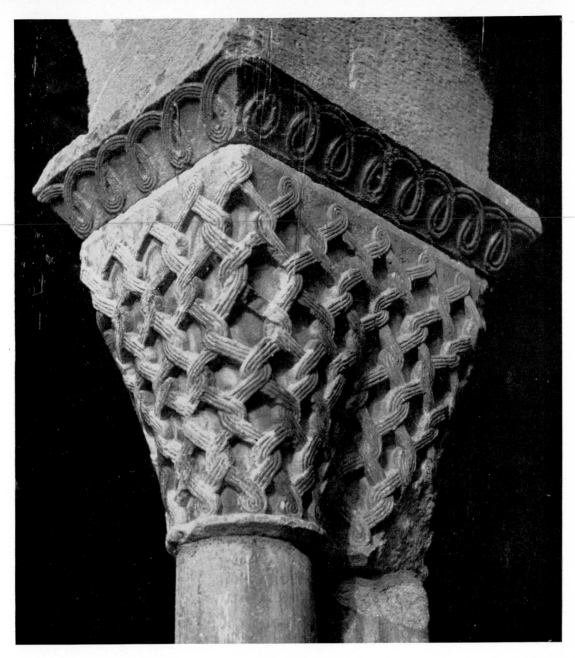

45. Saint-Bertrand-de-Comminges (Haute-Garonne). Capital.

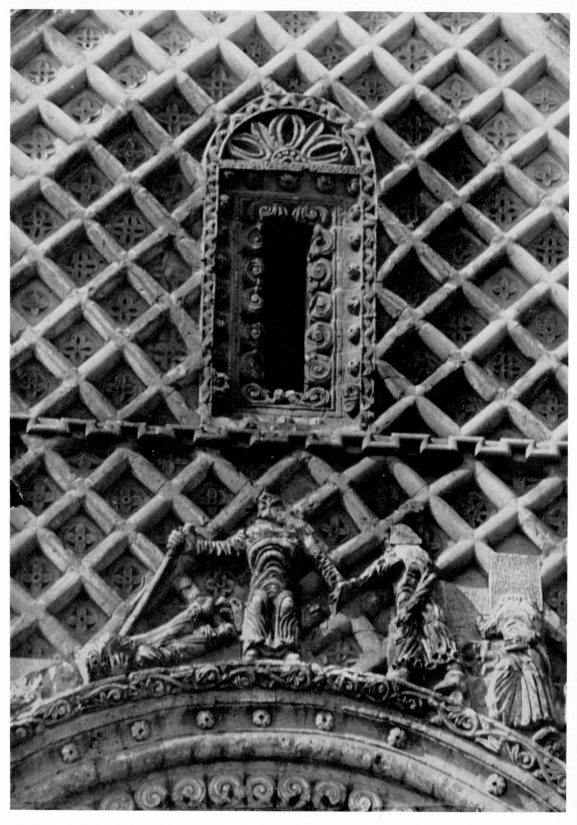

46. Beauvais (Oise), Saint-Etienne. Window in the gable of the north transept, middle of the twelfth century.

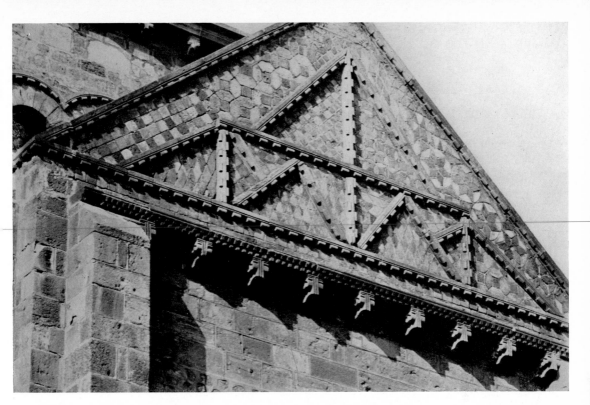

47. Clermont-Ferrand (Puy-de-Dôme), Notre-Dame-du-Port. Stone mosaic on gable of south transept, first half of twelfth century.

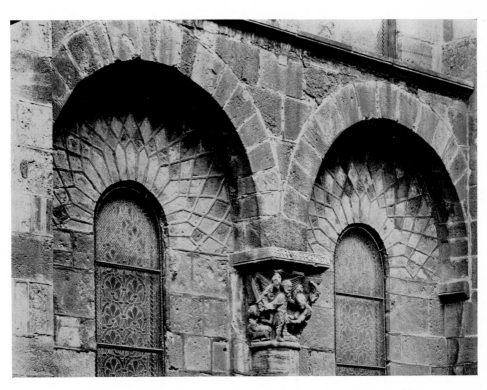

48. Clermont-Ferrand, Notre-Dame-du-Port. South side, first half of twelfth century.

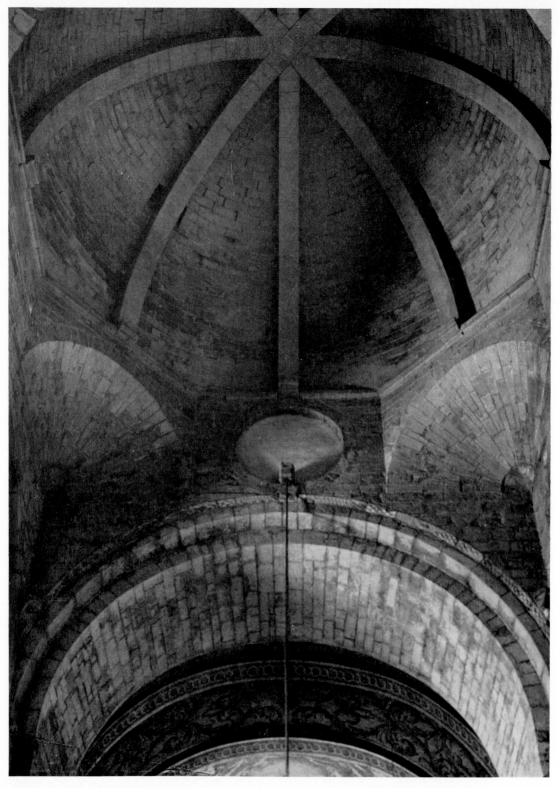

49. Jaca Cathedral (Aragon). Dome over the crossing, end of the eleventh century.

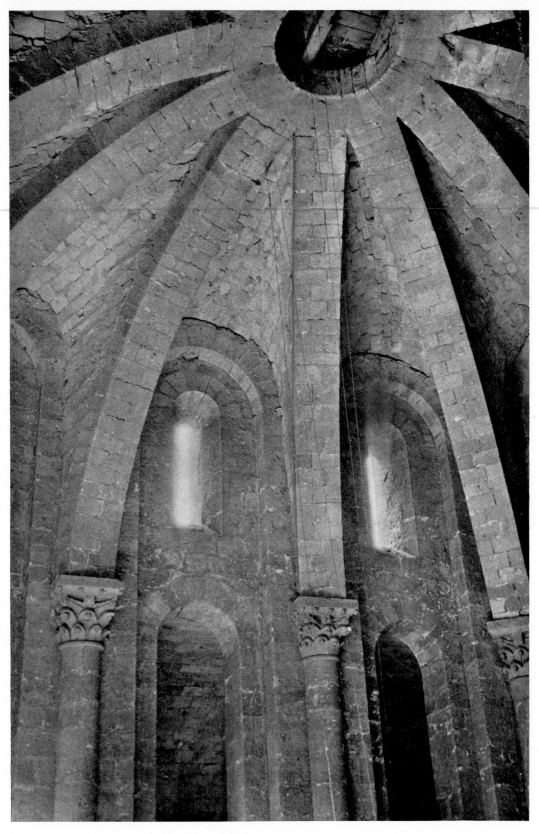

50. Moissac (Tarn-et-Garonne), Saint-Pierre. Rib vault in the upper storey of the porch-tower,
about 1120.

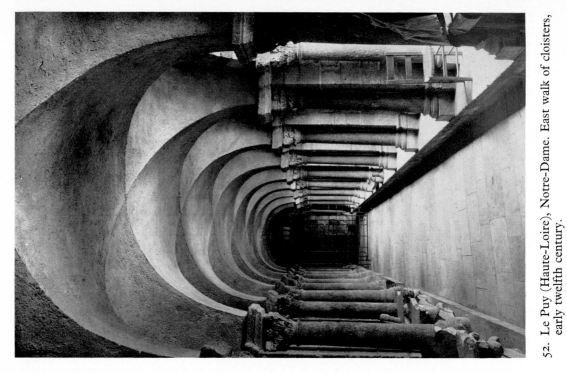

52. Le Puy (Haute-Loire), Notre-Dame. East walk of cloisters, early twelfth century.

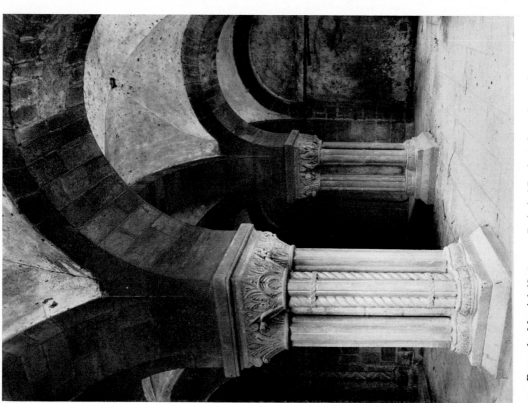

51. Paray-le-Monial (Saône-et-Loire). Narthex, late eleventh century.

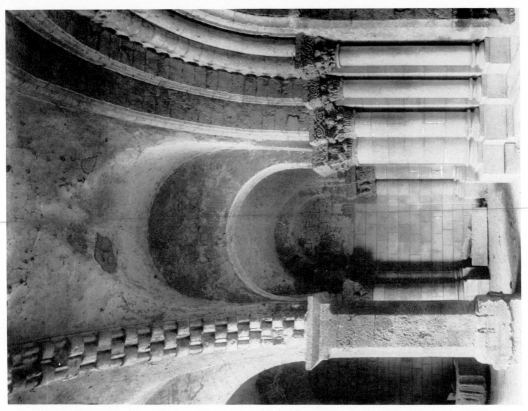

54. Airvault (Deux-Sèvres), Saint-Pierre. Narthex, first half of the twelfth century.

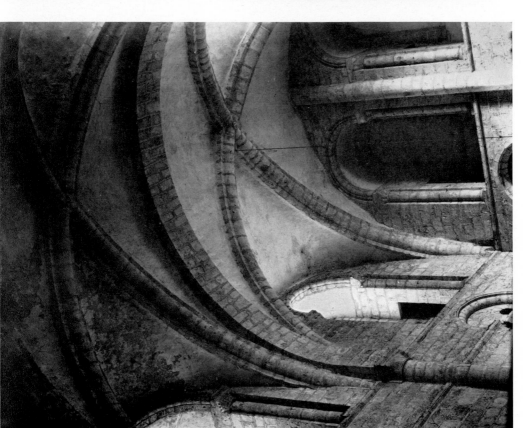

53. Lessay (Manche). Vaulting of north transept, about 1120.

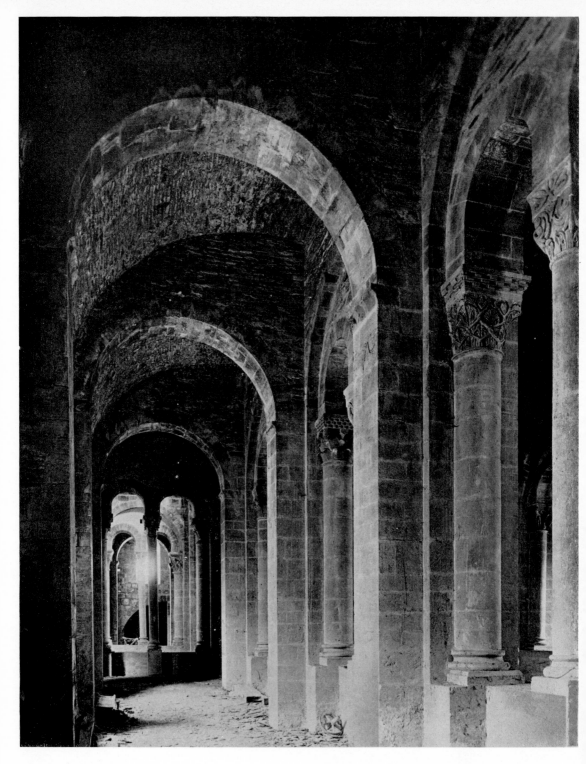

55. Conques (Aveyron), Sainte-Foy. Tribune above north aisle, late eleventh or early twelfth century.

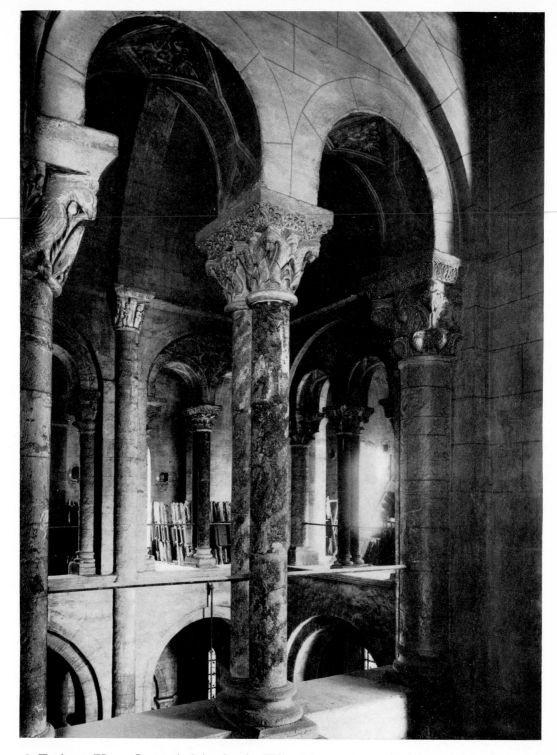

56. Toulouse (Haute-Garonne), Saint-Sernin, Tribune in transept, end of eleventh – beginning of twelfth century.

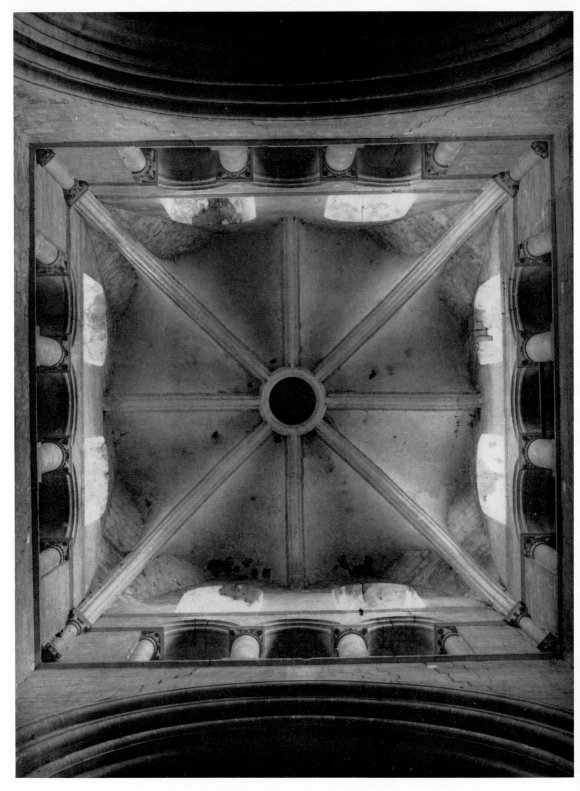

57. Caen (Calvados), Saint-Etienne. Interior vaulting of lantern, about 1130, rebuilt in the seventeenth century.

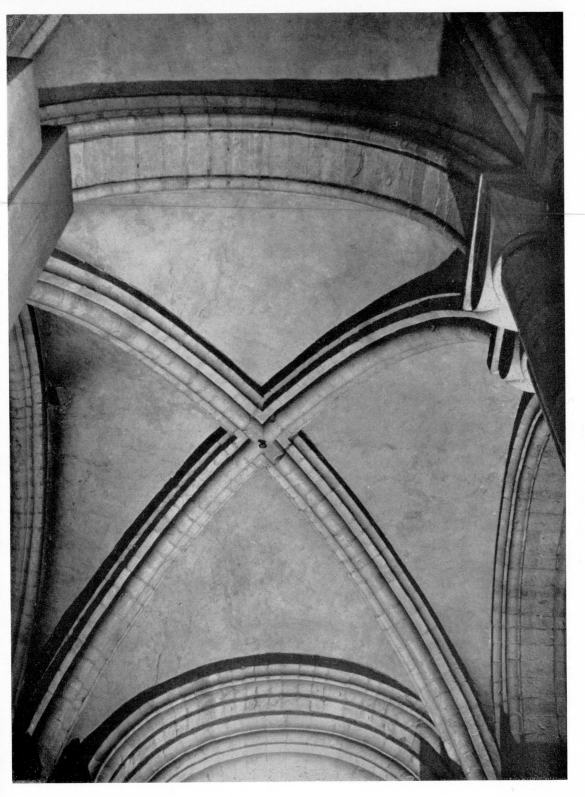

58. Durham Cathedral. Choir aisle vaulting, *c.* 1093–1097.

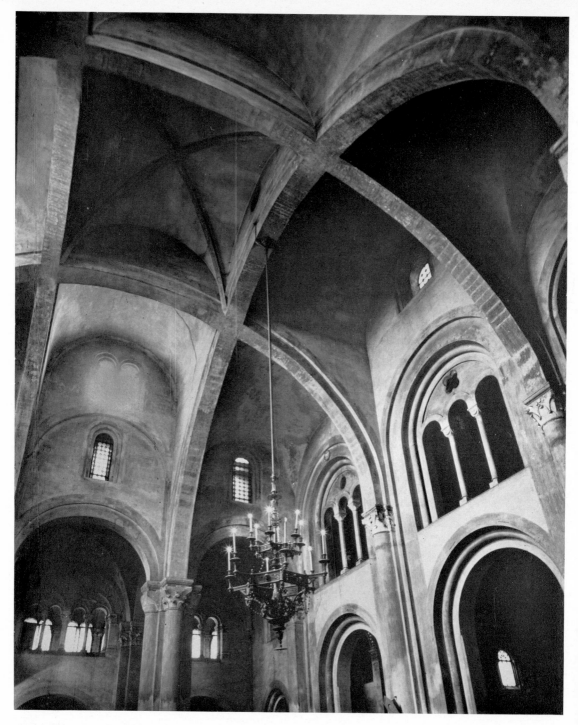

59. Casale-Monferrato (Piedmont), S. Evasio. Narthex, *c.* 1200.

60. Milan, S. Ambrogio. Use of rib-vaults in nave, after 1128.

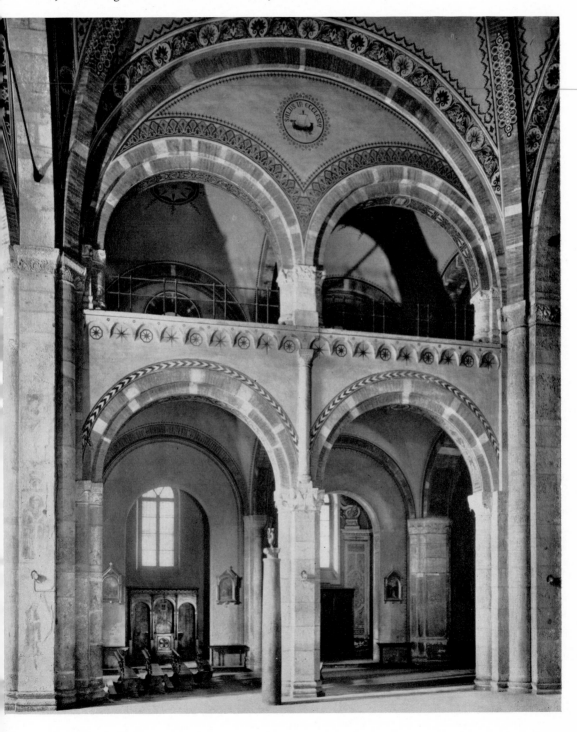

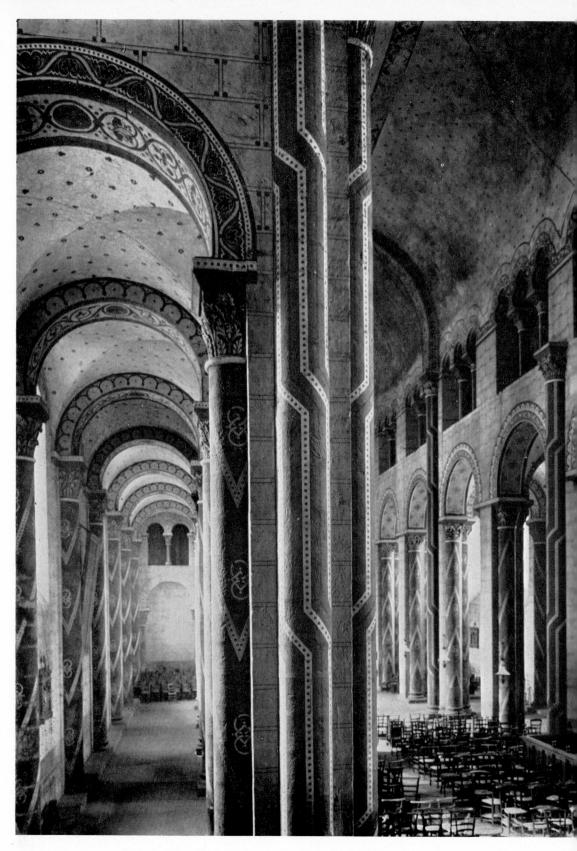

61. Issoire (Puy-de-Dôme), Saint-Paul. Nave, south aisle, middle of twelfth century.

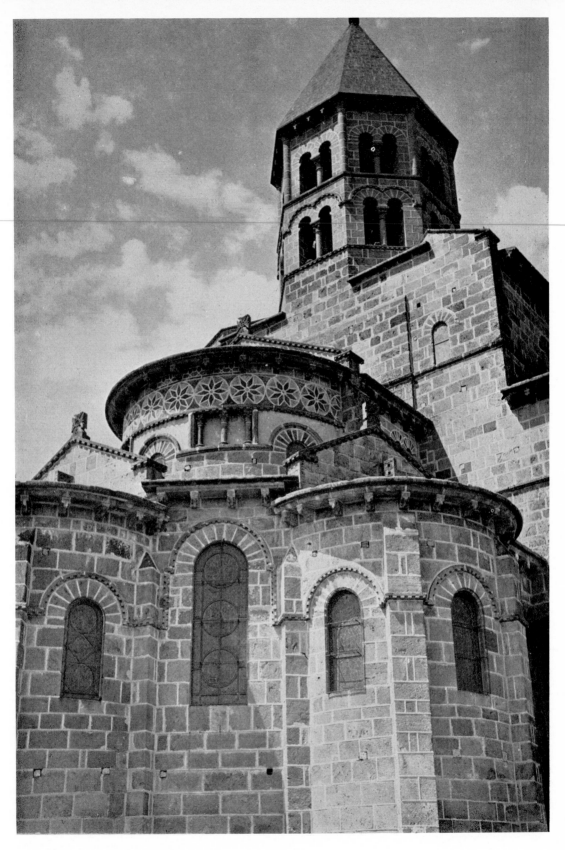

62. Saint Nectaire (Puy-de-Dôme). East end, twelfth century.

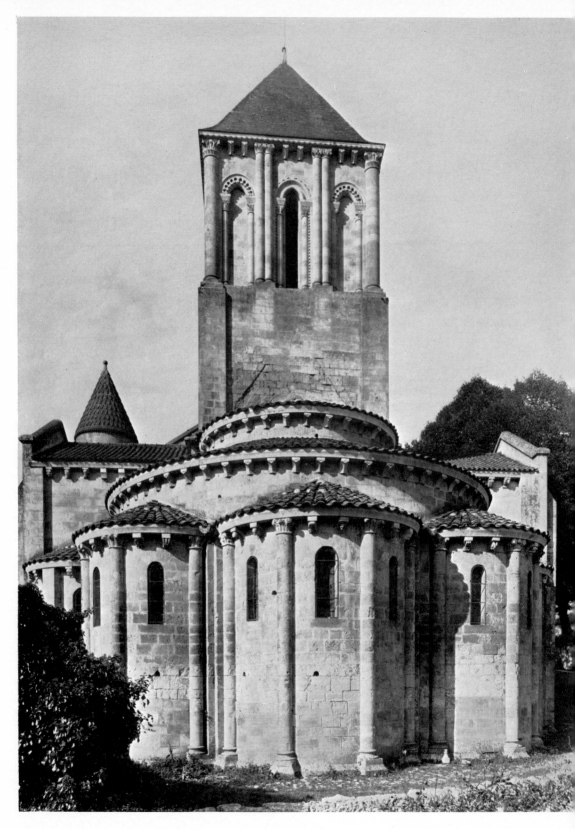

63. Melle (Deux-Sèvres), Saint-Hilaire. Twelfth century.

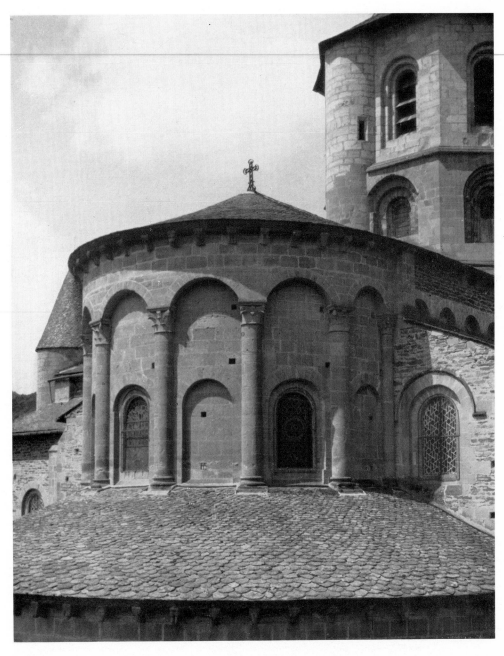

64. Conques (Aveyron), Sainte-Foy. Upper story of apse, middle of the twelfth century.

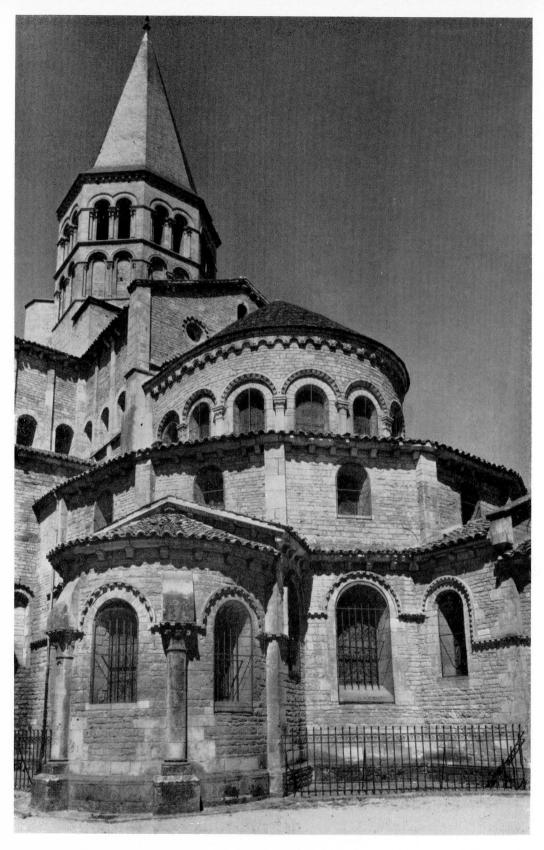

65. Paray-le-Monial (Saône-et-Loire). East end, about 1100.

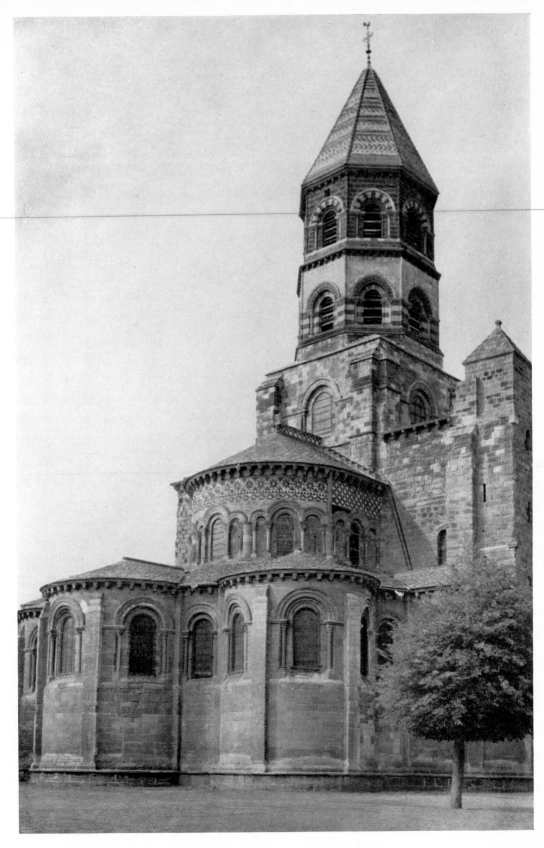

66. Brioude (Haute-Loire), Saint-Julien. Middle of the twelfth century.

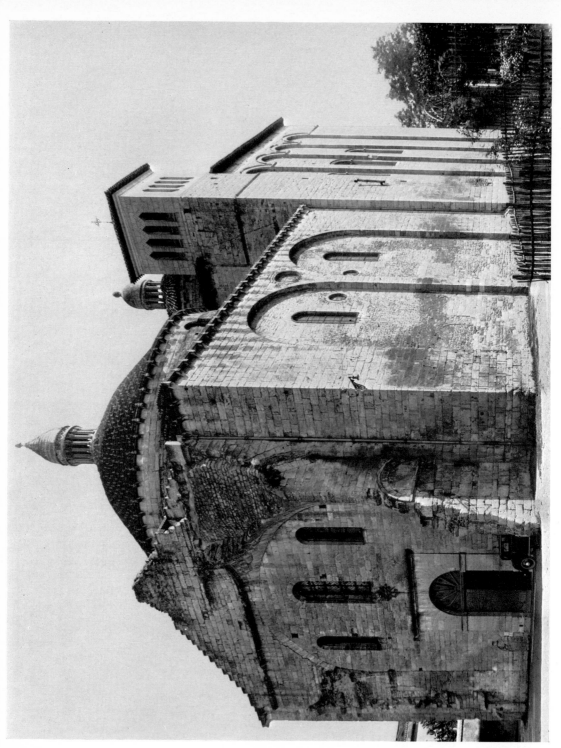

67. Périgueux (Dordogne), Saint-Étienne-en-la-Cité, begun about 1118.

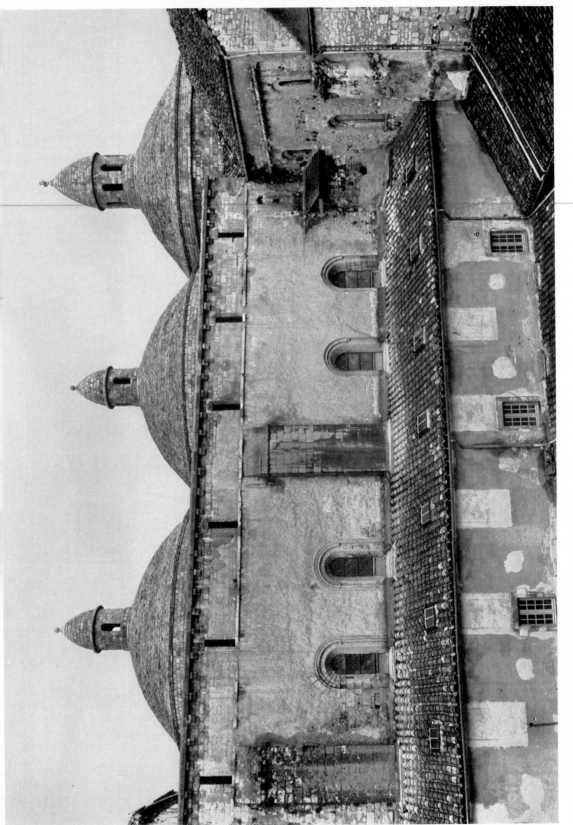

68. Souillac (Lot) Sainte-Marie. First half of twelfth century.

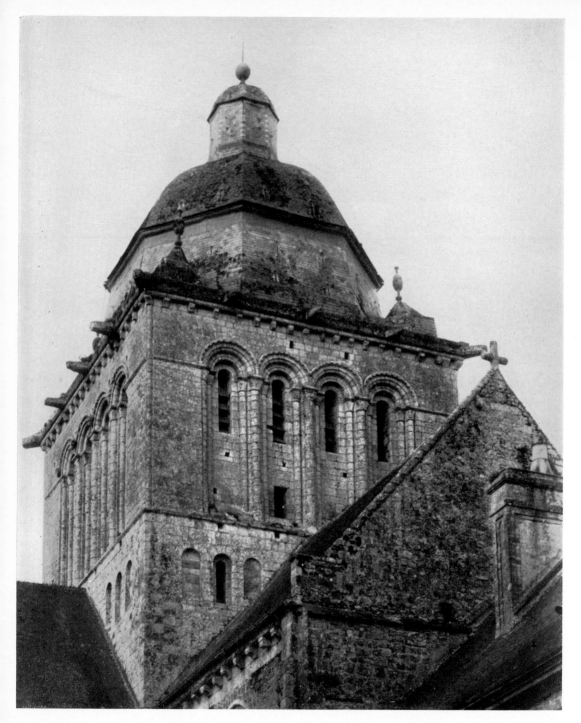

69. Lessay (Manche). Crossing tower, twelfth century (dome eighteenth century).

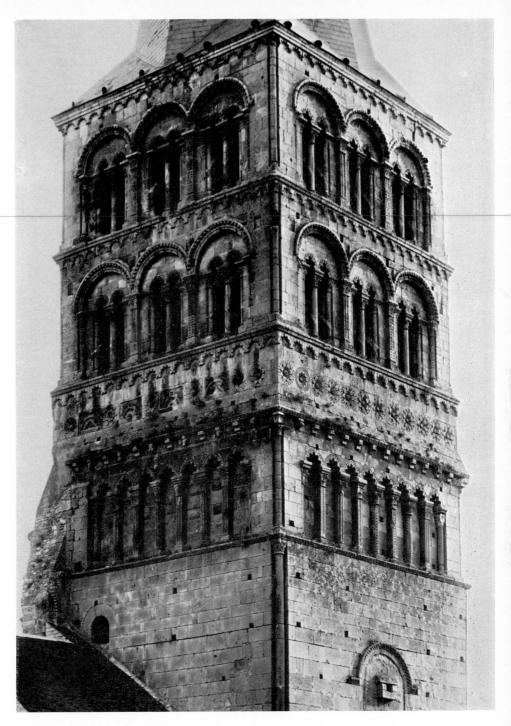

70. La Charité-sur-Loire (Nièvre). Bell-tower, middle of twelfth century.

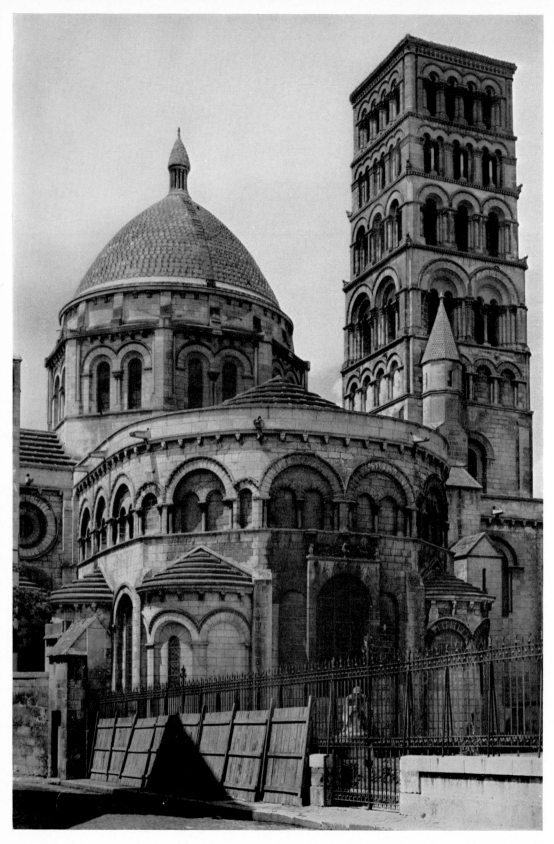

71. Angoulême, Saint-Pierre. Begun at the west about 1120, heavily restored.

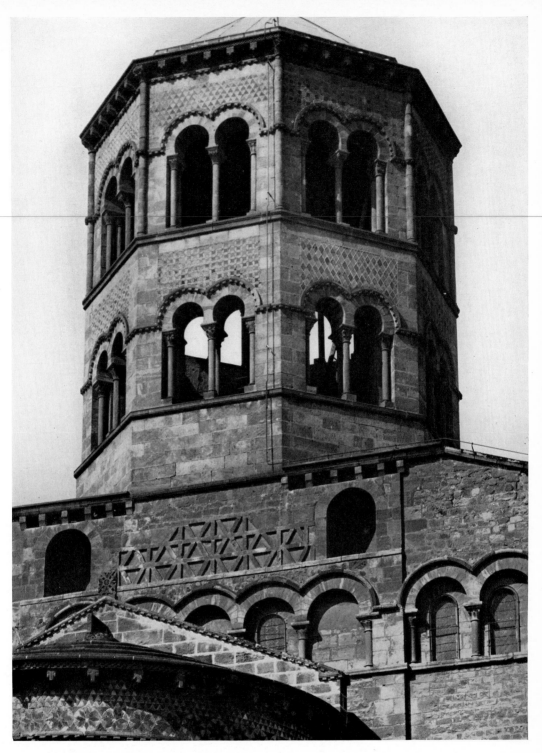

72. Issoire (Puy-de-Dôme), Saint Paul. Tower over crossing, middle of twelfth century.

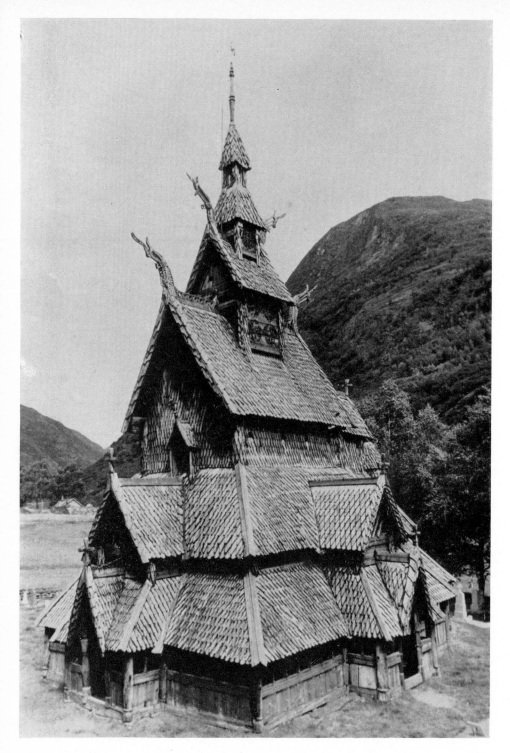

73. Borgund (Norway). Stave church, twelfth century.

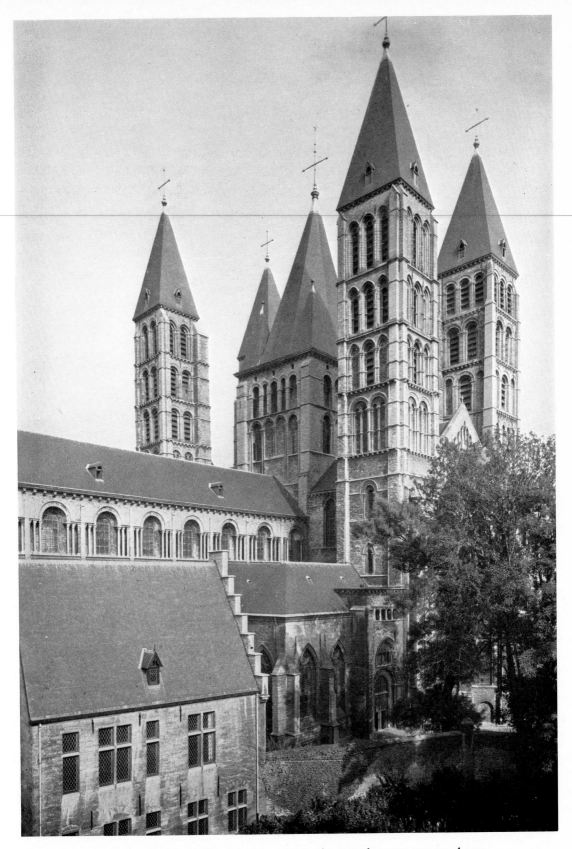

74. Tournai Cathedral (Belgium). Begun 1110; nave and towers between 1135 and 1200.

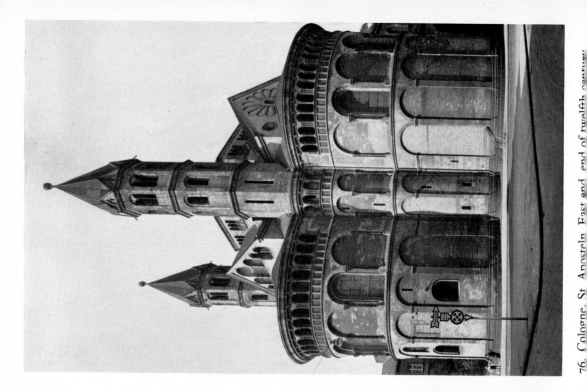

76. Cologne, St Aposteln. East end, end of twelfth century.

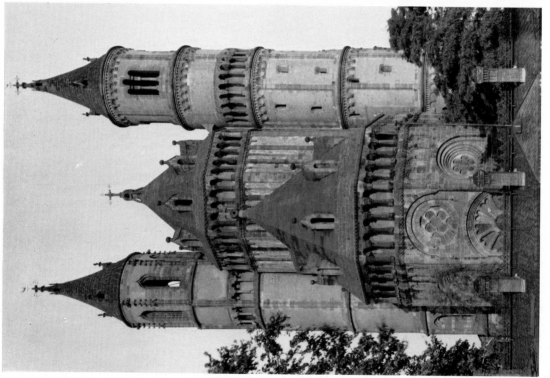

75. Worms Cathedral. West end, after 1181.

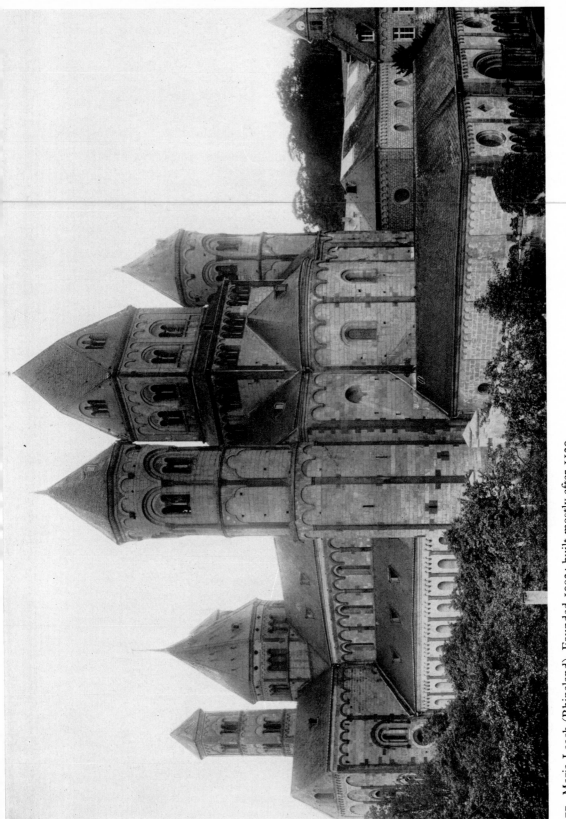

77. Maria-Laach (Rhineland). Founded 1093; built mostly after 1130.

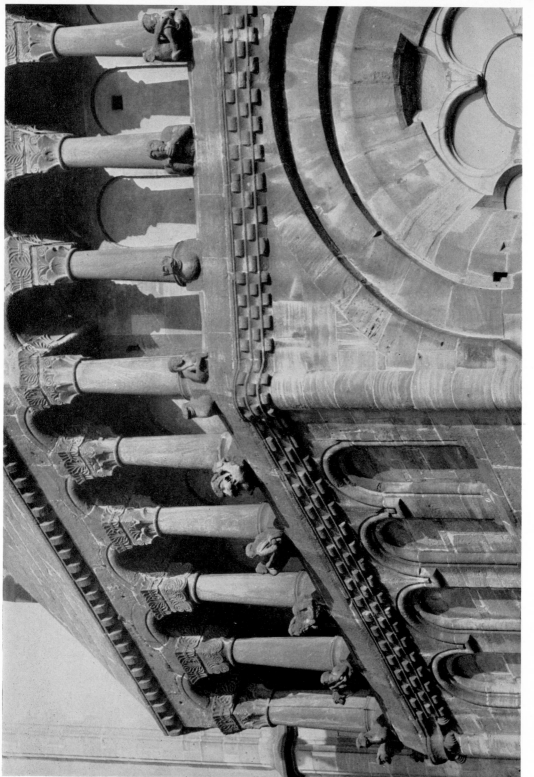

78. Worms Cathedral. Arcading on west choir, end of twelfth century.

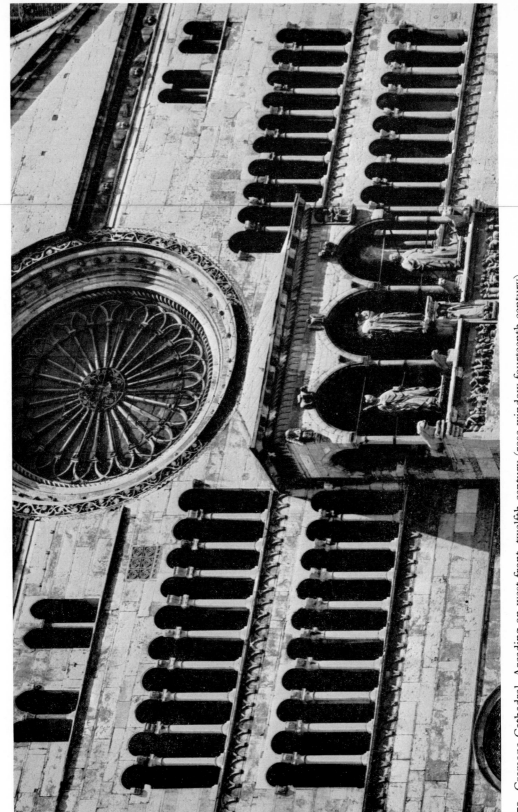

79. Cremona Cathedral. Arcading on west front, twelfth century (rose window fourteenth century).

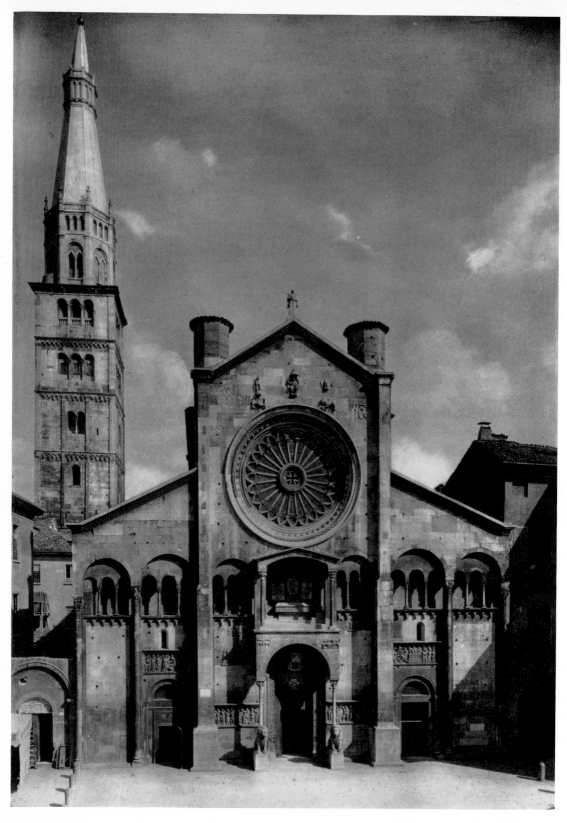

80. Modena Cathedral, begun 1099. West façade, designed *c.* 1120.

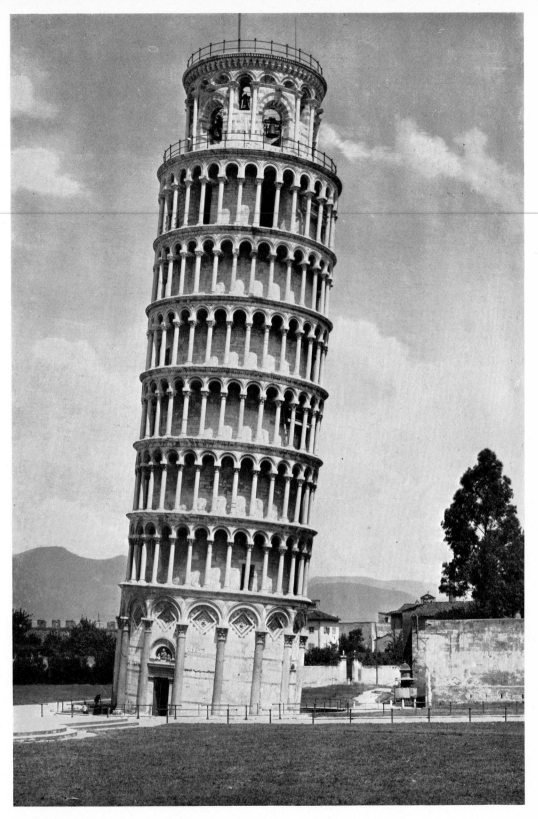

81. Pisa, Campanile. Early twelfth century.

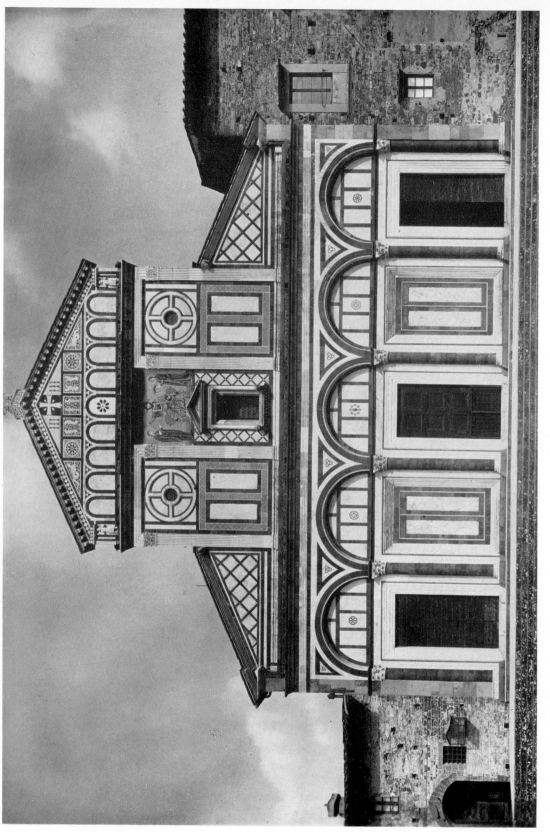

82. Florence, San Miniato al Monte. Façade, 1070–1150; gable about 1200.

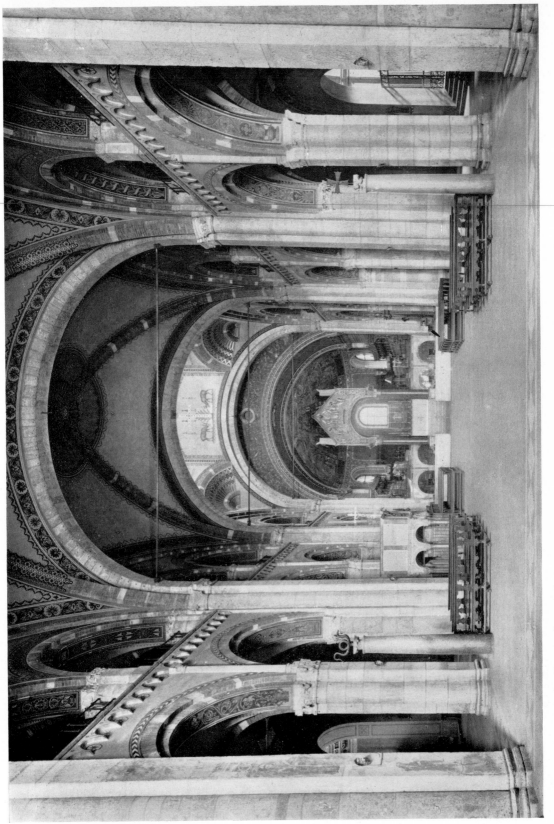

83. Milan, S. Ambrogio. Nave, after 1128.

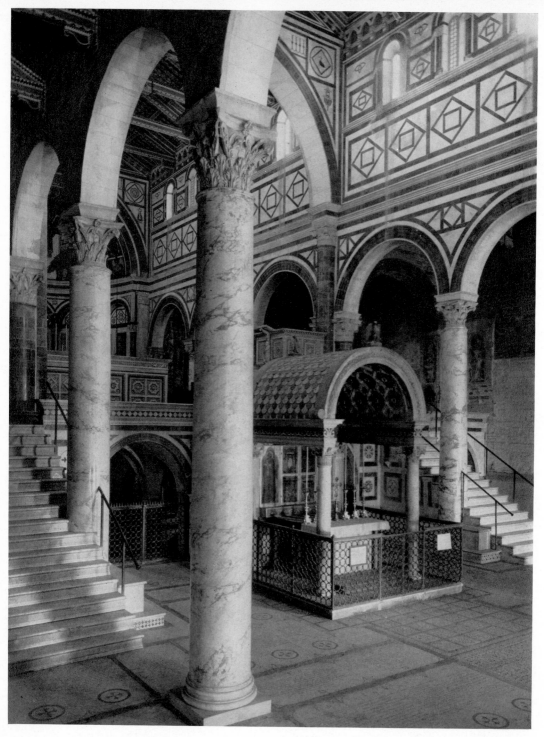

84. Florence, S. Miniato al Monte, 1070–1150.

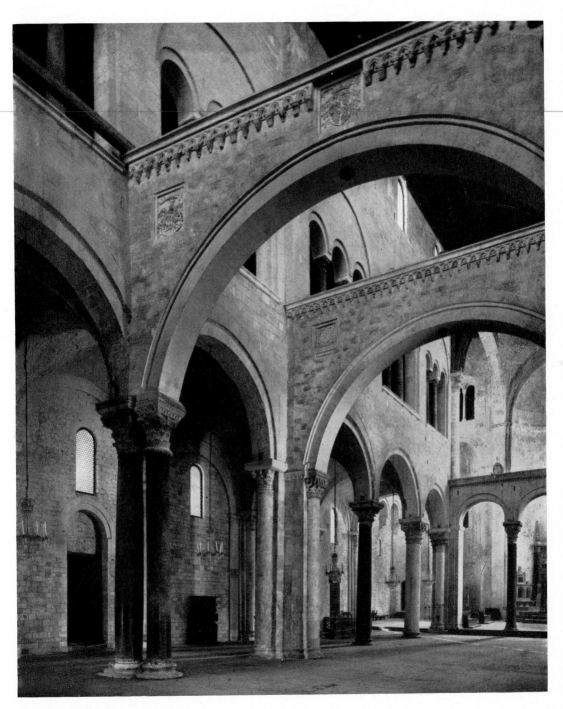

85. Bari, S. Nicola: 1089–after 1132.

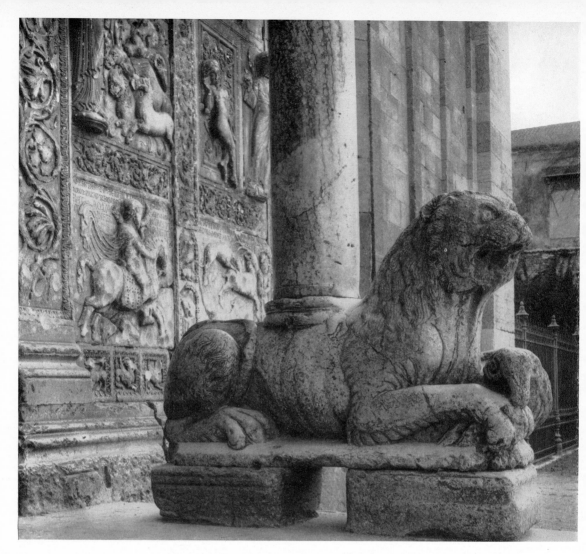

86. Verona, S. Zeno. Lion from main portal, middle of twelfth century.

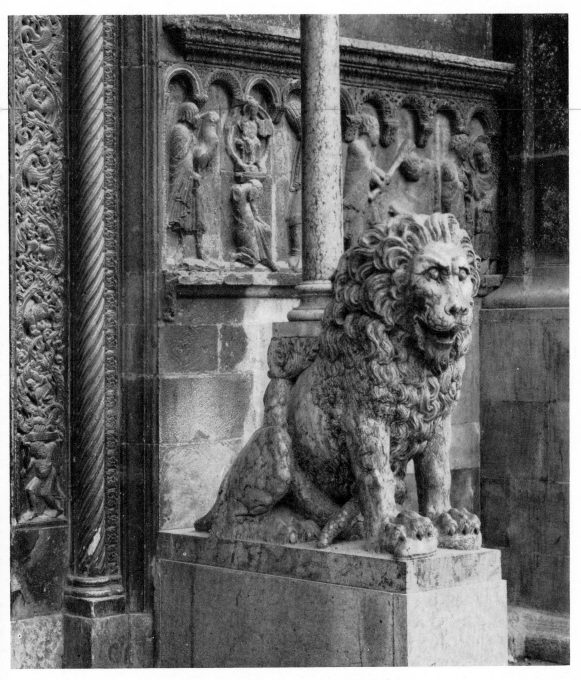

87. Modena Cathedral. Lion from main portal, early twelfth century.

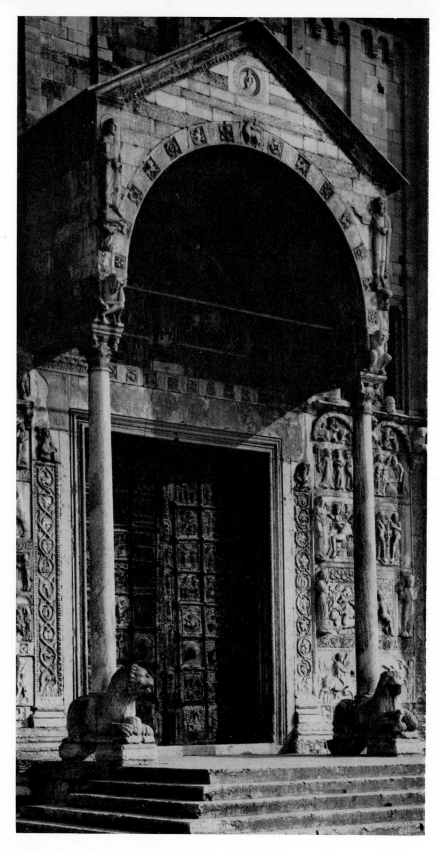

88. Verona, S. Zeno. Main portal.

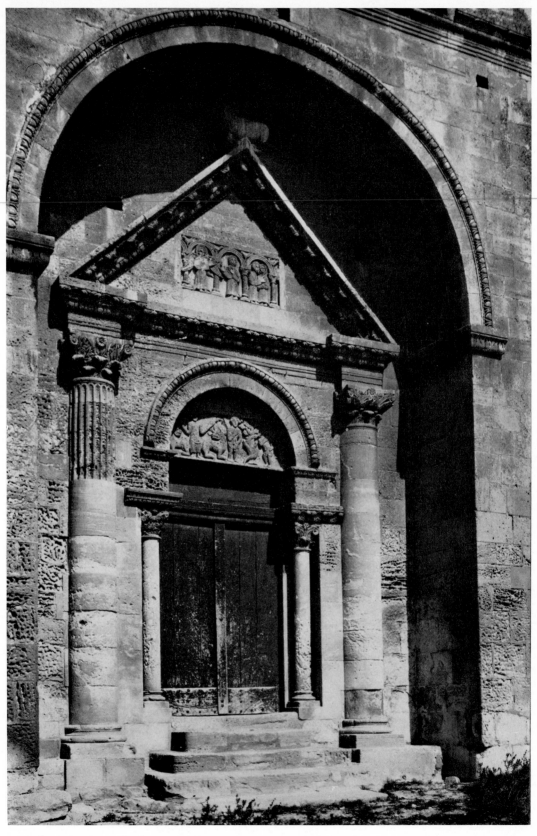

89. Saint-Gabriel (Bouches-du-Rhône). Portal, twelfth century.

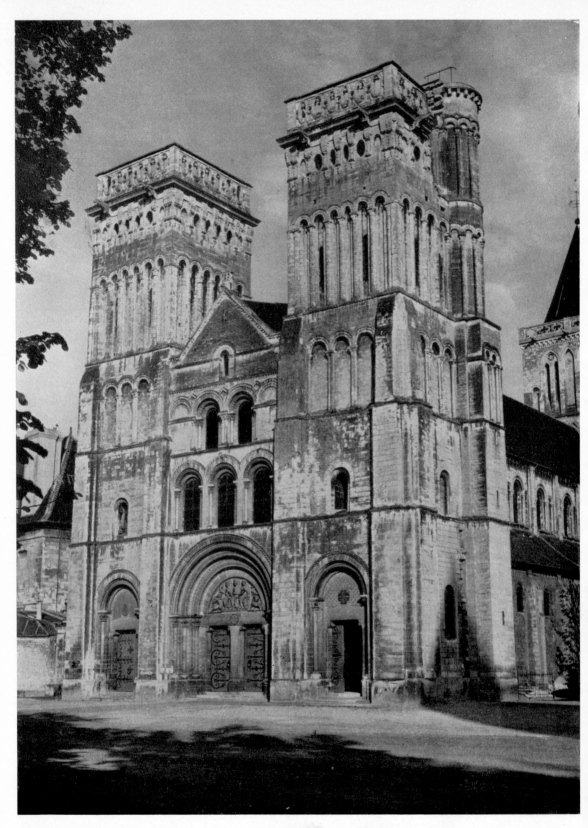

90. Caen (Calvados), La Trinité or Abbaye-aux-Dames. 1062–1140 (the doors modern).

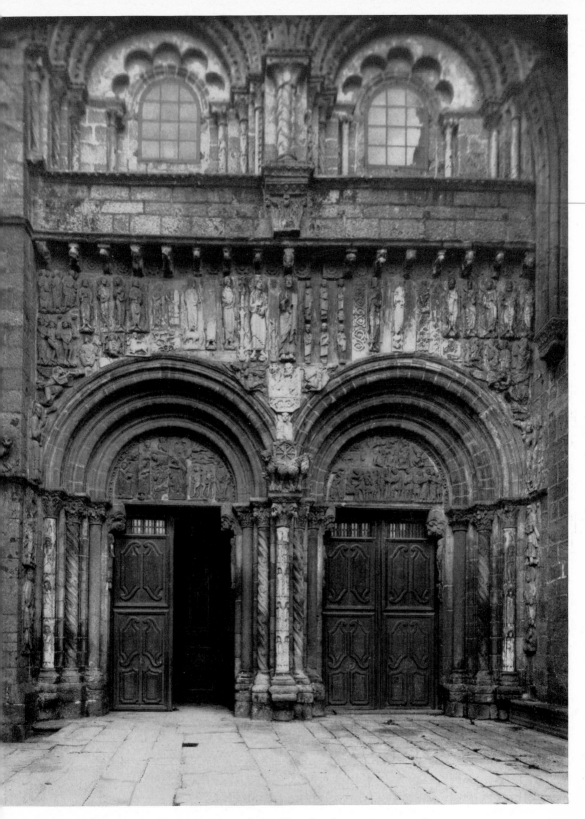

91. Santiago de Compostela (Galicia). Puerta de las Platerias, between 1105 and 1122.

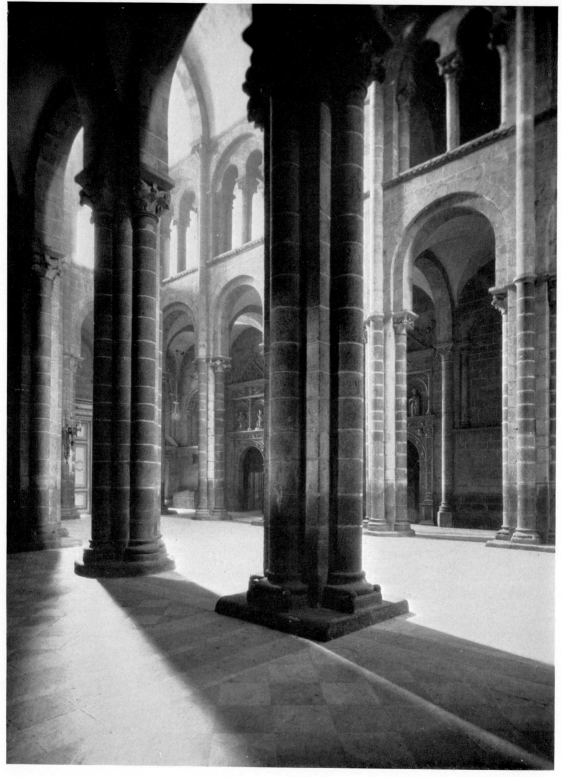

92. Santiago de Compostela (Galicia). Nave, about 1075–1122.

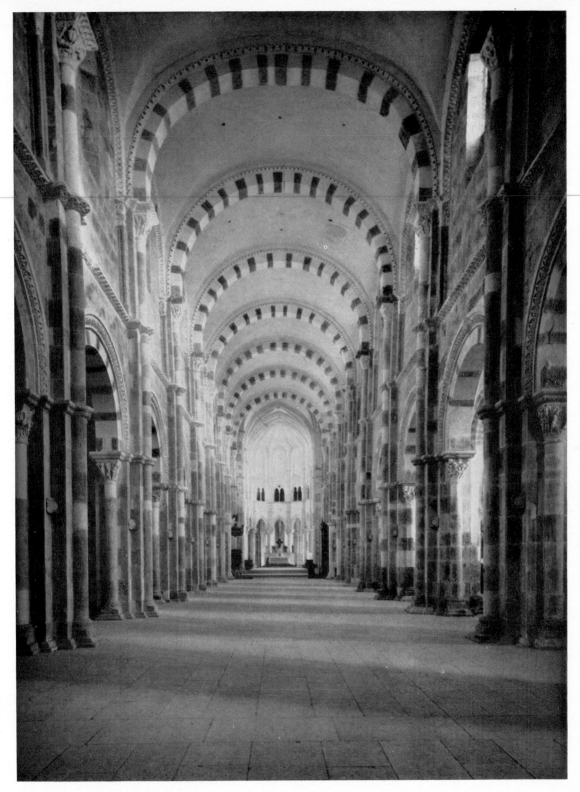

93. Vézelay (Yonne), Sainte-Madeleine. Nave, 1120–1140.

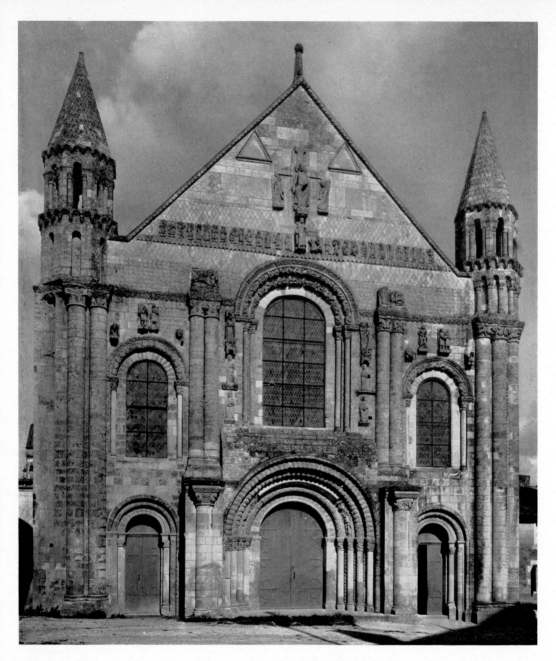

94. Saint-Jouin-de-Marnes (Deux-Sèvres). West façade, about 1130.

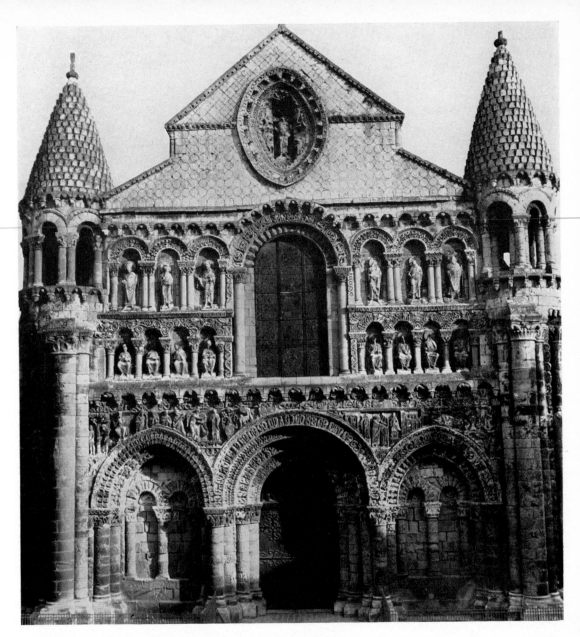

95. Poitiers, Notre-Dame-la-Grande. West façade, about 1140.

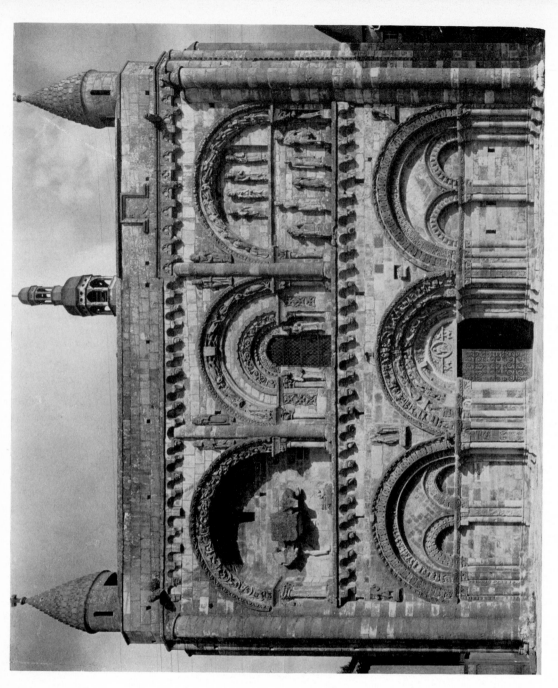

96. Civray (Vienne), Saint-Nicolas. West façade, middle of twelfth century.

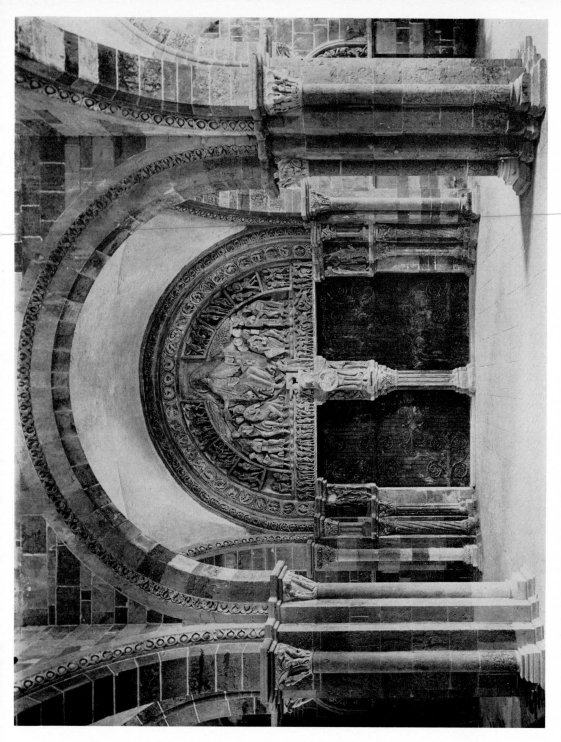

97. Vézelay (Yonne), Sainte-Madeleine. Narthex, completed about 1150. Sculptured tympanum about 1125.

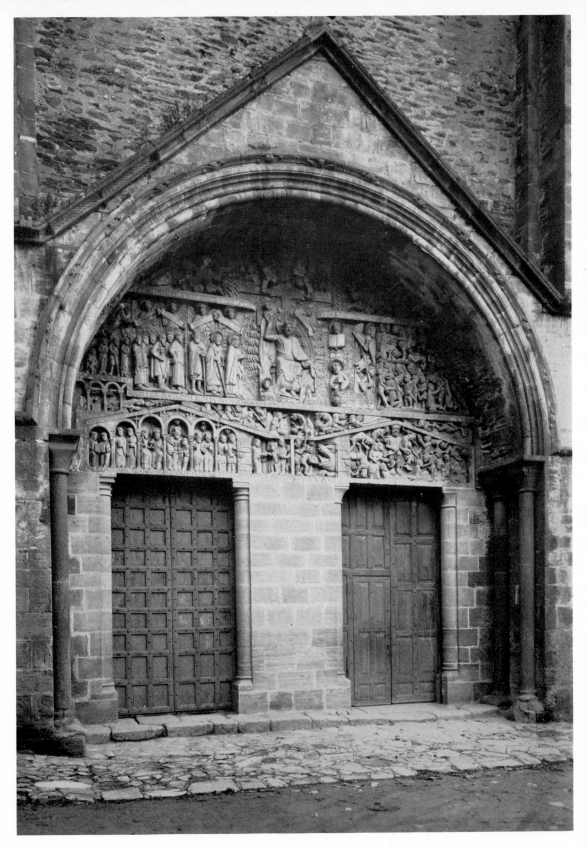

98. Conques (Aveyron), Sainte-Foy. West portal, tympanum about 1140.

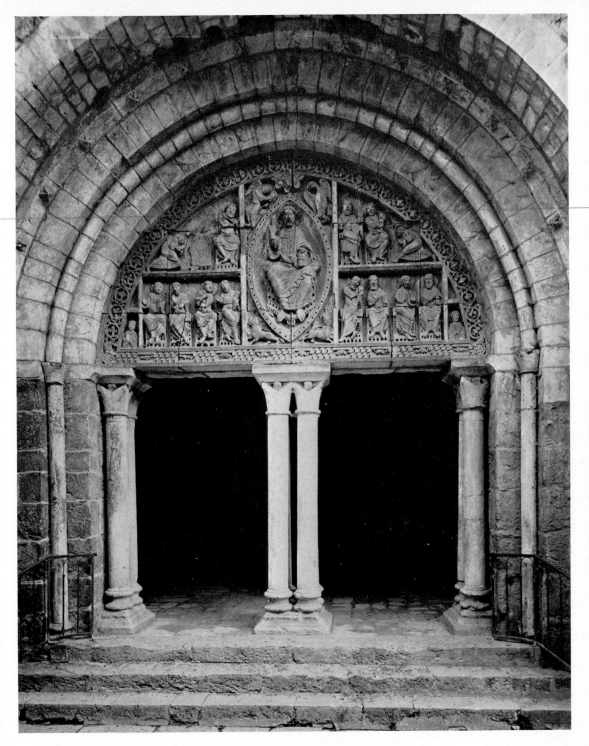

99. Carennac (Lot). Tympanum of west portal, second quarter of twelfth century.

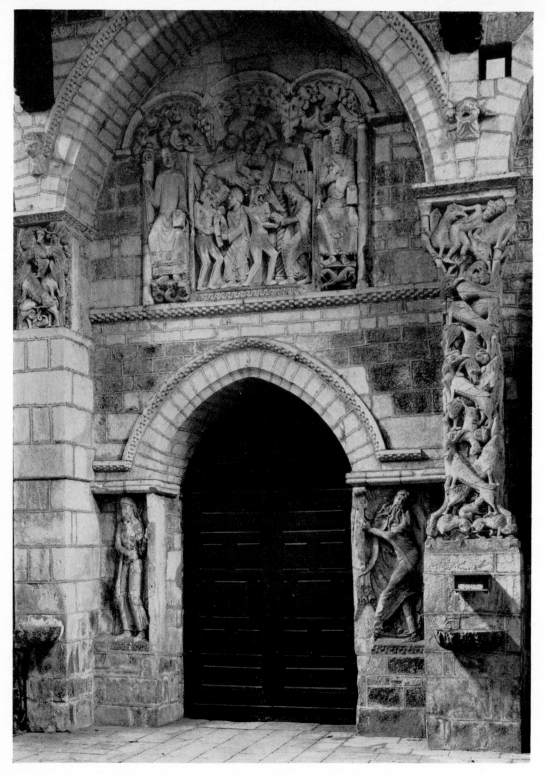

100. Souillac (Lot), Sainte-Marie. Reliefs from former portal, about 1130.

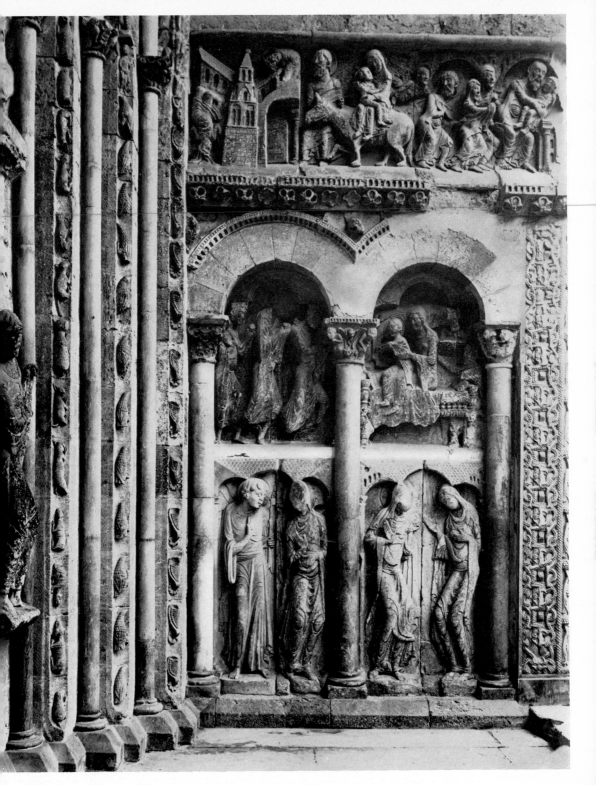

91. Moissac (Tarn-et-Garonne), Saint-Pierre. Right side of south porch, second quarter of the twelfth century.

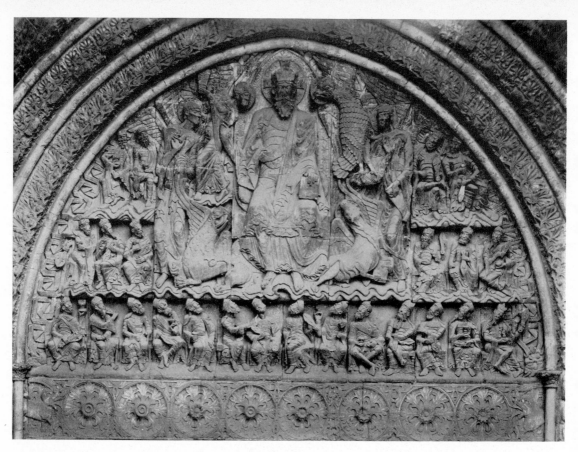

102. Moissac (Tarn-et-Garonne), Saint-Pierre. Tympanum over south portal, *Christ enthroned between two angels, the symbols of the Evangelists and the 24 Elders of the Apocalypse*, about 1115–1125.

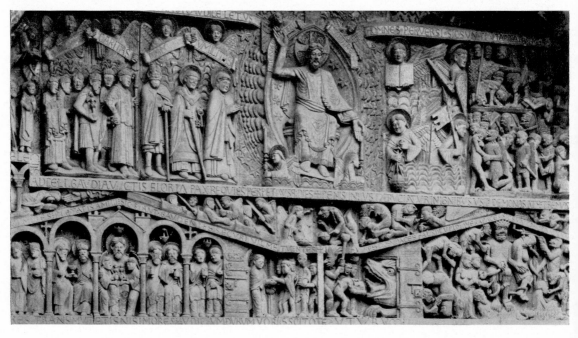

103. Conques (Aveyron), Sainte-Foy. Tympanum over west portal, *The Last Judgment*, about 1140.

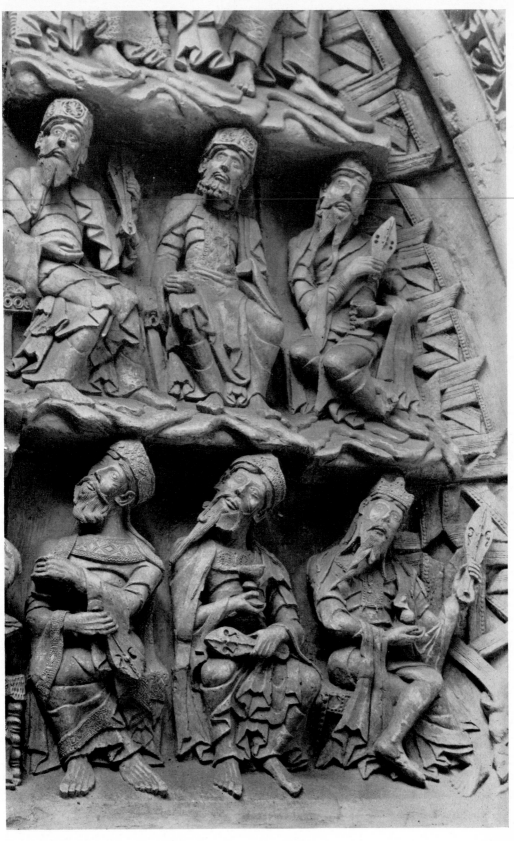

104. Detail of No. 102: *The Elders.*

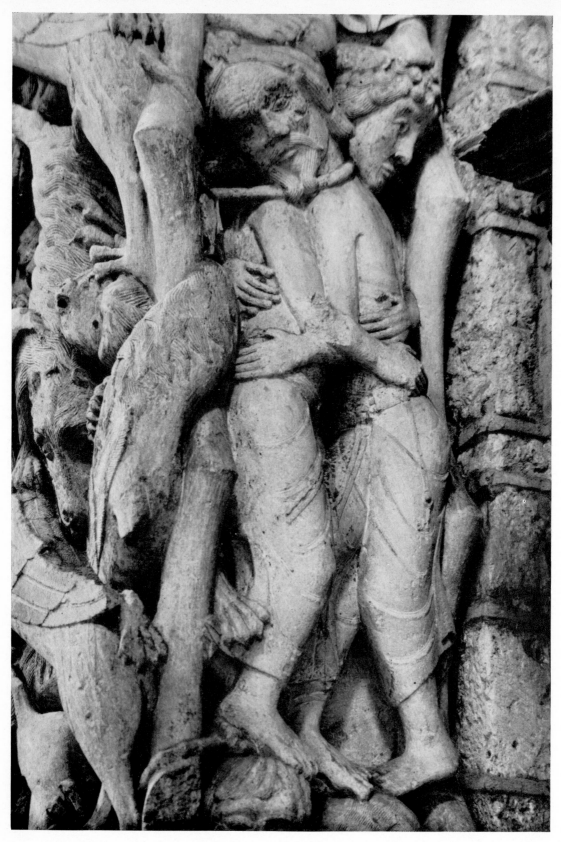

105. Souillac (Lot), Sainte-Marie. Detail from trumeau, *Two men wrestling*, about 1130.

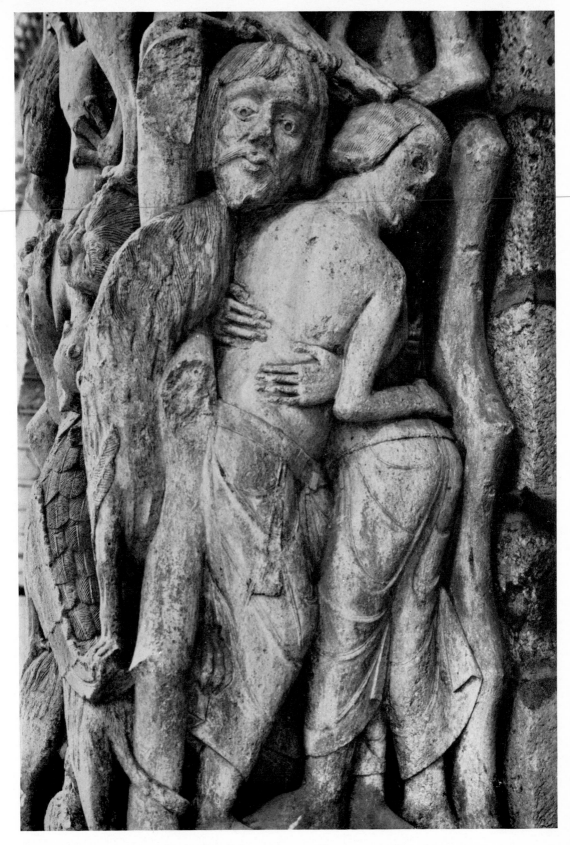

106. Souillac (Lot), Sainte-Marie. Detail from trumeau, *Two men wrestling*, about 1130.

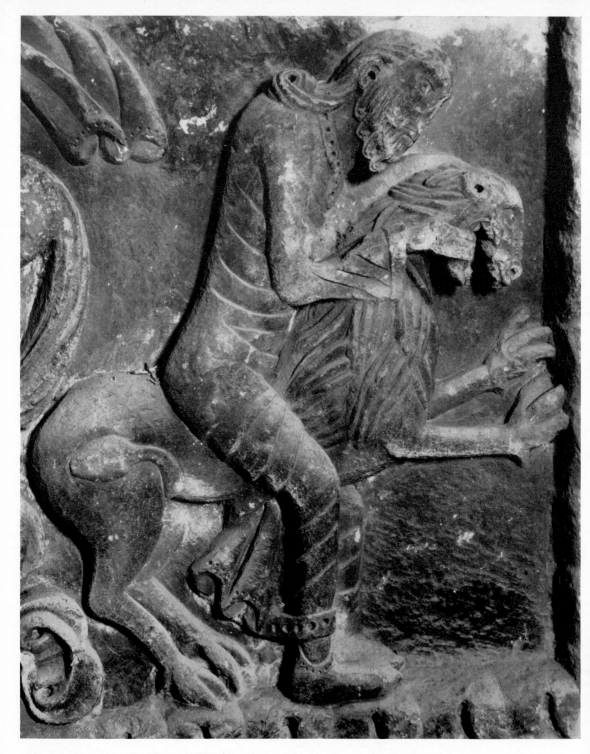

107. Sculpture from Cluny: *Man fighting a Lion*. Cluny, Musée du Farinier.

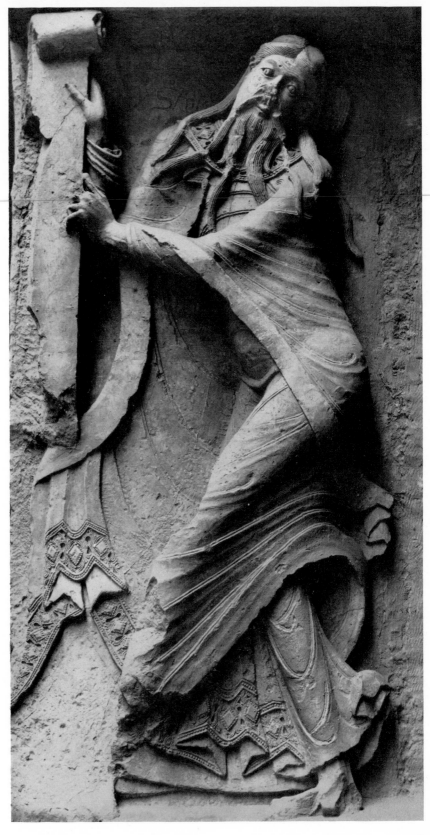

108. Souillac (Lot), Sainte-Marie. Relief on the Jambs of the door, *The Prophet Isaiah*, about 1130.

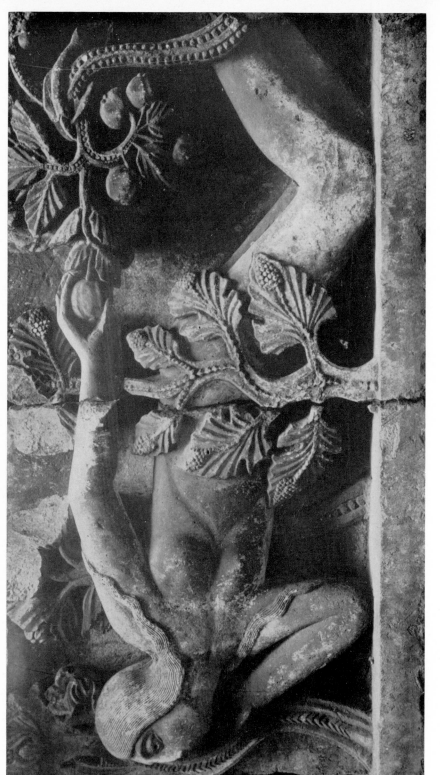

109. Autun (Saône-et-Loire), Saint-Lazare. Fragment of relief from north transept doorway, *Eve*, between 1125 and 1130.

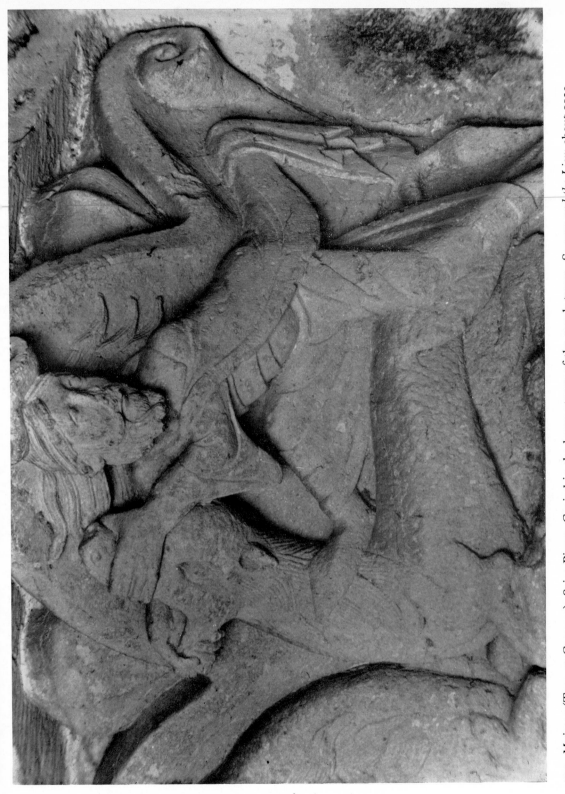

110. Moissac (Tarn-et-Garonne), Saint-Pierre. Capital in the lower storey of the porch-tower, *Samson and the Lion*, about 1120.

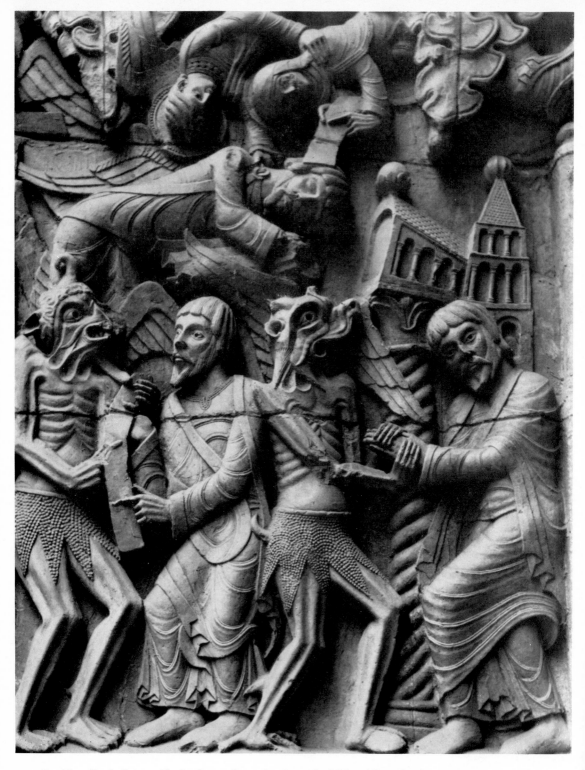

111. Souillac (Lot), Sainte-Marie. Scene from the *Legend of Theophilus*, about 1130.

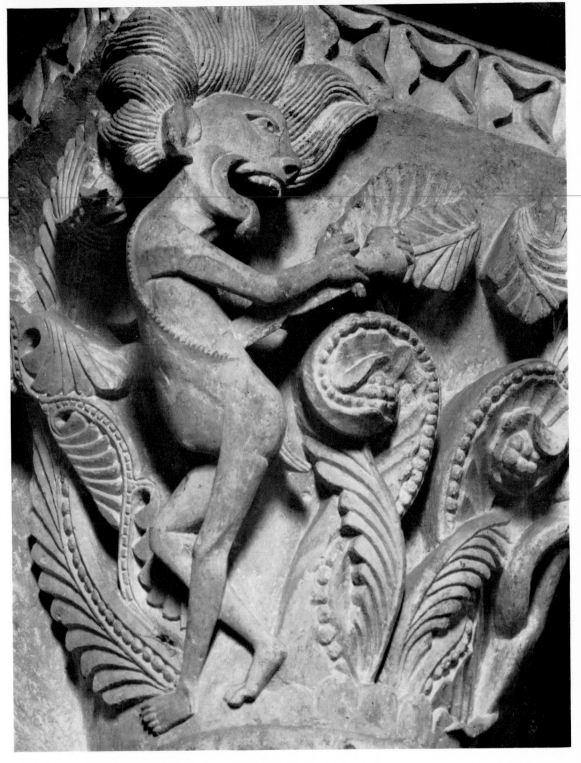

112. Vézelay (Yonne), Sainte-Madeleine. *Despair*, capital in the south aisle of nave, between 1120 and 1140.

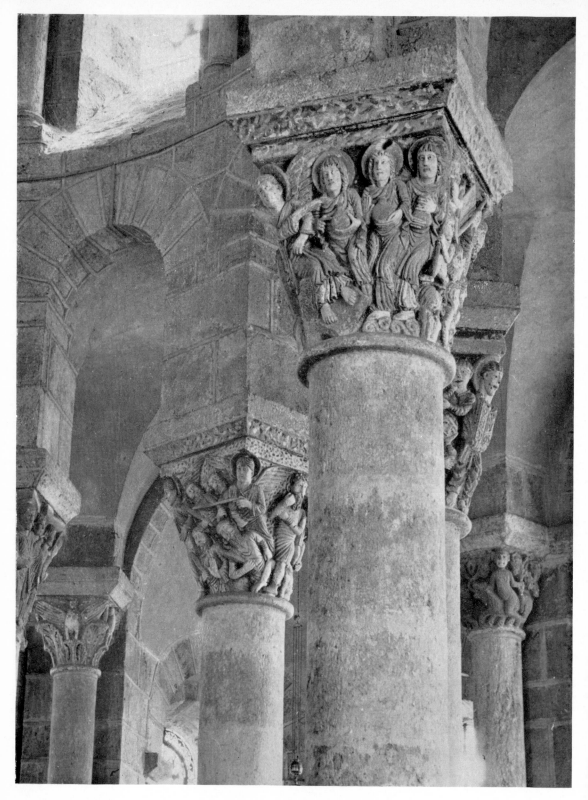

113. Saint-Nectaire (Puy-de-Dôme). Capitals, mid-twelfth century.

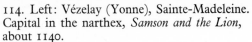
114. Left: Vézelay (Yonne), Sainte-Madeleine. Capital in the narthex, *Samson and the Lion*, about 1140.

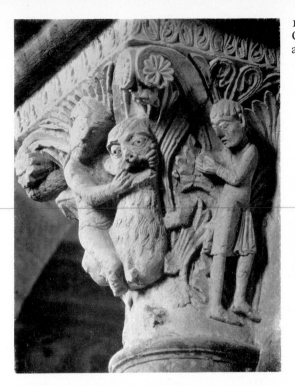

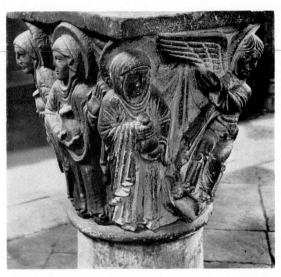

115. Right: Mozac (Puy-de-Dôme). Capital with the *Three Marys and the Angel at the Sepulchre*, mid-twelfth century.

116. Left: Saint-Nectaire (Puy-de-Dôme). Capital from the choir, mid-twelfth century.

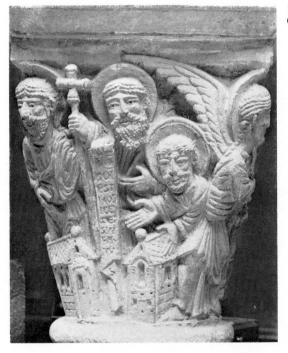

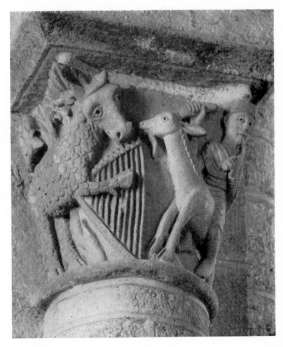

117. Right: Saint-Nectaire (Puy-de-Dôme). Capital, mid-twelfth century.

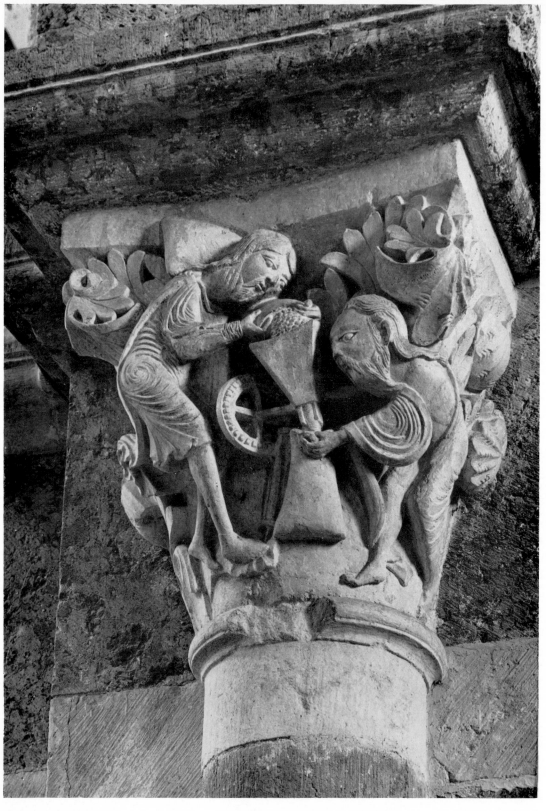

118. Vézelay (Yonne), Sainte-Madeleine. Capital on south side, *The Mystical Mill*, between 1120 and 1140.

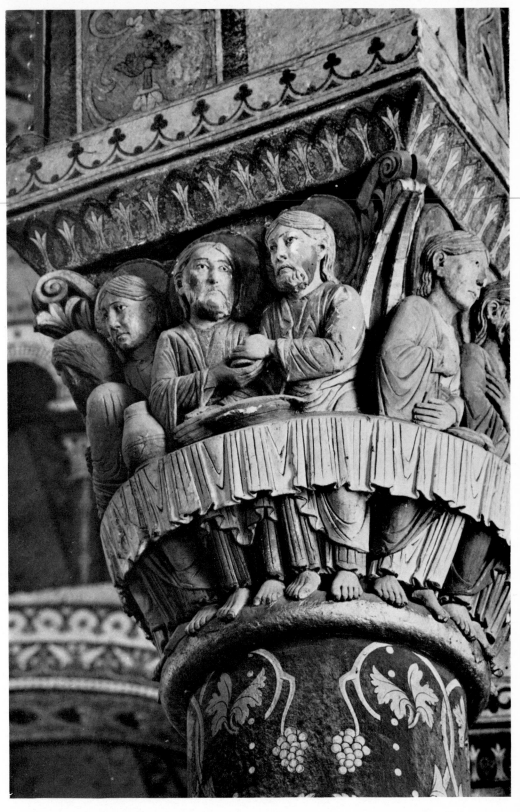

119. Issoire (Puy-de-Dôme), Saint-Paul. Capital, *The Last Supper*, middle of twelfth century.

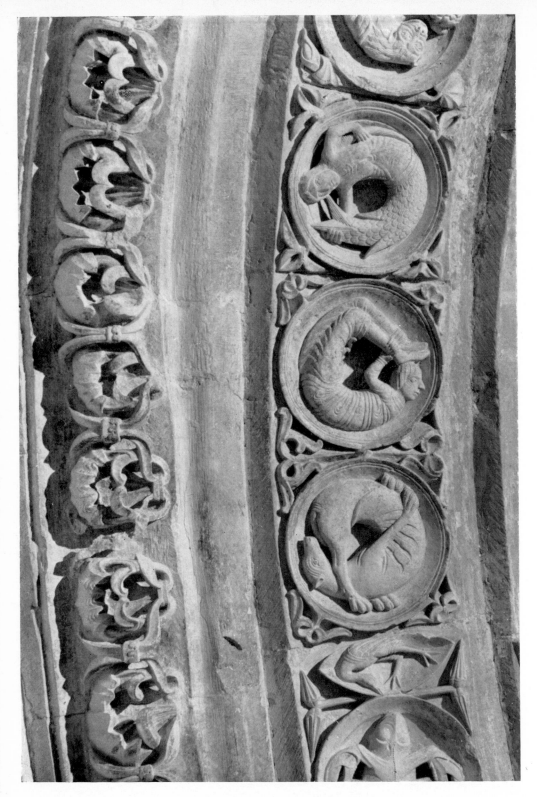

120. Vézelay (Yonne), Sainte-Madeleine. Detail of archivolts over the main doorway, about 1125–1135.

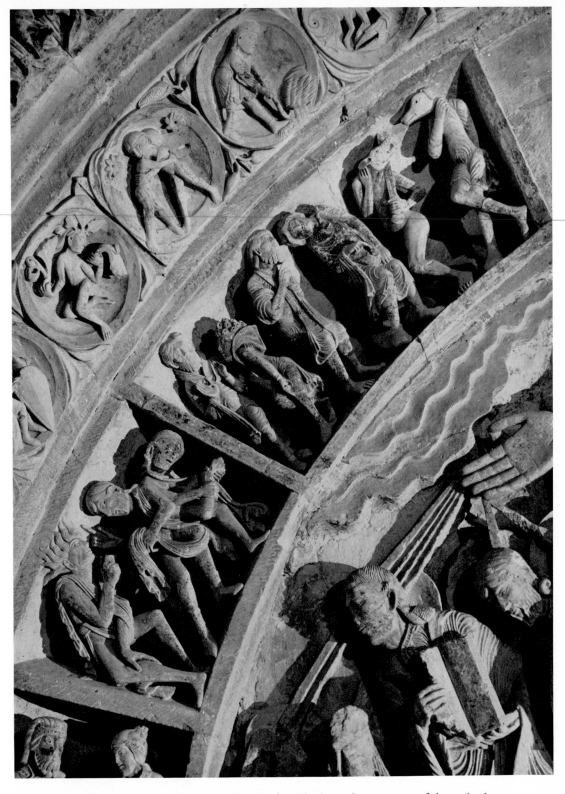

121. Vézelay (Yonne), Sainte-Madeleine. Detail of archivolts and tympanum of the main doorway, about 1125–1135.

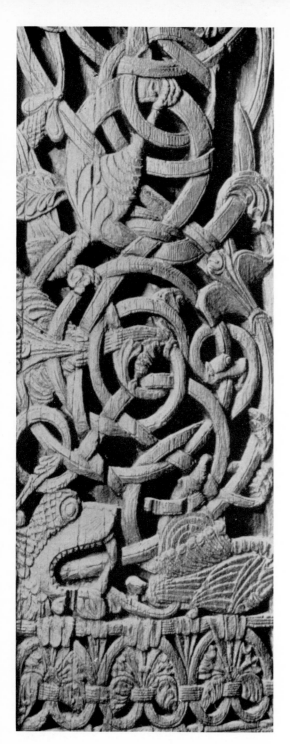

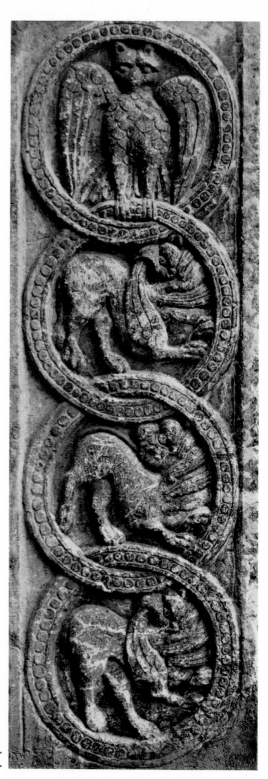

122. Ål (Norway). Decorative detail from the right jamb of the west portal, twelfth century.

123. Saint-Michel-de-Cuxa (Pyrénées-Orientales). Four medallions of the left portal, twelfth century.

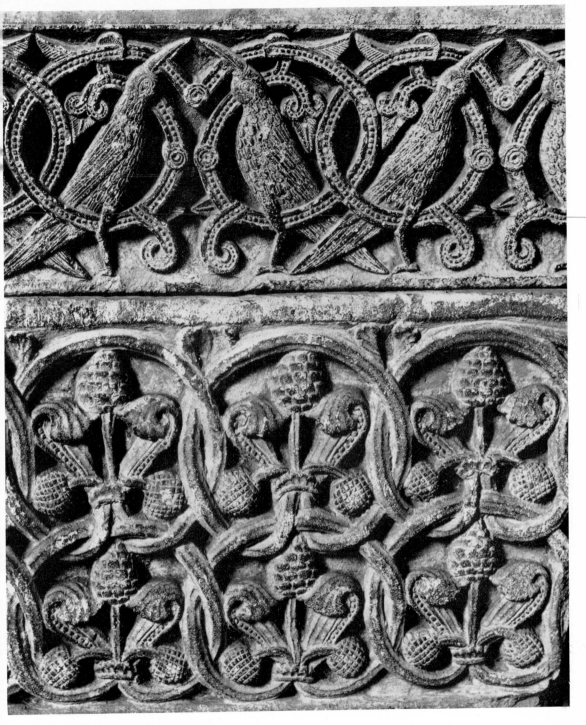

124. Frieze from the cloisters of Saint-Sernin in Toulouse, second half of twelfth century.
Toulouse, Musée des Augustins.

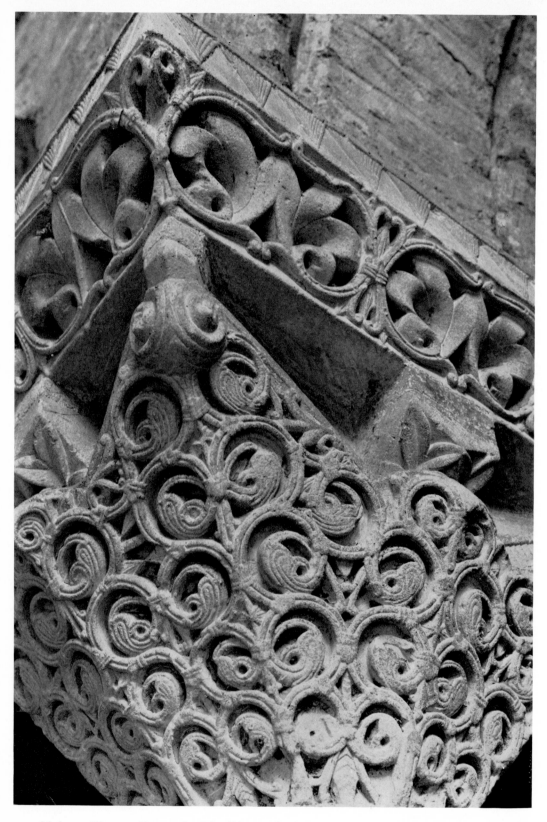

125. Moissac (Tarn-et-Garonne), Saint-Pierre. Capital in the north gallery of the cloisters, about 1100.

126. Le Puy (Haute-Loire), Notre-Dame. Wrought iron work from the west gallery
of the cloisters, twelfth century.

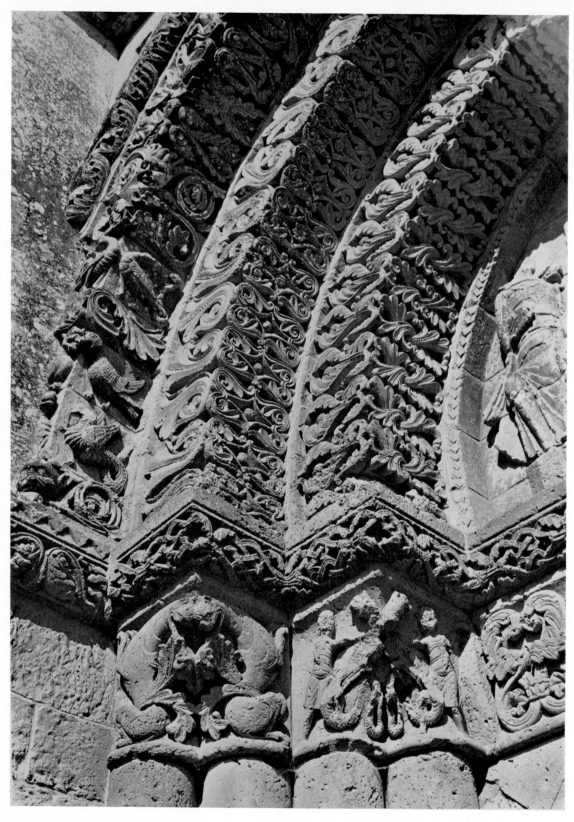

127. Aulnay (Charente-Maritime), Saint-Pierre. Archivolts on west front, about 1135.

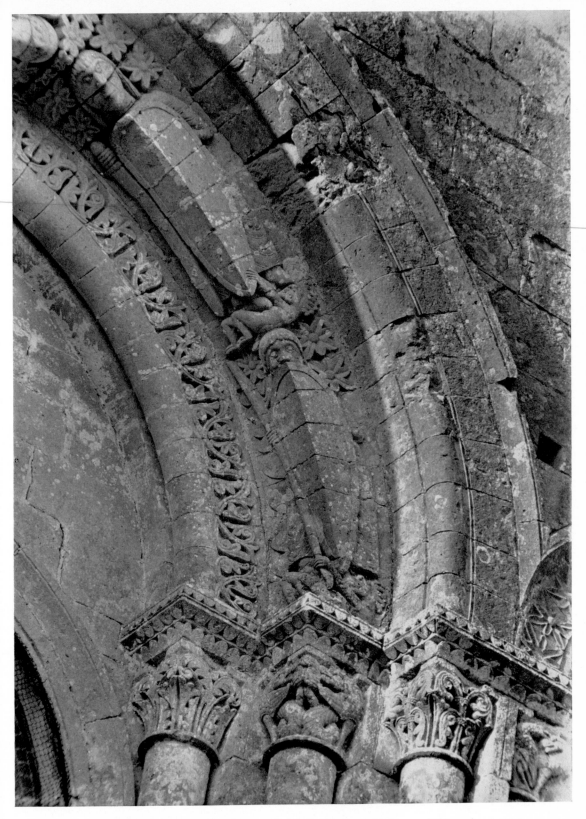

128. Aulnay (Charente-Maritime), Saint-Pierre. Archivolts showing *Virtues and Vices*, about 1135.

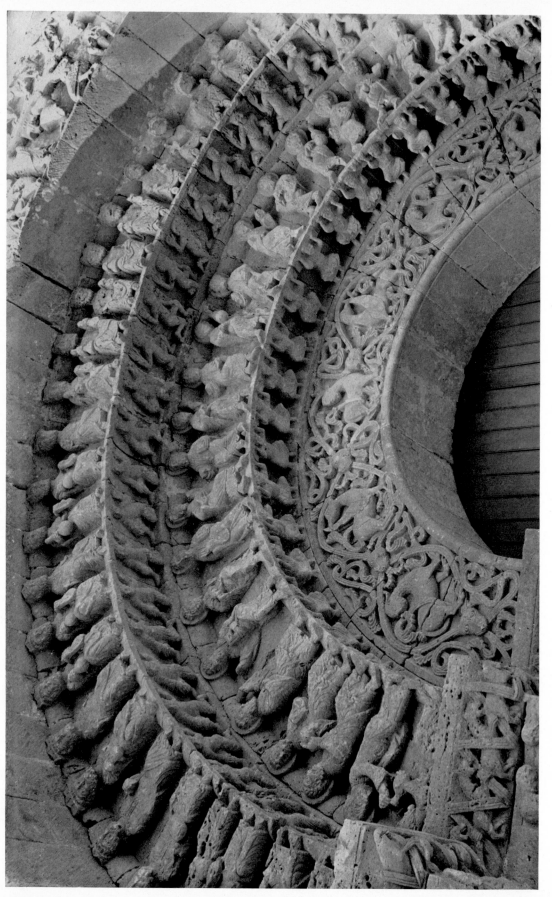

129. Aulnay (Charente-Maritime), Saint-Pierre. Decoration of south doorway, about 1120.

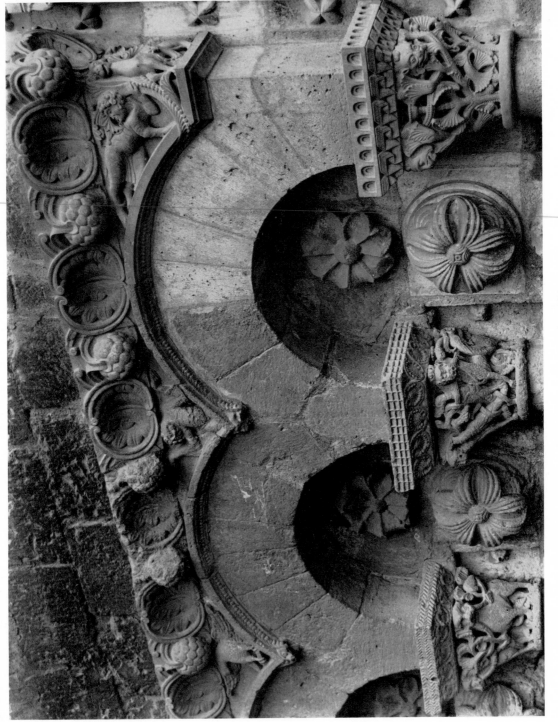

130. Cahors Cathedral (Lot). Detail of north porch decoration, middle of twelfth century.

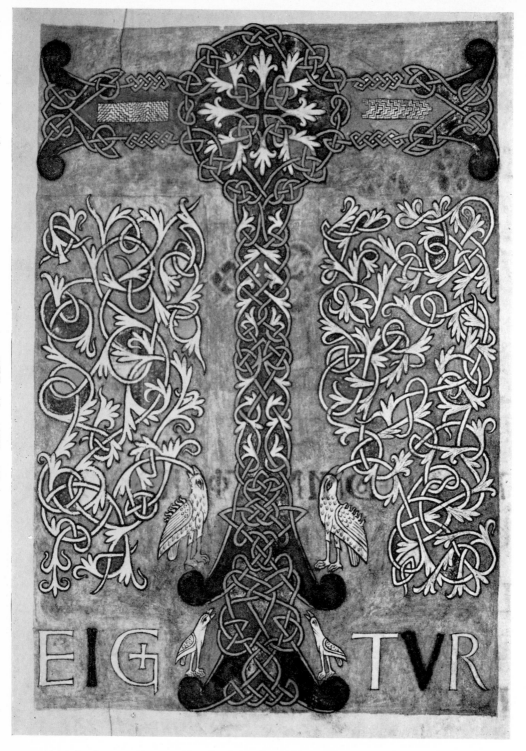

131. Initial from the Sacramentary of Saint-Sauveur de Figeac, eleventh century.
Paris, Bibliothèque Nationale, Ms. Lat. 2293, fol. 19 verso.

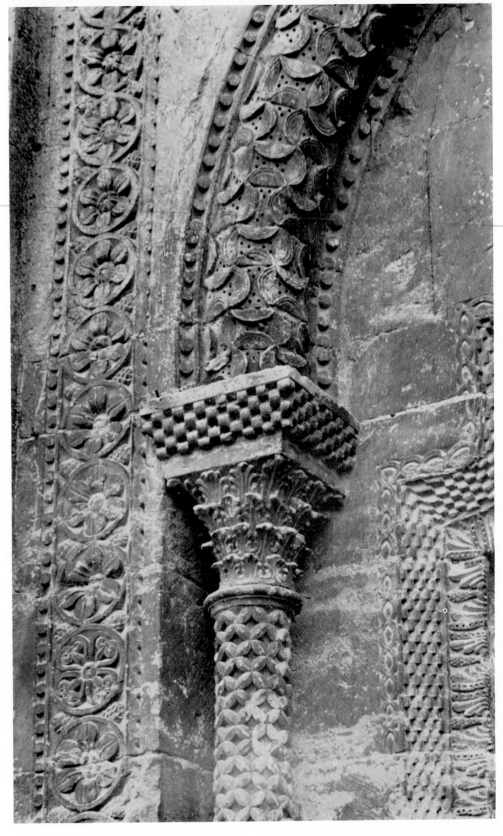

132. Paray-le-Monial (Saône-et-Loire). North portal decoration, beginning of twelfth century.

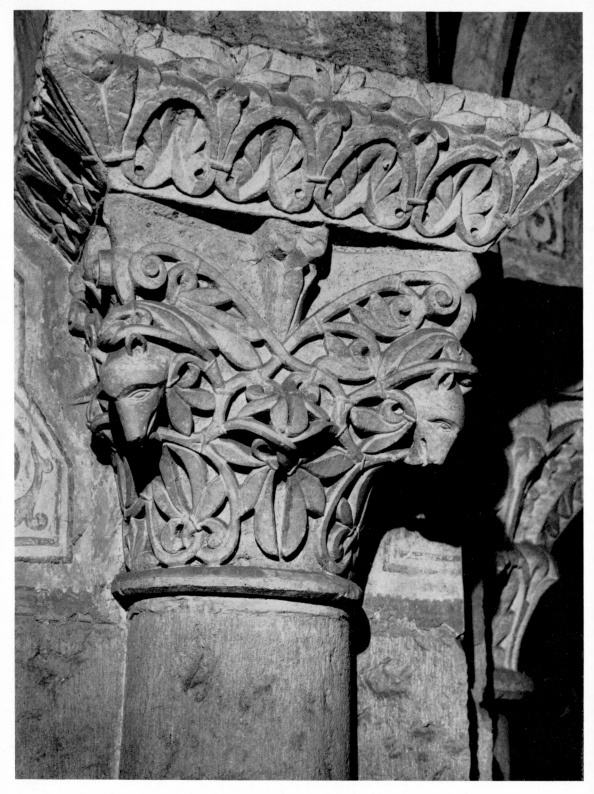

133. León, S. Isidoro. Capital in the narthex (Panteón de los Reyes), about 1063–1067.

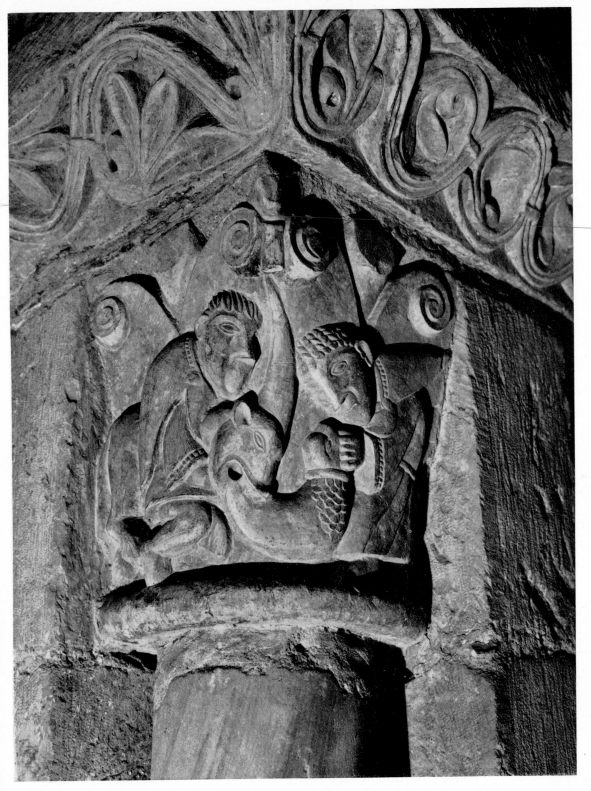

134. León, S. Isidoro. Capital in the narthex, about 1063–1067.

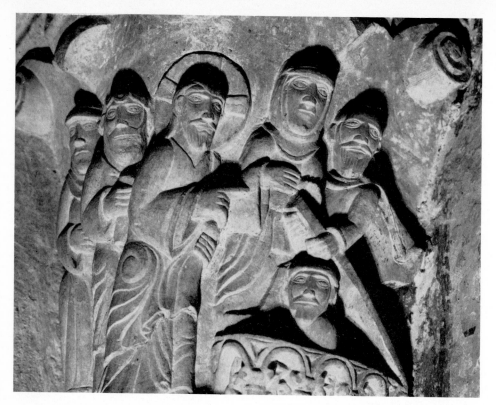

135. León, S. Isidoro. Capital in narthex, *The Raising of Lazarus*, about 1063–1067.

136. Silos, Santo-Domingo. *The Entombment*, first half of twelfth century.

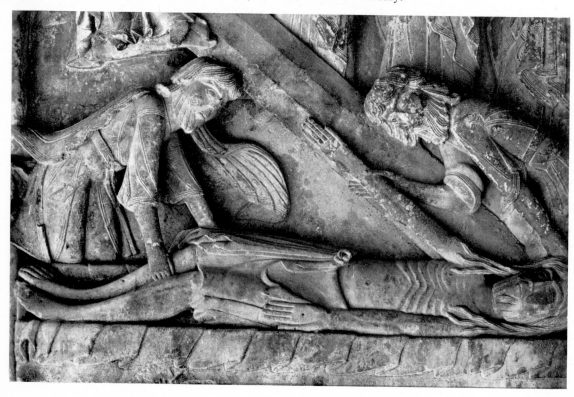

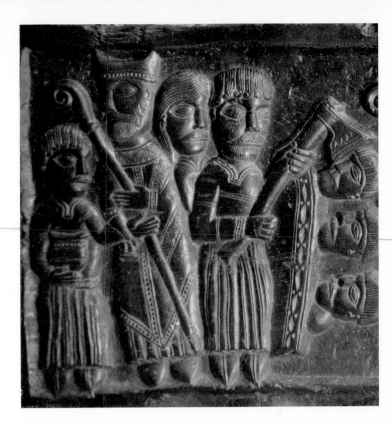

137 and 138. Winchester Cathedral. Details from the font, Tournai work, middle of twelfth century.

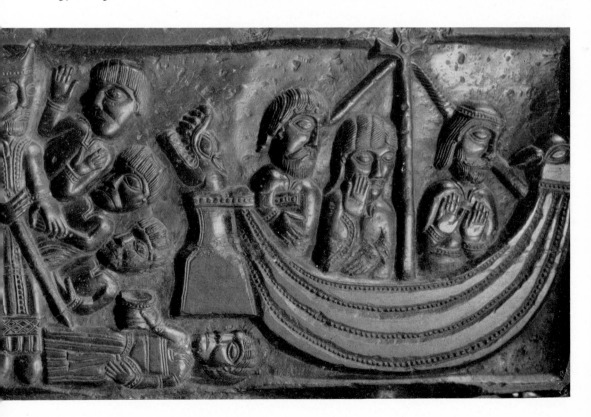

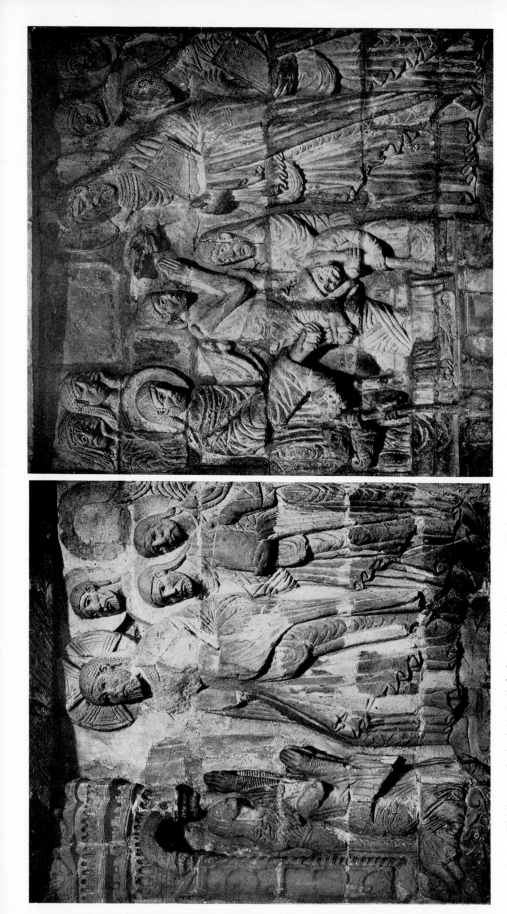

139 and 140. Chichester Cathedral. Reliefs from old choir screen, *Christ at Bethany* and *The Raising of Lazarus*, about 1140.

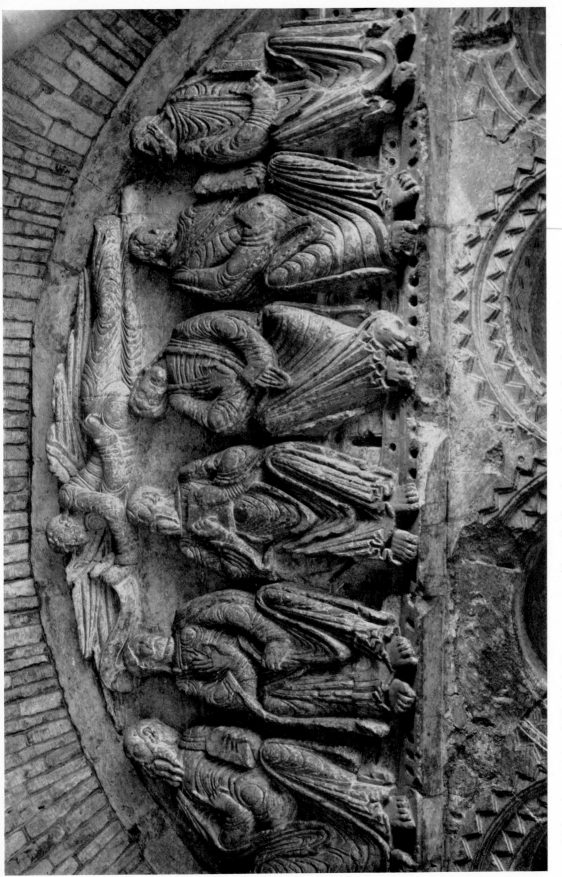

141. Malmesbury Abbey (Wiltshire). Tympanum on side wall of south porch showing *Apostles*, about 1160–1170.

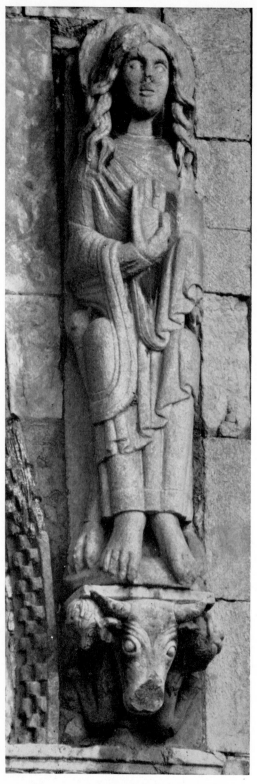

142. León, S. Isidoro. Statue of S. Pelayo,
about 1100–1110.

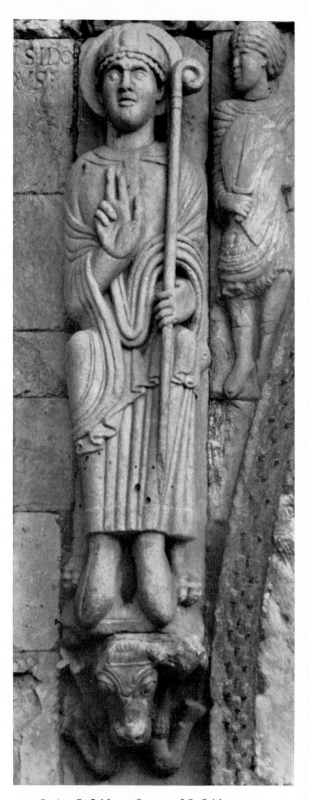

143. León, S. Isidoro. Statue of S. Isidoro,
about 1100–1110.

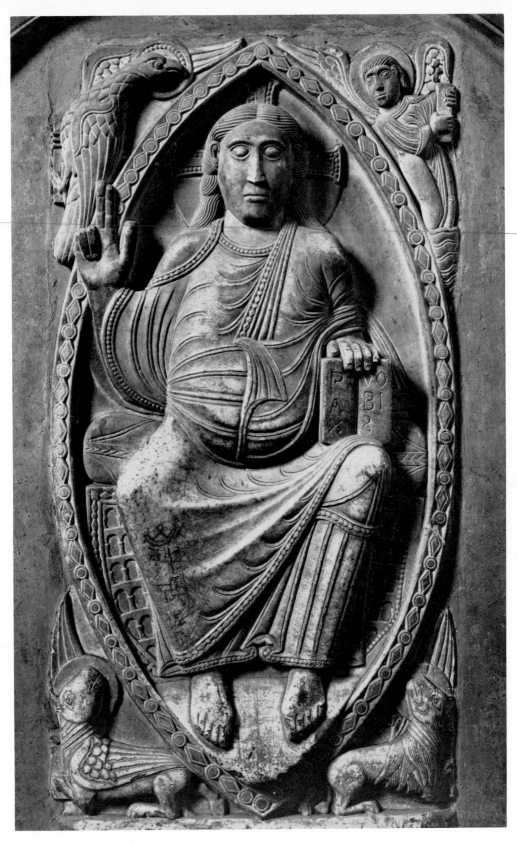

144. Toulouse, Saint-Sernin. Marble plaque of *Christ in Majesty* now in the ambulatory, about 1096.

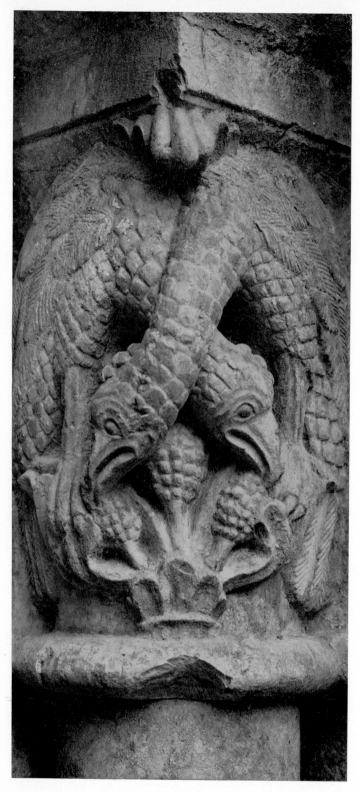

145. Gerona Cathedral (Catalonia). Capital from the cloisters, twelfth century.

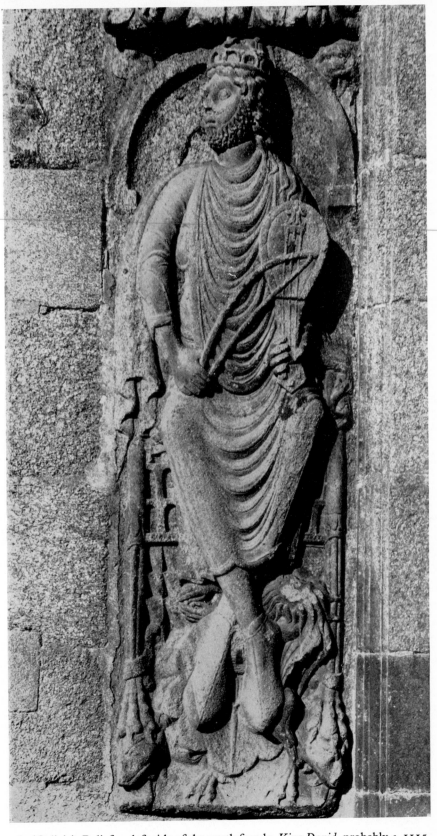

146. Santiago de Compostela (Galicia). Relief on left side of the south façade, *King David*, probably *c.* 1115.

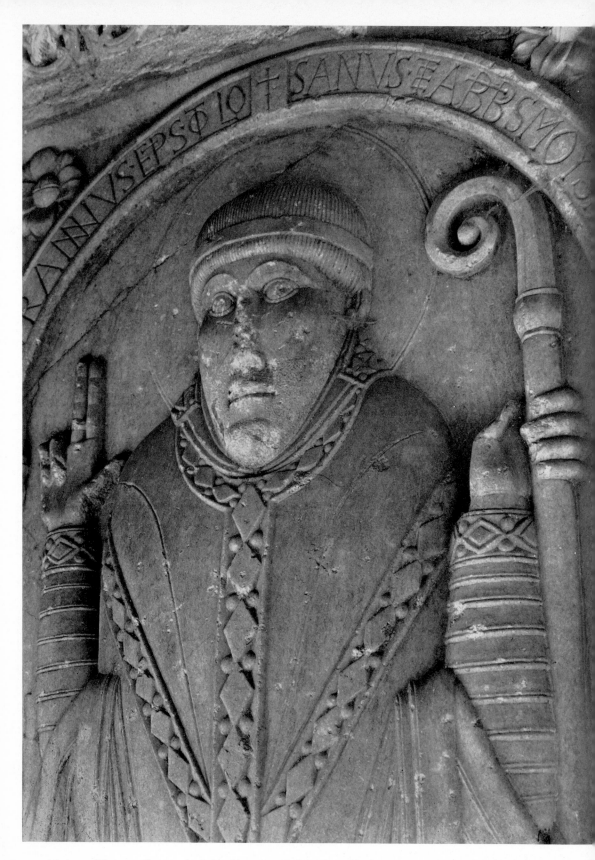

147. Moissac (Tarn-et-Garonne), Saint-Pierre. Relief in the cloisters, *Abbot Durandus*, about 1100.

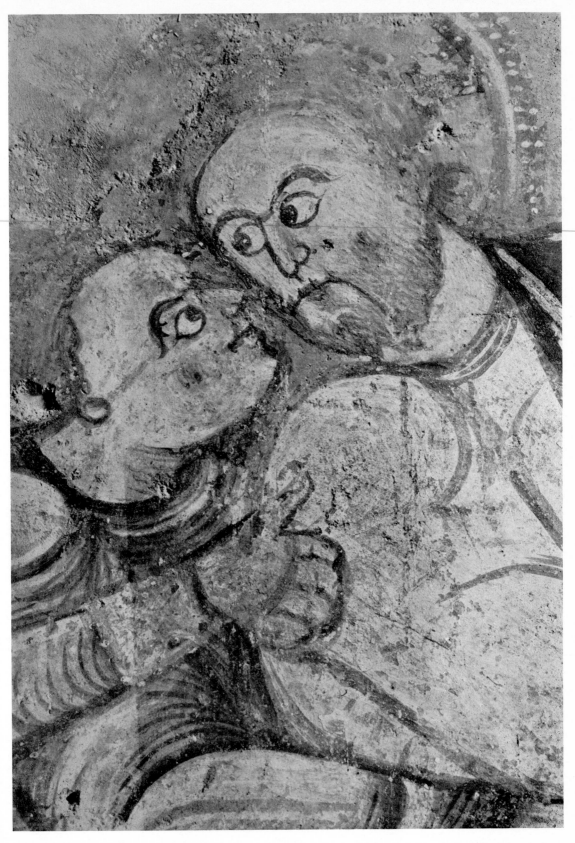

148. Nohant-Vicq (Indre), Saint-Martin-de-Vicq. Detail from the fresco of the north wall of the choir, *Christ betrayed by Judas*, middle of twelfth century.

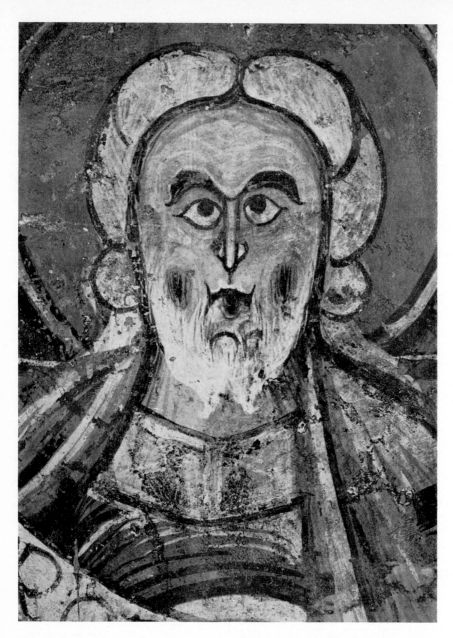

149. Nohant-Vicq (Indre), Saint-Martin-de-Vicq. Detail from the fresco
on the west wall of the choir. *Head of David*, middle of twelfth century.

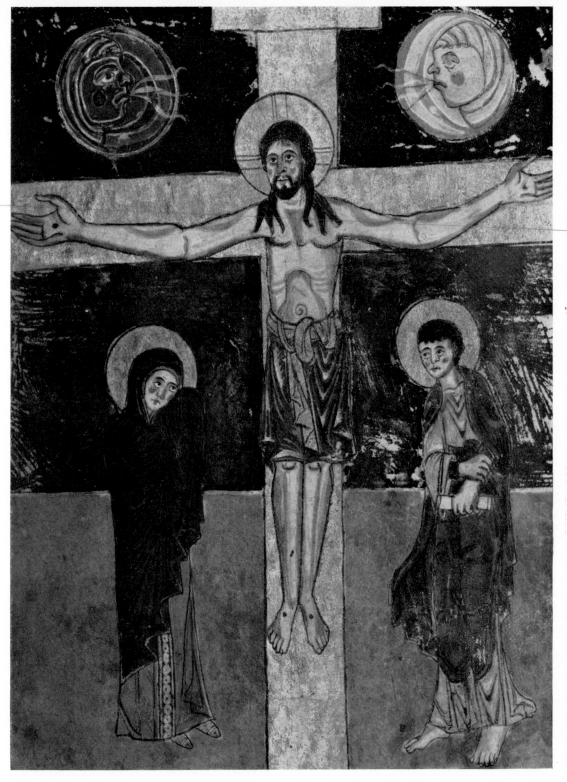

150. *The Crucifixion*. Miniature from a twelfth century Exultet Roll. Rome, Biblioteca Casanatense, Ms. 724.

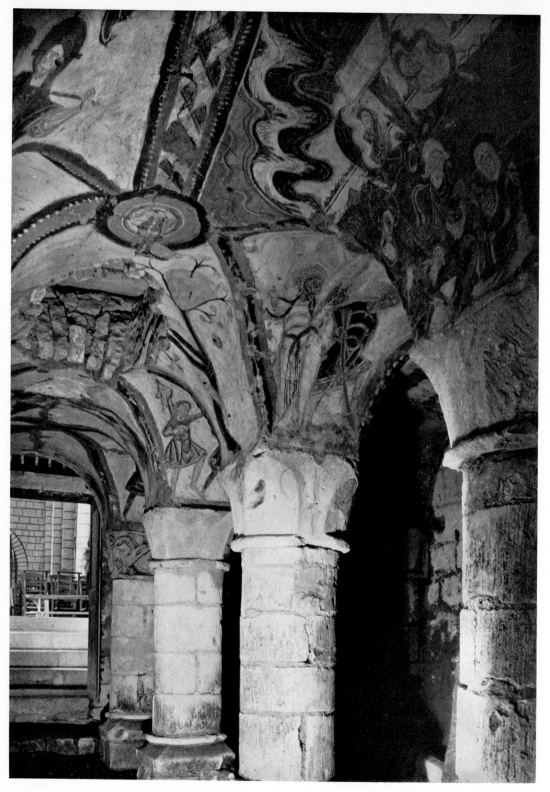

151. Tavant (Indre-et-Loire). Crypt, early twelfth century.

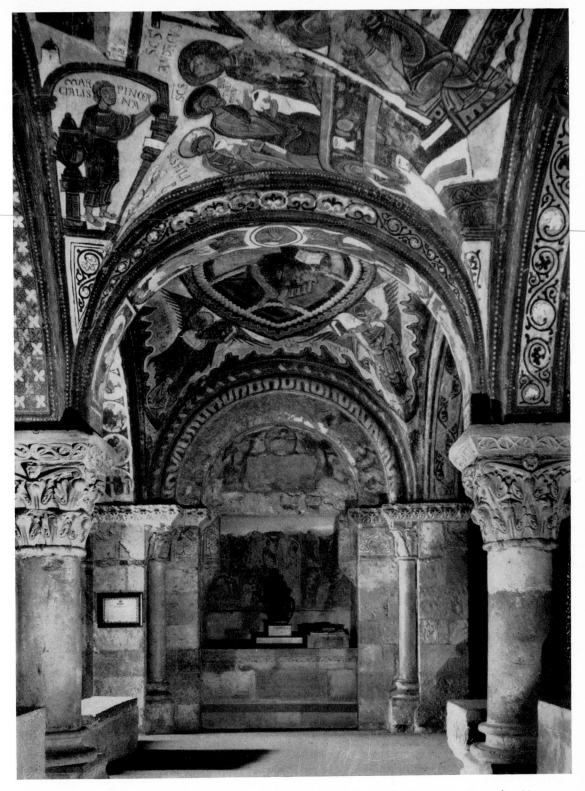

152. León, S. Isidoro. Panteón de los Reyes (narthex), painted decoration between 1164 and 1188.

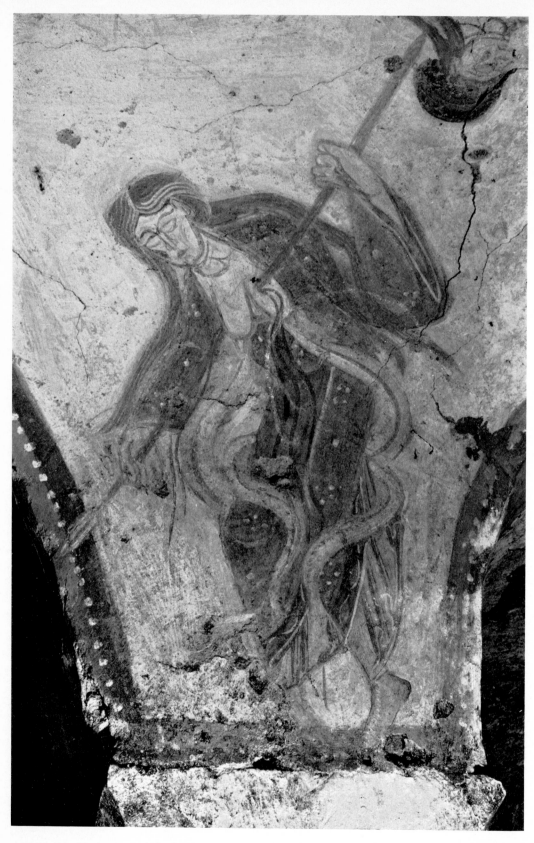

153. Tavant (Indre-et-Loire). Crypt painting, *Lust*, early twelfth century.

154. Tavant (Indre-et-Loire). Crypt painting, *David with Psaltery*, early twelfth century.

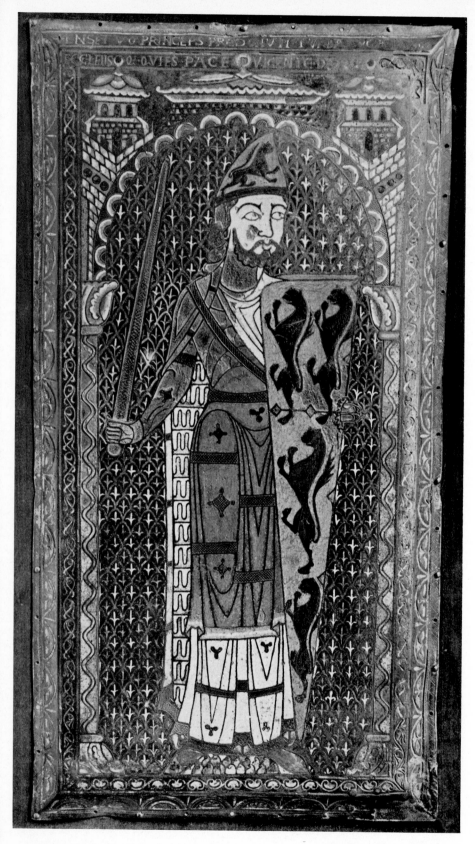

155. Enamel plaque of Geoffrey Plantagenet, about 1151–1160. Le Mans, Museum.

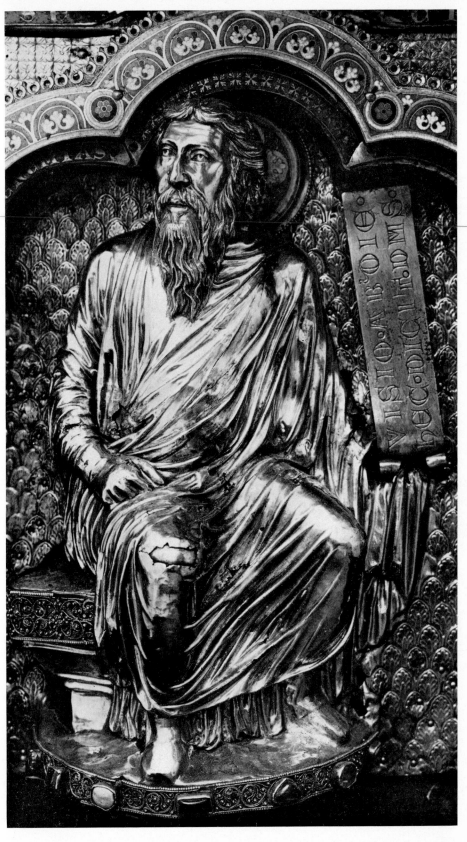

156. Cologne Cathedral. Figure from the Shrine of the Three Kings, *Jeremiah*, by NICHOLAS OF VERDUN, about 1185–1190.

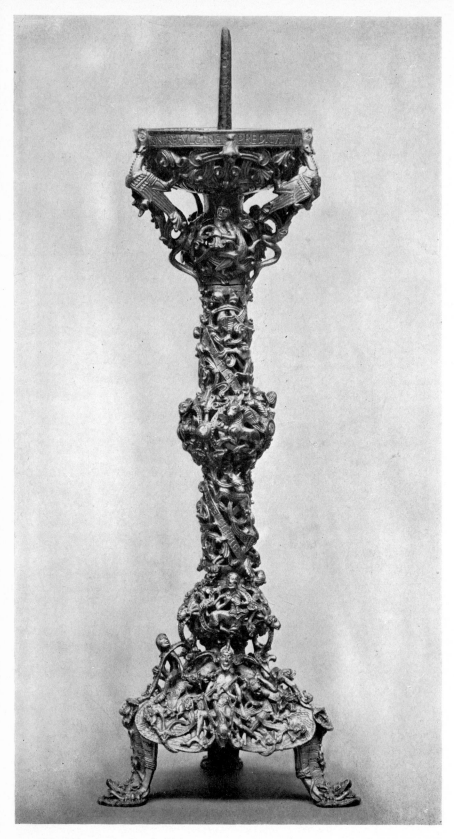

157. The Gloucester Candlestick, *c.* 1110. London, Victoria and Albert Museum.

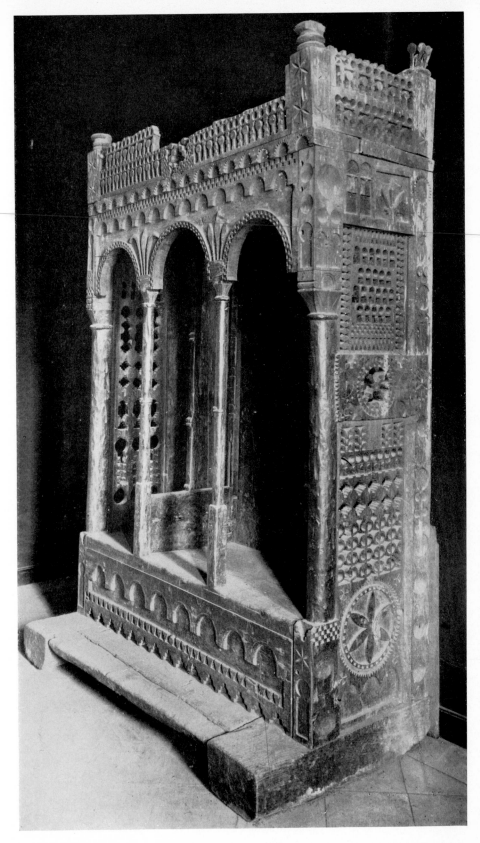

158. Wooden bench from Sant Climent de Tahull, twelfth century. Barcelona, Museo Arte de Cataluna.

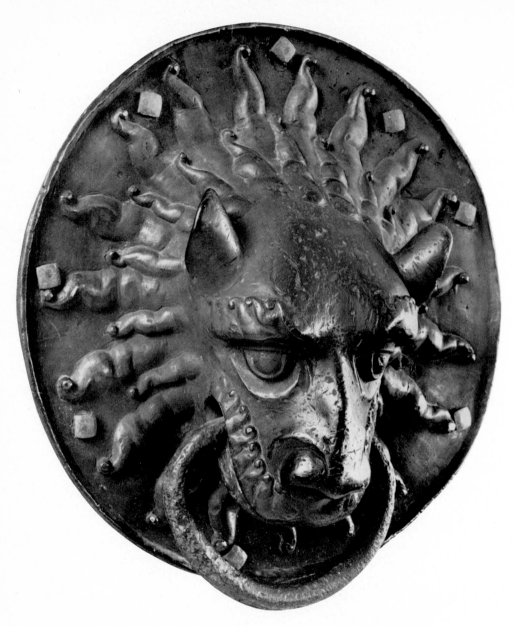

159. Bronze door-knocker, twelfth century. London, British Museum.

LIST OF ILLUSTRATIONS

GLOSSARY

abacus, flat block of masonry between the capital of a column and the arch or lintel which is supported by the column.

aedicule, as at Silos, p. 123, Vol. I, an arch framing relief sculpture, with architectural embellishments to suggest that the figures are inside a building. Aedicular canopies, canopies projecting over the heads of sculptured figures, in the form of miniature architecture, usually battlements, gables and towers.

(akme) ακμή the Greek word for summit or climax, used of a style to denote the point of most intense development.

ambo, a pulpit, one of a pair which in early Christian churches were placed on either side of the choir enclosure. One was used for reading the Epistle, the other for the Gospel during Mass.

ambulatory, extension of the aisles of the choir around the apse, often giving access to subordinate chapels. In French churches the ambulatory is usually semi-circular with chapels disposed radially from a point in the centre of the main apse. In England, however, the ambulatory in certain twelfth and thirteenth century churches is rectangular and the chapels are parallel to the main axis of the church.

angle volute, spiral form used at the corners of Ionic and Corinthian capitals, and their medieval derivations.

antependium, an altar frontal, either a metal relief, or painted wood, or textiles.

apse, the name given to the east end of a church or chapel when this was designed around a fixed point—i.e., apses are usually circular or polygonal. But there are instances where triangular apses are used, and irregular polygons occur.

apses in echelon, or staggered apses, a series of parallel chapels, aisles, chancel, etc., each of which terminates in an apse, and designed to produce an arrow head or chevron formation.

horseshoe apse, a curved apse in which the segment is more than a semi-circle.

apsidal chapel, a subordinate chapel, usually circular or polygonal, opening from the ambulatory around the apse of a great church.

arcade, a range of arches supported on piers or columns.

blind arcade, arches supported on attached columns or pilasters ranged along a wall surface for decorative purposes only.

arcade and band, see Lombard bands.

arch, a structural mechanism composed of a series of wedge-shaped blocks of masonry, called voussoirs, arranged concentrically. When suitably buttressed arches can support a much greater load than a horizontal lintel, and are therefore a more effective means of spanning space than the latter.

1. *Round arch,* a semicircular arrangement of voussoirs around a single centre.

2. *Pointed arch,* an arch composed of arcs struck from an even number of centres, usually two.

3. *Segmental arch,* an arch composed of a single arc, less than a semicircle. Sometimes called a depressed arch.

4. *Transverse arch,* an arch set at right-angles between two parallel walls.

5. *Relieving arch,* an arch constructed within the masonry of a wall to concentrate the downward thrust of the superstructure on to pre-selected points.

6. *Quadrant arch,* an arch composed of half a semi-circular or half a pointed arch, used as buttressing in the construction of a flying buttress (Gothic) and also in the vaults of side aisles and galleries in certain Romanesque churches, where they perform the same function as flying buttresses.

architrave, horizontal lintel supported by two columns or piers. Principally found in classical architecture, or in derivations from classical models, where it functions as an alternative to the arch.

archivolt, inner or under surfaces of an arch, more especially the recessed arches of doorways in Romanesque architecture. Sometimes loosely used as a synonym to voussoirs.

arkose sandstone, a type of sandstone containing quartz.

armillary sphere, a skeleton celestial globe made up of metal bands to represent the equator and the arctic and antarctic circles, revolving on an axis.

arris, an edge formed by the intersection of two surfaces in masonry.

atlantes, the plural form of atlas, the name derived from the giant in classical mythology to denote a sculptured figure carrying a load. The masculine equivalent of caryatids.

astragal, simple moulding around the neck of a capital masking the break between column and capital.

atrium, the forecourt of a Roman house, whose centre was occupied by an impluvium or basin, and whose roof was open to the sky over the ampluvium. By extension, the term was applied to an open court in front of early Christian and some Romanesque churches.

attic bases, a moulded base for columns or half columns with a concave member between two convex. Derived from classical Ionic and Corinthian forms.

banderole, a long narrow pennant or streamer.

basilica, originally a large administrative hall, but now generally applied to any aisled church with a clerestory.

bastion, a rampart or bulwark projecting from the corner of a fortified building.

bay, a spatial compartment achieved by the regular or near-regular subdivision of a larger unit such as a nave or aisle.

billet (of timber), the trunk or branch of a tree; i.e., length of timber with circular section.

billet moulding, a pattern of small cylinders of masonry, used in Romanesque architecture.

bosses (roof bosses), projecting keystones which usually have sculptural decoration to mask an intersection of ribs in a vault.

burin, chisel-like tool used for working an engraved plate.

buttress, a projecting mass of masonry, usually placed at right angles to a wall, but occasionally diagonally as at the corners of towers, to provide additional strength in order to resist the thrusts imposed against the wall from within by the vaults, or from above by the roof of a building. Buttresses usually take the form of a short section of wall, but flying buttresses are in effect quadrant arches which lean on the walls which they are meant to support at the points where this support is needed, and which are in turn supported at their fulcrums by buttresses proper.

cabbalist, one who claims acquaintance with the Cabbala, the unwritten (mystical after thirteen century) tradition of the Jewish Rabbis about the Old Testament. A secret or esoteric doctrine.

cabochon, any precious stone that is polished but uncut.

campanile, a bell tower often isolated from the church and having arcaded openings on several levels.

canephori, originally Greek sculptured female figures bearing baskets on their heads. Often used as supports in a similar way to caryatid figures.

capital, the architectural member which surmounts a column or a pilaster and which effects a transition between the support and what is supported. When used in conjunction with columns or half-columns capitals usually connect forms of circular sections with forms of square section. The transition therefore requires either concave or convex curves at the corners of the capital. The Corinthian capital exemplifies the former; the cushion capital the latter. But many variants are known and the capital at all times provided an excuse for decorative display.

caryatid, sculptured female figure supporting a superstructure in the same way as a column.

cella, the enclosed space within the walls of an ancient temple.

chamfer, a diagonal surface made by cutting off the edge of the right angle join between two surfaces.

champlevé, an enamelling technique in which each compartment of the enamel is cut away into the substance of the foundation plaque.

chapel, originally part of a large church set apart to house an altar other than that of the principal dedication. Usually a subordinate structure attached to the main building, but sometimes an extension of the main building itself, and sometimes defined only by an arrangement of screens. Chapels were also independent buildings serving the private needs of individuals, or corporate

and collegiate organisations. In this sense they are to be found in castles, palaces, colleges.

axial chapel, chapel set at the east end of a church on the same E.W. axis as the main building.

chapels in echelon, parallel chapels at the east end of a large church on staggered plan so that the central chapel projects further than the lateral ones.

radiating chapels, chapels opening on to a semicircular ambulatory.

chequer pattern, decorative patterning arranged in squares as on a chequerboard.

chevet, eastern complex of the church usually comprising the apse, ambulatory and chapels.

chevron, zig-zag ornament.

chlamys, a short mantle of Greek origin.

ciborium, a canopy over a tomb or an altar, usually supported on columns.

cinnabar, a red pigment obtained from mercuric sulphide.

clerestory, the upper part of the nave wall containing a range of windows.

cloisonné, an enamelling technique in which the compartments are first marked out with strips of metal and then each section filled with enamel.

collegiate church, a church other than a cathedral served by a body of secular canons.

colonnade, a range of columns.

colonnettes, small columns.

columns, vertical supports for a super-structure usually made of circular blocks of stone placed one on top of another, or of one single monolithic shaft.

coupled columns, are simply double shafts used for the same purpose as a single column.

communes, a corporate feudal lordship, usually exercised by the inhabitants of towns, whose immunity from other forms of feudal lordship, if recognised, was embodied in a charter. Communes arose all over Europe during the twelfth century.

consoles, classical form of corbel made up on scrolls and volutes.

corbel, a projection on the surface of a wall, often elaborately carved, to support a weight. Thus: to corbel out is to make a supporting projection on a flat surface.

cornice, in classic architecture this is the top part of the entablature, but the term is extended to describe any projecting decorative moulding along the top of a wall or arch.

coursed masonry, masonry arranged in regular layers instead of haphazardly.

crenellation, a parapet with indentations, most common in military architecture.

crockets, decorative projecting knobs of foliage arranged at regular intervals and much used in thirteenth-century architecture on spires, pinnacles and capitals.

crossing, the part of a church on which chancel, nave, and transepts converge. In a true crossing all four arches should be approximately the same height.

crown (of arch), highest point of an arch.

cruceros, Spanish for crossing.

cupola, a dome, semi-dome, or dome-shaped vault.

dagger, in Decorated or Flamboyant tracery, an elongated derivative of the cusped circle of the earlier Geometrical tracery (in French, *soufflet*).

damascene, to inlay metal, e.g., steel with patterns of gold and silver; by analogy, the similar technique applied to glass.

diptych, an altarpiece or painting of two hinged panels which close like the leaves of a book.

dripstone, or hood mould is a projecting moulding above an opening to throw off rainwater.

en delit, the setting of masonry at right angles to its bed in the coursing; e.g., detached shafts stood on end.

engaged column, column attached to a compound pier or wall immediately behind it.

extrados, the outer curve of an arch.

falchion, literally a broad curved sword, but on p. 145, Vol. II, it is applied to a particular tracery motif, elongated and asymmetrical (in French, *mouchette*).

finial, the sharply pointed peak of a gable or pinnacle, often decorated with foliage.

flamboyant, the name given to the latest style of French Gothic architecture, originating from the undulating, flame-like shapes in the window tracery.

fluting, decorative channelling in vertical parallel lines on the surface of a column or pilaster.

foliage scroll, decorative arrangement of leaves along a twisting stem.

formeret, in a ribbed vault the arch that carries the vault where it meets the wall—hence the alternative: 'wall rib'.

freestone, any good quality fine-grained sandstone or limestone.

fretted stone, stone that is carved with intersecting decorative patterns.

gallery, a substantial upper storey carried on the aisles of a church—also called a tribune.

annular gallery, a gallery turning round a semi-circular chapel, or an apse.

gesso, the prepared ground of plaster and size on which a painting can be applied.

glacis, any sloping wall or surface of masonry. More particularly the slope at the base of fortifications.

goffer, to indent with regular recesses, so as to produce a wavy or rippling effect.

grisaille, monochrome painting that gives the effect of a piece of sculpture.

guilloche-ornament, is a circular pattern formed by two or more intertwining bands.

Hathor, Egyptian goddess with cow's head.

hawser, a thick rope or cable used for mooring and anchoring ships.

high-warp, tapestries made with the frame holding the threads in a vertical as opposed to a horizontal position.

hypogeum, a subterranean chamber as in Saint-Hilaire at Poitiers.

icon, originating in the Eastern church, it is votive painting of a sacred figure.

impost, the moulding on which an arch rests.

interlace, a geometric criss-cross ornamentation.

intrados, inner moulding or soffit of an arch.

keystone, the central or topmost voussoir of an arch which locks the others in position.

(koinê) κοινή, the common form of Greek used in the Hellenistic world after the conquests of Alexander the Great—hence any universally understood idiom.

lancet, a slender window with an acutely pointed arch at the top.

lantern, a tower or turret pierced with windows that can admit light to the interior of a church.

lierne, short intermediate rib connecting bosses and intersections of vaulting ribs.

lintel, a horizontal beam of stone joining two uprights. Usually used over doors or windows. Because of its inability to carry heavy loads, in large churches the lintel was usually used in conjunction with an arch, and the intervening semicircular surface filled with a tympanum.

liwan, barrel-vaulted reception room opening axially on to a courtyard in Mesopotamian palace architecture, Sassanian and Islamic.

Lombard bands, flat pilaster strips used to articulate a large expanse of wall surface; usually connected at the top of the wall to which they are applied by small arcades. Found in N. Italy, N. Spain, Germany, and parts of France. It was one of the distinctive features of first Romanesque architecture, but persisted, especially in Germany, into the thirteenth century.

lunette, semicircular decorative arch.

maestà, in Italian this literally means Majesty, but in iconography it describes a large painting showing the Virgin enthroned.

Mameluke, Circassian, a military body, originally of Caucasian slaves, which seized control of Egypt in 1254 and ruled that country until 1517.

mandorla, a halo framing the figure of Christ or the Virgin Mary, either square, round or elliptical in shape.

meander ornament, a pattern of wavy lines winding in and out or crossing each other.

mihrab, a projecting niche on the side of a mosque that points towards the Great Mosque at Mecca.

minaret, a slender tower on a mosque surrounded by a balcony from which the muezzin can call the faithful to prayer.

miniature, in medieval art this term is used for the paintings in illuminated manuscripts.

modillions, small corbels supporting a cornice or corbel table.

mozarabic, term used to denote art and architecture of Christian origin produced under Moorish rule in Spain, especially during eighth–eleventh centuries.

mudejar, term used to denote the style of Moorish art and architecture, produced under Christian rule in Spain, especially during fourteenth–fifteenth centuries.

mullion, upright shaft dividing a window into a number of 'lights'.

multifoil arch, an arch which is decorated with numerous cusps and foils, as in Islamic architecture.

narthex, large enclosed porch at the main entrance of a church.

newel, a post in the centre of a circular or winding staircase.

nymphaeum, in classical architecture literally: a sanctuary for nymphs, i.e. a small temple structure in a pleasant rustic setting.

ochrous, of the colour of ochre which is a light browny yellow.

oculus, a round window, with or without tracery.

offset, the part of a wall that is exposed on its upper surface when the part above is reduced in thickness.

ogee, a moulding consisting of a curve and a hollow, thus an ogee headed frame has an arch with a double curve, one concave and one convex.

ogive, the French term for the diagonal rib in a ribbed vault.

openwork gable, spire, etc., architectural forms in which tracery patterns take the place of solid masonry.

orans, a standing figure with arms upraised and outstretched in an attitude of prayer.

oratory, small chapel for private devotion.

orthogonal (adjectival), projecting at right angles; hence sometimes applied to the illusory dimension of depth in a perspective construction.

pala, Italian name for an altarpiece.

palmette, ornamental motif in the shape of a single leaf.

pantocrator, in Byzantine art the Image of Christ Omnipotent, usually set in the apex of a dome or semi-dome.

patina, literally a film caused by the oxidisation of a metal, but on p. 113, the word describes the high quality finish on a painting.

patio, paved open space outside a house, particularly characteristic of Spanish and Moorish architecture.

pediment, low pitched gable over a portico or doorway.

pendentive, spherical triangle of masonry. One of the means of effecting a transition between a cube and a dome.

pier, in masonry any support other than a column. Medieval piers were usually made of coursed stone or brick, with or without a rubble core. The simplest forms were square or rectangular in section; but many more elaborate profiles were used.

compound pier, one whose profile includes re-entrant angles.

cylindrical pier, a pier without angles in which the courses of masonry are arranged concentrically, perhaps in imitation of a column, but not to be confused with one.

clustered pier, a pier comprising a bundle of colonnettes without the intervention of angular recessions.

angle pier, 'L' shaped pier to turn the corner of a rectangular building such as a cloister.

pier shaft, the part of the pier between the base and the capital, or one member of a compound pier.

pilaster strips, decorative vertical features attached to the wall surface in the shape of shallow pillars.

podium, a pedestal or base.

polychromy, colouring.

portal, doorway.

portico, colonnaded entrance to a building.

transverse portico, an entrance with columns running parallel to the face of the building.

predella, horizontal strip of smaller scenes below a main altarpiece.

psychomachia, an iconographical subject depicting the constant duel in the soul (psyche) between the virtues and the vices.

pyx, a sacred vessel to contain the host or the Sacramental Bread.

quadrant moulding, a moulding in the form of a quarter-circle.

quatrefoil, a geometric pattern arranged in the shape of a four leaf clover.

quoin, corner stone at angle of a building.

Rayonnant architecture, the style of French Gothic architecture which prevailed roughly 1250–1350; characterised by large tracery windows and refined, linear mouldings. The name is derived from the radiating tracery of rose windows for which the style is well-known.

reliquary, a portable casket containing sacred relics.

retable, a painting or carved screen standing on the back of the altar.

ribs, arches used to carry a vault.

ridge rib, a species of lierne used to connect keystones along the crown of a vault.

roof, lean-to, roof with one inclined surface.

span, roof with two inclined surfaces.

frame, timber construction in which the inclined rafters are connected by tie-beams.

rosette, round boss with radiating petals or leaf forms.

rotunda, a building with a circular plan.

samite, a rich silk cloth often enriched with gold thread.

scriptorium, literally a place for writing, but generally applied to a group of scribes working in a single place.

scutcheon, to carve a shield-shaped base for a coat of arms.

seven liberal arts, the group of sciences which in medieval times were the basis of secular education. They are: grammar, dialectic, rhetoric, music, arithmetic, astronomy and geometry.

severies, compartments of a vault.

trapezoidal severy, a polygonal compartment with two parallel and two converging sides, e.g. part of a turning ambulatory.

silver stain method, the application of a solution of silver to colourless glass, producing in the furnace a range of yellows; or green when grey-blue glass was used. Discovered c. 1300.

solar, a private chamber in a residential suite, usually adjoining the hall of a medieval castle or palace.

spandrel, a triangular space between the curves of two adjacent arches or between an arch and the rectangle formed by the outer mouldings over it.

spire, tall conical projection from the roof of a tower.

imbricated spire, a spire covered with tiles to repel the rain.

splay, a chamfered edge at the side of a door or window.

springing, level at which an arch rises from its supporting member.

squinch, an arch placed diagonally at the angle of a square tower to support a round or octagonal tower.

stringcourse, a horizontal moulding along the face of a building dividing one register from another.

strut, part of a framework placed so that it can resist a thrust or pressure.

taïfas, the provincial dynasties which ruled in Moorish Spain after the break-up of the Caliphate in 1031.

tempera, a kind of paint in which the pigment is mixed with a glutinous vehicle, often egg white, that is soluble in water. It can only be used on a gesso or fresco ground.

teratological, referring to monsters.

terra sigillata, clay coloured by iron oxide, also known as Earth of Lemnos. Used for manufacturing moulded pottery in the Roman Empire, and the name is applied to this ware.

tetramorph, composite representation of the four Symbols of the Evangelists.

theophany, the appearance of God or other heavenly bodies to Man.

thermae, public baths built in classical times.

tierceron, rib other than the transverse or ogive, running from the main springer to the crown of the vault.

toric, rounded, as applied to a roll moulding or torus.

tracery, geometrical patterns of cut stone, used in windows, on walls, or freestanding.

bar tracery, tracery composed of thin strips of moulded stone, in which the proportion of void to solid is relatively high.

plate tracery, tracery in which the patterns are formed by perforating continuous surfaces of masonry.

rose tracery, tracery pattern radiating outward from a single centre, e.g. in round windows.

tribune, gallery above the aisles with an arcaded opening on to the nave.

depressed tribune, less than a full gallery,

but not walled off to form a passage-way, like a triforium.

triforium, passage with an arcade opening on to the nave, and a wall behind, corresponding to the rafters of an aisle or gallery roof.

triptych, an altarpiece or votive painting which has hinged panels on either side that, when closed, cover the central panel.

trompe-l'oeil, illusionary effect of reality.

trumeau, central support for a tympanum in a large doorway.

truncated dome, a dome that is flatter than a half circle in section.

tufa, rough porous stone.

tympanum, the space between the lintel and the arch above a doorway.

typological, symbolical representation based on the notion of cyclical repetitions or parallelisms.

uncial, a rounded type of script used in classical manuscripts.

vault, a form of masonry ceiling, based on the principle of the arch. In classical Roman buildings, and certain buildings inspired by classical Roman examples, the vaults carry the roof directly. In most Northern medieval buildings, the roof was carried on a completely independent timber structure above the vaults.

barrel vault, a continuous half-cylinder of masonry, sometimes articulated by transverse ribs.

transverse barrel vault, sections of barrel vault carried on transverse arches, at right angles to the main axis of the building.

pointed barrel, a barrel vault whose section is that of a pointed arch.

half-barrel, an asymmetrical vault whose section is a quadrant, used to cover side aisles or galleries, and at the same time to act as buttresses for the adjacent main vault.

annular barrel vault, a barrel vault over a turning ambulatory.

groined vault, originally perhaps conceived as two barrel vaults intersecting one another at right angles. So-called because the lines of intersection form groins. Few medieval groined vaults however, strictly conform to this definition. In the majority of cases, the groins are rationalised into simple arcs, and

the cells of the vault are contiguous spherical triangles of different radii.

ribbed vault, a vault of which the cells are carried on a structure of arches. The minimum number of arches required are two transverse, and two ogives. In a fully developed ribbed vault however the system is completed by wall ribs (formerets). Additional ribs were sometimes included, either to strengthen the structure, or for the sake of visual effects.

domical vault, vaults of which the crown rises much higher than the sides. Hence an approximation to the form of a dome.

level crown vaults, vaults in which the longitudinal section through the crowns is approximately horizontal.

semidome vault, half a dome used to vault apses.

quadripartite vault, a ribbed vault of which the web is divided into four cells by two intersecting ogives.

sexpartite vault, a ribbed vault of which the web is divided into six cells by two intersecting ogives and an additional transverse rib through the same keystone.

five-part and eight-part, a ribbed vault in which five or eight ribs converge on the central keystone.

vault cell, any part of the web of a vault as defined by ribs or groins.

volutes, the term strictly refers to the spiral scroll of a classical capital but its more general sense applies to any curved ornament particularly on capitals and consoles.

volvic stone, stone from the quarries of Volvic, a district in Puy-de-Dome, France, about 4 miles from Riom.

voussoirs, the wedge shaped stones which are used to build an arch.

web, the stone infilling between the ribs of a vault.

window embrasure, the splay of a window.

dormer windows, windows placed vertically on a sloping roof—thus normally in an attic.

rose window, circular window with radiating stone tracery.

window register, range of windows.

woodshaving pattern, an arrangement of superimposed volutes, sometimes used to decorate the sides of modillions and corbels in Romanesque architecture.

INDEX

CONTENTS OF VOLUME TWO

Gothic Art

The Close of the Middle Ages

CHAPTER VI. SLUTER AND VAN EYCK

CHAPTER VII

THE MEDIEVAL ASPECT OF THE ITALIAN RENAISSANCE

CONCLUSION

ILLUSTRATIONS

LIST OF ILLUSTRATIONS · ACKNOWLEDGEMENTS

GLOSSARY · INDEX